Information and Knowledge Organisation in Digital Humanities

Information and Knowledge Organisation explores the role of knowledge organisation in the digital humanities. By focussing on how information is described, represented and organised in both research and practice, this work furthers the transdisciplinary nature of digital humanities.

Including contributions from Asia, Australia, Europe, North America and the Middle East, the volume explores the potential uses of, and challenges involved in, applying the organisation of information and knowledge in the various areas of Digital Humanities. With a particular focus on the digital worlds of cultural heritage collections, the book also includes chapters that focus on machine learning, knowledge graphs, text analysis, text annotations and network analysis. Other topics covered include: semantic technologies, conceptual schemas and data augmentation, digital scholarly editing, metadata creation, browsing, visualisation and relevance ranking. Most importantly, perhaps, the book provides a starting point for discussions about the impact of information and knowledge organisation and related tools on the methodologies used in the Digital Humanities field.

Information and Knowledge Organisation is intended for use by researchers, students and professionals interested in the role information and knowledge organisation plays in the Digital Humanities. It will be essential reading for those working in library and information science, computer science and across the humanities.

Koraljka Golub is a Professor in Information Studies at Linnaeus University in Sweden. Her research focusses on knowledge organisation of digital document collections, especially on subject access.

Ying-Hsang Liu is a Senior Researcher in Information Studies at Oslo Metropolitan University in Norway. His research lies at the intersections of knowledge organisation, interactive information retrieval and human information behaviour.

Digital Research in the Arts and Humanities
Founding Series Editors: Marilyn Deegan, Lorna Hughes
and Harold Short
Current Series Editors: Lorna Hughes, Nirmala Menon,
Andrew Prescott, Isabel Galina Russell, Harold Short
and Ray Siemens

Digital technologies are increasingly important to arts and humanities research, expanding the horizons of research methods in all aspects of data capture, investigation, analysis, modelling, presentation and dissemination. This important series covers a wide range of disciplines with each volume focussing on a particular area, identifying the ways in which technology impacts on specific subjects. The aim is to provide an authoritative reflection of the 'state of the art' in technology-enhanced research methods. The series is critical reading for those already engaged in the digital humanities and of wider interest to all arts and humanities scholars.

The following list includes only the most-recent titles to publish within the series. A list of the full catalogue of titles is available at: https://www. routledge.com/Digital-Research-in-the-Arts-and-Humanities/book-series/ DRAH

The Power of Networks
Prospects of Historical Network Research
Edited by Florian Kerschbaumer, Linda von Keyserlingk-Rehbein, Martin Stark and Marten Düring

Transformative Digital Humanities
Challenges and Opportunities
Edited by Mary McAleer Balkun and Marta Mestrovic Deyrup

Medieval Manuscripts in the Digital Age
Edited by Benjamin Albritton, Georgia Henley and Elaine Treharne

Access and Control in Digital Humanities
Edited by Shane Hawkins

Information and Knowledge Organisation in Digital Humanities
Global Perspectives
Edited by Koraljka Golub and Ying-Hsang Liu

Information and Knowledge Organisation in Digital Humanities

Global Perspectives

Edited by
Koraljka Golub and Ying-Hsang Liu

Routledge
Taylor & Francis Group
LONDON AND NEW YORK

First published 2022
by Routledge
2 Park Square, Milton Park, Abingdon, Oxon OX14 4RN

and by Routledge
605 Third Avenue, New York, NY 10158

Routledge is an imprint of the Taylor & Francis Group, an informa business

British Library Cataloguing-in-Publication Data
A catalogue record for this book is available from the British Library

Library of Congress Cataloging-in-Publication Data
A catalog record has been requested for this book

ISBN: 978-0-367-67551-6 (hbk)
ISBN: 978-0-367-67568-4 (pbk)
ISBN: 978-1-003-13181-6 (ebk)

DOI: 10.4324/9781003131816

Typeset in Times
by KnowledgeWorks Global Ltd.

To Tara Iris, for being so inspirational and
so patient. May she grow up in a world where
everyone has free access to information and
knowledge.

To Tara Lisa, for being so inspirational and
so patient. May she grow up in a world where
everyone has free access to information and
knowledge.

Contents

List of figures x
List of tables xi
List of contributors xii
Foreword xix
Preface xxi
Acknowledgements xxiv

1 **Knowledge organisation for digital humanities:**
 An introduction 1
 KORALJKA GOLUB, AHMAD M. KAMAL,
 AND JOHAN VEKSELIUS

PART I
Modelling and metadata 23

Modelling of cultural heritage data 24

2 **Modelling cultural entities in diverse domains**
 for digital archives 25
 SHIGEO SUGIMOTO, CHIRANTHI WIJESUNDARA,
 TETSUYA MIHARA, AND KAZUFUMI FUKUDA

Harmonising conceptual models 43

3 **Collection-level and item-level description in the digital**
 environment: Alignment of conceptual models IFLA LRM
 and RiC-CM 44
 ANA VUKADIN AND TAMARA ŠTEFANAC

Metadata aggregation 63

**4 Linked open data and aggregation infrastructure in the cultural
heritage sector: A case study of SOCH, a linked data aggregator
for Swedish open cultural heritage** 64
MARCUS SMITH

Metadata enrichment 86

**5 A semantic enrichment approach to linking and enhancing
Dunhuang cultural heritage data** 87
XIAOGUANG WANG, XU TAN, HENG GUI, AND NINGYUAN SONG

**6 Semantic metadata enrichment and data augmentation
of small museum collections following the FAIR principles** 106
ANDREAS VLACHIDIS, ANGELIKI ANTONIOU, ANTONIS BIKAKIS,
AND MELISSA TERRAS

From data to knowledge 130

**7 Digital research, the legacy of form and structure and
the ResearchSpace system** 131
DOMINIC OLDMAN

PART II
Information management 155

Management of textual resources 156

8 Research access to in-copyright texts in the humanities 157
PETER ORGANISCIAK AND J. STEPHEN DOWNIE

**9 SKOS as a key element for linking lexicography
to digital humanities** 178
RUTE COSTA, ANA SALGADO, AND BRUNO ALMEIDA

Preserving DH research outputs 205

**10 Linked data strategies for conserving digital research
outputs: The shelf life of digital humanities** 206
FLORIAN KRÄUTLI, ESTHER CHEN, AND MATTEO VALLERIANI

PART III
Platforms and techniques 225

Specific platforms 226

11 **Heritage metadata: A digital *Periegesis*** 227
 ANNA FOKA, KYRIAKI KONSTANTINIDOU, NASRIN MOSTOFIAN,
 LINDA TALATAS, JOHN BRADY KIESLING, ELTON BARKER,
 O. CENK DEMIROGLU, KAJSA PALM, DAVID A. MCMEEKIN,
 AND JOHAN VEKSELIUS

Data analysis techniques 243

12 **Machine learning techniques for the management
 of digitised collections** 244
 MATHIAS COECKELBERGS AND SETH VAN HOOLAND

User interfaces 260

13 **Exploring digital cultural heritage through browsing** 261
 MARK M. HALL AND DAVID WALSH

 Index 285

Figures

2.1 Digital archive outline 29
2.2 Conceptual/intangible objects and physical/embodied
 objects (CEDA model) 32
2.3 Data Models for Manga, Anime and game 36
2.4 JDTA data model 36
5.1 The workflow of the semantic enrichment approach
 to Dunhuang CH Data 93
6.1 Semantic relationships of co-located museum exhibits
 in room 9 (Archaeological Museum of Tripoli) 116
6.2 Connections across museums based on the concept
 of religious activities 119
9.1 Lexicographical categories for modelling the list
 of abbreviations in SKOS 190
9.2 Part of speech abbreviations in SKOS (noun and adjective) 191
9.3 Language abbreviations in SKOS (Portuguese and French) 192
11.1 Semantic annotation in Recogito of the word eikōn
 (meaning interchangeably icon, painting, likeness or image)
 in Pausanias's *description of Greece* 6.13.11, including
 gazetteer entry and organised free-text tags 235
13.1 The DMM generation process. The two steps in the item
 processing stage can be parallelised, but the remainder
 of the processing workflow is linear 271
13.2 The Museum Map browsing interface showing
 the floorplan interface for exploring the collection
 in the foreground and the grid of items for a single room
 in the background. The currently visited room is
 highlighted, as is the room the user has moved their
 mouse over. For the room the user's mouse is hovering
 over, a preview is shown in the bottom-left corner 277

Tables

3.1	RiC - LRM harmonisation	56
5.1	Principal KOS per domain and metadata standard	91
5.2	Primary dataset for enhancing Dunhuang CH data	94
9.1	Sample matches between the VOLP-1940 word classes and Universal Dependencies Part-of-Speech values	189
12.1	Examples of the results: URIs, labels and tokens for topics	255
13.1	The NLP heuristics. The "Heuristic" column shows the heuristic pattern, where A and B are one or more words. The "Extracted" column shows the extracted concepts and the order in which they are added to the classification value. The final column shows an example for each heuristic	272

List of Contributors

Bruno Almeida is a researcher at ROSSIO Infrastructure for Social Sciences, Arts and Humanities and an integrated member of NOVA CLUNL, the Linguistics Centre of NOVA University of Lisbon, Portugal. His research interests include terminology, linguistic Linked Data and knowledge organisation for digital humanities and cultural heritage applications.

Angeliki Antoniou is an Assistant Professor in the Department of Archival, Library & Information Studies at the University of West Attica (Greece) specialising in adaptive educational technologies in cultural information. Her research lies at the intersection of social science, humanities and cultural informatics, with a particular emphasis on profiling and personalisation.

Elton Barker is Professor of Greek Literature and Culture at The Open University in the United Kingdom. His research interests include the representation of space and place in non-modern narrative geographies, for which he has been developing digital methods and annotation tools since 2008. A founding member of the Linked Open Data initiative Pelagios, he co-founded the Pelagios Network in 2019, an open association for developing the ecosystem of online resources about places.

Antonis Bikakis is an Associate Professor in the Department of Information Studies at University College London, United Kingdom. His main research interests are in knowledge representation, computational argumentation, multi-agent systems, semantic technologies and the development of knowledge-based systems for intelligent environments and Cultural Heritage applications.

John Brady Kiesling is an independent researcher, writer and editor based in Athens, Greece and the creator of the award-winning ToposText app and website. A former diplomat, he has written books on diplomacy and political violence. His current focus is on organising textual and geographic information about Greco-Roman antiquity to maximise public engagement with the past.

Esther Chen is the Head of the Library at the Max Planck Institute for the History of Science, Berlin. Her research interests focus on the benefits of linked open data for library and research data and more broadly on the changing role of libraries in the digital humanities.

Mathias Coeckelbergs is a teaching assistant and PhD researcher in Information Science at the Université libre de Bruxelles (Belgium). He is working on a project in collaboration with the Quantitative Lexicology and Variational Linguistics (QLVL) department at KU Leuven (Belgium) on the use of text mining methods to detect and model intertextuality in ancient Hebrew. His broader research interests include applying machine learning to ancient literature, archives and libraries.

Rute Costa is the Head of NOVA CLUNL, the Linguistics Centre of NOVA University of Lisbon and Associate Professor with tenure and habilitation in linguistics, specifically in lexicology, lexicography and terminology, at the School of Social Sciences and Humanities of the NOVA University of Lisbon, Portugal. Her research interests include terminology, lexicography, linguistic Linked Data and knowledge organisation applied to subject fields related to humanities, medicine and industry.

Cenk Demiroglu is a researcher at the Department of Geography and Humlab at Umeå University in Sweden. His research focusses on the use of geographical information systems in combination with other methodologies for understanding social, environmental and humanistic phenomena.

J. Stephen Downie is the Associate Dean for Research and a Professor at the School of Information Sciences, University of Illinois at Urbana-Champaign. He is the Illinois Co-Director of the HathiTrust Research Center (HTRC). Professor Downie is a co-principal investigator on the "Scholar-Curated Worksets for Analysis, Reuse & Dissemination" (SCWAReD) project at HTRC, funded by the Andrew W. Mellon Foundation.

Anna Foka is Associate Professor in Digital Humanities in the Department of Archives, Library and Information Science and Museum and Heritage Studies and the Director of the Centre for Digital Humanities at Uppsala University in Sweden. Her research is at the intersection of information technology and historical disciplines, focussing on digital cultural heritage. Her current research interests are in digital research infrastructures for information organisation and knowledge production.

Kazufumi Fukuda is a Lecturer and Assistant Professor in the Department of Digital Entertainment at the International Professional University of Technology in Osaka, Japan. His main research interests are in game studies, metadata for popular culture resources and digital humanities.

He is a member of the development task team for the Media-Arts Database, a general catalogue for Japanese visual media organised by the Agency for Cultural Affairs.

Koraljka Golub is the Head of the iSchool and a Professor in Information Studies at Linnaeus University in Sweden. Her research at the intersection of knowledge organisation and information retrieval focusses on subject access to cultural heritage digital collections as well as databases of research articles, especially for humanities researchers. She explores how best to combine automated approaches with manual subject indexing by information professionals and end users.

Heng Gui is a PhD student at the School of Information Management at Wuhan University, China. His research interests include social media, data mining, digital humanities and semantic publishing. In his research, he applies mathematical models and data models to scientific articles and digital humanities resources for better knowledge discovery and service delivery.

Mark Michael Hall is a Lecturer in Computing and Communications at the Open University, United Kingdom. His research interests focus on the intersection between computation and the human user, particularly in information retrieval and the digital humanities. He is particularly interested in helping users explore large data sets that they are unfamiliar with, or where the users lack the expertise to know what they could find and how to find it.

Seth van Hooland leads the SEMIC action at the European Commission (EC), focussing on semantic interoperability between EU Member States. Before joining the EC, he was an associate professor at the Université libre de Bruxelles (Belgium), where he continues his teaching on topics such as information architecture and metadata. His research focusses on the documentation of cultural heritage and the usage of Linked Data.

Ahmad M. Kamal is a Senior Lecturer in the Department of Cultural Sciences at Linnaeus University, Sweden, where he teaches in the digital humanities as well as library and information science. His central research interest explores people's interactions with information across a range of contentious contexts, such as political transition or irregular migration, with special attention to the dual roles of digital technologies as both an object of study and the means to study.

Kyriaki Konstantinidou is an affiliated researcher on the project "Digital Periegesis" at the Centre of Digital Humanities, Uppsala University, Sweden. She also teaches in the program "Studies in Greek Civilization" at the Hellenic Open University (Greece). Her current research interests include the application of digital tools to ancient Greek texts, especially in relation to aspects of space, identity and ancient Greek religion.

Florian Kräutli is a Digital Humanities Specialist and Knowledge Graph Engineer at the Swiss Art Research Infrastructure (SARI), University of Zurich, Switzerland and a visiting researcher at Leuphana University Lüneburg, Germany. From 2016-2020, Kräutli led research activities in the digital humanities at the Max Planck Institute for the History of Science in Berlin. His research focusses on digital methods for knowledge production in the humanities, specialising in knowledge representation and visualisation.

Ying-Hsang Liu is a Senior Researcher at Oslo Metropolitan University in Norway. His research lies at the intersections of knowledge organisation, interactive information retrieval and human information behaviour, with particular emphasis on the design and evaluation of interactive information technologies. His research has focussed on issues related to individual differences in user perceptions and the relationship between visual search and user search behaviour.

David McMeekin is a Senior Lecturer within the Computing Discipline at Curtin University in Australia. His research interests are in the application of computer science, such as semantic web technologies, in various research disciplines. Some of his current research lies in semantically annotating 3D heritage datasets, the Digital Periegesis project and the development of the Australian Cultural Date Engine to aggregate cultural data for the creation of new knowledge retrieval capabilities.

Tetsuya Mihara is an independent IT consultant engineer, manga editor and researcher. He was an Assistant Professor at the Faculty of Library, Information and Media Science at the University of Tsukuba, Japan, until March 2021. He has been involved in the Media-Art Database project at the Agency for Cultural Affairs, Japan and develops linked open data for Japanese pop culture, especially manga, anime and video games.

Nasrin Mostofian is an affiliate researcher at the Centre for Digital Humanities in the Department of Archives, Libraries and Museums, Uppsala University and an independent computational linguist and Persian teacher. Her interest in both the humanities and computer science, as well as her multidisciplinary background, paved the way for her to join the Digital Periegesis project in 2019.

Dominic Oldman is a senior curator and Head of ResearchSpace at the British Museum and a graduate researcher in history at the University of Oxford, United Kingdom, studying knowledge representation in history. He is the deputy co-chair of the CIDOC CRM. ResearchSpace is a processural, dialectic and relations-based research environment using ontological commitment, historical context and argumentation.

Peter Organisciak is an Assistant Professor in Library and Information Science at the University of Denver, USA. Professor Organisciak's work

is grounded in large-scale text analysis applications for digital libraries, as well as approaches to scholarship over sensitive datasets. He previously worked at the HathiTrust Research Center.

Kajsa Palm is a Developer and Interaction Designer working at Humlab at Umeå University in Sweden. Her current focus is to help visualise material and data with graphic design in a way that supports the end user.

Ana Salgado is a researcher at NOVA CLUNL, the Linguistics Centre of NOVA University of Lisbon, Portugal, currently the recipient of a grant under the ELEXIS infrastructure. She is also a doctoral candidate in translation and terminology at NOVA FCSH. Ana is a lexicographer and is the coordinator of the first digital dictionary and of the orthographic vocabulary of the Portuguese language at the Lisbon Academy of Sciences (ACL).

Marcus Smith is an operations officer at the Swedish National Heritage Board. He has previously worked for the Archaeology Data Service and the Council for British Archaeology. He now works with the SOCH linked open data aggregation platform, digital archaeological fieldwork documentation and the digitisation of runic inscriptions.

Ningyuan Song is a postdoctoral researcher in the School of Information Management, Nanjing University, China. He researches knowledge organisation, semantic publishing and Digital Humanities and is committed to exploring semantic technology to organise the content of scientific literature. He also researches the argumentation structure, argumentation mining and description within scientific articles and the semantic representation of narrative literatures and images.

Shigeo Sugimoto is a professor emeritus at the University of Tsukuba, Japan. He was a professor at the Faculty of Library, Information and Media Science, University of Tsukuba until March 2019. His research interests include theoretical and technological aspects of metadata for digital archives of cultural and historical resources in the Linked Data environment and the longevity of digital archives.

Tamara Štefanac works as an Archivist in the Preservation and Storage Department of the National and University Library in Zagreb, Croatia. In her doctoral dissertation she explored concepts related to the description of archival material held in museums. Her other research interests include information representations and the social life of metadata, interoperability and cross-walks between heritage institutions, as well as the role of records as evidence and the role of information in support of societal needs.

Linda Talatas is an associate researcher at the University Paris 1 Panthéon-Sorbonne, France and an affiliated researcher at Uppsala University

(Center for Digital Humanities), Sweden. She holds a double PhD in Archaeology (Paris 1, France and University of Athens, Greece). Her current research interests lie in the use of digital tools and ancient texts to bring together various aspects of Greek social and religious life, relations with animals, gender dynamics and spatial movements.

Xu Tan is a PhD student in the School of Information Management at Wuhan University, China. Her research interests are in knowledge organisation and representation, digital humanities and cultural computing, particularly in the ideas and technologies of Linked Data and knowledge graphs to enhance the quality and discoverability of cultural heritage data. Her theoretical research has been put into practice, including in the Dunhuang Grottoes Knowledge Graph.

Melissa Terras is Professor of Digital Cultural Heritage at the University of Edinburgh, researching technical, procedural and theoretical issues surrounding digitisation of the past and their implications for interdisciplinary research. Terras leads digital research at the University of Edinburgh's College of Arts, Humanities and Social Sciences, as Director of the Edinburgh Centre for Data, Culture and Society and is Director of Research in the Edinburgh Futures Institute.

Matteo Valleriani is Research Group Leader at the Max Planck Institute for the History of Science (Germany), Honorary Professor at the Technische Universität Berlin (Germany) and Professor for Special Appointment at Tel Aviv University (Israel). His research focusses on the Hellenistic period, the late Middle Ages and the early modern period.

Johan Vekselius is an independent scholar, a political scientist and an ancient historian. His research interests lie mainly in emotions and politics in ancient Rome. His work locates ancient emotions in intersections such as public-private, status-gender, Rome-Greece and literature-history. His latest project, Mapping Roman Emotions, builds a digital map of political emotions in the city of ancient Rome.

Andreas Vlachidis is an Assistant Professor in Information Science in the Department of Information Studies at University College London, United Kingdom and an external member of the Alan Turing Research Interest Group (Humanities and Data Science). His main research interests are in natural language processing, knowledge bases, ontologies and metadata semantics, particularly in automatic metadata generation with respect to conceptual reference models and knowledge base resources.

Ana Vukadin is the bibliographic standards and metadata officer at the National and University Library in Zagreb, Croatia. Her main research interests are knowledge organisation, conceptual data models, ontologies and cross-domain data interoperability in the heritage sector.

David Walsh is a Senior Lecturer in Computer Science at Edge Hill University, United Kingdom. He is also a PhD student in the Information School at the University of Sheffield. His research interests include information seeking and user experience design to find potential solutions to human-centred problems, mainly focussing on the digital cultural heritage sector.

Xiaoguang Wang is the Associate Dean and a Professor in the School of Information Management at Wuhan University in China. He is a founder a founder member and the Director of the Centre of Digital Humanities at Wuhan University. His research focusses on digital asset management, knowledge organisation, semantic publishing and digital humanities.

Chiranthi Wijesundara is a Senior Assistant Librarian at the Main Library, University of Colombo, Sri Lanka and serves as a visiting lecturer at the National Institute of Library and Information Sciences at the same university. She has published several scholarly articles in the field of information science and her research interests are in metadata modelling for digital archives and metadata aggregation via cross-walks between memory institutions.

Foreword

Digital humanities and knowledge organisation have matured independently as areas of study over the last several decades. Each field has much to offer the other and this timely volume brings them into conversation.

The digital humanities have evolved from a niche area of textual analysis and concordances into a set of methods and practices that is central to humanities scholarship. The array of questions that can be asked of digital resources has expanded in parallel with the sophistication of technologies available to digitise extant content and to create "born digital" content. Scholars can explore any combination of historical, cultural, or linguistic inquiry using data (or "capta") from archives, open corpora, administrative records, publisher databases, websites and more. The plethora of content available to examine in digital form and the diversity of that content, poses immense challenges for knowledge organisation.

In parallel, mechanisms for knowledge organisation have evolved from text data retrieval to manipulating multimedia materials in all imaginable combinations. Today's information search over text, images, sound, numerical models, geographical regions and other data types was inconceivable only a few decades ago, when information retrieval consisted of humans typing Boolean queries at keyboards. These are not merely technical advances. Rather, they depend upon epistemological advances in metadata, thesauri, syntactic and semantic structure and interoperability.

The more sophisticated the array of content and technologies available for intellectual inquiry, however, the more difficult is the markup. To organise knowledge, assumptions are made about who will ask what questions of the content and in what form. The more malleable the content, the broader the audience and the longer the term for which access is to be sustained, the harder these challenges become (Borgman et al., 2019). As scholarship moves from concerns with text mining to data mining, all manner of new legal, institutional, economic and policy issues arise. These challenges include university contracts with publishers that determine allowable usage, copyright and ownership of content, privacy, data protection and open science policies (Borgman, 2020).

The digital humanities can serve as a fruitful testbed for research on knowledge organisation. Conversely, knowledge organisation methods are a fruitful testbed for research in the digital humanities. At the intersection of these areas also lies critical practice, as libraries, archives and museums – the memory institutions – acquire, create, organise, exploit and steward digital resources. These areas have so much to learn from each other that a volume such as this one is long overdue. The editors have assembled a distinguished group of authors from multiple disciplines and multiple continents, thus ensuring a diversity of topics and ideas. Similarly notable is the scale of material covered in a single volume, spanning historical analysis, current curricula, research methods and practical applications.

Lastly, the editors, authors and publisher are to be commended for disseminating this volume as an open access monograph, in the spirit of digital scholarship, to ensure that the lessons contained herein will reach as broad an audience as possible.

Christine L. Borgman, Distinguished Research Professor
in Information Studies and Presidential Chair Emerita
University of California, Los Angeles

References

Borgman, Christine L. (2020). "Whose Text, whose Mining, and to whose Benefit?" *Quantitative Science Studies*, 1(3), 993–1000. https://doi.org/10.1162/qss_a_00053

Borgman, Christine L., Andrea Scharnhorst, and Milena S. Golshan. (2019). "Digital Data Archives as Knowledge Infrastructures: Mediating Data Sharing and Reuse." *Journal of the Association for Information Science and Technology*, 70(8), 888–904. https://doi.org/10.1002/asi.24172

Preface

In recent years, we have been witnessing a significant growth in the number of edited volumes in the field of digital humanities (DH). The one topic that seems to have been buried under themes such as digital methods or theoretical discussions of the field is the role of knowledge organisation in the digital humanities. This work aims to address that gap by providing a range of international perspectives and approaches to organising information in DH.

Although knowledge organisation has in the past been viewed as one of the major disciplines within the field of Information Studies, it has found applications in numerous areas because the need to organise data, information or knowledge is omnipresent. However, we have also witnessed that, in many domains of human endeavour, information is being organised ad hoc, often resulting in systems that underperform and even effectively prevent access to data, information and knowledge. In order to help ensure that the best solutions are found for knowledge organisation in the digital humanities, it is important to bring the two communities of research and practice together, to explore potential solutions and jointly address challenges. This book attempts to achieve that by providing state-of-the-art examples of interdisciplinary projects and case studies while also discussing the challenges and suggesting a future agenda. Our hope is that this volume helps set the stage for evolving knowledge organisation in DH into a truly transdisciplinary approach that seamlessly harnesses the synergies of its component parts.

To produce this volume, we solicited book chapter proposals from an open call followed by a review and selection process, resulting in the final 12 chapters and 1 additional, introductory chapter. Following the introductory chapter to the field of knowledge organisation for DH, the first part of the book, Modelling and Metadata, comprises six chapters which address the challenges of modelling cultural heritage data, related conceptual models, approaches to metadata aggregation and metadata enrichment, as well as the need to move from organising data to organising knowledge. This is also the largest part of the book, reflecting the fact that metadata is the dominant area of research within the field of knowledge organisation for digital

humanities research. The second part, Information Management, consists of three chapters which discuss the management of in-copyright texts and lexicographical resources as well as DH research outputs. The third part, Platforms and Techniques, contains three papers which focus on specific platforms needed to support DH research, including one on data analysis techniques and one on browsing visualisation techniques to be deployed in user interfaces to cultural heritage collections. The three-part structure of the book is intended to help guide the reader who is interested in all of the topics; however, each part can be read independently of the other parts and each chapter can be read on its own.

The book is envisioned as a guide for university teachers, researchers and working professionals interested in the role of knowledge organisation in DH, and for those interested in exploring how both research and applied areas of Information Studies have traditionally intersected with or impacted studies in DH, as well as those interested in taking these developments to the next level. Each chapter provides an introductory overview of the topic under discussion, exemplified by a case study, concluding with reflections and suggestions for future work. As such, the volume will meet the needs of those who work with DH but are unfamiliar with the field of knowledge organisation and vice versa. The book could be used in postgraduate digital humanities programs, thus broadening pedagogy in DH from knowledge organisation perspectives. Similarly, it could also be used as a supplementary resource in advanced information studies courses on knowledge organisation, illustrating the potential for its application in the digital humanities. With its interdisciplinary and international perspectives, this work provides a good starting point for discussions on how knowledge organisation methodologies impact upon digital humanities and the other way around.

The book is by and large an international volume, as its 41 authors are affiliated with universities and related organisations in 16 countries on 4 continents: Asia (China, Israel, Japan, Sri Lanka), Australia, Europe (Belgium, Croatia, France, Germany, Greece, Norway, Portugal, Sweden, Switzerland, United Kingdom) and North America (United States of America). In addition to providing international perspectives, this wide pool of authors demonstrates the cross-sectoral nature of digital humanities: as many as eight authors are affiliated with a cultural heritage institution, a heritage board and the European Commission; two authors are IT developers.

In addition to identifying the need for a book at the intersection of digital humanities and information studies, another source of inspiration for this volume came from the work of the iSchools Organisation's Committee on Digital Humanities, in which the editors have been taking part since its start in 2018. Many of the authors of chapters are also affiliated with universities that are members of the iSchools Organisation: Curtin University in Australia, Linnaeus University in Sweden, Nanjing University in China, NOVA University Lisbon in Portugal, Oslo Metropolitan University in

Norway, the University of Denver in the United States, University College London in the United Kingdom, the University of Illinois Urbana-Champaign in the United States, the University of Sheffield in the United Kingdom, the University of Tsukuba in Japan and Wuhan University in China.

Still, as an edited volume of invited chapters, the book provides but a limited snapshot of international perspectives on a sample of topics from knowledge organisation in digital humanities. Examples of themes that could be more represented are automated methods and techniques such as entity linking in natural language processing or deep learning models for semantic representations. User perspectives in information interface design and in evaluation are also underrepresented. Finally, we would have liked to see more of humanities-driven knowledge organisation research rather than vice versa. Perspectives from Africa and South America are sadly absent.

On a final note, editing an interdisciplinary volume can be challenging as a result of different terminologies, research paradigms and writing styles; we have gained immensely from this work and learnt how to further widen our horizons inherited from our own disciplinary backgrounds. It is our wish that this book provides the same inspiration for the reader and sparks new interest in joining forces to devise and enable transdisciplinary approaches to knowledge organisation in the digital humanities.

Acknowledgements

We would hereby like to give our deepest thanks to each of the authors for their contributions of chapters, for their time and expertise, as well as for all of their hard work and dedication in addressing our frequent and numerous demands on their time. Special thanks are due to our colleagues Drahomira Cupar, Talat Chaudhri, Ahmad Kamal and Johan Vekselius for their editing help. We are also grateful to the editors at Routledge for all of their valuable feedback from the initial proposal to the final product: this has significantly improved the book's content, organisation and presentation.

We would also like to thank Linnaeus University for providing the funding to make this book open access and for facilitating the editing of the book. Specific thanks goes to the iInstitute (Linnaeus University's iSchool), the Department of Cultural Sciences at Faculty of Arts and Humanities and Linnaeus University Library.

Koraljka Golub and Ying-Hsang Liu

1 Knowledge organisation for digital humanities

An introduction

Koraljka Golub, Ahmad M. Kamal,
and Johan Vekselius

Introduction

The field of digital humanities (DH), which emerged as the umbrella term in the mid-2000s for humanities scholarship using computational techniques, has hosted many contentious discussions on the field's identity and purview, with think pieces positing "what DH means" and "what counts as DH" becoming a genre of its own (Kirschenbaum 2010). As the field has continued to develop since then, settling on a familiar assemblage of techniques, concepts, schools, tools and so on, it has nevertheless remained open to new opportunities for further exploration and growth. One avenue we see for the advancement of DH is a deeper engagement with the discipline of knowledge organisation (KO). Some aspects of KO have appeared piecemeal within the greater library of DH endeavours; as a result, introductory DH materials commonly include some facets of KO, e.g., the chapter on metadata in Drucker's coursebook (2021). Nevertheless, KO is not commonly engaged with head-on within the field. The wider repertoire of understandings, skills and resources that KO has to offer has been overlooked by the wider community of DH scholars. This volume addresses that gap by providing a range of international perspectives and approaches which reiterate the value of KO for the DH.

KO is a major discipline within the field of information science, and is largely concerned with the practices of institutions such as libraries, archives and museums (LAMs) as they organise, catalogue and classify resources for communities of users (e.g., researchers, students, the public or company staff). Yet the need to systematically organise information has become universal in the digital era. Ad hoc solutions from those unfamiliar with KO to manage new collections of data can suffer from problems of sustainability, scalability or tractability: these are challenges that DH researchers commonly face, as variously documented in some of the case studies presented in this volume. We argue that bringing together the understanding of the KO community and ambitions of the DH community can help provide strategic solutions to the challenge of managing information, thereby supporting better information retrieval systems, improving the stewardship of

DOI: 10.4324/9781003131816-1

data, creating more venues for information access, and discovering more meaningful information.

To support our argument for the importance of KO in DH, this book presents examples of interdisciplinary and cutting-edge DH case studies in which the practice of organising information is put at the forefront. The contributions by 41 authors, from 16 countries across 4 continents, represent an international range of perspectives, challenges and solutions. By exploring the various findings, the book posits a future research agenda for the field of DH where the role of KO is more clearly delineated, both in identifying the long-standing issues in DH which KO can help address and how DH scholars and practitioners could incorporate KO moving forward. This, we hope, will set the stage for a new transdisciplinarity in DH, a field whose defining characteristic since its inception – beyond its adoption of digital methods – has been in a constant search for partnerships and collaborations to realise new opportunities for knowledge production and sharing.

This chapter aims to highlight on a general level the relevance of KO for the DH, thereby providing an overarching context for the book and integrating the various contributions within it. After briefly introducing the fields of KO and DH, the chapter reviews how the two fields intersect, both in regards to work in DH in the cultural heritage sector and in academic scholarship (Background). It specifically focusses on those themes which are reflected in the contributed book chapters, summaries of which are then presented (Chapters overview). The end of the chapter (Moving forward) distils two constantly recurring issues in DH, based on the contributions, information discovery and information representation, which we argue KO is well positioned to help us address.

Background

Knowledge organisation and related research fields

The discipline of KO "is about describing, representing, filing and organising documents and document representations as well as subjects and concepts both by humans and by computer programs" (Hjørland 2016a). The practices of KO are omnipresent in people's lives, from the shopping list to the legal code and implements different types of KO systems (lists, subject headings, thesauri, taxonomies, classifications, catalogues etc.).

In order to support the organisation of information resources, the field of KO creates various standards and guidelines to create representations of information objects (e.g., library books, archival documents museum artefacts) such as those held by LAMs. The resulting representations are called metadata or data about data. For more nuanced definitions and discussions thereof, see Mayernik (2020); for an in-depth overview of related standards, see Zeng and Qin (2016). Examples of standards for data elements include cataloguing guidelines such as Resource Description and Access (RDA)

used by libraries, Cataloging Cultural Objects (CCO) used by museums and Describing Archives: A Content Standard (DACS) for archives. Standards for data values encompass controlled vocabularies such as the Library of Congress Subject Headings (LCSH) or the Dewey Decimal Classification (DDC), which offer consistency in assigning subject headings and classifying materials, respectively. While many of the standards were first created before the advent of computers, they have been adapted to meet the new demands for enabling data exchange. In fact, many of the developments in cultural heritage metadata in recent decades have been driven by the transition from paper catalogue records to online catalogues, especially with the establishment of the World Wide Web.

Another term for KO is *information organisation* (cf. Hjørland 2012; Hjørland 2016a), and in this volume the two terms are used interchangeably. The distinction between *knowledge* and *information* themselves, along with the related terms *data* and *wisdom*, is frequently discussed in the literature (for an overview, see Bates 2010). The ever-popular Data–Information–Knowledge–Wisdom (DIKW) pyramid is often used to illustrate a hierarchical relationship between the four concepts, from the least processed (data) to the most processed and contextual (wisdom). But the distinctions between these concepts, as well as the assumptions behind them, carry significant implications which have been the subject of contention. For instance, the perception of data as a "raw" descriptive unit has been well deconstructed (see Gitelman 2013), with prominent voices within DH suggesting the notion of *capta* in the place of *data* to emphasise the active interpretation that goes into the constitution of data (Drucker 2011). In turn, Oldman (Chapter 7) criticises any information system based on "data" as being ineffective for DH, especially for historical research and, as such, he calls for KO approaches based on textual narratives to facilitate knowledge creation and mediation.

KO is an important subfield of information studies or information science which is "the science and practice dealing with the effective collection, storage, retrieval, and use of information" (Saracevic 2009). Closely related to KO are several other research fields and disciplines. One is information retrieval (IR), which is focussed on developing and evaluating computational systems that provide information to address a user's search requirements (see Glushko 2016); like KO, IR is a separate sub-discipline within information science, but much of the research in IR occurs within the field of computer science as well, focussing on designing and modelling retrieval systems. Another related area within information science is information behaviour (IB), which investigates people's information needs, seeking, using and sharing it across different contexts and roles (Case and Given 2016). Human computer interaction (HCI), which studies the design of computer interfaces for optimal user experience, intersects with several disciplines, including information science. HCI is relevant to KO given that user interfaces play an important role in how effectively KO and IR systems

can be leveraged. We regard all these fields as being closely related because they all contribute to understanding the complexities surrounding KO, IR and information use. In order to improve information access in general and in interdisciplinary fields such as the DH in particular, it is important to employ KO correctly in conjunction with each related area of research.

Digital humanities

The Oxford English Dictionary defines DH as "an academic field concerned with the application of computational tools and methods to traditional humanities disciplines such as literature, history, and philosophy" ("Digital humanities", 2020). While adequate, this definition belies the continuous discussion and (re-)formulation by scholars and practitioners across a range of disciplines in how to describe the field (see Terras, Nyhan, and Vanhoutte 2013). Regardless, the field of DH is understood to sit at the intersection of computation and the humanities. Its roots are in the field of humanities computing, with early work reaching as far back as the 1940s (Busa 1980). The name "digital humanities" itself emerged in the early 2000s as a more representative and contemporary designation for the field (Vanhoutte 2013; Nyhan and Flinn 2016).

In this book DH is discussed in its broad sense while taking into consideration specific affordances, as set out in the definition formulated by Gardiner and Musto (2015, 4): "harnessing computing power to facilitate, improve, expand and perhaps even change the way humanists work". Since, as noted above, the field is at the crossroads of the humanities and computation, DH unites traditional humanities disciplines such as archaeology, history, philosophy, linguistics, literature, art, music and cultural studies with computing tools and techniques, e.g., hypertext/media, data visualisation, IR, statistics, 3D modelling, data/text mining, digital mapping and spatial analysis. But beyond DH scholars using computational methods to answer traditional research questions, we also see them developing new perspectives and new questions that can be solved through pioneering methods brought about by the digital transformation of knowledge creation (Kansa and Kansa, 2021). For an overview of DH and its concepts, technologies and methods, see Schreibman, Siemens, and Unsworth (2016) or Drucker (2021).

A consequence of DH's hybridity is the new-found importance of infrastructures and collaborations. Bringing together traditional scholarship and cutting-edge technical expertise, while also leveraging new repositories of digital assets, entails greater coordination and cooperation between individuals and institutions than is typical in humanities scholarship. It is therefore unsurprising to see LAMs playing a prominent role both in supporting DH scholarship and also undertaking their own DH initiatives. And it is this same impetus for the provision of digital cultural heritage (whether for scholarship or outreach) where the relevance of KO for DH can be most clearly seen.

Knowledge organisation for digital humanities

In the cultural heritage sector, KO has always been an essential component of managing collections. But KO also takes on a new level of relevance in the field of DH, both for those within LAMs who are already intimately familiar with KO systems and for scholars whose interactions with KO are generally quite limited, e.g., to conducting literature searches in library databases. The difference between those within DH working in the cultural heritage sector and those working in pure scholarship is compounded by the different orientations of their respective DH projects: in the cultural heritage sector DH initiatives are usually aimed at expanding access to cultural objects, whereas specific research questions shape DH projects in academia. Given these distinctions, we discuss each context in turn: first KO for DH within the cultural heritage sector, and then its role within academic research.

Within cultural heritage

We have already mentioned some examples of KO systems that have been developed for LAMs over the years. Today, the cultural heritage sector is once again responding to a dramatic shift in its information infrastructure in the form of the Semantic Web (Web 3.0), as an extension of the World Wide Web (Berners-Lee, Hendler, and Lassila 2001). The Semantic Web is envisioned to go beyond simply linking web pages for human navigation to linking entire datasets, thereby allowing computers to connect and disambiguate data or generate novel information. One of the foundational technologies in this ambitious endeavour is internationalised resource identifiers (IRIs) that uniquely identify concepts for people, objects, epochs, genres etc., represented by different terms. For instance, Mahatma Gandhi (also Mohandas Karamchand Gandhi, મોહનદાસ ગાંધી etc.) could be represented as a machine-readable IRI (https://viaf.org/viaf/71391324/); the same could be done for New Delhi (http://vocab.getty.edu/tgn/7001534) and the practice of nonviolent resistance (https://dbpedia.org/resource/Nonviolent_resistance).

Semantic Web technologies like IRIs and related standards allow for the aggregation of metadata from LAMs in order to access cultural heritage across otherwise isolated collections. However, data aggregation preceded the advent of IRIs. One example is Social Networks and Archival Context (SNAC), an international cooperative of archives, libraries and museums combining archival records with authority files from different institutions. Today the largest data aggregator for LAMs in Europe, Europeana, provides access to over 50 million digitised objects (Europeana 2021). Beyond facilitating data aggregation initiatives, Semantic Web technologies also allow datasets of cultural heritage objects to be linked to external data from across the Web, a concept known as linked data (LD), as defined by

the Word Wide Web Consortium (2015). Furthermore, if such data is made openly available, linked open data (LOD) is created.

Semantic Web technologies and LOD also allow metadata to be enriched by other metadata, a process known as semantic metadata enrichment. Europeana enriches its data providers' metadata by automatically linking text strings found in the metadata to controlled terms from linked open datasets or vocabularies (W3C Incubator Group 2011). In this way, further links across the Web are established and resources from datasets in different databases become linked. Semantic Web technologies also help make data from various cultural heritage institutions FAIR: findeable, accessible, interoperable and reusable (Wilkinson et al. 2016). LAMs strive to make their metadata available as LOD, FAIR, semantically enriched and aggregated with other LAMs' data in order to help make cultural heritage easily discoverable and openly available to all.

Interestingly, from the perspective of KO in the cultural heritage sector, the Semantic Web was in fact keeping in line with the ongoing developments. The 1990s witnessed efforts from LAM communities to create universal conceptual models for information object representations, spurred on by the transfer to a digital and networked world, rather than by representations based on any specific type of cultural heritage institution or any specific collection. These conceptual models represent metadata at the highest level of abstraction, articulated through entities (e.g., the person entity Mahatma Gandhi; the work entity "The Story of My Experiments with Truth") and relationships (e.g., Mahatma Gandhi is *the creator of* "The Story of My Experiments with Truth"). This simple entity-relationship model, which also incorporates attributes or properties, allows for very sophisticated KO networks whereby users can more readily identify, find, select and obtain cultural resources. In the libraries community, this is embodied by the Functional Requirements for Bibliographic Records (FRBR) family of conceptual models for catalogue functionality, which were consolidated into the IFLA Library Reference Model (IFLA LRM, International Federation of Library Associations 2017). In the museums sector, the standard corresponding to the IFLA's LRM is the ISO standard CIDOC-CRM (CIDOC Conceptual Reference Model; International Standards Organization 2006) developed by the International Committee for Documentation of the International Council of Museums (ICOM). Similarly, in archives, the conceptual model is Records in Context: A Conceptual Model for Archival Description (RiC, International Council on Archives 2019).

Within academic research

Apart from its application in the cultural heritage sector, KO offers other means for supporting DH research. This includes enriching digital objects (textual or non-textual), automated analyses of content, the documentation

and organisation of DH projects and their various outputs, or even the representation of humanistic knowledge itself.

As said at the outset, KO is in essence concerned with systematic representations of information resources. Traditionally, this has meant item-level or document-level descriptions (books, music scores, tapestries etc.). However, the shift to digital resources has allowed for more granular levels of representation to be embedded within the documents themselves. Standard generalised markup language (SGML) was developed in the 1980s as a means of structuring digital publications, with predefined tags included within the content of a document. These tags, instead of conveying explicit content, provided structural and formatting information. SGML was also adapted as a core technology for the Web in the hypertext markup language (HTML) which, when embedded in the content of a webpage, conveys instructions on how the page was to be displayed in a browser. Another derivation of SGML, extensible markup language (XML), is even simpler and carries no predefined tags. As such, it offers a highly flexible system for further enriching and describing the contents of documents according to any schema one might wish to develop. In cultural heritage institutions XML is a commonly used standard; an example is Encoded Archival Description (EAD) used for encoding archival finding aids.

DH scholars were quick to adapt these tools. For instance, textual scholarship in DH took up XML to markup (or encode) texts, and also collaborated in the development of an XML standard called the Text Encoding Initiative (TEI, Text Encoding Initiative 2017). TEI offers systematic guidelines for representing various aspects inherent within the texts that would be of interest to linguists, literary scholars, historians, philologists, dramatists and so on, whether that be a rhyme scheme of a poem, variations in spelling, references to a specific person or place etc.. As such, text encoding methods became a common standard in the humanities to explicitly structure the contents of texts by marking up constituent parts of a text. So rather than just document-level metadata typical of LAMs, metadata could be applied at the level of a chapter, page, paragraph, sentence, line, word or letter. But while TEI involves a novel degree of KO than was hitherto common in cultural heritage institutions, it has been adopted by some LAMs. Flanders and Jannidis (2018) see a clear distinction between applications of TEI (and other data models) for *curation-driven* activities, stressing access and preservation (see *TEI for Libraries*, Hawkins et al. 2018) and the application of TEI for *research-driven* activities (where research projects determine the assets of interest). For an overview of markup, see Chapter 4 of Druckner (2021).

Another area where KO dovetails with DH scholarship has developed from forays into *automated* information organisation. Efforts in libraries to automate the analysis and organisation of resources share a similar history with the efforts to apply computational text analysis for DH research. They are connected to the use of punch cards; e.g., Kilgour (1939) describes their use for library circulation records. Roberto Busa's plans to encode

nearly 11 million words of Thomas Aquinas' writings on IBM punch cards back in 1946 is often considered as the origin of DH (Sula and Hill 2019). In 1959, Busa's resulting concordance, an alphabetical list of words with their immediate context, inspired an information scientist at IBM, H. P. Luhn, to design the Key-Word-in-Context (KWIC) index, in which each word is presented together with its surrounding words (Haeselin 2017; Luhn 1960). In contrast with the traditional system of bibliographic indexes, KWIC offered a new, automated means of creating indexes based on the extracted contents of technical documents: in other words, a revolutionary new KO system In the decades that followed, KO has continued exploring ways of leveraging computation to move beyond manual information organisation towards semi-automated or fully automated approaches. A common application area is automatic subject indexing (for an overview, see Golub 2019) or metadata generation (Golub, Muller, and Tonkin 2014).

These automated approaches to representing documents also connect with a domain of DH that focusses on textual scholarship (Sula and Hill 2019). Applying computational methods to study massive corpora of literary texts has been referred to by Moretti (2000) as *distant reading*, which he contrasts with the slow and partial insights gleaned from the *close reading* typical of traditional literary scholarship. For instance, one could mine literary texts for emotional words ("sad", "forlorn", "rage", "joyous" etc.) to trace the predominance of particular classes of sentiments over historical periods or around historical events: see Acerbi et al. (2013) for an example; see Chapter 7 of Drucker (2021) for an overview. A common computational method is topic modelling to automatically extract topics in a collection of documents, which is especially useful for "reading" a large number of humanities texts and discovering hidden themes: see Blei (2012) for an example.

Finally, if we shift our attention from the digital methods applied within a DH project to long-term sustainability and access to the project itself, it is once again necessary to recognise KO as crucial for supporting the availability of digital research outputs like research data throughout their life cycle. Other digital research outputs that are particularly complex and challenging to maintain are websites, databases and interactive visualisation tools. Ensuring continued access and re-use of such outputs require metadata, KO procedures and technical solutions, not to mention funding; these challenges are addressed by Kräutli, Chen and Valleriani (Chapter 10).

Chapters overview

This book reflects the dominant research activities at the intersection of KO and DH. The volume is structured into the following main themes: Modelling and Metadata (Part I), Information Management (Part II) and Platforms and Techniques (Part III).

Part I: Modelling and metadata

The first part of the book, **Modelling and Metadata**, consists of six chapters which address the challenges of modelling cultural heritage data, harmonisation of conceptual models, approaches to metadata aggregation and metadata enrichment and the need to move from organising data to organising knowledge.

Engaging with the diversity of collections of digital objects in various cultural domains, **Chapter 2**, "Modelling cultural entities in diverse domains for digital archives", by Shigeo Sugimoto, Chiranthi Wijesundara, Tetsuya Mihara and Kazufumi Fukuda, is concerned with the construction of generalised data models for cultural heritage data, including intangible cultural heritage and new media arts. This work discusses digital archiving processes from the perspectives of model entity types (such as conceptual and embodied entities) and proposes metadata models for new media artworks and performing arts. It highlights the importance of well-organised data models for interoperability across domains, a recurring theme in several chapters (see Chapters 3 and 4). These data models are generalised to serve as a framework that is neutral towards application domains and can be used in combination with domain-oriented models such as CIDOC CRM for museums and IFLA LRM for libraries, echoing Vukadin and Štefanac in the following chapter. The authors emphasise that accurate modelling and clarification of types of entities is essential for the accurate identification of entities in the implementation of LD.

Chapter 3, "Collection-level and item-level description in the digital environment: Alignment of conceptual models IFLA LRM and RiC-CM", by Ana Vukadin and Tamara Štefanac, is an attempt to harmonise two conceptual data models for digitised historical resources. This work addresses the question of a cross-domain scheme at the intersection of digital scholarship and library and archival practices. Specifically, the case study demonstrates the harmonisation of the IFLA LRM and RiC, which brings together two different levels of data models from each respective field: the collection-level description of archiving with the item-level description of librarianship, thereby encompassing a wider range of descriptive granularity and abstraction/materiality. The resulting model allows for flexibility and implementation in various environments. It is crucial that metadata schemes are "scalable" according to the principle of functional granularity to support different needs and for metadata requirements to be met at different levels of description. The authors call for simple and straightforward guidelines based on models and standards from established communities in order to ensure uptake by DH projects with little expertise in information organisation.

Metadata aggregation is an important approach to facilitating resource discovery in cultural heritage. **Chapter 4**, "Linked Open Data and aggregation infrastructure in the cultural heritage sector: A case study of SOCH,

a Linked Data aggregator for Swedish open cultural heritage", by Marcus Smith, introduces LOD and metadata aggregation on both a theoretical and a technical level, introducing key concepts and standards, as well as giving a practical example in the form of the SOCH (Swedish Open Cultural Heritage) LD aggregator platform. The SOCH service implements the FAIR principles and LOD technologies to serve as the Swedish data infrastructure for the museums, archives and historic environment registers to share metadata. The metadata are mapped to a common data model and are made queryable via an application programming interface (API). Over its ten-year lifespan, SOCH has had significant success in opening up Swedish heritage data. However, as an early adopter of LOD in Swedish heritage since its establishment in 2008, SOCH has faced some challenges because it failed to keep up with developing standards within LOD. Its use of a bespoke data model and API now presents an obstacle to interoperability and integration with the wider Semantic Web.

Another approach to bolstering resource discovery of cultural heritage data is semantic enrichment. **Chapter 5**, "A Semantic enrichment approach to linking and enhancing Dunhuang cultural heritage data", by Xiaoguang Wang, Xu Tan, Heng Gui and Ningyuan Song, features a work on semantic enrichment which focusses on the construction of the Dunhuang Mural Thesaurus (DMT) by using natural language processing (NLP) techniques along with the domain knowledge of experts in the field. Incorporating semantic analysis, linking and augmentation, the thesaurus was ultimately published as LOD in order to support cultural studies of Dunhuang. It proposes future research in user studies to further improve its KO platform.

While large national institutions have been at the forefront of digitisation, smaller organisations have lagged behind. **Chapter 6**, "Semantic metadata enrichment and data augmentation of small museum collections following the FAIR principles", by Andreas Vlachidis, Antonis Bikakis, Melissa Terras and Angeliki Antoniou, is thus an important case study of how a small museum created a digital collection to improve access to the museum's artefacts.. This work emphasises the FAIR principles for sharing data widely and the application of semantic models and methods such as the selection of an underlying ontology and semantic enrichment to include historic reflections and interpretations of the data. Highlighting the importance of interoperability, the semantically enriched collection of data links to entities from external data sets. For smaller museums where digitisation of complete collections is impractical, semantically enriching the collection at hand with LOD offers a feasible alternative, by leveraging pre-existing digital assets within external repositories. A challenge that such a project faces, however, is the need to coordinate between the necessary actors (museum staff, DH researchers and computer scientists) who each bring a different discipline-specific understanding of data and information.

Earlier in this chapter we introduced the DIKW pyramid and the manner in which it makes *data* the basis of all other epistemic levels. In **Chapter 7**,

"Digital research in the humanities and the legacy of form and structure", Dominic Oldman makes an important and constructive critique of this data-driven approach to the organisation of information within DH. The chapter argues that the data-driven epistemology is fostered by the logic of commercial databases that have been imposed upon the humanities. Thus, DH tends to model and organise data in ways that poorly correspond to the needs of researchers themselves, failing to deliver on the promise of complementing humanistic inquiry with appropriate computational techniques. In a counterexample to this trend, Oldman presents the ResearchSpace system developed at the British Museum. As a departure from the typical design principles of such a system, ResearchSpace is concerned with contextualised representations of data using the textual narrative as a metaphor for how to structure and organise data. The idea is to create a platform that better captures and expresses different ways of thinking, various historical contexts and a diversity of knowledge in a manner that corresponds to researchers' requirements. ResearchSpace demonstrates the need for meaningful KO in DH, where relevant models for the representation of information and knowledge must be advanced, especially in the face of information models based on a narrow, technological world view instantiated in database management systems and LD.

Part II: Information management

The second part of the book, **Information Management**, is made up of three chapters which discuss the handling of different assets in DH research: the texts being studied, the research tools being developed and the outputs which are published (websites, scholarly editions etc.).

Chapter 8, "Research access to in-copyright texts in the humanities", by Peter Organisciak and J. Stephen Downie, is concerned with the management of resources for quantitative text analysis, specifically with regard to copyright concerns. The chapter proposes the principle of non-consumptive access. The case study explores how the HathiTrust Research Center constructed a dataset based on a massive digital library that allows researchers to do advanced quantitative text analyses of corpora without accessing the copyrighted text, to enable distant reading. The chapter thus demonstrates a practical solution to the highly relevant problem of copyright in the context of DH and KO.

Chapter 9, "SKOS as a key element for linking lexicography to digital humanities", by Rute Costa, Ana Salgado and Bruno Almeida, explores the relationship between DH, information science and lexicography through the lens of the digitisation of a Portuguese legacy dictionary. This chapter discusses the construction of lexical resources encoded according to TEI and using an information structure based on the Simple Knowledge Organisation System (SKOS), which enables the dictionary to be connected to other vocabularies. The project has proved fruitful, as its methodology

will inform the digitisation of other legacy dictionaries. One key challenge raised by the chapter is to combine the skills of the various scientific disciplines that together make up the humanities with those of information science in order to deliver a high standard of service for stakeholders.

Chapter 10, "Linked Data strategies for conserving digital research outputs: The shelf life of digital humanities", by Florian Kräutli, Esther Chen and Matteo Valleriani, considers the challenge of how to preserve DH research outputs like websites, digital editions and virtual exhibitions. The problem is presented through two projects, with the second project building off the insights from the first. The first project dealt with the history of a text and its various editions, where the limitations of using bibliographic data in a relational database were discovered. Finding that LD and a data model based on CIDOC-CRM would better structure the hierarchies and relationships among metadata elements, these approaches were then adopted for the second project, a large-scale infrastructure initiative. Based on their experiences, the authors emphasise the need for collaboration between KO and DH professionals within such projects.

Part III: Platforms and techniques

The third part, **Platforms and Techniques**, contains three chapters that focus on specific platforms and technical interventions to support DH research.

Chapter 11, "Heritage metadata: A digital Periegesis", by Anna Foka, Kyriaki Konstantinidou, Linda Talatas, John Brady Kiesling, Elton Barker, Nasrin Mostofian, Cenk Demiroglu, Kajsa Palm, David A. McMeekin and Johan Vekselius, makes meaningful connections between the literary heritage information contained in the 1st century CE Greek travel writer Pausanias' *Description of Greece* and archaeological remains (sanctuaries, temples, statues, inscriptions etc.) preserved in sites and museums in present-day Greece using an open-source semantic annotation platform and LOD to enrich the location of heritage information that has been mapped using GIS. The result is a geospatially enriched digital edition of the *Description of Greece* that can be used to better address the traditional humanities' research questions about identity, culture, memory and social interaction, which can also be exported to other platforms directed at various audiences.

Chapter 12, "Machine learning techniques for the management of digitised collections", by Mathias Coeckelbergs and Seth van Hooland, discusses the problems and potential of topic modelling as applied to archives and how that method can help manage large collections of electronic documents. The case study applies topic modelling to a European Commission Archives sample comprising over 24,000 multilingual documents from 1958 to 1982. It proved possible to automatically identify the topics of approximately 70% of the documents, with most failures being attributed to problems with the digitised documents, which suffer from poor optical character

recognition (OCR). The topics were then matched against the Eurovoc thesaurus, a multilingual, multidisciplinary controlled vocabulary covering the activities of the European Union. From a DH perspective this work shows how topic modelling in the context of KO systems can make large datasets, initially without much metadata, meaningful for researchers using automated methods.

Chapter 13, "Exploring digital cultural heritage through browsing", by Mark M. Hall and David Walsh, addresses the shortcomings of the traditional keyword search box as a navigation interface for non-expert users visiting online culture heritage collections. The chapter surveys various solutions to facilitate user navigation of collections, including faceted search and browsing using temporal or spatial interfaces (e.g., timelines, maps) as organisational principles. In their case study, the authors built the digital museum map (DMM), an automatically generated browsing interface that allows the user to experience a virtual museum with floors and rooms that display the collection. The museum objects were organised by topic using NLP and the Getty Art and Architecture Thesaurus (AAT). While building an open-source solution, the research calls for further context-based user evaluation.

In **summary**, the contributed chapters provide snapshots of how information can be organised in various contexts in DH. Organising cultural heritage in digital environments is addressed in topics such as the creation and adoption of conceptual models and metadata standards (Chapters 2–6), the incorporation of LOD (Chapters 4 and 5), ways of enriching metadata (Chapters 5 and 6) and the aggregation and interoperability of metadata across cultural heritage collections (Chapters 2–6). Further highlighting the role of KO for DH, these chapters discuss managing DH resources and DH documents for preservation and reuse (Chapters 8–10) and offer numerous examples of (semi-) automated approaches to support KO for improved access, discovery and navigation of materials (Chapters 5, 8, 11–13). Crucially, the chapters invite us to consider the nature of knowledge production within the humanities, and to actively work towards representing fundamental epistemic elements such as uncertainty, interpretation, context and narrative which are imported from systems and technologies adopted from outside the field (Chapter 7).

Moving forward

There are several recurring challenges in DH identified in this volume which emphasise the importance of KO for DH scholarly activities. To simplify, we might distil these challenges into two core areas where computation has long promised to surmount the limits inherent to traditional practices in the humanities: *information discovery* and *information representation*. While the two concepts are connected, since the discovery of an information object is determined by how the object is represented, we stress the perspective

of search and access in the former and the specific challenge of how representation is constituted in the latter. The chapters in this volume, echoing the established literature, indicate that the full potential of information discovery and information representation in the field of DH cannot be realised without genuine transdisciplinary collaborations that actively engage with the development of DH technologies, practices and outputs. Furthermore, as part of such transdisciplinary collaborations, KO and its associated disciplines stand to make invaluable contributions to both information discovery and information representation in DH.

Information discovery

Information search and retrieval are the *raison d'être* of KO, and KO systems are constantly being revisited and revised for their utility and efficiency in helping users perform these tasks. However, the usefulness of controlled vocabularies of KO have been a subject of debate for decades (Svenonius 1986; Rowley 1994; Gross, Taylor, and Joudrey 2015; Hjørland 2016b). This led to authorised subject index terms being neglected in the subsequent development of information retrieval systems and, as a result, today's information retrieval systems do not provide good quality subject-based access for humanities researchers (see Golub et al. 2020). Moreover, the assessment of controlled vocabularies during search has rarely been evaluated from a user perspective (see Wittek et al. 2016; Liu et al. 2017; Liu and Wacholder 2017 for exceptions). The same situation seems now to be playing itself out in the area of semantic data in cultural heritage: recent approaches in the development of semantic technologies and the application of semantic data enrichment in cultural heritage institutions are intended to expand access points to support the discovery of resource and knowledge discovery (see Wang et al., Chapter 5; Munnelly, Pandit, and Lawless 2018; Hyvönen et al. 2019; Zeng 2019). However, partly due to the disciplinary differences between the various groups designing and using such systems, as in the example of the retrieval system given above, the usefulness of semantically enriched data has not been rigorously evaluated in the context of information retrieval tasks from user perspectives.

Similarly, the search and browse interfaces of information retrieval systems affect information discovery, and their design needs to be informed by end user requirements. In addition to interfaces to IR systems such as the DMM, described in Chapter 13, also relevant here are interfaces and interactions that digitally enhance users' experience in physical museums, ranging from physical installations to mobile applications, interconnected activities and virtual/augmented/mixed (XR) reality experiences (Hornecker and Ciolfi 2019). The methodology of interaction design and participatory design from HCI studies could help reconceptualise ways of designing the tools that support DH research. Earlier efforts in this direction can be seen in the attempt by Fidel (2012) to bridge the gap between

human information behaviour and the design of information systems. This work provides a conceptual framework and analytical tools to consider the person in a specific context or situation. Also relevant is the sub-field of interaction design within HCI, providing a framework for the design and evaluation of interactive technologies, with emphasis on the involvement of stakeholders throughout the design life cycle (Sharp, Preece, and Rogers 2019). An example of this is co-design or participatory design visualisation framework, which deliberately involves the actors (users), activities and artefacts, using multiple methods and an iterative design approach (Dörk et al. 2020).

The adoption of KO for improved information discovery cannot be divorced from approaches from related disciplines that would allow for a clearer understanding of humanities scholars' information practices in specific contexts. DH scholars' information needs have to be thoroughly and continuously researched to inform all of these KO processes, models, standards and guidelines. Lessons learned from the ResearchSpace project (Chapter 7) provide a major wake-up call for user studies and participatory KO. Understanding humanities researchers is key to understanding what kinds of KO systems, processes and standards we should create and provide. Future research into KO in general, and into KO for DH specifically, should focus on gaining a deep understanding of the context of information needs, search, interaction and use.

Information representation

Representation is an essential component of KO. To take a simple example, a catalogue of journal articles consists of representations of each separate article. These representations may consist of descriptive information (author, title etc.) or subject information (thesauri descriptor, classification, keyword etc.). The catalogue records incorporating these representations act as surrogates for the documents themselves, abstracted and modelled into a format that is easier to process for any number of tasks, the most common of which are search and retrieval. This is not to suggest that KO is a purely pragmatic endeavour; the field also engages with the philosophical aspects of representation and consequences of representational devices (e.g., Olson 2002; Adler 2017). KO offers a rich collection of insights, strategies, tools and critical reflections on the representation of information and knowledge, and these stand to make valuable contributions to scholars in DH as they confront the challenges and limitations in how their objects of study are represented in the digital technologies that they employ.

Given the acknowledged connection between discovery and representation, it should be unsurprising that the ResearchSpace project (Oldman, Chapter 7) is also illustrative of the challenge of information representation for DH. ResearchSpace stands in sharp contrast to traditional databases

that do not support historical research. Oldman demonstrates that DH research practices and the ways humanities scholars interact with their sources do not match with what is conventionally expressed in databases. To meet the diverse information needs of DH scholars, we need to reconceptualise how digital tools can be designed to support and shape their research practices, and this means including representations with greater fidelity to the epistemic paradigms under which humanists operate.

The preceding criticism has been made of LOD, given its emphasis on data at the expense of context, which Oldman directly contrasts with ResearchSpace. Nevertheless, LOD implementation is still critical to ensure interoperability and increase information access to cultural heritage data. This is why many cultural heritage institutions are moving their metadata into LOD. However, while wide adoption is crucial for LOD to be of use and add value for users, it is limited by overstretched budgets in the cultural heritage sector. Another issue identified with rapidly developing technologies, as Smith points to (Chapter 4), is that early adopters may find themselves saddled with technologies that have already been rendered obsolete by successive innovations.

Good conceptual models are an important foundation for successful LOD implementation, for making data FAIR, and for enabling interoperability of LAM metadata in general (Sugimoto, Wijesundara, Mihara, and Fukuda, Chapter 2; Vukadin and Štefanac, Chapter 3). Conceptual models such as IFLA LRM, CIDOC CRM and RiC must, on the one hand, be harmonized to ensure interoperability while, on the other hand, leave ample flexibility for new object types and different levels of descriptive granularity reflecting target collections or specific needs. The next step would be to agree on practical metadata standards and guidelines based on the harmonised conceptual models. The challenge of implementing the guidelines should be anticipated through appropriate strategies: KO professionals need to be members of DH project teams; in cases where this is not possible, there should be clear and straightforward guidelines based on models and standards from established communities in order to ensure that DH projects with little expertise in KO can nevertheless adopt and apply said guidelines. Reflections upon information representation also serve as a critical counterpoint to the representations generated by computational tools and techniques that are fundamental to further inquiry in DH. Recent developments of automated techniques, for instance, show limited usefulness for users due to the challenges in interpreting the computational models they are based on (Aletras et al. 2017; Dieng, Ruiz, and Blei 2020; Hamdi et al. 2020). More generally, computational techniques such as those used in distant reading are limited by knowledge representations hard-wired into the automated technologies.. Consider, for instance, automatic topic identification. Theoretically, automating subject determination belongs to logical positivism: a subject is considered to be a string of characters occurring above a certain threshold frequency and appearing in

a given location, such as a title (Svenonius 2000, 46–49). But this assumes that topics, subjects or concepts have names: well-established and non-ambiguous ones. Such an assumption may be well founded in, e.g., natural sciences, but much less so in the humanities and social sciences where language is often purposefully metaphorical. The positivist approach to the representation of information (where word = concept) overlooks text as a complex cognitive and social phenomenon, or neglects the way cognitive understanding of text activates many knowledge sources, sustaining multiple inferences and soliciting a personal interpretation (Moens 2000, 7–10). Further research is needed to empirically test automated analytical tools, evaluating their performance for specific tasks in situated contexts (for an example of an evaluative framework for automated subject indexing, see Golub et al. 2016). It is therefore important to be critical when applying computational tools for DH research, especially in black box techniques such as topic modelling.

Concluding remarks

While KO has been finding applications in numerous areas outside its home field of information science to help address the almost universal need for organising information, we have also witnessed that, in many domains of human endeavour, information is being organised ad hoc, often resulting in systems that underperform and even effectively prevent access to data, information and knowledge. In order to help deliver the best solutions for organising information in DH, it is important to bring the two communities of research and practice together and explore their combined potential.

The early hype about "big data", where the data at a sufficient scale simply "spoke for itself", has fortunately subsided, creating a new-found recognition that any work with data needs to take a more interdisciplinary approach, whereby different fields can share their insights on how information could be constituted and managed. As elucidated by Borgman (2015, 15), the context matters, from data creation to use, because "data, standards of evidence, forms of presentation, and research practices are deeply intertwined". Data (however it is operationalised) plays an important role in digital scholarship in the networked world: this is just as true when we consider KO and DH separately as when we consider their integration.

This book attempts to achieve a synergy between KO and DH by providing state-of-the-art examples of interdisciplinary projects and case studies, discussing the challenges and opportunities. The volume calls for a future in which DH research is more interdisciplinary, cutting across KO, IR, HCI, IB and other related fields and disciplines. We need to harness these complementary perspectives in order to provide the best, evidence-based KO solutions which address the complexities of DH research and, in turn, feed back into KO research. Our hope is that this volume helps set the stage for advancing KO in DH towards the mutual benefit of both.

Bibliography

Acerbi, Alberto, Vasileios Lampos, Philip Garnett, and R. Alexander Bentley. 2013. "The Expression of Emotions in 20th Century Books." *PloS One* 8 (3): e59030. https://doi.org/10.1371/journal.pone.0059030

Adler, Melissa. 2017. *Cruising the Library: Perversities in the Organization of Knowledge.* New York, NY: Fordham University Press.

Aletras, Nikolaos, Timothy Baldwin, Jey Han Lau, and Mark Stevenson. 2017. "Evaluating Topic Representations for Exploring Document Collections." *Journal of the Association for Information Science and Technology* 68 (1): 154–67. https://doi.org/10.1002/asi.23574

Bates, Marcia J. 1994. "The Design of Databases and Other Information Resources for Humanities Scholars: The Getty Online Searching Project Report No. 4." *Online and CD-Rom Review* 18 (6): 331–40. https://doi.org/10.1108/eb024508

Bates, Marcia J. 2010. "Information." In *Encyclopedia of Library and Information Sciences,* edited by Marcia J. Bates, and Mary Niles Maack, 2347–60. 3rd ed. New York, NY: CRC Press. https://pages.gseis.ucla.edu/faculty/bates/articles/information.html

Berners-Lee, Tim, James Hendler, and Ora Lassila. 2001. "The Semantic Web." *Scientific American* 2001 (May): 29–37.

Blei, David M. 2012. "Topic Modeling and Digital Humanities." *Journal of Digital Humanities* 2 (1): 8–11.

Borgman, Christine L. 2015. *Big Data, Little Data, No Data: Scholarship in the Networked World.* Cambridge MA: MIT Press.

Busa, Roberto. 1980. "The Annals of Humanities Computing: The Index Thomisticus". *Computers and the Humanities* 14: 83–90. https://doi.org/10.1007/BF02403798

Case, Donald O. and Lisa M. Given, eds. 2016. *Looking for Information: A Survey of Research on Information Seeking, Needs, and Behavior.* Bingley: Emerald Group Publishing.

Dieng, Adji B., Francisco J. R. Ruiz, and David M. Blei. 2020. "Topic Modeling in Embedding Spaces." *Transactions of the Association for Computational Linguistics* 8: 439–53. https://doi.org/10.1162/tacl_a_00325

Dörk, Marian, Boris Müller, Jan-Erik Stange, Johannes Herseni, and Katja Dittrich. 2020. "Co-Designing Visualizations for Information Seeking and Knowledge Management." *Open Information Science* 4 (1): 217–35. https://doi.org/10.1515/opis-2020-0102

Drucker, Johanna. 2011. "Humanities Approaches to Graphical Display." *Digital Humanities Quarterly* 5 (1). http://www.digitalhumanities.org/dhq/vol/5/1/000091/000091.html

Drucker, Johanna. 2021. *The Digital Humanities Coursebook.* London: Routledge.

Europeana. 2021. https://www.europeana.eu/about-us

Fidel, Raya. 2012. *Human Information Interaction: An Ecological Approach to Information Behavior.* Cambridge MA: MIT Press.

Flanders, Julia, and Fotis Jannidis, eds. 2018. *The Shape of Data in Digital Humanities: Modeling Texts and Text-based Resources.* London: Routledge.

Gardiner, Eileen, and Roland G. Musto. 2015. *The Digital Humanities: A Primer for Students and Scholars.* Cambridge: Cambridge University Press.

Gitelman, Lisa. 2013. *'Raw Data' Is an Oxymoron.* Cambridge MA: MIT Press.

Glushko, Robert J. 2016. *The Discipline of Organizing: Professional Edition.* 4th ed. O'Reilly Media: Sebastopol, CA.

Golub, Koraljka. 2019. "Automatic Subject Indexing of Text." *Knowledge Organization* 46 (2): 104–121. https://doi.org/10.5771/0943-7444-2019-2-104. Also available in *ISKO Encyclopedia of Knowledge Organization*, edited by Birger Hjørland and Claudio Gnoli. https://www.isko.org/cyclo/automatic

Golub, Koraljka. 2020. "Automatic Identification of Topics: Applications and Challenges." In *Doing Digital Humanities: Concepts, Approaches, Cases*, edited by Joacim Hansson and Jonas Svensson, 5–26. Växjö: Linnaeus University Press.

Golub, Koraljka, Dagobert Soergel, George Buchanan, Douglas Tudhope, Marianne Lykke, and Debra Hiom. 2016. "A Framework for Evaluating Automatic Indexing or Classification in the Context of Retrieval." *Journal of the Association for Information Science and Technology* 67 (1), 3–16. https://doi.org/10.1002/asi.23600

Golub, Koraljka, Henk Muller, and Emma Tonkin, E. 2014. "Technologies for Metadata Extraction." In *Handbook of Metadata, Semantics and Ontologies*, edited by Miguel-Angel Sicilia, 487–522. Hackensack, NJ: World Scientific.

Golub, Koraljka, Jukka Tyrkkö, Joachim Hansson, and Ida Ahlström. 2020. "Subject Indexing in Humanities : A Comparison between a Local University Repository and an International Bibliographic Service". *Journal of Documentation* 76 (6): 1193–1214. https://doi.org/10.1108/JD-12-2019-0231

Gross, Tina, Arlene G. Taylor, and Daniel N. Joudrey. 2015. "Still a Lot to Lose: The Role of Controlled Vocabulary in Keyword Searching." *Cataloging & Classification Quarterly* 53 (1): 1–39. https://doi.org/10.1080/01639374.2014.917447

Hamdi, Ahmed, Axel Jean-Caurant, Nicolas Sidère, Mickaël Coustaty, and Antoine Doucet. 2020. "Assessing and Minimizing the Impact of OCR Quality on Named Entity Recognition." In *Digital Libraries for Open Knowledge. TPDL 2020. Lecture Notes in Computer Science*, vol. 12246, edited by Mark Hall, Tanja Merčun, Thomas Risse, and Fabien Duchateau, 87–101. Cham: Springer. https://doi.org/10.1007/978-3-030-54956-5_7

Haeselin, David. 2017. "Concordance". In *ArchBook*. Last modified April 1, 2019. http://drc.usask.ca/projects/archbook/concordance.php

Hawkins, Kevin, Michelle Dalmau, Elli Mylonas, and Syd Bauman. 2018. *Best Practices for TEI in Libraries.* https://tei-c.org/extra/teiinlibraries/4.0.0/bptl-driver.html

Hider, Philip, Barney Dalgarno, Sue Bennett, Ying-Hsang Liu, Carole Gerts, Carla Daws, Barbara Spiller, Pru Mitchell, Robert Parkes, and Raylee Macaulay. 2016. "Reindexing a Research Repository from the Ground up: Adding and Evaluating Quality Metadata." *Australian Academic and Research Libraries* 47 (2): 61–75. https://doi.org/10.1080/00048623.2016.1204589

Hjørland, Birger. 2012. "Knowledge Organization = Information Organization?." *Advances in Knowledge Organization* 13: 8–14.

Hjørland, Birger. 2016a. "Knowledge organization (KO)." *Knowledge Organization* 43 (6): 475–85. Also available in *ISKO Encyclopedia of Knowledge Organization*, edited by Birger Hjørland and Claudio Gnoli. https://www.isko.org/cyclo/knowledge_organization.

Hjørland, Birger. 2016b. "Does the Traditional Thesaurus Have a Place in Modern Information Retrieval?." *Knowledge Organization* 43 (3): 145–59. https://doi.org/10.5771/0943-7444-2016-3-145

Hjørland, Birger. 2017. "Subject (of Documents)." *Knowledge Organization* 44 (1): 55–64. https://doi.org/10.5771/0943-7444-2017-1-55

Hornecker, Eva, and Luigina Ciolfi. 2019. "Human-Computer Interactions in Museums." *Synthesis Lectures on Human-Centered Informatics* 12 (2): i–153. https://doi.org/10.2200/S00901ED1V01Y201902HCI042

Hyvönen, Eero, Petri Leskinen, Minna Tamper, Heikki Rantala, Esko Ikkala, Jouni Tuominen, and Kirsi Keravuori. 2019. "BiographySampo – Publishing and Enriching Biographies on the Semantic Web for Digital Humanities Research." In *The Semantic Web. ESWC 2019. Lecture Notes in Computer Science*, vol. 11503, edited by Pascal Hitzler, Miriam Fernández, Krzysztof Janowicz, Amrapali Zaveri, Alasdair J.G. Gray, Vanessa Lopez, Armin Haller, and Karl Hammar. Cham: Springer. https://doi.org/10.1007/978-3-030-21348-0_37

International Council on Archives. 2019. *Records in Contexts. A Conceptual Model for Archival Description. Consultation Draft v0.2 (preview)*. December 2019. https://www.ica.org/sites/default/files/ric-cm-0.2_preview.pdf

International Federation of Library Associations. 2017. *IFLA Library Reference Model, A Conceptual Model for Bibliographic Information*. https://www.ifla.org/files/assets/cataloguing/frbr-lrm/ifla-lrm-august-2017_rev201712.pdf

International Standards Organization. 2006. CIDOC Conceptual Reference Model. http://www.cidoc-crm.org/

Kansa, Eric, and Sarah Whitcher Kansa. 2021. "Digital Data and Data Literacy in Archaeology. Now and in the New Decade." *Advances in Archaeological Practice* 9 (1): 81–85. https://doi.org/10.1017/aap.2020.5

Kilgour, Frederick G. 1939. "A new Punched Card for Circulation Records." *Library Journal* 64 (4): 131–133.

Kirschenbaum, Matthew G. 2010. "What is Digital Humanities and What's it Doing in English Departments?". *ADE Bulletin* 150: 55–61.

Liu, Ying-Hsang, Paul Thomas, Marijana Bacic, Tom Gedeon, and Xindi Li. 2017. "Natural Search User Interfaces for Complex Biomedical Search: An Eye Tracking Study." *Journal of the Australian Library and Information Association* 66 (4): 364–81. https://doi.org/10.1080/24750158.2017.1357915

Liu, Ying-Hsang, and Nina Wacholder. 2017. "Evaluating the Impact of MeSH (Medical Subject Headings) Terms on Different Types of Searchers." *Information Processing and Management* 53 (4): 851–70. https://doi.org/10.1016/j.ipm.2017.03.004

Luhn, Hans Peter. 1960. "Keyword-In-Context Index for Technical Literature". *American Documentation* 11 (4): 288–95.

Mayernik, Matthew S. 2020. "Metadata". *Knowledge Organization* 47 (8): 696–713. Also available in *ISKO Encyclopedia of Knowledge Organization*, edited by Birger Hjørland and Claudio Gnoli. https://www.isko.org/cyclo/metadata

Moens, Marie-Francine. 2000. *Automatic indexing and abstracting of document texts*. Boston: Kluwer.

Moretti, Franco. 2000. "Conjectures on World Literature". *New Left Review* 238 (1). https://newleftreview.org/issues/ii1/articles/franco-moretti-conjectures-on-world-literature

Munnelly, Gary, Harshvardhan J. Pandit, and Séamus Lawless. 2018. "Exploring Linked Data for the Automatic Enrichment of Historical Archives." In *The Semantic Web: ESWC 2018 Satellite Events. ESWC 2018. Lecture Notes in Computer Science*, vol. 11155, edited by Aldo Gangemi, 423–33. Cham: Springer. https://doi.org/10.1007/978-3-319-98192-5_57

Münster, Sander. 2019. "Digital Heritage as a Scholarly Field—Topics, Researchers, and Perspectives from a Bibliometric Point of View." *Journal on Computing and Cultural Heritage* 12 (3): 22.1–22.27. https://doi.org/10.1145/3310012

Nyhan, Julianne, and Andrew Flinn. 2016. *Computation and the Humanities: Towards an Oral History of Digital Humanities.* Cham: Springer.

Olson, Hope A. 2002. *The Power to Name: Locating the Limits of Subject Representation in Libraries.* Dordrecht: Kluwer.

Oxford online dictionary, s.v. "Digital Humanities" accessed February 10, 2020, https://www.lexico.com/definition/digital_humanities

Resource Description and Access (RDA). 2021. https://www.loc.gov/aba/rda/

Rowley, Jennifer. 1994. "The Controlled versus Natural Indexing Languages Debate Revisited: A Perspective on Information Retrieval Practice and Research." *Journal of Information Science* 20 (2): 108–18. https://doi.org/10.1177/016555159402000204

Saracevic, Tefko. 2009. "Information science." In *Encyclopedia of Library and Information Science*, edited by Marcia J. Bates and Mary Niles Maack, 2570–2586. 3rd ed. New York, NY: CRC Press. https://tefkos.comminfo.rutgers.edu/SaracevicInformationScienceELIS2009.pdf

Schreibman, Susan, Ray Siemens, and John Unsworth. 2016. *A New Companion to Digital Humanities.* 2nd ed. Hoboken, NJ: John Wiley & Sons.

Sharp, Helen, Jennifer Preece, and Yvonne Rogers. 2019. *Interaction Design: Beyond Human-Computer Interaction.* 5th ed. Hoboken, NJ: John Wiley & Sons.

Svenonius, Elaine. 1986. "Unanswered Questions in the Design of Controlled Vocabularies." *Journal of the American Society for Information Science* 37 (5): 331–40. https://doi.org/10.1002/(SICI)1097-4571(198609)37:5<331::AID-ASI8>3.0.CO;2-E

Svenonius, Elaine. 2000. *The Intellectual Foundation of Information Organization.* Cambridge, MA: MIT Press.

Sula, Chris Alen, and Heather V. Hill. 2019. "The Early History of Digital Humanities: An Analysis of Computers and the Humanities (1966–2004) and Literary and Linguistic Computing (1986–2004)." *Digital Scholarship in the Humanities* 34 (1): 190–206. https://doi.org/10.1093/llc/fqz072

Terras, Melissa, Julianne Nyhan, and Edward Vanhoutte, eds. 2013. *Defining Digital Humanities. A Reader.* London: Routledge.

Text Encoding Initiative. 2017. Text Encoding Initiative. https://tei-c.org/

Vanhoutte, Edward. 2013. "The Gates of Hell: History and Definition of Digital Humanities Computing." In *Defining Digital Humanities. A Reader*, edited by Melissa Terras, Julianne Nyhan, and Edward Vanhoutte. 119–56. London: Routledge.

Wittek, Peter, Ying-Hsang Liu, Sándor Darányi, Tom Gedeon, and Ik Soo Lim. 2016. "Risk and Ambiguity in Information Seeking: Eye Gaze Patterns Reveal Contextual Behavior in Dealing with Uncertainty." *Human-Computer Interaction. Frontiers in Psychology* 7:1790. https://doi.org/10.3389/fpsyg.2016.01790

W3C Incubator Group. 2011. *Library Linked Data Incubator Group: Datasets, Value Vocabularies, and Metadata Element Sets, W3C Incubator Group Report 25 October 201.* https://www.w3.org/2005/Incubator/lld/XGR-lld-vocabdataset-20111025/# Introduction:_Scope_and_Definitions

Wilkinson, Mark D. et al. 2016. "The FAIR Guiding Principles for Scientific Data Management and Stewardship." *Scientific Data* 3: 160018. https://doi.org/10.1038/sdata.2016.18

World Wide Web Consortium. 2015. *Linked Data*. https://www.w3.org/standards/semanticweb/data.html

Zeng, Marcia Lei. 2019. "Semantic Enrichment for Enhancing LAM Data and Supporting Digital Humanities. Review Article." *El Profesional de La Información* 28 (1): 1–35. https://doi.org/10.3145/epi.2019.ene.03

Zeng, Marcia Lei, and Jian Qin. 2016. *Metadata*. 2nd ed. Chicago, IL: ALA Neal-Schuman.

Part I
Modelling and metadata

Modelling of cultural heritage data

2 Modelling cultural entities in diverse domains for digital archives

Shigeo Sugimoto, Chiranthi Wijesundara,
Tetsuya Mihara, and Kazufumi Fukuda

Introduction

Many digital collections of cultural and historical resources have been developed since the 1990s by libraries, museums and archives – also called memory institutions. Since then, the variety and volume of the resources, as well as the domains of the digital collections, have greatly expanded.

Metadata is a key component to organise digital collections of cultural resources, which are called digital archives in this chapter. On the one hand, metadata schemas used at memory institutions for digital resources are often developed based on metadata standards conventionally used at those institutions; so, those schemas tend to depend on the types of the institution, i.e., library, museum, archives and so forth. On the other hand, the basic functions of digital archives are neutral to the types of institutions, i.e., curate original resources, create and maintain digital collections and provide access to digital collections. An important issue for digital archiving is the diversity of the original resources, i.e., from tangible cultural heritage objects to intangible cultural heritage and from archaeology to contemporary arts. It is important to define generalised data models for digital archives to build their collections and to enhance interoperability across digital archives. The authors consider that digital archives of tangible cultural heritage objects are rather well-developed when compared to domains such as intangible cultural heritage and new media arts, which have less-developed archives. This chapter is aimed at discussing data models for digital archives from the viewpoint of data models as a basis for designing metadata for digital archives in various cultural domains.

The basic standing points of this chapter are as follows:

- the classes of original entities to be digitally archived, which may be tangible, ephemeral or intangible, should be identified to define the digital archiving process and to create links between archived digital objects (ADOs) and their original entities;

DOI: 10.4324/9781003131816-2

- an archived object of digital archives should be a proxy of an original real-world object (RWO) so that the relationships between the original object and the archived object can be properly traceable;
- archived objects of a digital archive on the Internet should be interoperable with those of other archives and reusable by third-party services.

The rest of this chapter is organised as follows. The section "Basic concepts – digital archives, metadata and data models for cultural resources" presents basic issues of digital archives, which include the definition of digital archives, and metadata standards and data models for digital archives. The section "Generalised models for digital archives" presents some generalised models of metadata for digital archives defined by the authors followed by a discussion on entity types of archived objects and their archiving processes. In the section "Metadata models for media art works and performing arts – case studies", the core portion of the data models defined in Media Art Database (MADB) and Japanese Digital Theatre Archives (JDTA) are shown and discussed from the viewpoint of data models discussed in the previous sections. The section "Discussions and concluding remarks" discusses some issues learned in MADB and JDTA as a conclusion of this chapter.

Basic concepts – digital archives, metadata and data models for cultural resources

Digital archives

In this chapter, those digital collections of cultural and historical resources are referred to as digital archives, defined as collections of digital items curated mainly in the cultural and historical domains and organised for access primarily via the Internet. Digital archives may contain digital objects curated by digitising original physical objects and those curated from born-digital objects. The term digital archive was originated in Japan in the late 1990s and is widely used there; this chapter uses this term instead of digital library or digital collection because the focus is on archiving of digital resources, which includes curating cultural resources into a digital collection and maintaining the collection over time. Early digital archives developed by memory institutions were mostly a collection of digital images created by digitising physical items of the institutional collections. An item of those digital archives is typically composed of a single image or a set of images for a single original physical object and a set of descriptions about the original object and its digital image(s). The domains of digital archives have been expanded to include new objects created with new technologies, e.g., intangible cultural heritage such as traditional performance and craftsmanship, large objects such as heritage buildings and archaeological sites and resources related to natural and man-made disasters. In parallel to

this expansion of domains, information and media technologies used for building digital archives have been changing, e.g., increase of born-digital resources both in their volumes and types, adoption of Linked Data technologies by increasing demands to link archived resources to various resources in the Internet environment, use of advanced visualisation technologies to present archived data resources and so forth.

In this chapter, the term digital surrogate is used to mean a digital object created from an original object. This term fits well with tangible cultural heritage objects. However, it would not fit well to intangible cultural heritage and events such as festivals, performances, craftmanship and resources related to natural and man-made disasters because they are not physical objects from which we can create digital objects directly. In general, the existing digital archives for intangible cultural heritage and events are collections of digital objects curated from recordings of performances of intangible cultural heritage and recordings of physical objects that appeared in the events. Therefore, it is crucial in metadata design to clearly define the relationships between original cultural entities and digital objects created from the original entities. Data models play an instrumental role in presenting the relationships in graphic forms to help metadata developers and users understand metadata schemas for their applications.

Metadata for digital archives – standards and data models

Metadata, which is known by the simple phrase "(structured) data about data", are in this chapter further defined as data about a resource that is useful to find and use. Metadata is key to organising and managing digital collections of cultural and historical objects. Metadata has several different roles and types (Svenonius 2000; Zeng and Qin 2016). Catalog records at memory institutions are a typical example of metadata. Metadata standards widely used at memory institutions such as Encoded Archival Description (EAD), Machine-Readable Cataloging (MARC) and Categories for the Description of Works of Art (CDWA) are primarily designed for description and access to items held at the memory institutions (Baca and Harpring 1999; Library of Congress 2020a; 2020b). Authority data to describe subjects, as well as people, are also an important component of metadata. These metadata standards are crucial to share data among memory institutions and to make their databases interoperable.

Functional Requirements for Bibliographic Records (FRBR), developed by the International Federation of Library Associations and Organization (IFLA), define three groups of entities for bibliographic description where Group 1, which consists of entity classes Work, Expression, Manifestation and Item, shows different levels of entities for bibliographic descriptions (IFLA Study Group 1997). The International Federation of Film Archives (FIAF) has a cataloguing manual that uses FRBR as its basis (Fairbairn,

Pimpinelli and Ross 2016). BIBFRAME developed by the US Library of Congress has a three-layer model composed of Work, Instance and Item (Library of Congress n.d.). A common feature among these models is the separation of intellectual contents and physical or digital objects. This separation of intellectual contents from physical or digital entities is a crucial aspect in the networked information environment to help users find and access resources. Users may first search for objects by intellectual contents, and then choose objects by the styles of expressions and by preferences to get the objects at their hands or to access the contents. In other words, conventional bibliographic databases at memory institutions are organised using item-centric metadata as those databases are primarily provided as a tool for the users to find and access items included in the institutional collections. However, the locations of physical items may have no important meaning for the users who find and access resources on the Internet, as the content of these resources is digital, and the location of the physical item becomes less relevant.

There are several generalised models for metadata on the Internet; for example, the One-to-One Principle of Metadata (Dublin Core Metadata Initiative 2021) as a simple model to design metadata, DCMI Application Profiles (Nilsson, Baker and Johnston 2008) and Interoperability Levels of Dublin Core as a framework for interoperable metadata schemas. Resource Description Framework (RDF; W3C RDF Working Group 2014) is an important standard to interconnect digital objects on the Web. RDF is used as the basis for the Europeana Data Model (EDM; Isaac 2013) and OAI-ORE (Open Archives Initiative n.d.) which are data models for aggregating metadata harvested from various data sources.

Linked open data is a crucial aspect of digital archives to provide their curated items in the Internet environment where any digital instances may be linked. Definition of terms and concepts used in metadata, which may be called ontology, is a semantic basis of metadata for linking data. Linked Data technologies are used to define ontologies and ontology-based tools in the cultural and historical domains (Hyvönen 2012; Orgel et al. 2015; Carboni and Luca 2016). CIDOC Conceptual Reference Model (CRM) defines a comprehensive set of classes and properties for museum metadata (Le Boeuf et al. 2018); IFLA Library Reference Model (LRM) defines classes and properties based on FRBR and its related authority data standards (Riva et al. 2017).

Generalised models for digital archives

A generalised model of archived objects

Figure 2.1 shows a generalised structure of digital archives and a generalised structure of an ADO. RWOs are curated into digital archives by digitising or converting the objects to digital objects organised by requirements for

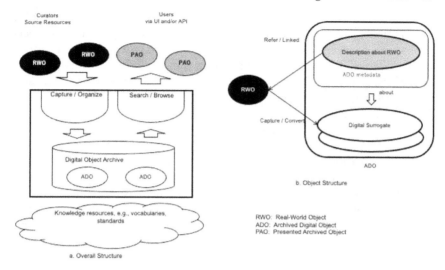

Figure 2.1 Digital archive outline.

digital archiving, and ADOs are presented to the users via the search and access functions. An ADO is composed of one or more digital surrogates for an RWO and related metadata. The metadata should contain descriptions about the RWO and those about the digital surrogates. Descriptive information and administrative information about the ADO should be contained in the metadata as well.

RWOs are digitally curated in two ways – direct curation, and curation via recordings of an original RWO. There are various types of RWOs as well as technologies used for digital curation. We can roughly classify RWOs into tangible and intangible entities, where tangible entities include non-digital, digital and hybrid instances, and intangible entities include skills, knowledge, activities and events. A digital surrogate may be realised as a file of a standardised audiovisual format or as a dataset that may be presented to users using visualisation/presentation technologies such as 3-Dimensional Computer Graphics (3DCG) and Virtual Reality (VR).

Generalised model of digital archiving process

A fundamental difference between digital archives and physical collections at memory institutions is that items of digital archives are mostly collections of digital copies, whereas physical collections are a mixture of original objects and recordings stored in electronic and optical media such as microfilms, videotapes, CDs and DVDs. These media are often called content carriers. The contents stored on those media can be classified into two types – original contents, and copies created from original objects. The former includes artistic original photographs and movies, video games,

animations, computer graphic images and so forth, and the latter includes photographs, videos and multimedia recordings of tangible objects, performances, motions, disasters and ephemeral objects and so forth. Image objects such as photographs, movies and computer graphics could be used in both types, e.g., an artistic photograph of a sports game vs. a photograph taken as a record of the game, an original artistic computer graphic image vs. an image converted from the original for archiving and preservation, a portrait photograph of a person taken over 100 years ago as an industrial heritage vs. the same photograph as a record of the person and so forth. Metadata creation policies for image objects need to reflect this feature, even if the boundary between the two types may not be clear because it depends on the aims of collections.

Identification of original RWOs is essential to create ADOs. In the case of Europeana, EDM uses URIs to identify original cultural objects from which digital surrogates are created. However, this scheme may not apply to those entities which are not identifiable by URIs, such as ephemeral or intangible entities.

Generally speaking, we can classify digital archiving into two types based on the instances to be archived – archiving objects which are recognisable by humans (i.e., visible, audible, touchable etc.) and archiving things that we can experience (i.e., performance, action, activity, event etc.). For example, tangible cultural heritage objects and digital data instances are the former, and intangible cultural heritage and events are the latter. In this chapter, the former instances are called objects, and the latter events are called experientials as they are things which we can experience, i.e., do, see, listen and so forth. Since we can directly capture only those instances embodied in the real world such as dance performances, we can capture experiential entities by capturing real-world objects related to the entities.

The authors have proposed a digital archiving process model named Cultural Heritage in Digital Environment (CHDE) which covers both tangible and intangible cultural heritage (Wijesundara, Monika and Sugimoto 2017; Wijesundara and Sugimoto 2018). The CHDE model defines an entity called instantiation in the digital archiving process of intangible cultural heritage. Performances of traditional dance and traditional paper making are an example of instantiation. Those performances can be recorded in a digital form and archived as a surrogate of an instantiation of intangible cultural heritage.

A generalised model to help identify entities for digital archive metadata

The basic resource organisation at memory institutions is oriented to physical items because those institutions need to help users find and access the items in their collections held by the institutions. On the other hand, in the

networked digital archive environment, the physical locations of items have no important meaning for users, but accessibility via the Internet to the items which contain the contents which the users need is important to help users make the selection.

We use the idea of separation between an item and its intellectual contents shown in FRBR and BIBFRAME to define the generalised data model for digital archiving discussed in this section. Work is a conceptual entity representing intellectual creation, whereas Item is a physical/digital entity. Expression and Manifestation represent abstract entities like Work although Expression and Manifestation specify schemes to present and embody a Work. Thus, Work, Expression and Manifestation represent a conceptual entity and an Item represents an entity embodied as a physical or digital object. Superwork represents an abstract entity that connects Work entities, e.g., "Harry Potter" as a superwork entity which is linked to the Works for the four episodes expressed as a novel and a movie (Kiryakos and Sugimoto 2018; 2019). Superwork entities are often called Multimedia Franchise or Media-Mix, particularly in the context of commercialised popular culture domains.

FRBR fits well with those resources which have multiple expressions and manifestations for intellectual content and those which have multiple copies created from an original resource. In general, this feature fits well to libraries but not to museums or archives because FRBR is primarily developed for bibliographic description at libraries that hold multiple copies rather than unique copies typical of archives and museums. On the other hand, separation of intellectual contents and physical/digital objects is crucial for digital archives to provide content-oriented access to archived digital objects regardless of the type of the source cultural resources.

The meaning of "content" should be clearly defined because it is used in several meanings such as "intellectual entities contained in a book", "texts contained in a book", "audio-visual images contained in an electronic book" and so forth. FRBR's Work refers to the intellectual content of an item, which could be modelled as a conceptual entity shared among users and providers of the item. Tangible cultural object names such as "Mona Lisa" and "Stonehenge" are used not only to identify a physical item but also to mean the item as a conceptual entity. Thus, we can define a simple framework to model cultural objects in two different entity types – conceptual/abstract entity and embodied entity which is either physical or digital. Figure 2.2 shows a model for "Gion Matsuri" which is a historical festival in Kyoto, Japan, and a model for a "Harry Potter" novel and movie. Separation of conceptual and embodied entities is crucial to create archived digital objects and their metadata because embodied entities are used to create digital surrogates and conceptual entities are used for the organisation of digital archives based on the intellectual contents of the archived resources.

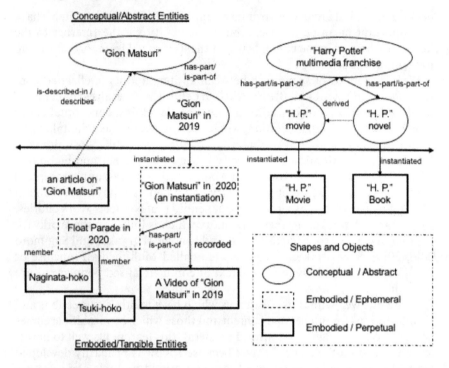

Figure 2.2 Conceptual/intangible objects and physical/embodied objects (CEDA model).

Entity types and digital archiving process

This section discusses digital archiving processes from the viewpoint of entity types in the real world. We can create archived digital objects from embodied entities but not from conceptual entities. As described in the previous section, we can digitally archive intangible cultural heritage via its instantiations. In this section, we discuss archiving of intangible real-world entities and present several aspects to bring differences in the archiving processes.

Basic issues in archiving intangible entities

Digital archives oriented to intangible entities collect records of performances and events, as well as objects related to those performances and events. Thus, their archived objects are heterogeneous. The paragraphs below discuss some basic issues in archiving intangible entities.

1 Archiving abstract entities: as explained earlier, abstract entities like Work have crucial roles in organising cultural digital archives and providing access to archived digital objects. Intangible cultural heritage such as traditional craftsmanship, dance and theatre plays and festivals

are abstract entities because they are inherited as a skill and knowledge. Therefore, we cannot create digital surrogates directly from those entities. However, as they are crucial components to organise digital archives, we need to include them in digital archives. On the one hand, a traditional methodology to solve this issue is to use thesauri or controlled vocabularies such as Library of Congress Subject Headings (LCSH) and Getty Vocabularies (Getty Research Institute n.d.; Library of Congress Linked Data Service n.d.). On the other hand, there are many digital resources on the Web which describe those abstract entities, which can be used to organise the archived digital objects and to link archived objects to other objects on the Internet. Thus, those abstract entities can be represented as digital objects used in metadata for digital archives.

2 Archiving objects and experientials: the Concepts, Embodiment and Digital Archives (CEDA) model depicted in Figure 2.2 proposes abstract and embodied entities (Wijesundara and Sugimoto 2019; Sugimoto et al. 2021). Digital archives of intangible cultural heritage collect digital objects created from physical objects and recordings related to intangible cultural heritage. We consider that we can apply the same model to digital archives for events such as disasters, exhibitions and performing arts; however, the term Object may not be appropriate for those intangible entities such as dance performance and skills for dancing. In this chapter, we call those intangible entities "experientials" because they are the things that we can experience, i.e., performances, services, actions and events. Experientials may not be directly archived, but they need to be recognised as an entity that is an objective of metadata description.

Aspects for digitisation

In the Linked Data environment, it is strongly suggested that digital archives assign a URI to every entity that should be identifiable in their services. It is rather simple to assign identifiers to tangible objects which are perpetual and maintained at memory institutions. However, there are various cases in which entity identification is not straightforward.

The following paragraphs show several aspects to help understand the types of source objects from which archived digital objects are created. These aspects are not a closed set so that we can add/remove aspects by domains and requirements of digital archives.

1 Source – original or referential: *Original objects* are created as an original entity, such as a book, a painting, a photograph created as an original work, a theatre movie or animation and a computer game. *Referential objects* are created as an entity which is a recording or description of an entity, e.g., a photograph created as a record of an event and object, a video of a dance performance and a description of craftsmanship.

2 Mode – static or dynamic: *Dynamic objects* have functional features such as motion, shape change and interaction. For example, video games and interactive web pages are dynamic. *Static objects* have no dynamic features, e.g., a printed book, a painting and a digital photograph/video.

3 Lifetime – ephemeral or perpetual: *Ephemeral objects* exist temporarily or have a limited lifetime, e.g., an ice carving, a living animal or plant and a dance performance. *Perpetual objects* continue to exist unless destroyed intentionally or unintentionally, e.g., a printed book, a painting, an inscription on a stone.

4 Physical collectability – Movable or immovable: *movable objects* are physical objects which can be moved and stored at an archival institution. *Immovable objects* are physical objects which are not movable.

5 Digital tangibility – digital objects or digital functions: *Digital objects* are entities realised as a sequence of bits. *Digital functions* are functions or virtual objects realised by digital objects. *Digital objects* may be called tangible objects or virtual tangible objects in the digital space.

Summary

This section showed basic models to help illustrate the basic structure of objects stored in digital archives which are neutral to the types of source entities to be archived, as well as digital archiving processes by the source entity types, i.e., tangible vs. intangible, ephemeral vs. perpetual and so forth. The aspects given above show some features of real-world objects and issues we need to take into account for digital archiving.

Digital archives must be able to archive various types of cultural entities as digital entities and make those entities linkable with each other, often referred to as Linked Data. Linked Data encourages the connection between entities via links that express meanings of the relationships between the connected entities. This means that we need a framework that helps us formally define both structural and semantic features of the entities. Therefore, it is important to define metadata vocabularies and ontologies using technologies oriented to Linked Data, e.g., RDF and OWL (Web Ontology Language). This section presented the generalised models which help us identify entities in the application domains and assign URIs to them, which is a crucial basis to design metadata schemas in the Linked Data environment.

Metadata models for media art works and performing arts – case studies

This section introduces metadata models defined for MADB and JDTA developed as a part of projects funded by the Agency for Cultural Affairs (ACA) of the Japanese government. MADB covers four domains, Japanese comics (Manga), animations (Anime), video games (Game) and new media

artworks (Media-Art). JDTA covers Japanese theatre performances, which include contemporary theatre, dance and traditional performing arts. This section presents the core features of the data models developed by the MADB and JDTA projects. (Note: Figures included in this section are simplified from the original figures provided by the projects and translated from Japanese by the authors. As of April 2021, MADB and JDTA are accessible at https://mediaarts-db.bunka.go.jp/ and https://enpaku-jdta.jp/, respectively.)

Overview of the data models

Media art database (MADB)

MADB collects data about works in the four domains – Manga, Anime, Game and Media-Art. The data is collected from various sources which include libraries, museums, online and offline datasets maintained by publishers, data tables contained in published materials, and so forth. The basic styles of the works in these domains are quite different; books and magazines for Manga, broadcasting, theatre movies and packaged media for Anime, packaged and online media for Game and various types of Media-Art works. MADB is composed of component databases for these domains. Each component database has its metadata schema.

As discussed in the previous sections, both content-oriented and item-centric are crucial aspects for organising the databases of all domains of MADB. The Group 1 of FRBR, which is abbreviated as WEMI, is more easily able to model Manga because Manga is typically published as a volume and in magazines. On the other hand, WEMI would not fit well to the Media-Art domain, as these resources are created as individual artworks. In all domains of MADB, users can find desired resources more easily if their metadata are related for the resources based on both their intellectual/artistic contents and their physical/digital embodiments.

The following paragraphs briefly explain the four domains of MADB – Manga, Anime, Game and Media-Art. Figure 2.3 shows the data models for Manga, Anime and Game, which are extracted from the original models and re-organised to present their core features and to help readers compare the data models. Figure 2.4 includes Superwork which is defined as a bibliographic entity connecting Works in different domains. Media-Art is not included in this figure because of the fundamental difference of the data models between Media-Art and other domains.

1 Manga: a common publishing media for Manga are a volume (i.e., printed/electronic books) and magazines (i.e., serials). An important issue for data modelling is the structural feature of Manga works published across different media; for example, a story published as a series included in a magazine may be re-published as a set of volumes.

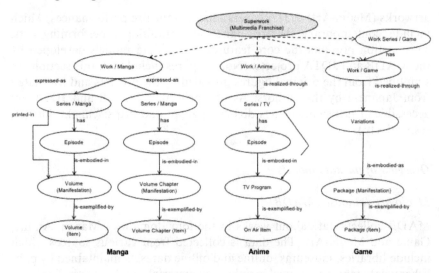

Figure 2.3 Data Models for Manga, Anime and game.

Applying FRBR to Manga is rather straightforward because of its pub-
lishing media. The core entities of the data model for Manga are shown
in the left-most part of Figure 2.3.

2 Anime: There are several media to publish animations, e.g., a pack-
 age medium such as video cassette and discs, TV broadcasting, theatre
 movie, streaming and so forth. Like Manga, there are a series of ani-
 mations under a single title. The data model for Anime works via TV
 broadcasting is shown in the central part of Figure 2.3. FRBR WEMI

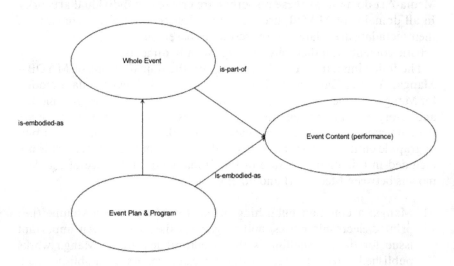

Figure 2.4 JDTA data model.

can be applied to Anime since multiple copies are created to deliver Anime contents to users.

3 Game: video games can be classified into several types, such as personal video game machines, PC games, arcade games, online games and so forth. The right-most part of Figure 2.3 shows the data model for games for personal video game machines. In this genre of video games, a single title of game may be created for multiple platforms of video game machines so that several variations are created under a single Work. Those variations may be created to adjust video games to cultural and social environments (Fukuda and Mihara 2018).

4 Media-Art: Media-Art covers various new digital media arts as well as performing arts and installation arts. This domain is quite different from other domains of MADB because every Media-Art work is a unique instance whereas works in other domains may have multiple copies. The data model has two major entities which represent Media-Art works as an abstract entity and Media-Art works as an event although the data model is not fully fixed as of April 2021. Those objects such as tangible objects created as artworks and recordings of artworks can be modelled as entities linked to the core entities. The Media-Art domain shares some features with theatre performing arts discussed in the next section because the Media-Art artworks are exhibition event-oriented. In other words, they are dynamic and ephemeral.

Japan digital theatre archives (JDTA)

The Tsubouchi Memorial Theatre Museum of Waseda University has developed the JDTA as a part of Emergency Performing Arts Archive + Digital Theatre Support Project (EPAD) funded by the ACA. The JDTA collects visual records of performances in various genres, which include traditional Japanese performing arts to contemporary theatre and dance. The primary goal of the JDTA is to archive theatre performances in various genres so that the data model for the JDTA should be neutral to all genres. Figure 2.4 shows the core part of the JDTA data model which has three entities – *Whole Event*, *Event Content (performance)* and *Event Plan & Program*. A theatre performance event may be composed of one or more individual events. For example, a musical theatre show may present the same program for several days/weeks with one or more sets of performers and staff. In this case, a *Whole Event* and *Event Content (performance)* represent a show for several days as a single event and each performance presented in the show, respectively. An *Event Plan & Program* is an entity representing the show as an intellectual creation by creators, e.g., producers and directors. Various objects are to be connected to these core entities, e.g., agents such as performers, directors and scenario writers, goods and instruments used in performances, scenario documents and recordings of performances and so forth.

Discussions

The paragraphs below discuss the data models shown above in aspects, 1 creation process, 2 embodiment, 3 objective and 4 superwork.

1 Creation process (multiple copies vs. unique item, conceptual vs. embodied): A common feature among Manga, Anime and Game domains is that multiple copies of Items are created from a single Work entity so that the data models of these domains can be defined based on FRBR WEMI. On the other hand, artworks in the Media-Art and theatre performing arts domains are a unique item so that FRBR WEMI does not fit well. However, it is reasonable to model artworks in these domains as a set of conceptual entities and embodied entities because we can recognise those artworks as an intellectual creation as well as an actual performance presented to their audience. *Event Plan & Program* of JDTA is an entity that represents a performing art as an intellectual creation and is embodied as *Whole Event* and *Event Content (performance)*.

2 Embodiment (perpetual vs. ephemeral, simple vs. structural): The Media-Art domain contains different types of artworks, such as digital media, installation, performing arts and so forth. The Media-Art data model includes an entity to describe artworks as an exhibition and performance, i.e., an event. The JDTA data model has this feature as well. This is a basic difference from the data models for Manga, Anime and Game because their objects are essentially perpetual. On the other hand, those artworks in these three domains are created on multiple media, e.g., print media, electronic package media and network/broadcasting media. As those artworks created on different media may be mutually related, the data models have to express their structural features. Media-Art exhibitions and theatre performances may have structures expressed as their programs. The JDTA model reflects the structural aspect by the two entities, *Whole Event* and *Event Content (performance)*.

3 Objectives (original objects vs. recordings, physical/digital objects vs. experientials): Some types of artworks exist only while they are performed or exhibited, meaning we need to create recordings and documentation to archive those artworks. This feature is found not only in intangible artworks and cultural heritage but also intangible artworks which cannot be archived as they are, e.g., digital media arts designed for a specific exhibition environment and those which require specialised hardware and software. As discussed in the CEDA model, intangible cultural heritage may be archived as a collection of recordings and related objects. Thus, performing arts and new media arts have similar features with intangible cultural heritage.

4 Superwork: Superwork is a crucial aspect to link objects in the different domains of media arts. It is known that there are many popular

superworks which cover Manga, Anime and Game, such as Gundam, Dragon Ball and so forth. Performing arts may be close enough to share superworks with Manga, Anime and Game. Organising dictionaries of superworks will help organise artworks in media arts. Since the automated generation of superwork dictionaries is crucial, the authors experimentally developed software to identify superworks using Wikipedia articles (Oishi et al. 2019).

Summary

In this section, the core entities of the MADB and JDTA data models are presented, but the metadata schemas are not included. The authors consider that clearly defined data models help develop metadata schemas for digital archives and databases and improve their interoperability across domains. These data models help develop precisely designed properties and classes, i.e., ontologies, in the Media Art domains. The domains covered by MADB and JDTA have features that are different from those of many existing digital archives oriented to cultural heritage.

Discussions and concluding remarks

This chapter presented generalised data models of metadata for digital archives and some aspects which are crucial for archiving intangible cultural entities as well as new media artworks. The focus of this chapter is data modelling, which is known as an important process to design databases and software. In general, data models provide metadata designers with the semantic basis to design metadata schemas in their application domains and to enhance the interoperability of metadata across domains.

While the chapter outlined generalised data models, no metadata schemas designed for particular applications were given. The data models shown in the section "Generalised models for digital archives" present the logical features of digital archives and the generalised data models of metadata for digital archives. The cases shown in the section "Metadata models for media art works and performing arts – case studies" present features of cultural entities in the application domains, Manga, Anime, Game, Media-Art and Theatre Performing Arts. Those entities in these domains have features significantly different from those archived in digital archives oriented to tangible cultural heritage objects. The data models developed in MADB and JDTA reflect the features discussed in the generalised data models – separation of intellectual contents and physical/digital items, recognition of entity types defined in CHDE and CEDA and separation of objects which may be physical, digital or abstract, and experiential entities such as events, activities and services.

The authors have been involved in the MADB project for more than five years, but not from the very beginning of the project. On the one hand, we

learned of the advantages when applying FRBR WEMI to Manga, Anime and Game compared to some earlier versions of metadata schemas for these domains. On the other hand, we learned that metadata schemas developed without well-organised data models are likely to lose interoperability across domains, even if they satisfy requirements in their application domains. We consider that the generalised data models and concepts defined in the models help metadata developers design data models and metadata schemas for the application domains.

The generalised data models presented in the section "Generalised models for digital archives" cover several aspects crucial for digital archives, i.e., from a structure of archived objects to archiving processes and to types of entities to be archived, so that the models as a whole provide a framework neutral to application domains. We consider that this feature helps understand entities constituting digital archives and their metadata. These models may be used in combination with domain-oriented models such as CIDOC CRM and IFLA LRM to create domain-oriented models for digital archiving.

An important point shown in the generalised models is the clarification of types of entities to be curated into digital archives, i.e., conceptual/abstract vs. embodied, ephemeral vs. perpetual, object vs. experientials and so forth. Once these entities are identified, we can assign identifiers to them, which is an essential requirement to utilise those entities on the Internet. Entities of any type can be linked once they are given identifiers such as URIs. There are many useful resources on the Internet that we can use as dictionaries and encyclopaedias of cultural objects and knowledge. In conventional digital archives provided by memory institutions, dictionary resources are provided, but they are likely to be limited to several so-called authority resources.

Linked Data technologies have the potential to utilise various types of Internet resources like a dictionary for digital archives. The authors consider that the generalised data models presented in this chapter provide a basis to utilise those Internet resources for cultural digital archives.

Lastly, we learned of the importance of data modelling of the entities in the application domains and creating generalised data models to develop metadata from discussions with domain specialists in the MADB and JDTA projects. Simple visual representation of data models was indispensable for communication between domain specialists and metadata designers and consensus-building across domains for interoperability of metadata.

Acknowledgements

The authors would like to thank Tomonori Nakanishi and his colleagues at The Tsubouchi Memorial Theatre Museum of Waseda University for their support to include the JDTA metadata model in this article. We thank Senan Kiryakos and Mitsuharu Nagamori for their contributions in the design of the data models CHDE and CEDA. We also express our sincere thanks

to Agency for Cultural Affairs and Dai Nippon Printing who have been running the MADB project. The models discussed in this article are a part of the achievements of a research project supported by JSPS KAKENHI Grant (Grant-in-Aid for Scientific Research) number: (A) #16H01754.

Bibliography

Baca, Murtha and Patricia Harpring. 1999. *Categories for the Description of Works of Art*. Santa Monica, CA: J. Paul Getty Trust. https://www.getty.edu/research/publications/electronic_publications/cdwa/

Carboni, Nicola and Livio de Luca. 2016. "Towards a Conceptual Foundation for Documenting Tangible and Intangible Elements of a Cultural Object." *Digital Applications in Archaeology and Cultural Heritage* 3 (4): 108–116.

Dublin Core Metadata Initiative. 2021. "One-to-One Principle." Glossary. https://www.dublincore.org/resources/glossary/one-to-one_principle/

Fairbairn, Natasha, Maria Assunta Pimpinelli, and Thelma Ross. 2016. *The FIAF Moving Image Cataloguing Manual*, edited by Linda Tadic. International Federation of Film Archives. https://www.fiafnet.org/images/tinyUpload/E-Resources/Commission-And-PIP-Resources/CDC-resources/20160920%20Fiaf%20Manual-WEB.pdf

Fukuda, Kazufumi and Tetsuya Mihara. 2018. "A Development of the Metadata Model for Video Game Cataloging: For the Implementation of Media-Arts Database." *IFLA WLIC*. http://library.ifla.org/id/eprint/2132

Getty Research Institute. n.d. "Getty Vocabularies." Accessed May 07, 2021. http://www.getty.edu/research/tools/vocabularies/

Hyvönen, Eero. 2012. "Publishing and Using Cultural Heritage Linked Data on the Semantic Web." *Synthesis Lectures on the Semantic Web: Theory and Technology*. San Rafael, CA: Morgan & Claypool Publishers.

IFLA Study Group. 1997. "Functional Requirements for Bibliographic Records: Final Report." *IFLA*. https://www.ifla.org/files/assets/cataloguing/frbr/frbr_2008.pdf

Isaac, Antoine, ed. 2013. "Europeana Data Model Primer." Europeana. https://pro.europeana.eu/files/Europeana_Professional/Share_your_data/Technical_requirements/EDM_Documentation/EDM_Primer_130714.pdf

Kiryakos, Senan and Shigeo Sugimoto. 2018. "The Representation of a Multimedia Franchise as a Single Entity: Contrasting Existing Bibliographic entities with Web-Based Superwork Portrayals." *LIBRES: Library and Information Science Research Electronic Journal* 28 (2): 40–57. https://www.libres-ejournal.info/2718/

Kiryakos, Senan, and Shigeo Sugimoto. 2019. "Building a Bibliographic Hierarchy for Manga through the Aggregation of Institutional and Hobbyist Descriptions." *Journal of Documentation* 75 (2): 287–313. https://doi.org/10.1108/JD-06-2018-0089

Le Boeuf, Patrick, Martin Doerr, Christian Emil Ore, and StephenStead. 2018. "Definition of the CIDOC Conceptual Reference Model." ICOM/CIDOC Documentation Standards Group and CIDOC CRM Special Interest Group, version 6.2.4. http://www.cidoc-crm.org/sites/default/files/2018-10-26%23CIDOC%20CRM_v6.2.4_esIP.pdf

Library of Congress Linked Data Service. n.d. "Library of Congress Subject Headings." Accessed May 07, 2021. https://id.loc.gov/authorities/subjects.html

Library of Congress. 2020a. "Encoded Archival Description – Official Site.". Accessed May 07, 2021. https://www.loc.gov/ead/

Library of Congress. 2020b. "MARC standards." Accessed May 07, 2021. https://www.loc.gov/marc/.

Library of Congress. n.d. "Bibliographic Framework Initiative." Accessed April 30, 2021. https://www.loc.gov/bibframe/

Nilsson, Mikael, Tom Baker, and Pete Johnston. 2008. "The Singapore Framework of Dublin Core Application Profiles." Dublin Core Metadata Initiative. Accessed April 30, 2021. http://dublincore.org/specifications/dublin-core/singapore-framework/

Oishi, Kosuke, Tetsuya Mihara, Mitsuharu Nagamori, and Shigeo Sugimoto. 2019. "Identifying and Linking Entities of Multimedia Franchise on Manga, Anime and Video Game from Wikipedia." *International Conference on Asian Digital Libraries*, 95–101. Cham: Springer. https://doi.org/10.1007/978-3-030-34058-2_10

Open Archives Initiative. n.d. "Open Archives Initiative: Object Exchange and Reuse." Accessed April 30, 2021. https://www.openarchives.org/ore/

Orgel, Thomas, Martin Höffernig, Werner Bailer, and Silvia Russegger. 2015. "A Metadata Model and Mapping Approach for Facilitating Access to Heterogeneous Cultural Heritage assets." *International Journal on Digital Libraries* 15 (2–4): 189–207.

Riva, Pat, Patrick Le Bœuf, and Maja Žumer, eds. 2017. "IFLA Library Reference Model; A Conceptual Model for Bibliographic Information." IFLA International Federation of Library Associations and institutions. https://www.ifla.org/files/assets/cataloguing/frbr-lrm/ifla-lrm-august-2017_rev201712.pdf

Sugimoto, Shigeo, Chiranthi Wijesundara, Tetsuya Mihara, and Mitsuharu Nagamori. In press. "A Generalized Data Model for Digital Archiving in Cultural and Historical Domains." *Boosting the Knowledge Economy*, edited by Calsada-Prado. Elsevier.

Svenonius, Elaine. 2000. *The Intellectual Foundation of Information Organization.* Cambridge, MA: MIT Press.

W3C RDF Working Group. 2014. "Resource Description Framework (RDF)." Accessed April 30, 2021. https://www.w3.org/RDF/

Wijesundara, Chiranthi and Shigeo Sugimoto. 2018. "Metadata Model for Organizing Digital Archives of Tangible and Intangible Cultural Heritage, and Linking Cultural Heritage Information in Digital Space." *LIBRES: Library and Information Science Research Electronic Journal* 28 (2): 58–80. https://www.libres-ejournal.info/2706/.

Wijesundara, Chiranthi and Shigeo Sugimoto. 2019. "Shifting from Item-centric to Content-oriented: A Metadata Framework for Digital Archives in the Cultural and Historical Domains." 9th *Asia-Pacific Conference on Library and Information Education and Practice (A-LIEP)*: 310–324.

Wijesundara, Chiranthi, Winda Monika, and Shigeo Sugimoto. 2017. "A Metadata Model to Organize Cultural Heritage Resources in Heterogeneous Information Environments." *In International Conference on Asian Digital Libraries*, 81–94. Cham: Springer. https://doi.org/10.1007/978-3-319-70232-2_7

Zeng, Marcia Lei and Jian Qin. 2016. *Metadata.* 2nd ed. ALA. Chicago, IL: Neal-Schuman Publishers.

Harmonising conceptual models

3 Collection-level and item-level description in the digital environment

Alignment of conceptual models IFLA LRM and RiC-CM

Ana Vukadin and Tamara Štefanac

Introduction

Digital materials created in the course of a research project should be provided with infrastructure that supports their discovery, authenticity, accuracy, reliability and reuse. In this sense, the creation and maintenance of a research repository shares many concerns typical of archives and libraries, such as records management, information retrieval and long-term preservation. Well-known archival and library metadata practices could provide a useful framework for recording the structure and history of the repository itself, as well as for identifying individual items in the repository and linking them to similar objects of interest.

Descriptive standards and practices in archives and libraries differ on a number of levels, not least because they reflect specific business functions and legal mandates that each of these communities has in a broader social context. However, when archival and library holdings are digitised and made available on the web, their institutional context is replaced by a new environment in which boundaries between them become less distinct, while their relationships with other cultural stakeholders, including private collectors, scholars and researchers, potentially become more evident. As a consequence, the requirements for their organisation, management and description, which were once (at least to a certain point) community specific, become more and more entwined.

With this in mind, we intend to explore how harmonisation of library and archival models for resource description might enhance discovery, management and use of digitised heritage objects, but also how in turn it might affect discovery, management and use of their originals. It should be noted that this study does not research directly into users' needs and experiences of information retrieval in digital repositories. Instead, as a starting point we take the conceptual data models that underpin archival and bibliographic

DOI: 10.4324/9781003131816-3

description, but in doing so we implicitly take into account user studies that were built in the models (Pisanski and Žumer 2012), as well as reflections on information behaviour in the digital environment that helped shape the structure of the models (Bailey 2013).

Conceptual data models are high-level descriptions of concepts and their relationships that are to be stored as data in an application. In a broader sense, they are abstract representations of a certain domain of knowledge or activity. The models we will be focusing on in this study are *Library Reference Model* (LRM), developed under the auspices of the International Federation of Library Associations and Institutions (IFLA), and *Records in Contexts: A Conceptual model for Archival Description* (RiC) of the International Council on Archives (ICA). Both models were designed by scholars and professionals who set up their perspectives from respective institutional and educational context, while also having greater interoperability opportunities in mind. Therefore, both models are able to express archival/bibliographical description in the form of Linked Data, which encourages data sharing and reuse in the digital environment.

To the best of our knowledge, there have yet been no attempts to align these two models, although formal representation of RiC is expected to be complemented with mappings between some concepts or properties in LRM (RiC-O 2021). We therefore hope that this research will encourage more extensive semantic and structural alignment in the future. So far, the need to achieve a certain level of interoperability between archival and bibliographic metadata has been recognised and addressed by scholars and professional bodies in numerous occasions. Many of these attempts have been motivated by large digitisation projects in the period of late 1990s and early 2000s, which will be discussed in more detail later. Willer (2015) reports on the two-way relationships between the creators of the *International Standard Archive Authority Record for Corporate Bodies, Persons and Families* (ISAAR(CPF)) and IFLA's working groups on the development of authority data models. IFLA's Permanent UNIMARC Committee, the body responsible for the maintenance and development of the UNIMARC data format, has been working on the specialised Guidelines for Archives in order to ensure better access to archival material held in libraries. The use of the UNIMARC format for archival description has been analysed, among others, by Zhlobinskaya (2020). *International Standard Bibliographic Description* (ISBD) has long been aiming to expand its scope to unpublished and archival materials, e.g., through collaboration with music cataloguers and archivists (Gentili Tedeschi 2011). Library metadata standard *Resource Description & Access* (RDA) has also recently announced the intention of including archival materials, even if this expansion, similarly to ISBD, seems to be limited to items such as letters or manuscripts, and does not (yet) address more complex issues of collection-level description (Glennan 2020).

Our research is based on two main questions: is it possible to harmonise the RiC and LRM conceptualisation of the information resource in order to produce a working model for multifaceted description of heritage materials, and what would be the benefits of this approach for digital humanities scholars, heritage institutions and end-users? By multifaceted description we intend the description that is able to express (and link) various aspects of described objects, such as their level of granularity (e.g., collections vs. single items), level of abstractness/physicality (content vs. carriers), provenance or mode of creation (e.g., original sets vs. "post-production" sets) and last but not least, changes that all these aspects undergo over time. We aim to demonstrate the benefits of this approach on the example of a digital repository that was created around a research project and contains diverse kinds of digitised materials (books, journals, photographs, postcards, letters, legal documents etc.), whose originals are held in various types of heritage institutions. In the search for a useful example, we were guided by Theimer's inputs regarding the relationship between archives and digital humanities: "Surveying the landscape of the digital humanities, the 'archives' that attracted my attention were primarily online groupings of digital copies of non-digital original materials, often comprised of materials (many of which are publications) located in different physical repositories or collections, purposefully selected and arranged in order to support a scholarly goal" (Theimer 2012).

In the following section we reflect on the concepts from Library and Information Sciences, Archive and Records Management Studies and Digital Humanities that have influenced the positioning of our research agenda. This is followed by the case study in which we align the semantics of the RiC entities Record Resource and Instantiation and the LRM entities Work, Expression, Manifestation and Item and investigate the possibilities of their merging into a common scheme. The scheme is then applied to a chosen number of examples from the digital repository. In the discussion section we elaborate further on the results of the study and its application in various contexts, including its implications for library and archive practices. We conclude by pointing to possible future areas of research and application.

Background

Libraries are predominantly concerned with publications, i.e., information recorded on mass-produced or otherwise widely available objects in various media. Hence, one of the principal concerns of bibliographic information organisation is establishing relationships between content and its carriers. From Panizzi's *Ninety-One Cataloguing Rules* to Cutter's objectives of the library catalogue, from Ranganathan's laws of librarianship to the discussions that informed the first modern international cataloguing standards (Verona 1959) and theories of bibliographic relationships

(Wilson 1978; Tillett 1991; Leazer and Smiraglia 1999), the main function of library information tools has been to safely lead the user through the entangled forest of versions, recordings, translations, editions, impressions and transformations of works on various subjects to the particular item that will best suit her information needs. Information needs are defined through five basic user tasks that have to be supported by bibliographic data: find, identify, select, obtain, explore (Riva, LeBoeuf, and Žumer 2017, 15).

Archives also deal with records on diverse media, but these records are usually not widely available (indeed, in many cases they are unique) and are, as a rule, aggregated into sets (fonds, series, subseries etc.) based on the traditional archival principle of provenance, which requires that records should be arranged and maintained in the same order as they were originally placed by the creator (Bolfarini Tognoli, and Chaves Guimarães 2019). Archival description is thus mainly concerned with multilevel, hierarchical representations that place each record into the context of a larger unit. However, during the last few decades the conceptions of description in contemporary archival studies theory have put emphasis on broader, more dynamic, contextual information. This means that metadata should not only reflect a fond as a hierarchically structured, self-contained unit, but also point to its historical and current relationships with other fonds or collections and their members.

As more and more heritage objects of all kinds are being digitised (i.e., re-instantiated in a new medium), uploaded on the Web (i.e., published) and included in a new context that to a lesser or greater extent differs from their original environment (i.e., recontextualised), bibliographic and archival approaches to description seem to begin to converge. For example, an archival fond that has been digitised and presented on the Web will still display metadata describing circumstances of its original creation, such as names of agents or terms for business activities and functions that brought it into being. On the other hand, the fact that it is published on the Web makes it part of bibliographic universe, which means it can also be described as a publication (e.g., identified by International Standard Serial Number, which is assigned to continuing bibliographic resources such as web portals and databases). Both descriptions are "correct" and both serve a certain purpose.

There is also a third perspective, the one that aims to establish a connection between bibliographic and pre-bibliographic context. The connection, established both at the collection- and item-level, should facilitate resource discovery by creating a navigable network of originals, reproductions, editions and copies that carry the same content. At the same time, it should provide digitised items with contextual information, which falls back directly into archival and records management domain where a record is always considered within a certain context. Records can be recontextualised, but the necessity to explain the original context is a matter of transparency, and as such is firmly related to trustworthiness.

It is needless to stress the importance of transparency, trustworthiness, accountability and ethics in the field of (digital) scholarship. This brings us to a converging point in which knowledge, standards and best practices of archival and library communities get challenged by the ideas coming from digital humanities realm. We are still facing the issues that Theimer raised almost a decade ago, when she surveyed digital humanities scholars about their concepts of the term "archive" and found them disconnected with the archivists' conceptions (Theimer 2012). For example, digital humanities do not always capture the specific value of archival knowledge which is reflected in trustworthiness of data, long-term preservation and stability of representations. However, if we attempt to produce valid and useful representations of digital collections, we will soon realise that we have entered the slippery ground where different professions and scholar disciplines each have their own understanding of the concepts that need to be captured and delivered through descriptive metadata. What is needed is a common semantic framework that will not only help integrate metadata from various sources, but also be able to explicate various metanarratives that may have affected them, considering that the act of description is always performed by a certain agent, in a certain time and place and for a certain purpose.

In our opinion, such a framework should provide: (i) the possibility of item-level description, to enable access to individual objects, (ii) distinction between content and carrier, to provide information about different physical manifestations of the same object, which might affect its accessibility, use and interpretation (Owens and Padilla 2020), (iii) the possibility of collection-level description, to capture the context within which individual objects are described, and relate it to other contexts, if they exist and (iv) the possibility of establishing relationships between described objects at all of these levels.

Similar frameworks have already been proposed, particularly in the period of the late 1990s and early 2000s, when they were largely encouraged by mass digitisation. From the <indecs> project emerged the principle of functional granularity, i.e., the idea that a well-formed metadata schema should provide a way of identifying any possible part or version of the document that is required by a practical need, from a particular sentence in the document to an entire collection of documents (Rust and Bide 2000). In the UK, the Research Support Libraries Programme (RSLP) attempted to take a holistic view of library and archive activities in order to enhance access to research resources in higher education libraries (Powell, Heaney, and Dempsey 2000). From the RSLP Collection Description Project emerged *An Analytical Model of Collections and their Catalogues* by M. Heaney, which offered a scheme for identifying resources at the conceptual level (Content) and physical level (Item), and for linking individual Items to collections into which they had been included (Heaney 2000, 7). Last but not least, during this period the Conceptual Reference Model of International Committee

for Documentation (CIDOC CRM) came out as the first comprehensive conceptual model originated from a professional body of a cultural heritage community. In 2006, it became an international standard for exchange of cultural information (ISO 21127).

The question of a cross-domain scheme for description of cultural heritage is therefore not new, and during the recent decades there has been more than one attempt to address it. How is, then, the harmonisation between RiC and LRM relevant for our purpose? The main reason is that RiC and LRM are the most recent models of cultural heritage information, and currently the most likely to be implemented into general descriptive standards and practices in archives and libraries. For example, LRM is implemented quite literally in RDA, which is turning into an internationally recognised standard for creating library metadata. The ISBD elements are also presently being mapped to the LRM entities. By exploring the harmonisation between LRM and RiC, we create a basis for evaluating interoperability of future descriptive practices based on LRM and RiC, which will also affect the description of digital holdings in archives and libraries. The mapping to earlier cross-domain models, especially CIDOC CRM, can further serve to verify the logical validity of RiC and LRM, as well as their derivative schemes. However, this is out of the scope of the present chapter (particularly taking into consideration the complexity and comprehensiveness of CIDOC CRM), and is left to future analyses both in scholarly and professional field. At the time of writing, the LRM-CIDOC CRM harmonisation is being carried out by the IFLA's Bibliographic Conceptual Models Review Group.

Case study

In this section we investigate the harmonisation between the RiC and LRM entities that represent the information resource and seek to demonstrate the applicability of the harmonised scheme on the example of the Morpurgo Topotheque. The Morpurgo Topotheque is a repository that contains digitised materials about the history of the Morpurgo bookstore, one of the oldest bookstores in Croatia, whose founder and owner was also a prominent publisher. Since the foundation in 1860 the bookstore has been operating at the same location in the historical centre of Split, within the walls of the famous Diocletian palace. In 2014 it was included in the List of Protected Cultural Heritage by the Ministry of Culture and Media of the Republic of Croatia.

The story of the Morpurgo bookstore is important for both local and national cultural history, and for this reason it was recently chosen as the subject of the doctoral thesis (later turned into a book) by the researcher Nada Topić (2017), who explored its influence on the culture of reading in Croatia. In the course of the research the author collected and digitised a variety of sources (photographs, legal documents, letters, books etc.) that served her purposes as research data. She eventually published about

a hundred of digitised sources in an open-access repository on the Topotheque platform, which is created to support local virtual collections of European historical heritage (available at https://morpurgo.topoteka. net/). The sources published in the Morpurgo Topotheque are accompanied by minimal-level, non-standardised metadata assigned by the researcher, including title, name of the owner and keywords.

The status and history of this repository make it a good example of digital humanities practices. It clearly falls within the category of projects aiming to address the history of important cultural heritage objects (in their immovable, movable and intangible cultural dimensions) from the perspectives of humanities. The sources stored in the repository are presumed to be relevant for future research purposes. But it is important to note that, besides providing access to digitised heritage materials for future researchers, the project created an additional value – an overtly context-specific online collection of heritage materials whose physical originals are held in local and national institutions. It is context-specific because both its content and possible future use are determined by circumstances that brought it into being (a specific research agenda). For example, other researchers might have chosen a different set of resources or might have presented them differently. Anyone who might want to reuse the resources from the repository should not only be able to retrieve them, but also aware of the context for which they were aggregated, published and described.

In the rest of the section, we aim to demonstrate how a cross-domain model derived from the RiC-LRM harmonisation could enhance discovery of the content of the Morpurgo repository and to provide a better understanding of its context, but also how it might enhance discovery and interpretation of original materials held in archives, museums and libraries. We will propose a way for describing both the repository as a whole and its individual items, based on a few typical examples: (i) a digitised historic photograph representing the entrance to the Morpurgo bookstore (*Ulaz u knjižaru Morpurgo*), (ii) a digital image of the cover of the poetry book *Zvezdane staze* (*Star paths*) by the Croatian author Ante Cettineo, published by Morpurgo in 1923, (iii) a digital image of the front page of *Knjižarstvo* (*Bookselling*), the official journal of the Croatian Society of Booksellers in the 1920s and (iv) a digitised memo sent to the bookstore by one of the suppliers, the José Subasich Bookshop in Buenos Aires (*Ponuda knjižare Jose Subasich*).

RiC: Record resource, instantiation

Conceptualisation of the archival record in RiC revolves around the entity RiC-E02 Record Resource, defined as an information object produced or acquired and retained by one or more agents in the course of their activity.

Record Resource has three sub-entities: RiC-E03 Record Set, RiC-E04 Record and RiC-E05 Record Part. The level at which a particular information object will be described is based on judgment in a specific context (ICA-EGAD 2019, 8).

Record is a basic independent conceptual unit that serves as the evidence of a certain activity carried out by an agent. It is the smallest unit that has its own recognisable content, structure and context and is accessible through a medium of some kind (e.g., a deed of rights, whether on paper or properly digitised). Record Set is a body of Records that are associated by categorisation and/or physical aggregation by the creator or other agent responsible for preserving the creator's records (archival fond, series etc.). Record Part is part of a Record with discrete information content that contributes to the Record's physical or intellectual completeness. An example would be a geological report with an attached map, in which the map might be considered a visually interesting document on its own, but at the same time it is a part of the record and needs to be interpreted primarily in this context.

This structure reflects a hierarchical, top-down approach to description of archival fonds and their subunits (series, subseries, dossiers etc.), which is the backbone of the *General International Standard Archival Description* (ISAD(G)). It arises from the aforementioned principles of provenance, according to which archival material created by a certain agent should be preserved as an inseparable whole, and organised in the same order as it was kept by the creator.

However, RiC uses the Record Set entity to broaden this traditional approach. As Popovici (2016, 26) notes, Record Set "[...] is intended to be an umbrella term, helping to denominate any aggregation of records and describe it accordingly to archival practices". Thus, the same Record can belong to more than one Record Set, e.g., it can be a part of the original fond held by an archival institution, but also included in a digital repository by another agent. In RiC (Consultation Draft 0.2) this is modelled with the help of the entity RiC-E06 Instantiation, which is a physical manifestation of a record, i.e., the inscription of information on a physical carrier in any persistent, recoverable form, such as a piece of paper, a video cassette or a jpeg file. Every Record Resource is instantiated at least once, but it can also have other Instantiations, whether simultaneously or over time.

LRM: Work, expression, manifestation, item

Conceptualisation of the information resource in LRM is represented by four disjunct entities that run from most abstract to most concrete: Work, Expression, Manifestation and Item. LRM-E2 Work is intellectual or artistic content of a distinct creation. It is an abstract idea in the mind of

a creator, which is realised through LRM-E3 Expression, a distinct combination of notation, sound, image or any other type of signs (e.g., specific sentences, paragraphs, melodies or visual forms). For example, *Romeo and Juliet* by Shakespeare is an instance of Work, whereas its English original and Croatian translation are instances of Expressions of this Work. Sergei Prokofiev's ballet *Romeo and Juliet,* albeit based on Shakespeare's play, is a distinct Work, because independent intellectual or artistic effort was involved in its creation.

Every Expression of a Work can have one or more Manifestations. LRM-E4 Manifestation is a physical embodiment of an Expression. Any change concerning medium or carrier results in different physical features, and hence in a new Manifestation. For example, a digitised poster has at least two Manifestations: the original print and computer file containing its digitised image. Manifestation encompasses all physical objects (carriers) that result from the same production plan: in some cases, this includes only a single unique object (e.g., a manuscript), while in other cases it encompasses an entire set of identical copies (e.g., the 2007 edition of *Romeo and Juliet* by Penguin Classics). If the latter is the case, each physical exemplar of a Manifestation is a distinct LRM-E5 Item. In practice, Item represents the main source for identification and description of other three entities.

The notion of information resource in RiC and LRM: Harmonisation

Harmonisation is the combination of two or more schemes into a new scheme that may have its own structure and scope, and functions as an interoperation facilitator (Zeng 2018). It is based on the structural and, above all, semantic mapping between elements of source schemes. Structural mapping between RiC and LRM is facilitated by the fact that both are entity-relationship models. Semantic mapping consists of comparing meanings of their concepts. As stated by Zeng (2018), "semantic interoperability/integration is basically driven by the communication of coherent purpose. In the practice of integration and achieving interoperability, multiple contexts (including but not limited to time, spatial frame, trust, and terminology) have to be addressed".

Consistencies in meanings of the RiC and LRM entities will be compared based on their definitions, scope notes and properties presented in the models, taking into account specific domain knowledge and descriptive practices of communities within which each model was developed. In certain aspects LRM and RiC share a common view of the information resource, although with some subtle distinctions, while in other aspects they focus on entirely different features. For example, RiC models the resource according to two basic criteria: level of granularity (Record Resource and its sub-entities) and degree of abstractness/physicality (Record Resource

vs. Instantiation). LRM models it only according to a degree of abstractness/physicality, but in a more fine-grained way, introducing four instead of RiC's two entities.

However, LRM also recognises the inherent connection between Work and Expression by stating that, even if a Work has more than one Expression, its original Expression (e.g., the original English text of *Romeo and Juliet*) stands out from other Expressions as the most canonical representation of the creator's intention, and therefore its attributes can also be used to describe a Work. In this sense, Work and Expression together could correspond to the entity Record Resource, and the relationship LRM-R2 *Work is realized through Expression* can partly be matched to some RiC relationships between Records, e.g., RiC-R011 *Record is draft of/has draft Record*. Manifestation and Item, on the other hand, correspond to Instantiation.

RiC provides no possibility to distinguish between different copies of the same Instantiation, e.g., identical printed copies of a memo, because from the legal point of view each of them is original and thus represents a distinct Record Resource. LRM does not model its entities based on their level of granularity, but through the relationships LRM-R18 *Work has part/is part of Work*, LRM-R23 *Expression has part/is part of Expression*, and LRM-R26 *Manifestation has part/is part of Manifestation*, it provides a mechanism to organise resources hierarchically. However, this relationship is semantically restricted to the cases in which resources were conceived, realised and/or produced together as a whole and its inherent part. It does not apply to cases in which a resource is subsequently included in another resource (a collection) based on certain properties that meet the aggregator's criteria. On the other hand, RiC does not distinguish between a Record Set that was created as an organic whole and another that was created by accumulating already existing, independent objects. This distinction can be expressed on a more concrete level, i.e., in a concrete implementation scenario, if needed.

LRM recognises collection of objects, or more precisely a plan for collection, as a creative effort that can be identified as Work. However, its notion of collection is limited to publication context and implies a set of multiple independently created Expressions which are published together in a single Manifestation (Riva, LeBoeuf, and Žumer 2017, 93): anthologies, selections, books with independently written chapters, compilations, journals (aggregations of issues), journal issues (aggregations of articles) etc. Therefore, relationship between a collection and its members can only be established at the Expression level (LRM-R25 *Expression was aggregated by/aggregated Expression*). LRM is not concerned with collections of Items because they are seen as a "post-production" phenomenon which is out of scope of a bibliographic model, although Riva (2018, 27–31) makes an attempt to model bound-withs within the LRM

framework. If Work is determined by a planned or intended activity aimed at creating something, physical collections of Items might also be regarded as Works. However, this remains to be discussed. Another option is to model a collection outside the Work-Expression-Manifestation-Item stack, simply as a sub-entity of LRM-E1 Res, which is a superclass of all the other LRM entities, whether those explicitly defined in the model or any others that are not specifically labelled (Riva, LeBoeuf, and Žumer 2017, 20).

It should be noted here that the meaning of Work/Expression is not completely equivalent to that of Record Resource. Record Resources are outcomes of an activity that may or may not be undertaken with the explicit creative plan or purpose. For example, a personal fond as a whole does not necessarily emerge from any clear plan or intention of its creator. On the other hand, a personal fond that has been digitised and made available on the web is an outcome of an intended action. As stated above, RiC does not distinguish between these different modes of creation, e.g., the relationship RiC-R028 *accumulated by/accumulates* relates "a Record Resource or an Instantiation to the Agent that accumulates it, be it intentionally (collecting) or not (receiving in the course of its activities)" (ICA-EGAD 2019, 71). Record Resource has a broader meaning than Work. Therefore, the harmonisation of these concepts will result in a hierarchical structure, in which Work and Expression are sub-entities of Record Resource.

The term *record* is typical for the archival community. Since a harmonised scheme should not serve only the purpose of archives, but be applicable to a wider range of heritage objects, in further text terminology will be modified so that the entity corresponding to Record Resource is called simply Resource. In the context of LRM, Resource can be expressed as a sub-entity of the top entity LRM-E1 Res. Its definition will remain that of an immaterial, intellectual object produced or acquired and retained by one or more agents in the course of their activity. If the activity in question is undertaken, or is assumed to have been undertaken, with the plan or intention to produce a distinct creation, Resource can be more precisely defined as Work. This includes planned aggregation of intellectual objects, among which a digital repository. However, Works will not include collections of Items – these are identified and described at the broader level, as Resources.

The entity Instantiation can be seen as equivalent to Manifestation. Manifestation is explicitly defined as the outcome of a certain production plan (Riva, LeBoeuf, and Žumer 2017, 25), and Instantiation, being a recording of information on a physical carrier, is also presumably always the result of a production plan. The totality of physical objects that make up a collection is therefore not regarded as Instantiation (indeed, RiC states that a Record Set may or may not have an instantiation). However, this may

represent a logical obstacle if we want to describe the content of a collection separately from its various physical forms (e.g., original, microfilmed or digitised), each of which may have particular physical characteristics (e.g., extent). We therefore propose an umbrella entity (we will provisionally call it Physical object) that includes not only carriers, but also accumulated sets of carriers. It is important to bear in mind that the term *physical* includes digital objects as well, because they also manifest through a medium and have certain physical characteristics.

The harmonised scheme would therefore contain the following provisionally defined entities:

Resource = distinct information unit created or acquired and retained by one or more agents in the course of their activity

- Work = Resource created as a result of intended creative action
- Expression = realization of Work through a distinct combination of signs (shapes, sounds, words etc.)

Physical object = physical embodiment of Resource

- Instantiation/Manifestation = recording of Resource on a physical carrier in any persistent, recoverable form, according to the same production plan
- Item = single copy of Instantiation/Manifestation

As shown before, Record Resource in RiC already has three subentities: Record (individual level), Record Set (set level) and Record Part (component level). Instantiation is not subtype in an analogous way, presumably because it inherits the level of granularity from the respective Record Resource. However, neither in archival nor bibliographic context is this level necessarily inherited: aggregations or multipart works can be recorded on a single carrier (e.g., a collection of videos on a single CD), while single works can be recorded in multipart physical form (e.g., a novel published in two volumes). In any case, both RiC and LRM allow a concrete implementation scenario where both abstract and concrete entities will be described at any level of granularity, whether this level is inherited or not.

We can therefore model Resource and Instantiation/Manifestation as concepts or classes subdivided along two facets: one is level of granularity, and the other is a degree of abstractness/physicality. If these facets are mutually combined, the result is a scheme that is compatible with Heaney's model for collection-level description and builds on it by introducing the LRM entities as an extension for publications. The scheme is represented in Table 3.1 below, accompanied with examples from the Morpurgo repository.

Table 3.1 RiC – LRM harmonisation

	Individual level	Set level	Component level
Resource	* Comprises individual Works and Expressions.		* Comprises component Works and Expressions.
Work	• photograph *The Entrance to the Morpurgo Bookstore* • a poem from the collection *Zvezdane staze (Star Paths)* by Ante Cettineo • memo sent by the José Subasich Bookstore in Buenos Aires to the Morpurgo Bookstore	• the Morpurgo Family Fond in the State Archive in Split • the Heritage Collection in the Public Library in Split • the Photograph Collection in the City Museum of Split • the Morpurgo Topotheque digital repository (aggregation of digitized materials) • collection of poems *Zvezdane staze (Star Paths)* by Ante Cettineo • journal *Knjižarstvo (Bookselling)*	• a stanza from a poem in the collection *Zvezdane staze (Star Paths)* by Ante Cettineo • introductory paragraph from the memo by the José Subasich Bookstore
-Expression	• original black and white photograph *The Entrance to the Morpurgo Bookstore* • original Croatian text of a poem by Ante Cettineo • original Croatian text of the memo from the José Subasich Bookstore in Buenos Aires	• Morpurgo Topotheque with text in Croatian • Morpurgo Topotheque with text in English • original Croatian text of the collection of poems *Zvezdane staze (Star Paths)* • text of all the articles that make up the journal *Knjižarstvo (Bookselling)*	• original Croatian text of the stanza from a poem by Ante Cettineo • original Croatian text of the introductory paragraph from the memo by José Subasich Bookstore
Physical object	* Comprises individual Instantiations/Manifestations and Items.	• totality of physical objects in the Morpurgo Family Fond in the State Archive in Split • totality of physical objects in the Heritage Collection in the Public Library in Split • totality of physical objects in the Photograph Collection in the City Museum of Split	* Comprises component Instantiations/Manifestations and Items.

(Continued)

Table 3.1 RiC – LRM harmonisation (*Continued*)

	Individual level	Set level	Component level
Instantiation/Manifestation	• printed black and white photograph *The Entrance to the Morpurgo Bookstore* • jpeg file with digital image of the black and white photograph *The Entrance to the Morpurgo Bookstore* • printed edition of the poetry collection *Zvezdane staze* in a single volume, published by Morpurgo in 1923 • jpeg file with digital image of the cover of the 1923 edition of *Zvezdane staze* • jpeg file with digital image of the front page of journal *Knjižarstvo* • typed version of the memo by the José Subasich Bookstore	• all computer files that make up the Morpurgo Topotheque • all computer files that make up the digitized version of the 1923 edition of *Zvezdane staze* (https://digitalnezbirke.gkmm.hr/object/10148) • all volumes that make up the print edition of the journal *Knjižarstvo*	• cover of the 1923 print edition of *Zvezdane staze* • front page of the copy of the printed issue of the journal *Knjižarstvo*, vol. 1, no. 1 (1925)
-Item	• copy of printed black and white photograph *The Entrance to the Morpurgo Bookstore* stored in the City Museum of Split (HR-MGS 16378) • copy of jpeg file with digital image of the cover of the 1923 edition of *Zvezdane staze*, included in the Morpurgo Topotheque • copy of memo by the José Subasich Bookstore, stored in the State Archive in Split within the Morpurgo Family Fond	• all volumes that make up the print edition of the journal *Knjižarstvo* and are stored in the National and University Library in Zagreb (90.960)	• cover of the copy of the printed 1923 edition of *Zvezdane staze*, stored in the Public Library in Split (821.163.42-1 CET zv), which was digitized for Morpurgo Topotheque • front page of the copy of printed volume of the journal *Knjižarstvo*, vol. 1, no. 1 (1925), stored in the National and University Library in Zagreb, which was digitized for Morpurgo Topotheque

Discussion

The presented scheme, derived from partial harmonisation of the RiC and LRM, meets the requirements for cross-domain description of heritage materials listed in the Background section. It observes the principle of functional granularity by providing different levels of description, from general (Resource – Instantiation) to more fine-grained. In this way it represents a framework in which institutional policies, or particular information systems, or other extrinsic factors can determine the level of description according to specific goals and needs.

The description at the Individual and Component level facilitates finding and accessing individual objects, especially in the environment where metadata can be shared between different repositories, and links established e.g., between the description of the photograph in the City Museum in Split and the reproduction of the same photograph in a digital research repository. These links can be very precise and context-preserving if needed, thanks to the elaborate distinction between content and carriers provided by LRM entities. For example, bibliographic features of an edition can be distinguished from characteristics of a particular copy used for digitisation. A concrete physical copy of the journal (Item), characterised by evidence of its particular life cycle, can be distinguished from an "ideal" copy of the journal (Manifestation), digitised for representation from the several most preserved physical copies.

Although this provides a great support for records management, particularly in the digital environment, the level of description of individual objects is still seldom reached in archives. However, its benefits are being recognised (Higgins, Hilton, and Davis 2014) as more and more archival materials are digitised or born-digital. On the other hand, the description at the Set level ("collection-level"), typical of archives, is largely underused both in libraries and digital humanities projects (e.g., the Morpurgo Topotheque does not provide any metadata related to the collection itself). Yet describing an aggregation of objects has many advantages (Wickett 2018, 1187), whether the aggregation is an archival fond, an institutional collection, a private collection, or a repository of research data. Collection-level description reveals its importance in both physical and digital preservation and representation through several aspects: (i) the use of collection-level metadata often represents the initial step in information seeking process, as it serves as an entry point to more detailed levels of description (Heaney 2000, 3), (ii) it contextualises a collection by providing valuable information about its provenance and evolution and (iii) it documents business activity and keeps track of changes in management and use of a collection, enhancing its long-term accessibility and adaptability. If the Morpurgo repository displayed metadata about itself, instead of keeping it in the administrative technical background, the user would be provided with structured contextual information such as when, by whom

and for what purpose the materials were collected, which might shape her understanding and use of the repository content.

Metadata could also capture changes such as augmentation of the collection by another agent. This is certainly valuable information, whether from the perspective of a repository of historic materials about a bookstore, or historical manuscripts, or medical data or any kind of collected research data. Through linkage with institutional collections that provided original material, heritage institutions would have a better insight into the use and interpretation of their holdings, which in turn might affect their decisions about collection management. These kinds of connections enhance visibility and distinctiveness of heritage institutions as holders of original materials, while also adding a layer of trustworthiness and authority to repositories derived from digital humanities projects.

Holm, Jarrick, and Scott (2015, 80) list digital archives as one of the research trends in digital humanities, but it seems that over the years digital humanities have scarcely addressed typical archival concerns such as authenticity and long-term preservation. Collaborative theoretical and practical researches on these matters are necessary and urgent. This is not only a matter of how both fields rise to the challenges of technological development, but foremost about how they conceive their roles in the digital world.

Conclusion

"Good cataloguing makes archival material findable and digitised facsimiles enable remote users to replicate the experience of the reading room. But the extra possibilities of the digital environment – search engine discovery, linkages across collections to related material, user arrangement and a merging of the description and digital resource – provide the user with an onward journey" (Higgins, Hilton, and Dafis 2014, 13). This implies onward journey for metadata as well. While being shared, reused, merged and integrated, metadata should still be able to express both original and transitional context in which heritage materials are created, evaluated, used and preserved.

Through partial harmonisation of archival and bibliographic conceptual data models, in this work we have underlined the advantages of cross-domain resource description for archives, libraries and digital humanities projects. We also aimed to demonstrate how multifaceted description might make digital project collections more discoverable and trustworthy from the point of view of information professionals, but also how in turn digital scholarship might enrich information provided by libraries and archives. Repositories that display digitised materials originally held in a heritage institution not only document the use of the institutional collection, but also complement it and add to its discoverability, since institutional digitisation projects are often partial and incomplete due to organisational and financial circumstances.

Furthermore, also due to organisational and financial circumstances, it is reasonable to expect that metadata standards based on the new conceptual models will largely be tested through collaborative digital projects with other stakeholders from the cultural and educational sector. One of the most important conditions for networked collaboration is a scheme that ensures a common understanding of metadata. Heritage institutions, especially libraries, have century-long experience in creating and applying descriptive standards, as well as in adapting them to new technologies and needs (e.g., integrated access to information prompted by search engines). On the other hand, as shown by the example of the Morpurgo Topotheque, digital humanities repositories rarely provide metadata in a standardised form or use standardised metadata sets. Clear and simple guidelines based on widely accepted models and standards should help address this issue, but they have to be rooted in a common semantic framework.

While over the recent decades there have been many valuable proposals for such a framework, they are continually reviewed and improved as new disciplines, technologies and needs emerge to shape our ever-changing information environment. In this sense, future research into harmonisation of metadata models and standards could take several directions. One of them, described above, includes alignment of the new models with earlier cross-domain schemes, from simple ones such as Dublin Core (DC) to more elaborate ones such as CIDOC CRM.

Another direction could be towards user verification of the model, along the line with Pisanski and Žumer (2012) who researched user understanding of the Work-Expression-Manifestation-Item stack. However, user needs are only one, albeit essential aspect of resource description in heritage institutions; others, e.g., might include business needs. In addition, in the context of the web the notion of the "user" is sometimes fuzzy. For this reason, it is crucial that metadata schemes are "scalable" according to the principle of functional granularity, which has been explained in the Background section and demonstrated through the case study. It allows for different needs and requirements to be met at different levels of description.

In the domain of archives and libraries, the proposed descriptive framework requires reconceptualisation of the process of information management so that benefits of both collection-level description (in libraries) and item-level description (in archives) can be taken into account. The impact on research in the digital humanities domain might be in reinforcing a clear Information Science perspective (Archival and Library Studies included) that asks for setting the information landscape in an interoperable, reusable and sustainable mode. Hopefully this research will attract the attention of digital humanities scholars that share interest for information organisation and provide them with a useful insight into archival and library metadata concepts.

Bibliography

Bailey, Jefferson. 2013. "Disrespect des Fonds: Rethinking Arrangement and Description in Born-Digital Archives." *Archive Journal 1*. https://www.archive journal.net/essays/disrespect-des-fonds-rethinking-arrangement-and-description-in-born-digital-archives/

Bolfarini Tognoli, Natália, and José AugustoChaves Guimarães. 2019. "Provenance." In *ISKO Encyclopedia of Knowledge Organization*, edited by Hjørland, Birger, and Claudio Gnoli. Toronto: International Society for Knowledge Organization, 2016–2021. http://www.isko.org/cyclo/provenance

Gentili Tedeschi, Massimo. 2011. "Cataloguing Commission: SubCommission on ISBD and Music." *Fontes Artis Musicae* 58 (4): 391–392.

Glennan, Kathy. 2020. "Ongoing RDA Development: What's Next for the RSC?." http://www.rda-rsc.org/sites/all/files/IFLA-EURIG%20Ongoing%20RDA%20Development%20%281%29.pdf

Heaney, Michael. 2000. "An Analytical Model of Collections and Their Catalogues. Third Issue, Revised." http://www.ukoln.ac.uk/metadata/rslp/model/amcc-v31.pdf

Higgins, Sarah and Christopher Hilton, and Lyn Dafis. 2014. "Archives Context and Discovery: Rethinking Arrangement and Description for the Digital Age." *Girona 2014: Arxius i Industries Culturals*. https://www.girona.cat/web/ica2014/ponents/textos/id174.pdf

Holm, Poul, Arne Jarrick, and Dominic Scott. 2015. *Humanities World Report 2015*. London: Palgrave Macmillan. https://doi.org/10.1057/9781137500281

International Council on Archives. 1999. *General International Standard Archival Description ISAD (G) Second Edition*. Stockholm: International Council on Archives. https://www.ica.org/sites/default/files/CBPS_2000_Guidelines_ISAD%28G%29_Second-edition_EN.pdf

International Council on Archives. 2016. *RiC-CM Consultation Draft v0.1*. https://escritoriopt.bn.gov.ar/pdfs/ICA-2016-Modelo%20conceptual-RiC-0.1.pdf

International Council on Archives. 2019. *RiC Consultation Draft v0.2 (preview)*. https://www.ica.org/sites/default/files/ric-cm-0.2_preview.pdf

Leazer, Gregory H. and Richard P. Smiraglia. 1999. "Bibliographic Families in the Library Catalog: a Qualitative Analysis and Grounded Theory." *Library Records & Technical Services* 43 (4): 191–212.

Ministry of Culture and Media of the Republic of Croatia. *List of Protected Cultural Heritage*. https://registar.kulturnadobra.hr/#/

Owens, Trevor John and Thomas Padilla. 2020. "Digital Sources and Digital Archives: Historical Evidence in the Digital Age." *International Journal of Digital Humanities*. https://doi.org/10.1007/s42803-020-00028-7

Pisanski, Jan and Maja Žumer. 2012. "User Verification of the FRBR Conceptual Model." *Journal of Documentation* 68 (4): 582–592.

Popovici, Bogdan F. 2016. "Records in Context: Towards a New Level in Archival Description?" In *Tehnični in Vsebinski Problemi Klasičnega in Elektronskega Arhiviranja*, edited by Ivan Fras, 13–31. Maribor: Pokrajinski arhiv Maribor. http://www.pokarh-mb.si/uploaded/datoteke/Radenci/radenci_2016/013-031_popovici_2016.pdf

Powell, Andy, Michael Heaney and Lorcan Dempsey. 2000. "RSLP Collection Description." *D-Lib Magazine* 6 (9). http://www.dlib.org/dlib/september00/powell/09powell.html

RiC-O. Next steps. 2021. https://ica-egad.github.io/RiC-O/next-steps.html

Riva, Pat, Patrick LeBoeuf, and Maja Žumer. 2017. "IFLA Library Reference Model: A Conceptual Model for Bibliographic Information. As Amended and Corrected through December 2017." https://www.ifla.org/files/assets/cataloguing/frbr-lrm/ifla-lrm-august-2017_rev201712.pdf

Rust, Godfrey and Mark Bide. 2000. *The <Indecs>Metadata Framework: Principles, Model and Data.* Indecs Framework Ltd. https://www.doi.org/topics/indecs/indecs_framework_2000.pdf

Theimer, Kate. 2012. "Archives in Context and as Context." *Journal of Digital Humanities* 1 (2) (Spring). http://journalofdigitalhumanities.org/1-2/archives-in-context-and-as-context-by-kate-theimer

Tillett, Barbara B. 1991. "A Taxonomy of Bibliographic Relationships." *Library Resources & Technical Services* 35 (2): 150–158.

Topić. Nada. 2017. *Knjižara Morpurgo u Splitu (1860. – 1947.) i Razvoj Kulture Čitanja.* Zagreb: Naklada Ljevak.

Topić, Nada. 2017. *Knjižara Morpurgo Split.* https://morpurgo.topoteka.net

Verona, Eva. 1959. "Literary unit versus bibliographic unit." *Libri – International Journal of Libraries and Information Services* 9 (2): 79–104.

Wickett, Karen. 2018. "A logic-based Framework for Collection/Item Metadata Relationships." *Journal of Documentation* 74 (6): 1175–1189. https://doi.org/10.1108/JD-01-2018-0017

Willer, Mirna. 2015. "Library and Archival Name Authority Data: The Possibilities for Functional Interoperability." In *Records, Archives and Memory: Selected Papers from the Conference and School on Records, Archives and Memory Studies,* edited by Mirna Willer, Anne J. Gilliland, and Marijana Tomić. Zadar: University of Zadar, 309–342. http://www.unizd.hr/Portals/41/elektronicka_izdanja/RAMS_tisak_konacno.pdf?ver=2016-10-20-104937-423

Wilson, Patrick. 1978. *"Two Kinds of Power: an Essay on Bibliographic control."* Berkeley, CA: University of California Press.

Zeng, Marcia L. 2018. "Interoperability." In *ISKO Encyclopedia of Knowledge Organization* edited by Hjørland, Birger, and Claudio Gnoli. Toronto: International Society for Knowledge Organization, 2016–2021. https://www.isko.org/cyclo/interoperability

Zhlobinskaya, Olga. 2020. "Archival Description Using UNIMARC: Presidential Library Experience." *Organizacija znanja* 25 (1/2). https://doi.org/10.3359/oz2025001

Metadata aggregation

4 Linked open data and aggregation infrastructure in the cultural heritage sector

A case study of SOCH, a linked data aggregator for Swedish open cultural heritage

Marcus Smith

Introduction

Publishing openly licensed data is increasingly becoming the norm for research project outputs, museum and archive collections, monuments registers and more within the cultural heritage sector. Going a step further, this approach is often combined with making the data machine-readable on the semantic web as Linked Data, such that it can be queried and reused on a technical level as well as related to other data sets. This represents a change in mindset for how heritage data is published and disseminated, as well as for public engagement, institutional collaboration and how research is carried out.

Both of these changes – towards open licenses and Linked Data across systems – can be seen as a response to preexisting problems with the field of cultural heritage data. With digitisation, new questions of the copyright of scanned material have arisen – some as yet unresolved – which can lead to representations of a shared heritage being made inaccessible and unusable by most people. At the same time, the increased use of digital tools, workflows, and datastores have resulted in a plethora of closed, siloed systems that frequently record information about the same sorts of things, but can't talk to one another, and use incompatible terms and technologies. Thus, linked open data (LOD), with its emphasis on explicit open licensing, links between data sets, and interoperability through shared standards and vocabularies, is in many ways a natural fit.

This chapter aims to present an (incomplete) overview of the theory and practice of LOD in cultural heritage from a Swedish perspective, introducing key concepts and standards. We will begin by presenting an introduction to LOD and metadata aggregation as philosophical and technical concepts within digital cultural heritage, before providing an in-depth case study of the Linked Data platform Swedish Open Cultural Heritage (SOCH) at the

DOI: 10.4324/9781003131816-4

Swedish National Heritage Board, which aggregates and publishes open metadata from Swedish heritage institutions and provides a technical interface for software developers to build applications. Then follow some reflections over the state of linked cultural heritage through the lens of the case study as presented, as well as challenges for the future. Since many new concepts, standards and acronyms will be introduced, a short glossary of terms is also included, with links for further reading.

Background: Linked Data aggregation

LOD and FAIR principles

The idea of LOD is described by a set of principles, both philosophical and technical, first articulated by Sir Tim Berners-Lee as a logical extension of the World Wide Web (see e.g., Berners-Lee 2006). The web can be seen as a distributed, decentralised directed graph: a network of documents – web pages – as nodes/vertices connected by hyperlinks as edges/arcs pointing from source to target, across a multitude of systems and domains with no single point of control. With Linked Data, rather than a web of linked *documents*, there is a web of semantically linked machine-readable *data*. "Semantically linked", in the sense that it is significant not only *whether* there is a link between two nodes in the web and in what direction it points, but also what the *nature* of that link – or relation – is. We might wish to assert, e.g., that the node representing an artefact was *found at* the node in the web representing a particular site, is *depicted by* the node for a photograph, *described by* a report etc. In this way, the web of data is at a very basic level composed of simple three-part assertions of the form *subject* → *predicate* → *object*, connecting two nodes – the subject and object – using a relation – the predicate. Just as HTML is the standard of interchange used to describe the web of documents we're familiar with, the Resource Description Framework (RDF; see Schreiber and Raimond 2014) is the model used to describe the web of data, and just like HTML, it uses IRIs as identifiers. IRIs are Internationalized Resource Identifiers, a generalisation of Uniform Resource Identifiers (URIs). These are unique machine-readable identifiers which include – but are not limited to – the resolvable URLs most Internet users are familiar with (See RFC 3987 [Duerst and Suignard 2005], RFC 2396 [Berners-Lee, Fielding, and Masinter 1998] and URI Planning Interest Group, W3C/IETF (2001) for the [lack of] distinction between URIs and URLs). Subjects in an RDF triple can be IRIs, strings or "blank" nodes leading to further triples, objects can be IRIs or "blank" nodes, and predicates are always IRIs. The IRIs serve as unique identifiers for nodes (resources) on the web and, preferably, as resolvable addresses on the World Wide Web (that is, valid locations on the global Internet that can be dereferenced to return structured data).

From these basic building blocks, complex and flexible data structures can be created spanning multiple organisations and platforms, distributed across the Internet. The use of IRIs as unique identifiers that are also addressable allows for seamless linking together of disparate resources, and facilitates both extensibility and the use of shared vocabularies and ontologies. Structured vocabularies, in the Linked Data sense, are lists of concepts and terms each with their own IRIs and often with links describing how they relate to one another in a hierarchy or to related terms in other vocabularies. They are typically expressed using the RDF applications RDFS (RDF Schema; see Brickley and Guha 2014) for simple term lists and Simple Knowledge Organization System (SKOS; see Miles and Bechhofer 2009) for structured thesauri. Linked Data ontologies expressed using the Web Ontology Language (OWL; see Motik et al. 2012) define properties and relations that can exist between nodes, as well as the types of nodes such relations can have as subject and object (their "domain" and "range") and what such relations might entail, semantically, if anything. Vocabularies and ontologies allow different users within a domain or field to describe their data using consistent terminologies and structures. This use for IRIs also decouples attributes from identifiers, in the sense that instead of recording for example a string value, you instead reference an identifier which in turn may have multiple string labels associated with it in different languages, and possibly other attributes such as links to related (e.g., broader, narrower) terms. It also allows your data to be enriched and augmented by others simply by linking it with their own data. The rewards of applying a Linked Data model to data publication are interoperability, interconnectedness, and reusability. The paradigm facilitates citation, source verification, accessibility and reuse. Linked Data connects records within and across data sets, providing machine-readable context in a way that would otherwise be lacking, which in turn can allow unexpected connections to appear or be inferred indirectly between records. Using shared ontologies and resolvable identifiers from vocabularies and structured thesauri increase interoperability with other data sets by ensuring that records are described in a consistent way using machine-readable terms that are language-independent and common across data sets within the same field of knowledge. And links to the sources which corroborate the assertions in a record, or on which the record itself is derived provide a degree of verifiability and increase user trust.

The "open" part of LOD refers to the use of open licenses that permit the data to be used and repurposed. In most cases this in practice means the use of Creative Commons (CC) licenses and the Public Domain mark for works whose copyright has expired. The most open of the CC licenses is the Creative Commons Zero (CC0) license which effectively permits any use and imposes no demands on the user, and the Creative Commons Attribution (CC BY) license whose only condition for use is proper citation of the copyright holder. Use of CC0 is strongly encouraged for metadata, as

metadata is often reused and combined with other data potentially drawn from multiple contexts and sources in such a way that citation of individual rights holders would be difficult. Otherwise, the CC BY license is generally recommended, and its requirement of proper citation makes it a good fit in academic contexts. Less open variants of the CC BY license exist with combinations of additional restrictions, such as forbidding derivative works (ND), requiring derivative works be licensed under the same terms (SA) or allowing reuse only in non-commercial contexts (NC). The latter variants are particularly problematic due to the vague definition of what counts as "commercial" which often leads to unforeseen consequences, for example precluding use in many academic and educational contexts even when allowance for such uses is intended by the rights holder; as such they are best avoided.

Nb. that CC licenses do not override copyright, but work just as other licenses do, by granting permission to use material despite copyright; CC licenses simply happen to be unusually liberal in what permissions they grant. Non-CC open licenses, such as Open Data Commons licenses for databases and licenses for software (see e.g., https://choosealicense.com/) may also be applicable in other open data contexts.

FAIR principles – Findability, Accessibility, Interoperability, and Reuse for digital data – are an extension and development of the general move towards open data within academia, tangential – but beneficial – to LOD specifically. FAIR principles go beyond simply publishing data with an open license, but specifically require that it be Findable, Accessible, Interoperable, and Reusable. In practice this means taking steps to address resource discovery, long-term availability and digital preservation, structure and machine-readability, and adherence to applicable data standards, in addition to open licensing. Again, the intention is to facilitate collaboration, compatibility, and the combinations and reuse of data.

The application of LOD in general and within the heritage sector in particular embodies not just a shift in technical platforms, but more broadly a change in mindset, moving away from silos of incompatible data, meaningless distinctions between otherwise homogeneous data sets based solely on the institution or collection they happen to belong to, and towards a collaborative, distributed, standards-based, interdisciplinary machine-readable semantic web of data.

Metadata aggregation

The principles of LOD are predicated on a distributed model: a web of connected data spread across the Internet, hosted by multiple organisations, each one responsible for their own data and assertions. This web, in whole or in part, describes an open-world knowledge graph – collections of subject-predicate-object assertions describing and relating entities/resources to one another, together forming a knowledge base in the form of a network or

graph – accessed through IRIs across multiple domains (both in the sense of subject areas and Internet domains). This web of knowledge can also be queried using federated search through SPARQL (SPARQL Protocol and RDF Query Language; see Harris and Seaborne 2013) or less commonly other query languages. It would seem on the face of it that platforms aggregating Linked Data resources – such as Europeana or SOCH (q.v.) – or those collecting large-scale Linked Data statements in a single place – such as Wikidata – ought to be antithetical to the inherently distributed nature of the Linked Data model, but this need not necessarily be the case.

For platforms such as Wikidata, it is simply a consequence of the scope of the project that it covers large numbers of triples describing metadata on topics and records more or less within the domain of the "the sum of all human knowledge" within a universal ontology. Its scope does not make it a node in web of data of any less value – on the contrary, its comprehensive nature means that in practice it functions much like a directory of identities within the world of Linked Data, providing basic metadata on vast variety of subjects, but also crucially outbound links to corresponding resources elsewhere on the web that cover more than just metadata. Thus, its broad scope and consolidated wealth of identities serve the distributed link data model.

The role of Linked Data aggregators is perhaps less obvious but no less vital, and is possibly best described as being a means rather than an end in and of itself. Both federation and aggregation attempt to solve the problem of being able to search across data sets through a single interface and receive homogenous results. While a federated search across a number of institutions/data sets is the platonic ideal of a distributed Linked Data infrastructure, there are at present practical challenges that make aggregation preferable in a number of use cases. At the performance level, federated queries face the challenge of returning results in a timely fashion, as anyone who has used an older inter-library search based on the federated Z39.50 protocol can attest. This problem is exacerbated as more endpoints are added to the network. By collecting metadata from multiple systems into a single database or index, an aggregator can provide a much more performant search across the same data sets, with the trade-off that some of the records may have become stale depending on how often the aggregator's cache is updated from the source.

Aggregation forces the source data to be mapped from its internal representation to a common data model using shared vocabularies. This occurs either at the source as the data is exposed to the aggregator for harvesting, or on the aggregator side as a part of the aggregation process. (In some cases, such as with Europeana, mappings occur on both sides of the harvesting process: first to an intermediate format, and then to a target format.) The mapping of disparate data sets from different systems with bespoke data models to a shared data model greatly simplifies cross-search. While such mappings are also possible with a federated search

strategy, in that case it is the individual endpoints with each respective system that are responsible for responding to queries, and thus the mapping may not be of the source data to a shared data model, but rather of the query itself to a form which better fits the capabilities of the source system to respond to it.

An aggregator also partially addresses the question of resource discovery, a problem which has yet to be satisfactorily solved for Linked Data. If you want to run a federated query, how do you find out which data sets might have data pertinent to your interests? With aggregation, this issue is delegated to the aggregator: you can search all (but also, only) the data sets harvested by the aggregator. Some progress has been made in this field, beginning with RSS feeds to provide notification of new/updated/deleted records, and more recently with Linked Data Notifications (LDN) which allow a sender to push structured RDF messages to receiving systems as changes occur.

However, the strongest argument for aggregation of Linked Data within the heritage sector is often a pragmatic one. Cultural heritage institutions (CHIs) are almost invariably short on resources, and have to accomplish a lot with a little. Publishing and maintaining a Linked Data platform is rarely part of a CHI's core mission, and frequently ranks low on its list of priorities; not because it's not considered important (although sometimes it is), but because there are so many other things that are more important and only a limited amount of money and staff to do them. Even when LOD is recognised as a priority, it can be difficult and costly to recruit or train staff with the necessary technical expertise. Aggregation thus offers a solution in such scenarios, by offloading responsibility for the LOD platform to another party. Making your data available in a way that can be harvested by an aggregator presents a lower threshold than operating your own Linked Data platform, both in terms of cost and required technical skill. Joining an aggregator shared by other similar CHIs also offers benefits in terms of networking and collaboration around shared problems and requirements.

It is to be hoped that this is not a permanent state of affairs, and that the need for aggregation of Linked Data will diminish over time, as the problems of federated query performance, resource discovery, and technical accessibility are resolved to the point that a truly large-scale federated Linked Data infrastructure no longer has any need for aggregation.

Case study: SOCH

SOCH (*K-samsök* in Swedish) <http://kulturarvsdata.se/> is a national aggregator for cultural heritage data in Sweden. The platform is operated by the Swedish National Heritage Board on behalf of participating and contributing data partner institutions from within the Swedish cultural heritage sector. SOCH harvests metadata records from these museums,

archives and historic environment registers, and publishes them as LOD. The records are mapped to a common RDF-based data model, indexed, and made queryable via a web application programming interface (API). Data from SOCH is then in turn aggregated from the national to the European level via Europeana. Participation in and contribution of data to SOCH is free of charge and entirely voluntary on the part of the CHIs, and almost all national and county-level museums are data-providing partners. The fact that separate domain-based aggregators to Europeana exist for archives and libraries, and a historical focus on archaeological museum collections explains why museums are better-represented among SOCH partners and content than other CHIs.

At the time of writing, SOCH harvests and indexes data from almost 80 partner institutions from within the Swedish cultural heritage sector, who provide around 9.2 million records from 176 different data sets – in some cases discrete collections, in others multiple collections managed by a single information system. SOCH includes records covering both tangible and intangible heritage, including protected sites and monuments, historic buildings, artefacts and small finds, photographs and drawings, sound and video recordings, documents and literature, as well as historic personages, events, and more.

SOCH harvests and indexes only the metadata for records already published elsewhere; the metadata always includes a link back to the source. In cases where a record describes a digital resource such as an image, only the metadata is harvested, not the resource itself. However, the metadata contains a link to such resources where they are published, so that they can be accessed. As an aggregator, SOCH packages and republishes metadata from multiple sources in a more convenient – structured and searchable – format, but it not itself a source for that metadata; as such, it's important that it always includes a link back to the source (and to any associated media) at the relevant CHI.

SOCH itself offers a technical interface for machine agents via its API and the record metadata from dereferencing SOCH IRIs. A human-friendly web interface is provided in the form of Kringla http://www.kringla.nu/ which allows users to search, browse, and view all records indexed in SOCH, including associated media (images, audio, video), links between records, (e.g., from a photograph to the monument, artefact or person it depicts or the reverse – from a monument to all the photos that depict it), and links to the records' source. However, the combination of structured open data using a shared data model, semantic linking between records using RDF, and an API, is intended to facilitate interoperability with other platforms and to encourage use and re-use of cultural heritage data by third parties – via apps, websites, and other media, alone or in combination with other open data sets, and in ways we cannot anticipate. See Riksantikvarieämbetet (2021c) for a non-exhaustive list of applications using the SOCH data and API, including mobile apps for finding

nearby ancient monuments, digital museum exhibitions, apps for digital storytelling in relation to cultural heritage, academic research platforms, Twitter bots, and more.

Background and development

Development on SOCH began in 2008 building on prior work to link together records from the Swedish National Heritage Board's national monuments register (FMIS) and the digital catalogue of the Swedish History Museum. The platform was developed as part of a government mandate at the Swedish National Heritage Board, and was launched in 2010. SOCH continued to receive earmarked funding from the Swedish Ministry of Culture until 2017, from which point it was financed as part of the National Heritage Board's annual budget. SOCH's launch broadly coincided with the launch of the European cultural heritage aggregator Europeana, and SOCH was among the first national aggregators to provide data downstream to Europeana as the national aggregator for Sweden, a role it still fulfils today.

All metadata records in SOCH are openly licensed as CC0, and for records that describe a digital resource the metadata must also include a rights statement for the resource itself; SOCH advocates for open CC licenses and public domain statements, but copyrighted works with all rights reserved are also permitted.

Prerequisites and requirements

Both CC0 licensing of the metadata and the provision of machine-readable rights statements per SOCH's rights model (Riksantikvarieämbetet 2021a) are prerequisites for partners to provide metadata to SOCH. Other requirements that must be met by providing data partners are that records are already published online (so that SOCH can link back to the record source), and that the data is reliably maintained by an institution (so that there is a point of contact, and data management is not tied to a single individual).

In addition to this there are technical requirements necessary to enable harvesting and indexing of the data to SOCH. SOCH harvests metadata as eXtensible Markup Language (XML; see Bray et al. 2006) using the Open Archives Initiative Protocol for Metadata Harvesting standard (OAI-PMH; see Lagoze et al. 2015), and metadata must be in the form of SOCH's RDF-based data model (Riksantikvarieämbetet 2021b). This requires firstly that the provider has a server set up that can speak the OAI-PMH protocol and respond to requests; this is typically not too onerous as there are multiple open implementations of the protocol that integrate with a variety of programming languages. Secondly, it requires a mapping from the providing institution's internal data model to the SOCH RDF data model. This component is typically much more

demanding, requiring as it does a combination of technical programming and data modelling skills, detailed domain knowledge of the data set and associated model in question, and familiarity with SOCH's data model. The importance of such a mapping should not be overlooked, however: by requiring data to be provided according to a common model and format, we not only ensure that the data is harmonised and searchable across heterogenous data sets, but also that it is decoupled from its source format. SOCH doesn't care what model or system data partners use to manage their data, and makes no demands other than those outlined above, as long as the data has been mapped to comply with the SOCH model when it is harvested. Typically, SOCH partners are mapping data from digital collections management systems which use their own bespoke internal data models.

The requirements for providing data as a partner institution in SOCH are intended to be few and simple to accomplish in order to make it as frictionless as possible for institutions to publish their data for harvesting. In order to ensure that the metadata is available for reuse in as broad a variety of contexts as possible, including those where it may be combined with data from other sources or in other contexts where proper citation required by more restrictive open licenses such as CC BY may not be practical, requiring CC0 for metadata is more or less unavoidable. Requiring rights statements for media resources is likewise vital if users are to know if and under what conditions they may use the media. Requiring a link to the source, and a point of institutional contact are important for an aggregator republishing metadata for which it is not itself responsible, as well as for sustainability. Mapping to a common data model and the harvesting protocol used are perhaps less vital, but are nonetheless pragmatic technical necessities for homogeneity and realistic implementation within the heritage sector.

Metadata harvesting

SOCH data sets are harvested via the OAI-PMH protocol. Metadata harvests are scheduled and carried out automatically by the system, the frequency of harvesting varying according to the preferences of the providing data partner and the frequency with which the source data sets are updated; weekly harvests are typical, but some data sets are updated less often. Normally only changes since the last harvest – deletions, insertions, and updates – are requested, but in cases where the providing system does not support this facet of the protocol, the full data set is harvested every time. Harvested data is first saved to disk as RDF/XML, and then inserted into the SOCH database which represents records as discrete RDF/XML documents. Finally, the SOCH index is updated with the records' content. It is the SOCH index which drives the majority of the platform's functionality. The index not only enables searching of metadata in SOCH – from simple

text searches to complex queries – but also maintains reciprocal semantic links between records.

SOCH records are published with permanent IRIs under the kulturarvs-data.se domain (*kulturarvsdata* is Swedish for "cultural heritage data"). These IRIs function both as record identifiers and as resolvable addresses. Depending on the format requested, dereferencing a record's kulturarvs-data.se IRI returns that record's RDF from the database as either RDF/XML or JSON-LD (Kellogg *et.al.* 2020) for machine agents, or redirects to the source for that record for human-operated user-agents such as web browsers.

As part of the harvesting process, SOCH keeps track of records which have previously been harvested but have subsequently been removed at the source; the permanent IRIs for such records are still valid as identifiers, but return an HTTP "410 Gone" code if dereferenced (indicating that the IRI is correct but the resource has been removed; cf. "404 Not Found" where the IRI is unknown to the system).

The choice of the kulturarvsdata.se domain for SOCH IRIs rather than, for example, a subdomain of the Swedish National Heritage Board's raa. se was deliberate. Firstly, although the platform is operated by the Swedish National Heritage Board, the Board is only one of almost 80 partners represented in SOCH, and using the raa.se domain would thus not accurately reflect the content of the platform. Secondly, decoupling the domain from the Heritage Board contributes to the longevity of SOCH records' permanent IRIs – should Swedish government agencies be restructured at some future date, for example, and the Heritage Board be dissolved or its responsibility for SOCH reassigned, ownership of the kulutrarvsdata.se domain can easily be transferred and records can keep their existing IRIs.

The SOCH data model

Within the framework of RDF, SOCH uses its own bespoke data model of defined elements, attributes/properties, and types. The model is defined as OWL under the namespace <http://www.kulturarvsdata.se/ksamsok#> and documented on the SOCH homepage (Riksantikvarieämbetet 2021b, *idem.* 2020a). A number of the attributes correspond exactly to, and in some cases are interchangeable with, well-known attributes from other ontologies – most notably OWL for e.g., owl:sameAs identities, Dublin Core terms and elements for fundamental metadata, Friend-of-a-Friend (FOAF), attributes for describing people and organisations, and even some properties from the CIDOC-CRM ([ICOM] International Committee for Documentation Conceptual Reference Model). In general, however, the SOCH data model is bespoke.

Any mapping between data models inevitably leads to information loss, and this is particularly acute in the case of aggregators, where detail from the bespoke data models of the source may become blurred when the same

data is viewed through the lens of an aggregator. Aggregation services walk a tightrope: one the one hand they must maintain a data model abstract enough that it allows data from multiple sources – sometimes across multiple disciplines – to be combined. On the other, the model must be detailed enough that it remains useful to users.

At its core the SOCH data model consists of "items" or "entities" – the records – which are described with the help of various metadata attributes. Attributes include descriptors such as itemLabel, provenance information such as parish, chronological information such as fromTime and toTime, links to related objects such as isVisualizedBy and more. Most attributes take strings or IRIs as values, conforming to the RDF subject-predicate-object model. Defined item types and their umbrella super-type for records are referred to by their IRIs, defined by SOCH (Riksantikvarieämbetet 2018a).

In cases where attributes take IRIs as values, it may be to refer to an authority record, for example when giving a thesaurus term, or to describe a semantic relation to another record. Such attributes are described as "relations", and are an important part of not only the SOCH data model but its implementation of the philosophy of Linked Data, placing records within a wider semantic context by describing their relationships to one another. Some attributes take further qualifying attributes themselves before arriving at a value, represented as blank nodes in RDF. For example, a record might have an itemName consisting of a type, e.g., "Keyword", and the name itself e.g.,"Axe".

A particular case of such multifaceted attributes and values tied to SOCH records is that of "contexts". Contexts provide a temporal and spatial dimension to the objects they describe by providing information about instances in the objects' history – although not to the same extent as a fully event-based model such as CIDOC-CRM. An object's record may have multiple contexts, each of which describes a different aspect or event in the life of the object. Like items themselves, contexts have defined types and supertypes (Riksantikvarieämbetet 2020b). For example, an artefact might have a context for its creation, containing attributes for date, place, and perhaps maker if known; it may have other contexts detailing when it changed ownership (and to whom), when/where it was used, when/where it was found and by whom, and even in some cases the occasion of its destruction.

Only a few of the basic attributes are required for a record to be valid under the SOCH data model, keeping the threshold for data provision low. At the same time, the model provides for much richer and more nuanced records where such data exists through the use of contexts, multiple attributes, reference to common authorities, and links to other records. Mandatory properties for a record are limited to protocol version, service name and organisation, source URL, item type, item name and label, last-changed date, and license (CC0).

Authorities

Within the realm of Linked Data interoperability, it is very often prefera-
ble to have attribute values (the "objects" of an RDF triple) that take IRIs
rather than text strings, not only when referring to other records but in
particular when referring to authorities for well-known things, concepts,
features, categories, etc. Data partners in SOCH are encouraged to do this
in the general case, for well-known resources. Common useful authorities
within the heritage sector include inter alia the Getty Arts and Architecture
Thesaurus (AAT), PeriodO for spatio-temporal chronologies, sites and mon-
uments types thesauri such as those at Heritage Data, Virtual International
Authority File (VIAF) for authors, and GeoNames and relevant national
authorities for places. Linking to generic and well-known meta-authorities
such as Wikidata is also useful from a general interoperability perspective.
However, SOCH specifically provides a number of authority IRIs under the
prefix <http://kulturarvsdata.se/resurser/aukt/*> which are of particular
use for Swedish heritage data (Riksantikvarieämbetet 2020b). These consist
of concepts integral to the SOCH data model (object types, context types,
broad topic keywords, and licenses for media), geographical divisions for
Sweden (parishes, municipalities, counties, provinces, and countries and
continents linked against GeoNames), as well as concepts specific to the
study of runes and runic inscriptions.

The SOCH API

Metadata records in SOCH can be accessed by dereferencing the resource's
IRI, but for most practical applications, the main point of access to the
content in SOCH is its web API (Riksantikvarieämbetet 2019), the technical
interface by which programs can query the index and receive structured
data in response. The API provides a number of methods for searching and
retrieving records, as well as for finding and following links between records,
and options for formatting the metadata output. There are also helper
methods for aggregate searches (e.g., statistics on records matching search
criteria or listing the frequency of certain property values in the index),
auto-complete and stemming for search terms, and for other information
about the contents of the index. Search indices are delineated by attribute
according to the SOCH data model (Riksantikvarieämbetet 2018b). The
search methods use the Contextual Query Language (CQL) standard for the
specification of queries and indexes. This allows for faceted search across
multiple indices, as well as for complex searches using Boolean AND/OR/
NOT operators.

The default output of the search API is an XML result set encapsulating
the full RDF/XML documents of matching records. However, the API allows
clients to specify other preferred output formats; JSON may be substituted
for XML, and JSON-LD for RDF/XML as when dereferencing records' IRIs.

User-generated content

Parallel to – but separate from – SOCH is a second system that allows third parties to contribute semantic links of their own between SOCH records or between SOCH records and external resources on the semantic web such as identities maintained by other organisations, vocabulary terms or related records elsewhere on the web. This system is called the UGC Hub ("UGC" for "User-Generated Content") and it has its own index and API. User-generated links may be queried or added via the API or via the Kringla web interface http://www.kringla.nu/. The UGC Hub allows records in SOCH to be enriched and augmented with additional links not provided by SOCH data partners, while keeping such third-party links separate and distinct from the metadata curated by those institutions. User-contributed links typically follow the property and relation types of the SOCH data model, relating records to one another or to external identities and vocabularies. However, as the links should take the form of fully qualified IRIs, they may in theory include any valid RDF property type (although clients, such as Kringla, may not understand all such properties). At the time of writing the UGC Hub boasts an index of 2.7 million links. Among other benefits, the UGC Hub has allowed for much tighter integration between SOCH and other sites, thanks to automated agents maintaining links between SOCH records and their corresponding IRIs at Europeana, Wikidata, and Wikipedia, as well as associated media on Wikimedia Commons. These added links provide identity relations with records describing the same thing on other platforms, contextual relations, additional visual media, and starting points for further reading or research.

Applications

The open nature of both the content of the metadata in SOCH and its API was from the very start intended to foster and encourage the creation of third-party applications to use the data and combine it with data from other sources. It was and is felt that the Swedish National Heritage Board's role is to ensure that the heritage data is made available in a way that ensures that it is accessible, reusable, and flexible, and to maintain the SOCH platform and its technical interface – not to create multitudes of websites and apps for various platforms to satisfy every possible use-case and niche interest. Indeed, the de-facto default web interface to SOCH, Kringla, was originally intended simply to be a proof-of-concept showcase for the data, presenting it in a more accessible manner than the RDF/XML-based SOCH interface.

Aside from the Kringla website and a now-defunct proof-of-concept Kringla app for Android phones, the National Heritage Board has also developed prototype applications to examine alternative non-search-based methods of exploring the records, collections and objects published through SOCH using "generous interfaces" (Generous Interface Fashion; Kringla

Visualized). Furthermore, a new research platform for runes and runic inscriptions has been developed using SOCH in collaboration with Uppsala University (Runor). However, the overwhelming majority of applications using and building upon the open data in SOCH and its API have been created by third parties, from mobiles apps to mashups with other data sets, and even programming frameworks designed to make it easier for other developers to use SOCH from their programming language of choice (see Riksantikvarieämbetet 2021c for a list of examples). It is interesting to note that in some cases, museums providing their collections data to SOCH have built interfaces to those collections using SOCH, rather than the collections management software (CMS) in which their master data is managed. In some cases this is because SOCH offers a more convenient API than their in-house CMS (or because the CMS offers no API at all) but it also illustrates the tangible benefits of Linked Data through SOCH, as objects from one collection may be enriched by links to objects from another collection or institution – for example if related objects are at different museums or one museum has photographs or other documentation depicting or describing artefacts from another. In a very real sense, publishing collections as Linked Data can enable institutions to get more out than they put in. A good example of such applications is the School Posters digital exhibition from the Museum of Gothenburg, http://www.stadsmuseetsskolplanscher.se/.

Problems and challenges

The SOCH platform in its current state is however not without its weaknesses, and it would be remiss not to address them in this case study – particularly in the interests of promoting best practice and of warning others not to repeat our mistakes.

Firstly, SOCH's technical platform itself, while sturdy and reliable, shows its age at 10+ years, in particular in the way it handles RDF data. SOCH is not a triplestore, and doesn't treat its RDF as a graph; rather, each record is held and indexed as an RDF/XML document. This causes some limitations in how the platform can be used and what kinds of data it can store. For example, it is not possible for two institutions or data sets to provide complementary records for the same object using the same IRI – each record must have its own IRI – and it is not possible to nest record IRIs within the same document – each must be the root element of its own document. Were SOCH a true triplestore with an RDF graph, these limitations would not exist.

The SOCH API, too is showing its age. In the time since it was first designed, web services have coalesced around REST-based APIs (Representational State Transfer; see Fielding 2000) serving JSON as a de-facto standard interface paradigm, which SOCH does not conform to. (SOCH can serve JSON-LD, but responds with RDF/XML by default, and does not support a RESTful interface at all.) This may present an off-putting

barrier to use for modern web developers. On the other hand, SOCH does not provide a SPARQL endpoint interface of the kind expected by Linked Data users either (partly as a direct consequence of the platform architecture mentioned above), thus failing to satisfy two of our main developer target audiences.

As mentioned above, the SOCH data model is bespoke for the platform. At the time it was developed, Linked Data had not been widely deployed in the heritage sector, and while some standards did exist for linked heritage data, they were not yet in widespread use. Now, however, standards such as CIDOC-CRM and the Europeana Data Model (EDM) are well-known within the sector, and from an interoperability standpoint it would make more sense to use them – or a compatible application of them – rather than using custom types and attributes that are unique to the platform. The data model also makes poor and sometimes curious use of the Linked Data capabilities of RDF. A number of attributes take IRIs as values but type them as strings; in other cases, values which are IRIs are split into prefix and "slug" (suffix) halves which are assigned to separate attributes, defeating the point of having the link in the first place. Perhaps most seriously, the data model makes no attempt to address the "httpRange-14" issue of Linked Data (W3C 2002), that of distinguishing between the IRI of a physical object and the digital record that describes it; the SOCH data model merges the two under a single IRI, and resolves the fact that the object and the record may have separate and distinct values for attributes such as "date created" by having separate attributes rather than separate entities.

As described earlier, records in SOCH are assigned IRIs by their providing institutions as part of the mapping and harvesting process, often based on the internal IDs used by the providers' collections management system. Having IRIs tied to both institutions and their internal systems poses challenges in terms of long-term sustainability as both are potentially subject to change. This has been addressed recently with support for relations describing changed IRIs (dcterms:replaces), allowing data providers to change their IRIs if necessary, providing a new identity relation between the old and the new IRIs. SOCH will redirect requests for the old IRI to the new one that replaces it, and transitively treats relations that apply to one as if they also applied to the other.

Finally, the quality of SOCH as a platform is in large part dependent on the quality of the metadata it aggregates, and the quality of this metadata is highly variable between heritage institutions. Despite being a platform predicated on Linked Data, links between records are less common than we would like, and links between data sets and providers even less common. Attribute values are almost always provided as strings rather than as IRIs linking to terms from a shared vocabulary. The potential offered by Linked Data is, in other words, not always exploited to its fullest. Data provided by SOCH partners usually comes from collection management systems originally intended for internal (rather than public) use, and the data itself may

have been digitised from older analogue records that were taken with a different purpose in mind; this also contributes to the variability in metadata quality. In most cases it is not possible for SOCH to check whether incoming data is correct; however, in some cases, such as copyright status, an independent verification can be made: data partners can check to see if their provided data sets contain any obviously incorrectly licensed records using an online tool at https://riksantikvarieambetet.github.io/ksamsok-data-portal/. Typical errors include claiming copyright over media that has fallen to the public domain, media licensed with a CC BY license but with no data on to whom attribution should be given, and photographs dated both to the future and to before the invention of photography. Aside from these cases, however, SOCH is dependent on data partners to ensure data quality.

When SOCH was first developed, the threshold for data provision was deliberately kept as low as possible in order to make it easy for CHIs to be able to provide data from their collections. Aside from licensing and a link to the published record, no conditions were set as to data quality. It was deemed more important to enable institutions to publish their records through the platform regardless of the metadata quality, on the understanding that metadata quality could always be improved upon at a later date, and that no data set will ever be "perfect". This made uptake easier, but has meant that the quality of metadata in the SOCH index can vary wildly, from rich records with detailed metadata and semantic links to records which are barely more than empty placeholders for the artefacts or resources they represent. The threshold for data provision is still too high for some smaller resource-starved heritage institutions, and efforts are now being made to explore alternative methods of data harvesting that may enable them to become partners in SOCH using their existing technical infrastructures, for example by harvesting from the APIs of CHI's content management systems and mapping that to the SOCH data model, harvesting unstructured or semi-structured data from CHI's web pages or by harvesting a simplified record description based on standard generic Linked Data attributes such as Dublin Core, schema.org, and FOAF.

Reflections

The application of the LOD paradigm in SOCH has benefited both the heritage sector and the general public by making search possible across multiple institutions, collections and data sets, by making heritage data available to freely reuse and develop in ways that were not possible before, by integrating and linking together records across collections, placing them in a wider context, and by offering users the opportunity to themselves engage with and contribute to the Linked Data platform via the UGC Hub.

Over its, at the time of writing, ten-year lifespan, SOCH has had significant success in opening up Swedish heritage data from institutional silos and linking it together, especially for institutions which otherwise lack the

resources to publish their data in a machine-readable and searchable format. All metadata records harvested to SOCH are licensed as CC0, and all media resources must be marked up with rights statements, making terms of reuse clear. Semantic links between records are strongly encouraged, as are links out to external resources, vocabularies and authority files. Links to Wikipedia, Wikimedia Commons, Wikidata and bibliographic records at the Swedish National Library are particularly useful for connecting the aggregated records with the wider semantic web, providing a wider context, references and a jumping-off point for further research through onward links. SOCH data and its open API are used by numerous third-party applications to present, explore and reuse Swedish cultural heritage data in a variety of ways, both on its own and in combination with other open data resources; from serious academic research platforms to smartphone apps for casual use, to more trivial uses in games and Twitter bots. Despite their different uses, contexts, and target audiences, all these applications are built on the same linked open heritage data and API. Material in SOCH is seen and used more broadly and by more people than it otherwise would be.

The SOCH platform has served Swedish heritage well since its inception in 2008, and there are now plans to develop it further in order to better serve the needs of modern users and developers, as well as to better align with modern heritage data standards and address some of the challenges described above. It is hoped that the redeveloped SOCH will not be the only platform to learn from the experience of the past 13 years, and that it may serve as inspiration for other LOD heritage platforms in future.

Ultimately, in the longer term, it is to be hoped that the need for aggregators such as SOCH and Europeana will become unnecessary as CHIs find themselves more able to publish and reliably maintain their own standards-based LOD platforms, and the problems of resource discovery (e.g., widespread adoption of LDN) and responsive federated search are mitigated. Indeed, some institutions, such as the Swedish National Library, have already gone this route, publishing via a robust Linked Data platform and eschewing aggregation. Until this approach becomes more widespread, however, aggregators fill a valuable role, centralising search via a single API endpoint and providing timely responses, enforcing adherence to a homogenous data model, and relieving CHI of some of the economic and technical burdens concomitant with maintaining such a platform. The challenges facing linked open cultural heritage data in the coming years are ones of data quality, skills and training among heritage professionals, funding, and adoption. Of these, data quality is in some ways both the most pressing and the easiest to make swift progress in: despite best efforts, linked open heritage data is still not especially linked, with string values carried over from other systems still being published instead of proper links to other records or to vocabularies/authorities. Updating such references is in itself not difficult but would at a stroke vastly improve the usefulness and value of the linked heritage data web by enriching and contextualising the data.

Conclusions

This chapter has given an introduction and overview of elementary LOD and metadata aggregation on both a philosophical and a technical level, introducing key concepts and standards, as well as giving a practical example in the form of the SOCH Linked Data aggregator platform. We have shown that the LOD model solves the problems of closed data platforms within the heritage sector – both in terms of licensing and reuse, and interoperability and accessibility – posed by the widespread data silo model, by leveraging the possibilities of connecting data sets together over the web.

Covering the background of LOD and metadata aggregation, we have seen how data can be more richly and flexibly described in a machine-readable manner by using semantically meaningful links to describe properties and relations according to a graph-based model. We have also seen how this can increase interoperability across data sets, especially with the use of shared structured vocabularies for terms and ontologies for structure and meaning. By publishing data in this way, assertions from different data sets describing the same or related subjects can complement one another, and can be expanded upon by others publishing their own Linked Data.

The SOCH Linked Data platform and aggregator for SOCH was presented as a concrete example of a large and successful platform showing how some of these principles can function in practice. However, while advanced for its time in 2008, SOCH has failed to keep up with developing standards within LOD. Its use of a bespoke data model and web API now serve as a hindrance to greater interoperability and integration with the wider semantic web. We also saw how metadata aggregation can work to in tandem with the goals of Linked Data: despite the fact that the distributed model of Linked Data might seem counter to aggregation's essential centralisation, in fact aggregated Linked Data works well when circumstances otherwise preclude the fully distributed semantic web data utopia that LOD aims to create.

Reflecting on the glimpse into the state of linked open cultural heritage data presented here, we have seen that the open, connected publication model that LOD advocates is beneficial for the sector and users. Openly licensed data is able to reach more people simply by dint of ease of publication and proliferation via copying on the web, and is not just accessible by (re)usable. Linked Data is more useful, both to researchers and casual users, providing as it does the potential for citable sources, context, language-independent shared terminologies and greater interoperability beyond a single data set or source, within a distributed hypermedia platform.

The future is not without challenges however. Linked Data benefits greatly from wide adoption – the more data sets that are published as LOD, the more links there are between data sets (and data using the same vocabularies and ontologies), enriching other data sets indirectly. However, there are barriers to wider adoption within heritage, particularly a lack of

domain knowledge and, crucially, resources, in a sector that is often already stretched thin and has to prioritise.

It is nonetheless to be hoped, however, that the LOD paradigm will continue to flourish within the cultural heritage sector – perhaps connecting via SOCH or Europeana, or inspired by their example – and that more institutions will expose their data using RDF and applicable shared Linked Data standards.

Glossary

AAT: Getty Arts and Architecture Thesaurus; a structured Linked Data vocabulary for artistic terms, styles, periods, object types etc. http://vocab.getty.edu/

CHI: Cultural Heritage Institution

CIDOC-CRM: The CIDOC Conceptual Reference Model, an event-oriented ontology for cultural heritage with a focus on museum collections. http://cidoc-crm.org/cidoc-crm/

CQL: Contextual Query Language, a simple index-based query language with Boolean logic originally intended for use in library contexts but found in many search applications; maintained by the Library of Congress. https://www.loc.gov/standards/sru/cql/spec.html

Creative Commons: A non-profit organisation promoting free culture and set of widely-used open attribution-based licenses for creative and cultural works. https://creativecommons.org/

CRMarchaeo: An extension to the CIDOC-CRM adding properties for archaeological methods and concepts. http://www.cidoc-crm.org/crmarchaeo/

Dublin Core: A set of 15 fundamental metadata properties (later expanded) widely used and accepted as a baseline for metadata. http://purl.org/dc/elements/1.1/; http://purl.org/dc/terms/

EDM: The Europeana Data Model, a data model for cultural heritage data used by the Europeana aggregator Europeana. http://www.europeana.eu/schemas/edm/

Europeana: A European digital cultural heritage aggregator operational since 2008 and with collections data from more than 3,000 CHIs, operated under the auspices of the European Commission. https://www.europeana.eu/

FAIR: A set of principles for Findable, Accessible, Interoperable and Reusable digital data, complementary to Linked Open Data and movements such as Free Software, but with a focus on academia and scientific data. https://www.go-fair.org/fair-principles/

FOAF: Friend-Of-A-Friend; a Linked Data schema for describing people, organisations and social networks. One of the earliest Linked Data ontologies, it is in widespread use. http://xmlns.com/foaf/0.1/

Generous Interface Fashion: An experimental application built on the SOCH API and data as a prototype "generous interface", allowing users to explore a digital collection rather than having to search. https:// riksantikvarieambetet.github.io/Generous-Interface-Fashion/

GeoNames: An authority for geolocated place names and geographical divisions (countries, provinces, cities etc). http://www.geonames.org/

Heritage Data: A set of Linked Data SKOS vocabularies and thesauri from the UK heritage bodies, including monuments types thesauri, https://heritagedata.org/live/schemes

JSON-LD: A variant of the JavaScript Object Notation data format with support for Linked Data; a serialisation format of RDF; see Kellogg et al. 2020.

Kringla: A web application built on SOCH allowing users to search, browse and view records in SOCH, including associated media, links between records and out to the broader web etc.; https://www.kringla. nu/

Kringla Visualized: A proof-of-concept application for visualising statistics and trends in the properties of records in SOCH; https:// riksantikvarieambetet.github.io/Kringla-Visualized/index_en.html

K-samsök: See SOCH

LDN: Linked Data Notifications, a protocol for pushing RDF-based messages from a sender to a receiver, for example as a notification of changes to a data set; https://www.w3.org/TR/ldn/

OAI-PMH: Open Archive Initiative Protocol for Metadata Harvesting; see Lagoze et al. 2015.

Open Data Commons: https://opendatacommons.org/licenses/odbl/1-0/

OWL: Web Ontology Language; an RDF ontology for describing RDF ontologies; see Motik et al. 2012

PeriodO: A linked open data gazetteer for historical and archaeological chronological periods, bounded both temporally and geographically. https://perio.do/

RDF: Resource Description Framework, the meta-model for linked open data and the semantic web, comprised of three-part statements called triples; see Schreiber and Raimond 2014

RDFS: RDF Schema, a set of RDF types and predicates for describing data schemas and vocabularies; see Brickley and Guha 2014

REST: Representational state transfer, a method of designing web APIs using hypertext transfer protocol semantics; see Fielding 2000.

RSS: RDF Site Summary, or alternatively Really Simple Syndication, a method of providing a data feed of new or changed records (or blogposts, or podcasts…) over the web; https://www.rssboard.org/rss-specification

Runor: A digital research platform for Nordic runic inscriptions built using SOCH, in collaboration with Uppsala University; https://app.raa. se/open/runor/

schema.org: A widely adopted standard for embedding generic structured semantic metadata in web pages. https://schema.org/

SKOS: Simple Knowledge Organization System, a set of RDF types and predicates for describing multihierarchical structured vocabularies as Linked Data; see Miles and Bechhofer 2009

SOCH: Swedish Open Cultural Heritage (in Swedish K-samsök) the Swedish national cultural heritage aggregator and linked open data platform, operated by the Swedish National Heritage Board. http://kulturarvsdata.se/

VIAF: Virtual International Authority File. a set of aggregated authorities for bibliographic entities such as authors, works etc. collected from national libraries across the world; http://viaf.org/

Wikidata: Crowd-sourced structured linked open data from Wikimedia; http://www.wikidata.org/

Wikimedia Commons: Crowd-sourced open media from Wikimedia; https://commons.wikimedia.org/

Wikipedia: Crowd-sourced open knowledge from Wikimedia; https://www.wikipedia.org/

Z39.50: A federated search protocol that used to be popular for inter-library resource discovery; standard maintained by the Library of Congress; https://www.loc.gov/z3950/agency/

Bibliography

Berners-Lee, Tim, Roy Fielding, and L. Masinter 1998. *RFC 2396: Uniform Resource Identifiers (URI): Generic Syntax*. Internet Engineering Taskforce. http://tools. ietf.org/html/rfc2396

Berners-Lee, Tim 2006. *Linked Data*. Cambridge, MA, World Wide Web Consortium (W3C). http://www.w3.org/DesignIssues/LinkedData.html

Bray, Tim; Jean Paoli, C. M. Sperberg-McQueen, Eve Maler, François Yergeau, and John Cowan (eds.) 2006. *XML 1.1*, 2nd edition. Cambridge, MA, W3C Recommendation. https://www.w3.org/TR/2008/REC-xml-20081126/

Brickley, Dan and R.V. Guha (eds.) 2014. *RDF Schema 1.1*. Cambridge, MA, World Wide Web Consortium (W3C). http://www.w3.org/TR/rdf-schema/

Duerst, Martin and Michel Suignard 2005. RFC 3987: Internationalized Resource Identifiers (IRIs). Internet Engineering Taskforce. http://tools.ietf.org/html/rfc3987

Fielding, Roy Thomas 2000. *"Architectural Styles and the Design of Network-based Software Architectures."* PhD diss., University of California, Irvine. http://www. ics.uci.edu/~fielding/pubs/dissertation/rest_arch_style.htm

Harris, Steve and Seaborne, Andy (eds.) 2013. *SPARQL 1.1 Query Language*. http:// www.w3.org/TR/sparql11-query/

Kellogg, Gregg, Pierre-Antoine Champin, Dave Longley, Manu Sporny, and Markus Lanthaler. 2020. *JSON-LD 1.1: A JSON-based Serialization for Linked Data*. Cambridge, MA, World Wide Web Consortium (W3C). http://www.w3.org/TR/json-ld/

Lagoze, Carl, Herbert Van de Sompel, Michael Nelson, and Simeon Warner (eds.) 2015. *The Open Archives Initiative Protocol for Metadata Harvesting*. http://www. openarchives.org/OAI/openarchivesprotocol.html

Miles, Alistair and Sean Bechhofer (eds.) 2009. *SKOS Simple Knowledge Organization System Reference*. Cambridge, MA, World Wide Web Consortium (W3C). http://www.w3.org/TR/skos-reference

Motik, Boris; Patel-Schneider, Peter F. and Bijan Parsia (eds.) 2012. *OWL 2 Web Ontology Language: Structural Specification and Functional-Style Syntax*. 2nd edition. Cambridge, MA, World Wide Web Consortium (W3C). http://www.w3.org/TR/owl-syntax

Riksantikvarieämbetet. 2018a. *Objektstyper*. https://www.raa.se/hitta-information/k-samsok/att-anvanda-k-samsok/objektstyper/

Riksantikvarieämbetet. 2018b. *Index för statistic/facet*. https://www.raa.se/hitta-information/k-samsok/att-anvanda-k-samsok/index-for-statistic-facet/

Riksantikvarieämbetet. 2019. *Metoder*. https://www.raa.se/hitta-information/k-samsok/att-anvanda-k-samsok/metoder/

Riksantikvarieämbetet. 2020a. *Relationstyper*. https://www.raa.se/hitta-information/k-samsok/att-anvanda-k-samsok/relationstyper/

Riksantikvarieämbetet. 2020b. *Auktoriteter*. https://www.raa.se/hitta-information/k-samsok/att-anvanda-k-samsok/auktoriteter/

Riksantikvarieämbetet. 2021a. *Rättigheter*. https://www.raa.se/hitta-information/k-samsok/att-anvanda-k-samsok/rattigheter/

Riksantikvarieämbetet. 2021b. *Protokoll och parametrar*. https://www.raa.se/hitta-information/k-samsok/att-anvanda-k-samsok/protokoll-och-parametrar/

Riksantikvarieämbetet. 2021c. *Exempel på användning av K-samsök*. https://www.raa.se/hitta-information/k-samsok/att-anvanda-k-samsok/exempel-pa-anvandning-av-k-samsok/

Schreiber, Guus and Yves Raimond (eds.) 2014. *RDF 1.1 Primer*. Cambridge, MA, World Wide Web Consortium (W3C). http://www.w3.org/TR/rdf11-primer/

URI Planning Interest Group, W3C/IETF. 2001. *URIs, URLs, and URNs: Clarifications and Recommendations 1.0*. https://www.w3.org/TR/uri-clarification/

W3C. 2002. *httpRange-14: What Is the Range of the HTTP Dereference Function?* W3CTAG Issues List. https://www.w3.org/2001/tag/issues.html#httpRange-14

Metadata enrichment

5 A semantic enrichment approach to linking and enhancing Dunhuang cultural heritage data

Xiaoguang Wang, Xu Tan[i], Heng Gui, and Ningyuan Song

Introduction

The rapid development of information technologies and the data-driven research paradigm of Digital Humanities (DH) have led to a wave of document digitisation projects on books, newspapers, periodicals, photos, ancient texts etc. to meet the growing demands of data resources (Hockey 2004; Berry and Fagerjord 2017). In the last three decades, many institutions from the gallery, library, archive and museum (GLAM) community have made contributions to the digitisation and organisation of cultural heritage (CH). Some renowned GLAMs in Europe, such as the *Louvre* (Louvre 2021) and the *British Museum* (The British Museum 2021), first offered digital platforms for their collections in the mid-1990s. In April 2009, the *United Nations Educational, Scientific and Cultural Organization* (UNESCO) launched the *World Digital Library Project*. It provided free access to a vast wealth of artistic works from human history to a worldwide audience. It now contains 1,057,175 item files from 158 GLAMs in 60 countries (U.S. Library of Congress and UNESCO 2009).

The need to organise digital resources has created new challenges for CH informatics (Hyvönen 2016). Specifically, since most digital collections, archives, indexes and databases are still stored in separate repositories, they have been characterised as isolated islands of data, often called data silos. Because of the distinct formats, descriptive frameworks, vocabularies and recording methods used by different institutions, a collection of data held by one group is hardly and partly accessible to other groups (Zeng and Tan 2021). From the perspective of data processing, inconsistencies and idiosyncrasies in methods cause errors and the duplication. From the perspective of usability, the isolated data is only machine-readable instead of machine-understandable or machine-processable (Zeng 2017). From the perspective

i The research team affirms that Xiaoguang Wang and Xu Tan (txishuo@163.com) have equal contributions to this chapter.

DOI: 10.4324/9781003131816-5

of user-friendliness, it is difficult to comprehensively display rich cultural knowledge to audiences without contextual information.

Data silos also diminish the value of Dunhuang CH data and impede the development of Dunhuangology. Dunhuangology is an academic study of the city of Dunhuang, China, in particular its cultural and historical heritage (MediaWiki 2019). To manage and maintain Dunhuang CH data and support Dunhuangology research, many GLAMs have constructed databases for Dunhuang CH, for instance, the *International Dunhuang Project* (International Dunhuang Project 2016), the *Dunhuangology Database* (Lanzhou University Library 2013) and the *Digital Library of Dunhuang Literature* (Shaanxi Normal University Press 2016). However, these existing databases have a limited scope in advancing the field of Dunhuangology and cannot support DH research (Hu 2018; Wang et al. 2019a). Since artefacts from Dunhuang are scattered worldwide, the execution of projects and the establishment of databases are usually carried out by different institutions. In the absence of domain-specific standards and specifications, the databases are generally incompatible with each other in their methods of digital acquisition, processing and storage, which results in data silos. Researchers with shared interests continue to invest enormous resources in building up their own databases. However, despite a significant trend in DH that could support the further development of Dunhuangology, existing DH resources and infrastructure cannot currently meet the requirements of academic research.

We therefore explore the ideas and techniques of semantic enrichment for enhancing CH data and supporting Dunhuangology research. The concept, processing methods and related Knowledge Organization System (KOS) of semantic enrichment are reviewed in section "Background". We then present a broad description of the *Digital Dunhuang Project* (DDP) in section "The Digital Dunhuang Project". In section "The semantic enrichment approach to Dunhuang CH data", we focus on the construction of the *Dunhuang Mural Thesaurus* (DMT) and the analysis and enhancement of Dunhuang CH data to accelerate the development of DH research infrastructure for Dunhuangology. Also, this chapter describes how to transform the DMT into Linked Data in section "The semantic enrichment approach to Dunhuang CH data". We contend that linked open data (LOD) is the best means to facilitate the sharing, association, enrichment and reuse of Dunhuang CH data. Finally, we discuss the future development of DH research infrastructure in the field of CH.

Background

The rapid development of DH, alongside the huge demand for large-scale and high-quality data, has made data processing an essential and necessary part of DH research. As one of the foundations of this research, the digitisation of CH resources has led to the creation of massive, heterogeneous

and multi-modal CH data, to which the semantic enrichment approach is well placed to process. Semantic enrichment is a strategy that applies semantic techniques to enhance the value of data. For example, by constructing links and associations between CH data and related digital resources, providing rich contextual information improves users' understanding of CH content. It is an effective means to enhance the quality of data in the CH field (Zeng 2019).

Virtually any digital file format (text, audio, video or office formats) is suitable for semantic enrichment, but the semantic enrichment of text is the most mature among them (Retresco 2021). In addition to different file formats, the semantic enrichment approach can process the data in different structures such as structured, semi-structured and unstructured data. The algorithm employed in semantic enrichment uses explicit semantic relationships such as hierarchical relationships and associative relationships to identify people, places, organisations, items, events and other entities (Damjanovic et al. 2011). Subsequently, the algorithm determines the relative importance of the entities by considering the relevance of the information and how the entities contribute to the meaning of the text. Lastly, by identifying or recognising entities in the text, structured and machine-readable data is created from unstructured text, and this interoperable standardised content is published as LOD and made freely available. This approach can also be flexibly implemented with either a combination of human and machine processing or be fully automated (Zeng 2017). By applying semantic enrichment strategies or approaches, the retrievability and reusability of data can be improved within the CH field and the construction of research infrastructure construction can be significantly accelerated.

One of the most productive international semantic enrichment projects for CH data was launched by Europeana, the leading service platform of the European cultural community. It contains the metadata of more than 50 million digitised CH items (such as books, music, artworks) across more than 3,000 European institutions. However, the diverse types of unstructured and semi-structured data in Europeana constitute the main challenge to data processing (Europeana Collections 2021). Based on the semantic enrichment strategy, Europeana enriches its data providers' metadata by automatically linking text strings in the metadata to controlled terms from LODs or KOS vocabularies (Europeana Pro 2020). The *Europeana Semantic Enrichment Framework* was created to standardise the entire process (Isaac et al. 2017). Europeana asserts that the better way to understand the semantic enrichment process is to distinguish conceptually between the three main stages of datafication. These major stages include:

1 Analysis: focusses on analysing the metadata fields in the original resource descriptions, selecting potential resources to be linked to and deriving rules to match and link the original fields to the contextual resource.

2 Linking: the process of automatically matching the values of the metadata fields to the values of the contextual resources and adding contextual links (whose values are most often based on equivalent relationships) to the dataset.
3 Augmentation: the process of selecting values from the contextual resource to be added to the original object description. This might include not only (multilingual) synonyms of terms to be enriched but also further information, e.g., broader or narrower concepts (Isaac et al. 2017; Europeana Pro 2020).

Similarly, Zeng (2019) extensively reviewed the semantic enrichment practices from the perspective of structured, semi-structured and unstructured data. She summarised four semantic enrichment practices, methods and approaches that are applicable to the GLAM and CH fields:

1 enhancing existing metadata quality and discoverability with more contextualised meanings by using KOS vocabularies and other resources that are available as LOD. For example, *Europeana* enriches names of concepts with values from the *Art & Architecture and Thesaurus* (AAT) and the *Library of Congress Subject Headings* (LCSH). Their vocabularies are published as LOD to align concepts and values automatically (Europeana Pro 2020);
2 transforming semi-structured data into structured data through entity-based semantic analysis and annotation to extend access points. For example, *Kent State University* uses the semantic analysis tool *OpenCalais* to transform the descriptive information of finding aids, such as creator histories, scope, content notes and abstracts, to extract access point candidates (Davidson and Gracy 2014; Gracy and Zeng 2015);
3 mining unstructured data and generating knowledge bases to support knowledge discovery and enabling one-to-many usages of GLAM data across data silos while delivering intuitive online user interfaces. For example, drawing on oral history transcripts, the *Pratt Institute's Linked Jazz* project uses Linked Data to uncover meaningful connections between documents and data related to the personal and professional lives of jazz artists and to expose relationships between musicians that reveal their community network (Pattuelli 2012);
4 making the heterogeneous contents from diverse providers semantically interoperable via shared ontology infrastructure. For example, the *Semantic Computing Research Group* (SeCo) has designed a circular data publication system to improve interoperability. Here, a shared semantic ontology infrastructure is at the heart of the system. It includes mutually aligned metadata and shared domain ontologies, modelled using semantic web standards such as the Resource Description Framework Schema (RDF Schema) and the Web Ontology Language (OWL).

If content providers outside of the circle provide the system with meta-data about a CH object, the data is automatically linked and recipro-cally enriched, thus forming a *Giant Global Graph* (Hyvönen 2016).

This process of semantic enrichment puts entities, such as the label on the mural and location, at the center and reflects the transformation from document-centric to entity-centric knowledge modelling. Regardless of which step of the process that the data has reached, KOS and external resources are always critical. For instance, in the case of projects related to Europeana, each place-name in the metadata is enriched by creating links with the global geography database and knowledge-sharing platform *GeoNames*, the *Integrated Authority File* (widely known as Gemeinsame Normdatei or GND), and the community-based encyclopedia *DBpedia* (which extracts structured contents from Wikipedia and serves them as Linked Data). The links, together with the use of URIs, provide each place in the metadata with geographic coordinates and multi-language names, thus achieving the semantic enrichment of those place names (Europeana Pro 2020). There is a growing number of high-quality KOS that are com-monly used. Table 5.1 below lists the recognised KOS that are relevant to this chapter.

Table 5.1 Principal KOS per domain and metadata standard

KOS	*Domain*	*Introduction*
DCMI (Dublin Core Metadata Initiative) Metadata Terms	General	This document is an up-to-date specification of all metadata terms, including properties, vocabulary encoding schemes, syntax encoding schemes, and classes (DCMI Usage Board 2020).
AAT (Art & Architecture Thesaurus Online)	Art and architecture	AAT is a thesaurus provided by Getty Vocabularies. It is a powerful conduit for knowledge creation, research, and discovery for digital art history and related disciplines (Getty Research Institute 2017).
CDWA (Categories for the Description of Works of Art)	Art	CDWA is a set of guidelines for the description of art, architecture, and other cultural works. CDWA represents common practice in this field and advises best practices for cataloguing based on surveys and consensus-building within the user community (Getty Research Institute 2016).
PM-DCH (Preservation Metadata for Digital Cultural Heritage)	Cultural Heritage	Sets out the general principles of cultural heritage metadata. Specific metadata standards or principles for categories of CH such as sculptures, porcelain, bronzes, furniture, potteries, caves, murals, and others (Peking University Library 2017).

The Digital Dunhuang Project

The DDP is a world-famous, pioneering project which has yielded greater access for art critics to the priceless Dunhuang artefacts and their rich CH resources and metadata. As a representative project in the CH field, the DDP provides an instructive example of digitisation and datafication.

Dunhuang CH and DDP

Dunhuang, famous as a significant stop on the ancient Silk Road, is a historical city that witnessed the blending of western and eastern cultures over thousands of years. Located in the Dunhuang oasis, the construction of the Dunhuang Grottoes began in AD 366. In 1987 the grottoes were added to UNESCO's list of *World Heritage Sites*. The Dunhuang Grottoes constitute the largest shrine and collection of Buddhist art, of immeasurable academic and cultural value to studies in history, culture and archaeology. Among these, the Mogao Caves contain more than 45,000 square meters of murals and more than 2,000 painted sculptures preserved in 492 caves (UNESCO World Heritage Center 2021).

The cultural and artistic value of the Dunhuang CH collection draws great attention from researchers. As a result, a specific area of study called *Dunhuangology* became internationally famous (Li and Li 2009). To permanently preserve Dunhuang culture and to further the development of Dunhuangology, Jinshi Fan proposed the construction of *Digital Dunhuang* in the 1980s (Fan 2014). Subsequently, the *Dunhuang Academy of China* (DAC), the *Mellon Foundation*, the *University of California Berkeley*, the *Chinese Academic of Science, Zhejiang University* and *Wuhan University* participated in the project.

In keeping with the national strategy for the preservation of cultural artefacts, the DDP is pursuing digitisation of the entire corpus, including collecting, processing and storing Dunhuang CH using advanced technology. The project integrates diverse data types, including photos, videos, 3D data and other literature data, into a digital repository of cultural artefacts found in the caves that can be shared globally over the Internet. Among the research outputs of the DDP are the *Mellon International Dunhuang Archive* (ARTSTOR 2021), the *Dunhuang Academic Resources Databases* (Dunhuang Academic 2019), the *E-Dunhuang* website (Digital Dunhuang 2020) and the research upon which this chapter is based.

The capacity and distribution of Dunhuang CH data

As a result of digitisation initiatives, the diverse digital data of Dunhuang have grown substantially. By 2018, DDP had finished digitising the collections of 221 caves, processing images of 141 caves, producing panoramic images of 144 caves and digitising the negatives of 45,000 photographs

(Wu et al. 2019). The total size of the digitised data reached 1PB (Digital Dunhuang 2020). Being an indispensable component of the Dunhuang corpus, the CH data plays an essential role in the preservation of Dunhuang. However, the massive, heterogeneous and multi-model properties of the data present challenges for its efficient management, organisation and practicability (Wang et al. 2019a).

The Dunhuang CH dataset is complex, reflecting both the multidisciplinary nature of its data organisation and that of CH more widely. The disciplines represented within its corpus include religion, art, history, archaeology, linguistics, literature, ethnography, geography, philosophy, technology, architecture and various other themes or domains of knowledge. In terms of data classification, it contains both digitally native and non-native information. For instance, the native data includes digital photographs and digital archaeological reports. In contrast, the non-native data consists of the digital 3D model data of the caves, the digital images of murals, digitally scanned copies of transcripts and manuscripts and the digital text of Dunhuangology research articles, books, newspapers and bibliographies. In addition, Dunhuang CH data are also multi-model, including text, images, audio, video, multispectral data and 3D modelling data. The majority of Dunhuang CH data are unstructured images of murals, ancient manuscripts and 3D models of caves (Wu et al. 2019).

The semantic enrichment approach to Dunhuang CH data

The semantic enrichment approach proposed in this chapter describes a complete process of applying semantic enrichment to Dunhuang CH data. As shown in Figure 5.1, the process consists of data acquisition and processing, the construction of the DMT, analysis and enrichment of Dunhuang

Figure 5.1 The workflow of the semantic enrichment approach to Dunhuang CH Data.

CH data and the creation and publishing of LOD-DMT. Firstly, academic books and papers, images and the *Dunhuang Academic Resources Database* metadata were collected, cleaned and preprocessed before being stored in the local database. Then, with the help of Dunhuangology experts, DMT was designed as a domain KOS with reference to the structure of AAT and constructed using a combination of Natural Language Processing (NLP) technology and manual inspections. Semantic analysis, linking and augmentation were implemented by considering the metadata specification and the knowledge units within the corpus. Meanwhile, Dunhuang CH data were connected with the DMT and with selected external resources for data enhancement. The DMT is also published as LOD-DMT for better access, storage and sharing of open data.

Data acquisition and processing

This chapter describes various types of data, including electronic textual data from books and papers, high-resolution digital images of murals, digitally scanned copies of the Dunhuang atlas and the metadata from research papers, newspapers and bibliographies related to Dunhuangology (as shown in Table 5.2).

Table 5.2 Primary dataset for enhancing Dunhuang CH data

Data	*Content and quantity*	*Format*	*Notes*
Books	*General Catalogue of Dunhuang Caves* (敦煌石窟内容总录): Contains an introduction to all of the 492 caves in the Dunhuang Mogao Grottoes. *Dunhuang Dictionary* (敦煌学大辞典): Contains more than 60 classes of 6,925 entries of posthumous writings and related research literature.	PDF and Text	Optical Character Recognition (OCR) and manual inspection
Papers	Dunhuang Research (敦煌研究), Journal of Dunhuang Studies (敦煌学辑刊): Contains the bibliography and full texts of 784 journals.	PDF, CAJ, and Text	Downloaded from the China National Knowledge Infrastructure
Images and metadata	High-resolution digital images of 5 classic Buddhist murals with a resolution of 300 ppi. Digital scan copies of the Dunhuang atlas: contains 2,877 images of the Dunhuang caves, murals, sculptures, and manuscripts less than 10 MB with a resolution over 96 ppi. Metadata from the Dunhuang Academic Resources Database.	PDF, JPEG, and Excel	Provided by DAC.

The *General Catalogue of Dunhuang Caves* and the *Dunhuang Dictionary* are the two most comprehensive and influential encyclopedias in Dunhuangology (Dunhuang Academic 1996; Ji et al. 1998). We converted the digitally scanned copies of these works from PDF into a textual format using OCR. In the process, manual reviewing was conducted to verify accuracy.

The journals *Dunhuang Research* and the *Journal of Dunhuang Studies*, contained in the Chinese Social Sciences Citation Index (CSSCI, Chinese Social Science Research Assessment Center 2017), were selected as the textual data source. In total, 985 candidate articles were collected by searching with the keyword "mural" (壁画) in the principal Chinese literature database *China National Knowledge Infrastructure* (CNKI 2021). After manual de-duplication, data cleaning and format conversion of the data, 784 items of literature related to the murals were selected.

The *Dunhuang Academic Resources Database* is developed by DAC, aiming to share academic resources for the study of Dunhuangology. It provides the metadata for research articles, bibliographies, conferences, degree theses and newspapers in the field. With the help of DAC, the metadata of the *Dunhuang Academic Resources Database* was collected and stored in our local database. In addition, the image data included five high-resolution digital images of the Dunhuang murals and digitally scanned copies of the Dunhuang atlas, as well as associated basic metadata provided by DAC.

The design and construction of the Dunhuang mural thesaurus

Due to the lack of any Dunhuang CH domain-specific thesauri, the construction of the DMT is described in this chapter to demonstrate the semantic enrichment approach in the analysis, linking and augmentation of the data. The thesaurus is a KOS that normatively organises words in a hierarchical structure and other associated structures. It usually consists of authority terms and standardised domain-specific terms, concepts and semantic associations. Compared with authority files and directories, thesauri have significant advantages in interoperability and data connectivity. As a result, they are an important and commonly used KOS.

The DMT was designed as a controlled and structured vocabulary in the Dunhuang CH field (Wang et al. 2019b). Using the standard terms from DMT, fast processing and extraction of the detailed metadata from constructed texts and semantic enrichment of complex image contents became feasible. As outlined in this chapter, the DMT was constructed by a combination of a top-down process and a bottom-up process, which corresponded to the structural design step and content acquisition step, respectively.

Top-down process: Structural design

The DMT was designed by adopting a top-down structure, which contained four categories and five facets. We researched the structure of AAT,

carrying out a deep analysis of its domain generality, organisation, annotations and metadata standards. The AAT is a hierarchical thesaurus that follows the widely accepted international ISO and NISO standards for thesauri construction, of which the hierarchical structure consists of facets, hierarchy, flags and concepts. Taking into account the design of AAT, we designed the DMT with four categories: *Facet, Hierarchy, Concept* and *Instance.* The *Facet* is located at the top level of the structure, representing a set of *Concepts* with similar characteristics. The *Concepts* and *Hierarchy* are found on the next level. They were used to describe the relationships within the thesaurus. The *Instances* are entity examples beneath the level of *Concepts* and *Hierarchy.*

The rich contents of the Dunhuang murals are the subject of a range of academic disciplines, including religion, history, art etc. We researched articles and authority books to obtain a better understanding of the murals, their subjects and the hierarchical relationships between them. Finally, with the guidance of domain experts from DAC, five facets were selected for the structure of the thesaurus: *Agents, Objects, Activities, Time* and *Physical Attributes.*

Bottom-up process: Content acquisition and extending thesaurus

To fill and extend the thesaurus and optimise its structure, we employed a bottom-up process. The content acquisition step was carried out by a combination of automated processes and manual inspections. Using the prepared textual database (including the *General Catalogue of Dunhuang Caves,* the *Dunhuang Dictionary,* the *Dunhuang Research* and the *Journal of Dunhuang Studies*), the NLP technology was used to tokenise the sentences and filter candidate words. Specifically, we used the *Jieba* Python package (Sun 2013). This tool is based on the *Dynamic Programming and Hidden Markov Model* (HMM) and is designed to recognise and type words. Contextual information such as the *Named Entities* corpus (including location names, Buddhist terms, Dynasty calendars, names of positions held) were added with manual inspections of the data to improve auto-selection accuracy and efficiency. During this process, 18,050 candidate words were selected. Subsequently, the filtering, proofreading and classification processes were carried out manually by Dunhuangology experts and by our team.

The step of extending the thesaurus proceeded simultaneously, in which the thesaurus structure was extended and modified to improve comprehensive and accuracy wherever it could not already accommodate the new entities. Sub-categories were added based on the current categorisation and the characteristics of the murals. For instance, extra categories were added to distinguish *Buddhist Deity* and *Secular Human* in the *Agent* facet, and *Buddhist Time* (based on the Buddhist calendar) was added to the *Time* facet. By iteratively modifying the computer algorithm and thesaurus

structure, we eventually created 25 sub-categories nested under five facets and selected 4,276 words as entities in the thesaurus.

Analysis and enrichment of Dunhuang CH Data

Semantic analysis, linking and augmentation and LOD-DMT publishing were the primary processes of the semantic enrichment approach that we used to process the Dunhuang CH data. Semantic analysis was used in the pre-enrichment phase, which focusses on analysing the metadata and fine-grained units of knowledge and selecting target resources for metadata enhancement. Linking and augmentation constituted the main enrichment phase, focusing on property values, identities of entities and data description and reliability. The publication of LOD-DMT was an initial exploratory phase in working towards the creation of a sustainable ecosystem of Dunhuang CH data.

Semantic analysis

ANALYSIS OF THE METADATA SPECIFICATION

Because of the absence of any domain-specific metadata about Dunhuang artefacts, we made reference to the CDWA, the PM-DCH (Peking University Library 2017), and metadata from the Dunhuang Academic Resources Database to design a metadata specification for the Dunhuang caves, murals, sculptures and manuscripts. The PM-DCH adopts principles for categories of CH and provides specific metadata specifications for objects such as sculptures, porcelain, bronzes, furniture, potteries, caves and murals, which are the main types of cultural artefacts found in Dunhuang. We reused the general core elements for artworks (*Name, ID, Subject, Material, Techniques, Construction, Specification and Description*) from PM-DCH and CDWA to construct a domain-specific metadata specification for the Dunhuang caves, murals, sculptures and manuscripts. In addition, the property *Topic* was added to describe the artwork type of the murals. *Location* was also added to describe the location of the murals, following the advice of Dunhuangology experts. Specifically, we added the sub-property *Cave belonging to, Caves* and *Bearing* to *Location* to express which cave the murals belong to and where the caves are located within the grottoes.

ANALYSIS OF THE FINE-GRAINED UNITS OF KNOWLEDGE

In the field of Knowledge Organization, knowledge units are usually used for the description of the people, events, times, places and things in images and texts (Xia 2017). By following this idea and reusing the information in documents and artefacts created by ancient ancestral artists, related

to these categories listed above, was used to create a set of specifications to describe the fine-grained knowledge units. For example, the metadata entity *Label* (榜题/题识) on the mural, which may be a title of a story or name of an entity, was selected as the knowledge unit. Based on the content of the mural, the label has six core elements: *Name, Type, Subject, Created Data, Current Location and Description.* Furthermore, by comparing this to the DMT, the sub-properties *Construction, People, Animals, Objects* and *Story* were added to *Description* to increase the detail of the metadata in the label.

ANALYSIS OF THE TARGET RESOURCES SELECTION

The selection of target datasets is the most crucial step in improving the quality of CH data. Besides the DMT, we make reference in this chapter to the criteria set out by the *Task Force on Enrichment and Evaluation* of Europeana to determine the external target resources for selection. These criteria were organised around seven dimensions: *availability, access, granularity, coverage, quality, connectivity* and *size* (Isaac et al. 2015). We made minor adjustments to these criteria based on the particular requirements of the Dunhuang CH field and the Chinese context. The *availability* and *access* criteria refer to the targets that should be available on the Web and should be reusable under an open license. The *granularity* and *coverage* criteria determine whether the targets should have the same coverage as the source data or can complement the source data. The *quality* criterion refers to the quality of the target in terms of semantic and data modelling, especially the structure and representation of the target. *Connectivity* describes how to select the target with incoming and outgoing links to other targets. The *size* of the target dataset, i.e., the number of concepts, is also a criterion of selection. A high number of classes, properties and triples is preferable for the *size* criterion. Finally, we chose *DMT, DBpedia, Wikidata, AAT, Geonames,* the *CNKI* and the *China Biographical Database* (Harvard University et al. 2017) as the external target resources for selection.

Linking and augmentation

DESCRIBE AND ENRICH THE PROPERTY VALUE

In this chapter, we used the *OpenRefine* tool to automatically map the strings in the specification to the values in the selected KOS vocabularies and other resources. It replaced the local values with the URI of the contextual resources. For instance, when enriching the concept *Big Fahua Temple,* the tool automatically found its property *dc:type* has the corresponding concept *Temple* in the external resource AAT and replaced the property with the new one.

CREATE IDENTITY LINKS TO REPRESENT EQUIVALENCE

When different external resources point to the same original resource (e.g., using both DMT and Wikidata to describe the "Bodhisattva"), the property *OWL:sameAs* is imported to create the equivalent association between the resources.

ENHANCE DATA DESCRIPTION AND RELIABILITY
VIA THE TRACEABLE DATA MODEL

To distinguish the various type of descriptions of mural images, we organised the descriptions into a *reality layer* and a *fiction layer*. The *reality layer* contained the properties from reality, including descriptions about the mural itself (*identified with the edm:providedCHO*). The web resources information (identified with *edm:webResource*) were likewise added in this layer for data traceability. The fictional layer contains the properties of the content of the mural (identified with *dh:ContentObject*), including general descriptions of the image and the semantic entities. The two layers are associated via the property *crm:P62_depicts*. Based on this, each knowledge unit was linked with all relevant related information. In this way, users can trace the links between any knowledge unit and track back to the original image or resource provider to get further information.

LOD-DMT publishing

SEMANTIC DESCRIPTION

We set up an ontology model by reusing the *Getty Vocabulary Program Ontology* (GVP Ontology, Getty Research Institute 2015), the *Simple Knowledge Organization System* (SKOS, W3C 2012) and *DCMI Metadata Terms* for the standardised semantic description of LOD-DMT. In keeping with the hierarchical structure of thesauri, five core properties were defined: *skos:ConceptScheme, gvp:Facet, gvp:Concept, gvp:Hierarchy* and *dho:Instance*. The *Facets* and *Hierarchy* properties reuse the GVP ontology model. The corresponding class expresses the property *Concepts* in SKOS. The *Instance* class is defined as the subclass of *Concepts*. In addition, the *Object* properties of the data model, corresponding to the associations between the data, are represented by *skos:inScheme, skos:hasTopConcept, skos:narrower, skos:broader, skos:exactMatch* and *skos:related*.

SEMANTIC TRANSFORMATION

We described the semantic transformation process for LOD-DMT based on the semantic description provided by the SKOS model. In this process, each entity was given a unique and corresponding HTTP URI. Meanwhile, the associations between terms were established via the object properties of

SKOS. The tools *D2RQ* and *OpenRefine* were adapted during this process to provide automatic semantic transformations. Subsequently, verification of the consistency of the semantic transformations was carried out via the *qSKOS* tool in order to ensure the high quality of the Linked Data.

ASSOCIATION ESTABLISHING

We created associations between the LOD-DMT and AAT by using the *skos:exactMatch* property. Establishing associations between databases is a basic requirement of Linked Data. Although vocabularies in DMT are usually domain-specific, general terms or concepts do exist. We associated those vocabularies with corresponding vocabularies in AAT by using the *skos:exactMatch* property. The corresponding vocabularies are determined via *SPARQL* query searching and manual inspection. Finally, after semantic description, transformation and establishing associations, 3,853 terms and over 27,500 triples were created in LOD-DMT, and 816 terms were associated with AAT.

Knowledge service and visualisation

We established a platform to visualise the LOD-DMT (Center for Digital Humanities of Wuhan University 2019). The platform contains basic services like a Web UI, concept resolving, themes guidance, intelligent searching and a term service. In addition, it also provides advanced searching and fuzzy searching and an API with multiple data forms. While the serialisation of the Linked Data enables machine learning, visualisation modules are also provided for better human understanding. We designed several visualisation functions for the platform, including knowledge graphs, sunburst charts, tree charts and circle packing.

Discussion

To realise the efficient knowledge organisation and management of Dunhuang CH data and to construct a sustainable DH research infrastructure for Dunhuangology, this study explores the idea and technologies of semantic enrichment through the construction of DMT, and by organising, linking and enhancing the CH content with the KOS and other contextual resources. The following section summarises the original ideas and best practices presented in this study, and discusses how they could be further expanded by future work:

Data silos and DH research infrastructure

The data silos problem is the major challenge for CH informatics. It diminishes the value of Dunhuang CH data and holds back the development

of Dunhuangology. Many databases have been developed by GLAMs in the Dunhuang CH field. However, those databases still cannot support Dunhuangology research. In this chapter, we use the ideas and technologies of semantic enrichment to manage, maintain and enrich Dunhuang CH data, in which the enhanced data can serve as a sustainable basis for the further development of Dunhuangology. By creating links with KOS vocabularies and other resources, the quality of existing CH data is enhanced with contextualised meaning. Moreover, by transferring the isolated data into Linked Data, CH data's discoverability, usability, reusability and value can be maximised. Our research demonstrates that semantic enrichment is a crucial technique in DH research infrastructure that should be applied widely across CH and other disciplines in the Humanities.

Domain KOS, DMT and LOD-DMT

Domain KOS is the essential contextual resource for semantic enrichment, especially for structurally complex and semantically rich CH data. However, in the Dunhuang CH field, the domain KOS for vocabulary control and contextual enriching was lacking, which hinders the efficient organisation of Dunhuang CH data and limits the growth of the field. The DMT is the first large-scale domain vocabulary in the Dunhuang CH field. It is constructed by pooling the knowledge of domain experts and NLP technology and building a vocabulary by combining automated and manual methods. Unlike the DMT, LOD-DMT provides an example of our semantic enrichment approach. It supports Dunhuangology by providing convenient and connective access to researchers and creates a self-sustaining ecosystem of Dunhuang CH data by transforming it into Linked Data. Linked Data can be seen as a higher-level KOS. It provides the means to construct a network of associations between datasets with rich semantic contents. The construction of LOD-DMT follows the *Best Practice Recipes for Publishing RDF Vocabularies* (W3C Working Group 2008), and linking it with AAT ensures that is shareable, reusable and better quality data.

Knowledge service and user demands

The evolution of DH demonstrates the vast potential of the data-driven research paradigm in academics, but difficulties in data retrieval and data usability impede Humanities researchers. Semantic enrichment can help scholars find more relevant knowledge by adding associations between CH data and contextual resources. We designed our platform based on LOD-DMT, but we believe that it is not sufficient for the deep needs of DH researchers. Future work needs to focus in greater depth on the user experience. Questionnaires and eye-tracking experiments could be employed to explore scene-oriented and personalised knowledge retrieval.

Conclusion

This chapter presents a semantic enrichment approach to linking and enhancing Dunhuang CH data. It fills in a blank in knowledge organisation in the Dunhuang CH field, provides a methodological reference for the construction of DH research infrastructure and demonstrates how to build high-quality data and an effective digital platform. By cooperation with Dunhuangology experts, the DMT was designed and constructed as a domain KOS using NLP technology. Domain-specific metadata specifications, fine-grained units of knowledge and target resources were analysed during the pre-enrichment phase. Links and associations with related digital resources were built to augment the Dunhuang CH data. Finally, we created and published LOD-DMT to explore the semantic enrichment approach and build a self-sustaining ecosystem in the Dunhuang CH field. In the future, we will focus on evaluating the knowledge service provision platform based on the enhanced data and exploring various service methods to improve user experience.

Acknowledgements

The authors would like to express their heartfelt appreciation to Mr. Shengping Xia from Dunhuang Research Academy for providing access to the valuable Dunhuang CH data. Thanks also to Marcia Lei Zeng, Ying-Hsang Liu and Koraljka Golub for providing inspiration and helpful feedback.

Bibliography

ARTSTOR. 2021. "The Mellon International Dunhuang Archive." Accessed March 25 2021. https://www.artstor.org/collection/mellon-international-dunhuang-archive/

Berry, David M. and Anders Fagerjord. 2017. *Digital Humanities: Knowledge and Critique in a Digital Age.* Cambridge, CB: Polity.

Center for Digital Humanities of Wuhan University. 2019. "The linked data publishing platform of Dunhuang Mural Thesaurus." Accessed May 06 2021. http://dh.whu.edu.cn/dhvocab/home

Chinese Social Science Research Assessment Center. 2017. "Chinese Social Sciences Citation Index." Nanjing University. http://cssci.nju.edu.cn/

CNKI. 2021. "China National Knowledge Infrastructure (cnki.net)." Accessed March 25 2021. https://www.cnki.net/

Damjanovic, Violeta, Thomas Kurz, Rupert Westenthaler, Wernher Behrendt, Andreas Gruber, Sebastian Schaffert. 2011. "Semantic enhancement: The key to massive and heterogeneous data pools". In *Proceedings of the 20th intl IEEE ERK (Electrotechnical and Computer Science) conference*, pp. 413–416. https://www.researchgate.net/publication/266603290_Semantic_Enhancement_The_Key_to_Massive_and_Heterogeneous_Data_Pools

Davidson, Sammy, and Karen Gracy. 2014. "Helping Users Finding the 'Good Stuff': Using the Semantic Analysis Method (SAM) Tool to Identify and Extract

Potential Access Points from Archival Finding Aids." In SAA Research Forum, Society of American Archivists. http://files.archivists.org/pubs/proceedings/ ResearchForum/2014/posters/DavidsonGracy-PosterAbstractBio14.pdf

DCMI Usage Board. 2020. "About DCMI." DCMI: DCMI Metadata Terms, Accessed May 06 2021. https://www.dublincore.org/specifications/dublin-core/ dcmi-terms/#section-1

Digital Dunhuang. 2020. "Enter Mogao Grottoes Here." Accessed March 25 2021. https://www.e-dunhuang.com/

Dunhuang Academic. 2019. "Dunhuang Academic Resources Database." http:// dh.dha.ac.cn

Dunhuang Academic. 1996. *General Catalogue of Dunhuang Caves.* Beijing: Cultural Relic Pressing House.

Europeana Collections. 2021. "Welcome to Europeana Collections." Accessed March 25 2021. https://classic.europeana.eu/portal/en/about.html

Europeana Pro. 2020. "Europeana Semantic Enrichment." Accessed March 25 2021. https://pro.europeana.eu/page/europeana-semantic-enrichment

Fan, Shijin. 2014. "The Meaning of Digital Dunhuang Is Permanent Utilisation." *Chinese Academy of Social Sciences.* http://ex.cssn.cn/lsx/sxpy/201408/t20140801_ 1276184.shtml

Fresa, Antonella. 2013. "A Data Infrastructure for Digital Cultural Heritage: Characteristics, Requirements and Priority Services." *International Journal of Humanities and Arts Computing* 7 (supplement): 29–46. doi:10.3366/ijhac. 2013.0058

Getty Research Institute. 2016. "Categories for the Description of Works of Art (CDWA)," Last modified February 28, 2019. http://www.getty.edu/research/ publications/electronic_publications/cdwa/

Getty Research Institute. 2017. "Art & Architecture Thesaurus Online" The Getty. Last modified March 7, 2017. http://www.getty.edu/research/tools/vocabularies/ aat/

Getty Research Institute. 2015. "Getty Vocabulary Program ontology - Report generated by Parrot", Accessed May 06, 2021. http://vocab.getty.edu/ontology# anchor1342708431

Gracy, Karen, and Marcia Lei Zeng. 2015. "Creating Linked Data within Archival Description: Tools for Extracting, Validating, and Encoding Access Points for Finding Aids." In Digital Humanities Conference of the Alliance of Digital Humanities Organizations (ADHO). https://dh-abstracts.library.cmu.edu/ works/2211

Harvard University, Academia Sinica, and Peking University. 2017. "China Biographical Database Project (CBDB), Accessed May 06 2021. https://projects. iq.harvard.edu/cbdb

Hockey, Susan. 2004. "The History of Humanities Computing." In *A Companion to Digital Humanities*, edited by Susan Schreibman, Ray Siemens, and John Unsworth, 1–19. Malden, MA: Blackwell Publishing Ltd. doi:10.1002/9780470999875.ch1

Hu, Xiao. 2018. "Usability Evaluation of E-Dunhuang Cultural Heritage Digital Library." *Data and Information Management* 2 (2): 57–69. doi:10.2478/ dim-2018-0008

Hyvönen, Eero. 2016. "Cultural Heritage Linked Data on the Semantic Web: Three Case Studies Using the Sampo Model." Invited Talk to Be Published in the Proceedings of VIII Encounter of Documentation Centres of Contemporary

Art: Open Linked Data and Integral Management of Information in Cultural Centres. https://seco.cs.aalto.fi/publications/2017/hyvonen-vitoria-2017.pdf

International Dunhuang Project. 2016. "The International Dunhuang Project: The Silk Road Online." Accessed March 25 2021. http://idp.bl.uk/

Isaac, Antoine, Hugo Manguinhas, Valentine Charles, and Juliane Stiller. 2015. "Selecting Target Datasets for Semantic Enrichment." https://pro.europeana. eu/files/Europeana_Professional/EuropeanaTech/EuropeanaTech_taskforces/ Enrichment_Evaluation//EvaluationEnrichment_SelectingDatasets_102015.pdf

Isaac, Antoine, Valentine Charles, Yorgos Mamakis, and Juliane Stiller. 2017. "Europeana Semantic Enrichment Framework." Accessed March 25 2021. https:// docs.google.com/document/d/1JvjrWMTpMIH7WnuieNqcT0zpJAXUPo6x 4uMBjlpEx0Y/edit#heading=h.bz78ahr21sjd

Ji, Xianlin, Changru Tang, Wenjie Duan, and Ke Ning. 1998. *Dunhuang Dictionary*. Shanghai: Shanghai Lexicographical Publishing House.

Lanzhou University Library. 2013. "Dunhuangology Digital Library." Accessed March 25 2021. http://lib.lzu.edu.cn/Html/Database-cn/2008-12/26/20081226134573.html

Li, Ruiyuan, and Hongen Li. 2009. "The Exploring and Experience of the Dunhuangology Literature Dataset Construction, Using the Dunhuangology Literature Dataset of Dunhuang Academic China as Example." In *2009 Annual Conference of Professional Library Branch of Library Society of China*.

Shaanxi Normal University Press. 2016. "Dunhuangology Literature Digital Library." Accessed March 25 2021. http://dunhuang.hanjilibrary.com/

Louvre. 2021. "Louvre." Accessed March 25 2021. https://www.louvre.fr/en/

MediaWiki. 2019. "Dunhuangology." Wiktionary. Accessed May 06 2021. https:// en.wiktionary.org/wiki/Dunhuangology

Pattuelli, M. Cristina. 2012. "Personal Name Vocabularies as Linked Open Data: A Case Study of Jazz Artist Names." *Journal of Information Science* 38 (6): 558–565. doi:10.1177/0165551512455989

Peking University Library. 2017. "The Metadata Standard Draft of Cultural Relics Digital Protection." Accessed March 25 2021. https://www.lib.pku.edu.cn/portal/ cn/news/0000001494

Retresco. 2021 "How Does Semantic Enrichment Work?" Accessed March 25 2021. https://www.retresco.de/en/encyclopedia/semantic-enrichment/

Schreibman, Susan, Ray Siemens, and John Unsworth. 2004. *A Companion to Digital Humanities*. Edited by Susan Schreibman, Ray Siemens, and John Unsworth. Malden, MA, Oxford: Blackwell. doi:10.1002/9780470999875

Sun, Junyi. 2013. "Jieba - GitHub." Accessed March 25 2021. https://github.com/ fxsjy/jieba

The British Museum. 2021. "The British Museum." Accessed March 25 2021. https:// www.britishmuseum.org/

U.S. Library of Congress, and UNESCO. 2009. "World Digital Library." Accessed March 25 2021. https://www.wdl.org/en/

UNESCO World Heritage Center. 2021. "Mogao Caves." Accessed March 25 2021. http://whc.unesco.org/en/list/440

W3C Working Group. 2008. "Best Practice Recipes for Publishing RDF Vocabularies." Accessed March 25 2021. https://www.w3.org/TR/2008/NOTE-swbp-vocab-pub-20080828/

W3C. 2012. "SKOS Simple Knowledge Organization System - home page (w3.org)". Accessed May 06 2021. https://www.w3.org/2004/02/skos/

Wang, Xiaoguang, Xu Tan, and Qingyu Duan. 2019a. "Enhancing Scholar Supportive Data: Surveying the Landscape of Information Resources for Digital Dunhuang." *Proceedings of the Association for Information Science and Technology* 56 (1): 798–800. doi:10.1002/pra2.180

Wu, Jian, Tianxiu Yu, Chunxue Wang, Xiaohong Ding, Liang Zhao, and Liang Jin. 2019. "Review of Digital Dunhuang Project." *Communications of the CCF* 9: 10–16.

Xia, Cuijuan. 2017. "The Research on the Digital Humanities Platform Construction Based on the Linked Open Resources Service." *Journal of Library and Information Science* 43 (1): 47–70. doi:10.6245/JLIS.2017.431/717

Wang Xiaoguang, Hanghang Cheng, Huinan Li, Xu Tan, Qingyu Duan. 2019b. "Chinese Dunhuang Mural Vocabulary Construction Based on Human-Machine Cooperation." In *Digital Humanities conference (DH 2019)*. https://dev.clariah.nl/files/dh2019/boa/1015.html

Zeng, Marcia Lei, and Xu Tan. 2021. "Semantic Enrichment of Data – Interpreting the New Trend of LAM Data in Supporting Digital Humanities." *Digital Humanities Research (China)* 2021 (1): 64–72

Zeng, Marcia Lei. 2017. "Smart Data for Digital Humanities." *Journal of Data and Information Science* 2 (1): 1–12. doi:10.1515/jdis-2017-0001

Zeng, Marcia Lei. 2019. "Semantic Enrichment for Enhancing LAM Data and Supporting Digital Humanities. Review Article." *Profesional de La Informacion* 28 (1): 1–35. doi:10.3145/epi.2019.ene.03

6 Semantic metadata enrichment and data augmentation of small museum collections following the FAIR principles

Andreas Vlachidis, Angeliki Antoniou,
Antonis Bikakis, and Melissa Terras

Introduction

Over a decade has passed since the European Agenda for Culture (European Commission 2007) recognised digitisation as a fundamental driver for fostering cultural diversity and intercultural dialogue. National galleries, libraries, archives, museums (GLAM) institutions across Europe have undertaken initiatives for digitising major parts of their collections but the same promise of digitisation is yet to be realised by many smaller and regional organisations. In particular, south European cultural heritage institutions appear to be slower adopters of ICT (Information and Communication Technologies) compared to their northern counterparts and the reasons for such lack of uptake are complex (Peacock 2008; Gombault et al. 2016), despite the fact that heritage in such regions is rich, diverse and forms a key strategic resource for economic development (see, e.g., Bonaccorsi et al. 2007). Semantic Web technologies can significantly benefit digitised collections by disclosing information in a scalable and interoperable way, aggregating previously heterogeneous and siloed data (Benjamins et al. 2004). Particularly, in the domain of cultural heritage, such aggregations can be extremely useful for providing context over relations between persons, artefacts, works, locations etc. while also supporting information seeking activities through semantic linking, recommendation and visualisation techniques (Clough et al. 2008).

This chapter explores the role and application of semantic models on smaller cultural heritage collections for facilitating data dissemination, interlinking and augmentation and for making their collection data FAIR, namely Findable, Accessible, Interoperable and Reusable (Go-Fair.org 2020), presenting a case study on the Archaeological Museum of Tripoli to demonstrate the applicability of this approach. The task of modelling and enrichment with semantic metadata has been achieved to deliver descriptions, references and structures of artefacts within the collection, withdrawing the silo barriers of museum items and enabling interoperable, multi layered representations that can be used to deliver a variety of user experiences. We reflect on the benefits of using the Conceptual Reference Model

DOI: 10.4324/9781003131816-6

of the International Committee for Documentation of the International Council of Museums (CIDOC-CRM; Doerr 2003) aligned to the FAIR principles and present considerations of how best the sector can support such work.

The remainder of the chapter is structured as follows. In Section Background, the background and relation of the semantic technologies with FAIR data principles is discussed. In Section The Archaeological Museum of Tripoli case study, the main case study is presented, following the methodological choices of the metadata model design. The chapter concludes with observations regarding the adoption of the FAIR data principles in small heritage organisations and the benefits for semantic linking and interoperability across cultural heritage collections.

Background

The FAIR data principles

The FAIR data principles are a set of guidelines and best practices for the management of scholarly data aiming at facilitating their discovery, integration and reuse both by humans and computer agents (Wilkinson et al. 2016; Go-Fair.org 2020). They refer to different aspects of data and the processes used for its production and communication, such as format, communication protocol, usage license and provenance. They were swiftly adopted by data producers in several scientific domains, but more widely in the life and natural sciences (see (van Reisen et al. 2020) for an analysis). This is not surprising considering the volume, volatility and diversity of the data used in these domains. However, other domains, such as the humanities, also suffer from similar problems that hinder the discovery, integration and reuse of data, particularly around data-complexity such as the "ambiguity of symbols, too many persistent identifiers for the same concept, semantic drift and linguistic barriers" (Mons 2018, 3).

The FAIR data principles have also recently gained the attention of Digital Humanities scholars. For example, the PARTHENOS (2019) project (Pooling Activities, Resources and Tools for Heritage E-research Networking, Optimization and Synergies) aims at developing a "trans-humanities research infrastructure" by integrating existing infrastructures and initiatives from different disciplines such as linguistic studies, humanities, cultural heritage, history and archaeology. Project activities were designed around FAIR data principles. They include the definition of data curation and intellectual property policies and the development of guidelines, standards, methods, services and tools that enhance the discoverability, interoperability and reuse of Digital Humanities resources. Some other initiatives and studies contribute to the specification and expansion of the FAIR data principles for Digital Humanities researchers given the specific characteristics of the data in its related disciplines.

For example, several European organisations, such as the Archives Portal Europe Foundation (APEF 2019), the European Research Infrastructure for Language Resources and Technology (CLARIN 2021), the Digital Research Infrastructure for the Arts and Humanities (DARIAH 2021), the Europeana and the European Research Infrastructure for Heritage Science (E-RIHS 2020) are working together on the conformation of a heritage data reuse charter. In the mission statement of this initiative (Heritage Data Reuse Charter 2020), they recommend a new set of principles: *Reciprocity* (agreement between institutions and researchers to share content and knowledge equally with each other); *Interoperability* (data is made available in formats that facilitates its reuse); *Citability* (data and any data-driven research should be fully citable); *Openness* (data should be shared under an open license whenever possible); *Stewardship* (attention should be paid to the long-term preservation, accessibility and legibility of cultural heritage data) and *Trustworthiness* (the provenance of data should be clear and openly available).

The Dutch knowledge centre for digital heritage and culture (DEN), has also published a similar set of minimal requirements along with associated guidelines, principles, policies, references and roadmaps for digitisation of cultural heritage, focusing on six areas of attention: Rights Management, Findability, Creation, Presentation, Digital Sustainability/Preservation and Description. These map onto the FAIR principles, although expand certain details and implementation, showing how they must be discussed in relation to particular domains. In a recent study, Koster et al. (2018) reviewed the FAIR data principles and other similar initiatives focusing on the reuse of Digital Humanities data, making a distinction between objects, object metadata and metadata records and proposing a roadmap for implementing the principles in libraries, archives, museums (LAM) collections. More recently, Barbuti (2020) argued that more emphasis should be put on the reusability of data in digital cultural heritage, and suggested an extension of the R element with four more requirements: Readability, Relevance, Reliability and Resilience. He also demonstrated how these principles were applied to the design of three digital libraries in the context of the Terra delle Gravine (2017) project. The adoption, specification and implementation of the FAIR data principles in Digital Humanities have also been the focus of some recent new conferences such as FAIR Heritage or among the main topics of interest of some bigger conferences such as the CIDOC conference (CIDOC 2018).

Using semantic technologies to implement the FAIR data principles

With regard to the application of the FAIR data principles in practice, most current approaches rely on the use of semantic technologies such as the Resource Description Framework (RDF) data model, the SPARQL Protocol and RDF Query Language (SPARQL), ontologies encoded in the

Web Ontology Language (OWL) and Linked Data vocabularies (for an overview of these technologies, see Vassalo and Felicetti (2020)). RDF is a W3C standard specification (W3C 2015) for the conceptual description of data as triples that express relations of data in the form of object-predicate-subject statements (e.g., statue – is made of – marble). Rich data structures expressed in form of triples can be stored in specialised databases known as triple-stores that enable data interrogation using SPARQL, which is the standard language for retrieving and manipulating RDF data. OWL, another W3C standard, is a family of knowledge representation languages for authoring ontologies, namely "explicit formal specifications of the terms in a domain and the relations among them" (Gruber 1993, 199) that aim at providing a shared conceptualisation and understanding of common domains between different communities. OWL ontologies can be processed by computer programs (called reasoners) to verify their consistency and to compute inferred knowledge. Linked Data is a collection of open interrelated structured datasets on the Web, which are formatted in the RDF and follow some standard principles (Berners-Lee 2020).

The adoption of semantic technologies to implement the FAIR data principles is not a surprise, as the design principles of Linked Data are to a large extent in line with those of FAIR data. The first Linked Data principle is to use URIs (Universal Resource Identifiers) to name web resources. This can be seen as a way to implement the first principle of FAIR data, according to which "(meta)data are assigned a globally unique and persistent identifier" (Go-Fair.org 2020). The second Linked Data principle, which is to use HTTP URIs so that people can look up those names, is in line with the first accessibility principle of FAIR data, according to which data and metadata "should be retrievable via a standardised communication protocol" (Go-Fair.org 2020). The third Linked Data principle is that when someone looks up a URI, some relevant useful information should be provided. This can be seen as a way to implement the FAIR data principles, according to which data should be described with rich metadata, using a formal, accessible, shared and broadly applicable language for knowledge representation. Formal models such as ontologies can guarantee the use of well-defined and interoperable knowledge representations that carry definitions and conceptual arrangements of entities and relationships to describe a domain or a resource. The fourth Linked Data principle is that data should include links to other URIs so that users can discover more things (by following such links). This can be seen as a way to implement the third interoperability principle, according to which (meta)data should "include qualified references to other (meta)data" (Go-Fair.org 2020).

In contrast with FAIR principles, the Linked Data principles refer to specific technologies with which the principles can be implemented (URIs, RDF, SPARQL). They can, therefore, serve as a good starting point for

making data FAIR. The implementation of the remaining FAIR principles requires some further steps. Most of them, however, point to the use of ontologies such as the second principle of interoperability I2 where "(meta) data use vocabularies that follow FAIR principles" and the first principle of reusability R1 where "meta(data) have a plurality of accurate and relevant attributes".

Following the last reusability principle, which recommends that "(meta)data meet domain relevant community standards" (Go-Fair.org 2020), most Digital Humanities projects using semantic technologies to implement the FAIR data principles rely on the use of standard ontologies, such as CIDOC-CRM and the Simple Knowledge Organization System (SKOS). CIDOC-CRM a well-established ISO standard (ISO 21127 2006) for the modelling of cultural heritage information (Doerr 2003). The model provides an extensible semantic framework of real-world entities such as Events, Types, Appellations, Actors, Places, Physical and Conceptual objects and others that any cultural heritage information can be mapped to. The model can be applied to traditional relational database implementations as well as to contemporary semantic web frameworks such as RDF and OWL. SKOS is a W3C standard for representing the semantics of structured vocabularies, such as thesauri, classification schemes, taxonomies, subject-heading systems, enabling publication of such vocabularies as Linked Data, defining classes and properties to represent common features like preferred labels, synonym, broader, narrower terms relations and others (Miles and Bechhofer 2009). This additional layer of concepts enables the typological specification of individual items, which cannot be achieved solely by the semantics of CIDOC-CRM and other ontologies.

For example, the Virtual Research Environment in Southeast Europe and the Eastern Mediterranean (VI-SEEM 2018; Vassallo and Felicetti, 2020) project develops an integrated research infrastructure for scientific communities in life sciences, climate science and digital cultural heritage following the FAIR data principles, based on CIDOC-CRM and its extensions, CRMsci and CRMdig. The project identifies CIDOC-CRM as the ideal knowledge representation and communication framework to address the requirements of the proposed infrastructure. It aims to: enable access and retrieval of various digital resources from different domains; enable interoperability among heterogeneous data; trace the provenance of data and to facilitate its interpretation and reuse. In the same paper, the approach is demonstrated using two case studies, in which datasets from different research domains, described according to different metadata formats, were mapped to CIDOC-CRM. This has enabled both a richer description of the available resources and interoperability between the different datasets.

The Advanced Research Infrastructure for Archaeological Dataset Networking in Europe (ARIADNE 2017) has a similar aim: to develop an

integrated research infrastructure for archaeology by integrating existing infrastructures, services and datasets. In order to achieve this, the project developed the ARIADNE Catalogue Data Model (ADCM), which is used to describe all available services, language and data resources from different project partners. Furthermore, the mapping of ADCM to CIDOC-CRM allowed the reuse of such resources in other fields of Digital Humanities, improving their discoverability and interoperability (Aloia et al. 2017). In the same domain, De Haas and van Leusen (2020) recently proposed the adoption of CIDOC-CRM as the standard ontology for archaeological research, as a means for implementing the reusability principles. They also proposed a domain-specific extension of CIDOC-CRM, which meets the specific data modelling needs of archaeology and described their work towards standardising the proposed extension. In the field of historical research, Beretta (2020) argues that the application of the FAIR data principles requires the development and use of a standard ontology and proposes adopting CIDOC-CRM as the core ontology for this domain, in combination with two other foundational ontologies, C.DnS (*Constructive Descriptions and Situation*; Gangemi et al. 2008) and DOLCE (*Descriptive Ontology for Linguistic and Cognitive Engineering*; Gangemi et al. 2002). Recently, the Science Museum Group's Heritage Connector project, a foundational project of the UK's *Towards a National Collection* initiative, aims to semantically link collections metadata using a variety of approaches to automatically establish cross-references between major heritage collections, looking also at how the outputs can be best shared (Lewis and Stack 2020).

Adoption of the FAIR data principles by cultural institutions

Having identified the potential benefits of FAIR data and their role in promoting and facilitating research, several GLAM institutions are working on making their collections FAIR. Some notable examples are the Rijksmuseum, British Library, Yale Center for British Art and the Wellcome Collection. They have all made part or all of their collections and the associated metadata publicly available, either as direct downloads or via APIs, relying in most cases on semantic technologies and standard ontologies. A comprehensive list of institutions that make their digital resources and metadata openly available using APIs is available at the "Museums and the machine-processable web" online forum (Museum-API 2015). However, there are very few examples of small institutions represented there. An obvious reason for this is that most small institutions have not digitised their collections, so do not have anything that they can share online.

According to a Europeana white paper (Nauta et al. 2017), 78% of European heritage has not been digitised and only 58% of the digitised content is available online, while a very small percentage of it (3%) can be accessed for reuse. In recent years, the GLAM sector has received support

from national and regional initiatives to develop digital capacity. In the UK, programmes such as the Digital Skill for Heritage (DSfH) and the Digital Heritage Lab have been designed to support digital capabilities and to raise digital skill sets of small and medium size cultural heritage organisations. However, the COVID-19 pandemic has revealed the clear disparity across GLAM organisations with 40% of the UK museums during lockdown lacking any digital access to their collections (Finnis and Kennedy 2020). The main challenges that cultural institutions face for making their collections open remain and include: extra time, effort and costs required for the digitisation of their collections, their proper documentation and rights clearance; technical challenges; lack of metadata for their collections and lack of relevant skills among their staff (Estermann 2015).

These challenges are more common in small and medium-sized institutions. The same study also identified some risks for these museums, the most common being the reuse of their content without proper attribution to the institution or creator and the misuse or mis-representation of content and copyright infringements by third parties. On the other hand, according to the same study, the majority of cultural institutions identify that opening up their collections will provide benefits including raising the visibility or perceived relevance of the institution, improving the discoverability of their holdings, extending their audiences, facilitating networking with other cultural institutions, encouraging interactions with their audiences and more generally, it will allow them to better fulfil their mission.

Thus, despite the potential risks, small and medium-sized cultural institutions seem to identify the benefits of adopting the FAIR data principles and want to follow the larger ones in making their collections and metadata FAIR. Semantic technologies and Linked Data design guidelines seem to be the most promising way for achieving this goal, as they open up the potential for interoperability and discoverability of the objects within these collections. In the next part of this chapter, we demonstrate an approach for making the collection of a small museum FAIR using semantic technologies. We focus on the Archaeological Museum of Tripoli, an example of a small and not well-known, peripheral archaeological museum with low visitor numbers and limited digital presence, but with a unique collection of regional antiquities.

The archaeological museum of Tripoli case study

Overview of the case study

The Archaeological Museum of Tripoli houses around 7,000 items, covering a large period of Peloponnese regional history. Its holdings provide a rich collection from various local excavations of Ancient Greek sanctuaries, cemeteries, residential areas and Roman villas. Despite this important collection, this small museum has very low numbers of physical visitors and

is not popular with locals and tourists. The museum participated as a pilot case in the EU Horizon 2020 CrossCult project which aimed at facilitating interconnections between different pieces of cultural heritage information, public viewpoints and physical venues by taking advantage of the advances of digital technologies, particularly focused on the aspects of interactivity, recollection and reflection (Lykourentzou et al. 2016). The pilot case offered non-typical, crosscutting and transversal viewings of the museum items, in order to allow the visitors to go beyond the typical level of history presentation (e.g., type of a statue or its construction date), into deeper levels of reflection, over social aspects of life in antiquity and its power structures. Prior to joining CrossCult, the museum did not use any technologies to assist its visitors and its collection was not exposed in any digital media. In addition, inside the museum, all object related information was presented to the visitors with old-fashioned labels.

The museum of Tripoli is not unique in its traditional, non-digital practices. There are thousands of small- and medium-sized museums across Europe that house important collections, but have a very limited or even a non-existent digital presence, with a variety of factors that can cause this. Lack of budget, limited human resources, slow technology acceptance, organisational attitudes and bureaucracy associated with decision-making in public institutions (Gombault et al. 2016), but also the geographical location of the museum, the museum type and reasons internal to the organisation such as leadership (Bonaccorsi, et al., 2007; Peacock, 2008) can provide hindrances for fulfilling the potential of digitisation and receiving the benefits of an effective adoption of ICT. Similar obstacles in the provision of interoperable online access to archival holdings and metadata have been reported by a comparative survey of the views of archivists from Croatian, Finnish and Swedish archive (Tanacković Faletar et al. 2017). Following discussions with the Tripoli museum, we discovered there were a number of hindrances for fulfilling their potential via digitisation, including general negative attitudes towards the use of technology within an archaeological museum, believing that the visitors' attention will shift to the technology rather than the exhibits and general fear of the unknown.

In addition, numerous bureaucracy procedures, e.g., the requirement of multiple licences, seem to delay processes. Furthermore, Greek IPR law does not easily permit the use of images of archaeological items and time-consuming procedures need to be followed to obtain licences. Finally, there is the wider recognised issue of a lack of understanding and communication between humanities and computing experts, which can be traced to their training: specialists from both domains seem to face difficulties in communicating, creating obstacles (Terras 2012). However, technology can help such institutions emerge from isolation and attract many new visitors. Innovative and engaging apps to present museum content, social media activity and games could be all employed to revive such a traditional space (Antoniou et al. 2019; Kontiza et al. 2020).

We selected a total of 36 Archaeological Museum of Tripoli items, following consultation with the museum director. These items were representative of different art styles, eras, functions and all had a very high historical value. Seven topics were also identified common to these 36 items, all related to women in antiquity: "social status", "appearance", "mortality and immortality", "daily life", "education", "names-animals-myths" and "religion and rituals". Reflection upon history was at the heart of the project, and the identified topics aimed at increasing engagement and historical re-interpretation.

The 36 museum items were digitised and a simple set of metadata was created for each of them by museum personnel who photographed the items. The set contained elements about the title, type, period and other relevant information about the items. This early set constituted the foundation upon which the FAIR metadata model was designed as discussed in sections below. In addition, the information related to the items was significantly enhanced, since each item was associated with a number of narratives. Narratives were also accompanied with numerous digital objects, like related images (usually from similar objects in other museum collections), videos (e.g., documentaries, clips from European cinema etc.), games (specially created games to enhance the museum objects and engage visitors further) etc. Thus, not only were the museum items digitised, but the digital content of the museum was augmented with the addition of multimedia items and narratives. This allowed a broad range of digital activities to be built upon the digitised collection.

Pre-processing the collection

When dealing with a traditional small museum collection which has undertaken limited digitisation, it is important to assess the state of available data in terms of existing format, structure and volume. This will help understanding the current state and coverage of data, the availability of any associated metadata, and to identify appropriate methods and tools for data cleaning required prior to metadata assignment. In the case of the Tripoli museum, available digital data and metadata was extremely limited and sparse. The majority of museum artefacts enjoyed unstructured data in the form of short descriptions, e.g.;

> **2279**: *Marble pediment tombstone with a representation of a family (enface). The female figure bears a chiton and a cloak. The male figure and the boy bear a short chiton. On the architrave there is the inscription ΑΝΤΙΟΧΙC ΦΟΡΤΟΥΝΑΤΟΥ*

> *ΘΥΓΑΤΗΡ ΚΑΛΛΙΣΤΗ. Found in Herod Atticus villa in Loukou, Kynouria. Roman era work (middle Antonine era, 161 A.D - 180 A.D.). Dimensions: Height 1.60m, Width 0.82m. Location: Room 15, 1st floor.*

The descriptions contained concise but rich information about the object in terms of: a physical and structural properties (size, material, type etc.); b descriptive attributes and symbols (inscriptions, representations); c related facts and events (place of excavation, period) and d curation related (location, category). The size and level of description was consistent across museum items. This, then, could be used to generate metadata descriptions in line with the CIDOC-CRM semantics, including e.g., elements of type, identifier, location, dimension and other as discussed in the Metadata Model section below.

Delivering structured metadata from unstructured descriptions is a challenging task that requires human intellectual effort or employment of sophisticated techniques for automatic metadata generation. The size of the collection (36 artefacts) did not justify the development of a Natural Language Processing (NLP) application for automatic extraction of information and generation of metadata. Instead, a manual process was followed to identify and extract relevant information from the descriptions in order to produce semantic metadata. Arguably, it would be inefficient to attempt a manual process on a larger collection when automated information extraction approaches have been used with relative success in the semantic indexing and automatic metadata generation with respect to CIDOC-CRM semantics (Vlachidis and Tudhope 2016).

The manual extraction task focused on identifying entities of interest that would support information retrieval, cross-searching and discovery across the collections participating in the CrossCult infrastructure (Lykourentzou et al. 2016). It included mentions of exhibit type, related material, temporal, spatial information, dimensions and other features such as inscriptions or visual representations. The major benefit of the manual process was the accuracy of metadata, which was ensured through a peer-review process which involved humanities experts and a research associate. The process involved review of annotated documents for identifying the individual metadata elements and a subsequent process that delivered structured metadata from the unstructured annotated text. The structured output organised the extracted information (metadata) into a machine-processable format (i.e., XML).

The intermediate (pre-processing) step is necessary before the final delivery of metadata in a semantic web serialisation for the following reasons. Firstly, it enables an agile development of a database for holding and reviewing the extracted values by initially hiding the finer semantics of the conceptual model. This is particularly beneficial for communicating the focus of the task to non-technical experts with no background of semantic metadata and conceptual models. Secondly, it decouples the process of storing data from aligning the data to the conceptual model. This provides flexibility to explore the finer semantics of the model and to implement diverse mappings and relationships from the original extracts as illustrated in Figure 6.1 And finally, it supports automation of data cleaning tasks that correct and

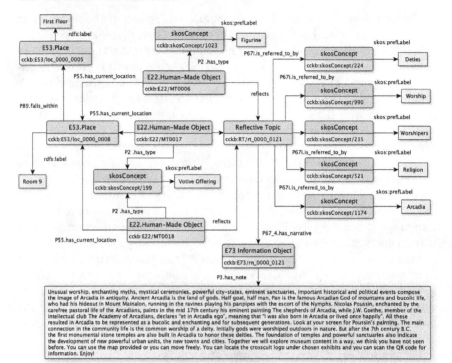

Figure 6.1 Semantic relationships of co-located museum exhibits in room 9 (Archaeological Museum of Tripoli).

standardise variations of data (e.g., labels of periods and units), data wrangling tasks that transform data to different serialisations (e.g., from XML to RDF), and enrichment techniques such as those discussed in section *Semantic Enrichment and Augmentation*.

Modelling the collection

The data modelling process had its own challenges. The first was the selection of the underlying ontology. Despite its growing popularity in the Cultural Heritage domain and its rich expressive capabilities, CIDOC-CRM was not the obvious choice to everyone. Researchers from CrossCult with an Information Science background preferred solutions based on taxonomies, classification systems or simpler metadata schemas (e.g., Dublin Core), while software developers found CIDOC-CRM unnecessary complicated and verbose for the needs of the services and applications that they wanted to develop. The adoption of the model came after careful consideration of the importance of modelling the relationships between the different cultural heritage resources of the museum, the need for semantically linking such resources with the collections of other cultural

heritage venues, and the FAIR principle for the use of "domain-relevant community standards".

In order to facilitate semantic data interoperability and to enable discovery, integration and reuse, we aligned the data of the museum collection to the upper-level ontology of the CrossCult project (Vlachidis et al. 2017). The upper-level ontology implements a core-subset of CIDOC-CRM semantics, which is supplemented with project-specific extensions that handle entities and properties on reflections and narratives. The upper-level ontology maintains full compatibility with CIDOC-CRM containing the least minimum set of CRM concepts, ensuring reusable and interoperable qualities of the data. The data of the 36 museum items were aligned to the classes of the upper-level ontology.

At the core of the model resides the CIDOC-CRM entity *E18 Physical Item*, which comprises all persistent physical items with a relatively stable form, human made or natural. The entity enables the representation of a vast range of items of interest, such as museum exhibits, gallery paintings, artefacts and monuments while providing extensions to specialised definitions for human made objects, physical objects and physical features. The well-defined semantics enable the description of static parameters of a museum item, such as dimension, unique identifier, title and type and allow for rendering rich relationships between the physical item and entities describing the item in terms of ownership, production, location and other conceptual associations.

Another critical challenge is related to the population of the ontology with appropriate individuals and statements describing the available cultural heritage resources. Mapping the terms used by historians in the original descriptions of the resources and the elements of the ontology was not straightforward. Reaching a common understanding of the precise meaning of the original descriptions and determining their mappings to the ontology required extensive communication between ontology experts and historians. By focusing on a representative sample from the museum collection and the collections of the other venues that participated in CrossCult, we developed semi-automatic processes, which could then be re-used for all the available data. The different backgrounds of the experts who were involved in the development of the CrossCult Classification Scheme (information scientists, historians and museum experts) brought two more challenges to the project: how to determine the scope of the vocabulary and how to come up with a commonly agreed structure. Two decisions that helped us address such challenges were: (i) to rely as much as possible to standard external vocabularies such as the Arts and Architecture thesaurus; (ii) to setup and use an online environment for collaborative development and management of vocabularies, thesauri and taxonomies. Among others, the environment enables discussions on the terms and structure of the ontology, linking the vocabulary to external terms and creating RDF descriptions of the vocabulary.

The entity *E22.Human-made Object*, which is a specialisation of the *E18. Physical Item* was selected as the key component for holding together the range of properties that specify a museum item. In detail, the information of the museum item "2279", as shown in the respective description, was aligned to the following properties of an *E22.Human-made Object*:

- *P1_is_identified_by* > *E42.Identifier* "2979"
- *P2_has_type* > *E55.Type* "Tombstone"
- *P3_has_note* "the original textual description"
- 2x *P43_has_dimension* -> *E54.Dimension* "height 1.60m" and "width 0.82m"
- *P45_consists_of* > *E55.Type* "Marble"
- *P50_has_current_keeper* > *E40.Legal Body* "The Archaeological Museum of Tripoli"
- *P55.has_current_location* > *E53 Place* "Room 15"
- *P102.has_title* > "Antiohis pediment tombstone"
- *P138i.has_represenation* > *E38.Image* "antiohis.jpg".

The CIDOC-CRM is a high-level model of concepts and relationships not tied to any particular vocabulary to describe types or ontology individuals. This level of abstraction, albeit very useful for the applicability of the model across the semantic requirements of the broader cultural heritage domain, does not cover the need for finer type specifications. For example, a *E22. Human-made Object* can have the particular type "Tombstone" which is a concept originating from a thesaurus structure. The relationships of the thesaurus structure can be further explored for revealing connections between items (i.e., CIDOC-CRM instances) as illustrated in Figure 6.2 and discussed by the scenario 2 "Connections across museums" in section *Interoperable Output and Retrieval*. Vlachidis et al. (2018b) discuss the details of the creation of the CrossCult knowledge base which aggregates a set of thesauri resources and the CIDOC Conceptual Reference Model.

The majority of the vocabulary terms originate from three external resources: the Arts and Architecture Thesaurus of Getty (AAT), the EuroVoc multilingual thesaurus and the Library of Congress Subject Authorities (LC) vocabulary. Vocabulary entries originating from these resources were arranged in a hierarchical terminological structure, called the CrossCult Classification Scheme (CCCS), providing a controlled vocabulary for specifying types, subjects and appellations. For example, the museum item titled "Antiohis pediment tombstone" has the type "tombstone", which is identified by the internal CrossCult reference "943" and links to the AAT term "tombstones (sepulchral monuments)". The model was also compensated by Dublin Core elements to support references to digital resources such as images and audio-visual media. For example, the *E38.Image* "antiohis.jpg" is assigned a *dc:source* that resolves to the actual web location of the image.

Figure 6.2 Connections across museums based on the concept of religious activities.

It is worth noting that the model supports chains of relationships to describe finer semantics beyond simple subject–predicate–object expressions. The metadata information about the dimensions of a museum item can be elaborated in expressions that define units, actual values and type. For example, an E54.Dimension P2_has_type E55.Type (height), P91_has_ unit (cm) and P90_has_value (160). Such relationships can be explored at the discovery layer to enable sophisticated retrieval and complex data aggregation as discussed below. In addition, the museum item ingests subject metadata from the CCCS, which add to its description, enhancing its retrieval capacity. For example, the subject "Roman (culture or period)" is used to describe the item in addition to "tombstone" and "marble" that were used to describe its type and material, respectively.

Semantic enrichment and augmentation

A semantic enrichment and data augmentation phase succeeded the data modelling. A key contribution of the CrossCult data-modelling phase, beyond the data alignment to CIDOC-CRM, was the definition and

specification of the classes and properties responsible for handling the semantics around historic reflection and interpretation. The CrossCult project aimed at spurring a change in the way European citizens appraise history by facilitating interconnections among pieces of cultural heritage information that have cross-cultural, cross border, cross-religion and cross-gender qualities. Central to this endeavour, from a data modelling perspective, was the definition of the *Reflective Topic* entity, which enables the creation of a network of points of view, aiding reflection and prospective interpretation, enabling interconnection between physical or conceptual objects of handmade or natural origin (Vlachidis et al. 2018b). The *Reflective Topic* can be understood as an extension of the CIDOC CRM *E89.Propositional Object* entity, extended with the project-specific property *reflects* (and its inverse property, *is reflected by*). The Tripoli museum item "2979 (Antiohis pediment tombstone)" was set as the primary subject of reflection for the topics "social status", "daily life", "name-animals-myths" and "appearance".

Reflective topics are abstract propositions that take the form of a keyword or a short phrase. Necessary for their contextualisation is the creation of associated narratives: short stories authored by historians and social scientists. These contextualise a reflection topic with inspiring viewpoints and facts around a particular artefact or a broader collection of exhibits, aiding reflection and re-interpretation by storytelling. For example, the following reflective narrative was used to interweave the museum item "2979 (Antiohis pediment tombstone)" with the reflective topic instance "Daily Life: Middle Class Family".

> A family is represented in this Roman time tombstone found in the amazing Herod Atticus Villa. You can access a video about this unique villa by the Arcadian coast and the excavations [there], as well as a map to take you [there]. Look at the family here. This is the basis of ancient society. Marriage is a very important institution in this ancient society. Only children born inside a marriage can have citizenship. It is unthinkable for a woman to be pregnant outside marriage. There are strict controls for the behaviour of women, since respectable women should stay indoors, should not have contact with males other than her family members and they are usually married at a young age. This is a reassurance to a man that the children he raises are his. This is the time before DNA testing and men worry about the paternity of their children. This is what Telemachus answers to the disguised Athena, when she asks about his parents, in Homer's Odyssey: "My mother certainly says I am Odysseus' son; but for myself I cannot tell. It's a wise child that knows its own father".

The reflective topic instance "Daily Life: Middle Class Family" was related via the CIDOC CRM property *P67i is referred* (inverse property of *P67 refers to*) to a number of subject keywords from the CCCS, such as

"Married Man", "Married Woman", "Marriage" and "Family". Moreover, the reflective narrative is further enriched with links to DBpedia concepts (crowd sourced structured content from the information created in various Wikimedia projects) following a Named Entity Recognition and Linking process (NERL). The process entails the automatic recognition of entities such a persons, places, historic periods etc. and their linking to definitions in the Web (i.e., Linked Data resources). This was achieved using the DBpedia Spotlight tool (Mendes et al. 2011), which automatically recognises mentions of DBpedia resources in natural language text of the target document, following a match and disambiguate process that links unstructured information sources to the Linked Data cloud. The process increased the semantic interoperable properties of the narratives by adding an additional layer of subject heading semantics. For example, the above reflective narrative was linked to the following DBpedia concepts and topics: "Arcadia", "Athena", "Family", "Roman Empire", "Citizenship", "Herodes Atticus", "Ancient History", "Headstone", "Homer", "Odyssey", "Telemachus", "Paternity (law)" and "Marriage in ancient Rome". The NERL process managed to automatically expand the original metadata coverage and to provide a new set of concepts for facilitating retrieval and reuse of the reflective narrative resource and the associated museum item. This benefited the discoverability and cross-linking quality of the item enabling retrieval and interconnection across museum collections, as discussed below.

Interoperable output and retrieval

The semantic metadata was accommodated by the CrossCult Knowledge Base (hereafter CCKB), which provided the framework for facilitating storage, reasoning and retrieval across the disparate museum collections that participated in CrossCult (Vlachidis et al. 2017). Based on a data ingestion process, the metadata was imported in the knowledge base for immediate use or storage. The ingestion covered the whole range of metadata of the 36 museum items, including structure, reference, description, relation to reflective topics and linking to DBpedia entities. DBpedia contains structured information extracted from Wikipedia articles which it makes freely available using Semantic Web and Linked Data standards. The creation of XML Schema Definition (XSD) was necessary for providing consistency to the automated data ingestion process by providing formal description of the elements and structure of the XML documents, which were used as the intermediate data format for mediating the transition of semi-structured data formats to the final OWL output. The resulting OWL statements consisted of class assertions, property assertions and named individual declarations. The final version of the unified OWL structure for 36 items of the Tripoli museum collection, including relevant reflective topics and narratives, contained in total 18,184 axioms and 3,491 ontology individuals of museum items, CCCS vocabulary entries and DBpedia references. Our final

data is made available (following FAIR guidelines) for others to access and reuse (Vlachidis et al. 2018c).

The semantic metadata can facilitate information retrieval and association discovery between museum items stored in the CCKB. The CCKB has been deployed as a triple store and the retrieval scenarios were executed using SPARQL queries. The scenarios demonstrate the capacity of the metadata model to support complex associative queries. The effectiveness of the model has been explored through the project pilot "One venue, non-typical transversal connections" but it has not been formally evaluated using standard information retrieval evaluation metrics. The details of the queries and their results are available in the CrossCult project deliverable D2.4 (Vlachidis et al. 2018a). The following sections discuss particular scenarios that demonstrate the advantages of using metadata semantics for retrieving information and revealing connections, which can leverage serendipity, stimulate curiosity and foster reflection. The examples unfold two separate information seeking and association discovery scenarios. The first scenario promotes the discovery of museum exhibits that are co-located in the same room and have a common reflective topic. The second scenario expands from the first to reveal cross-collection connections by discovering museum items that belong to different museums and share a common reflective topic.

In the first scenario, a user walks into the Archaeological Museum of Tripoli and wishes to find objects relating to a common reflective topic. In total, 15 separate reflective topics are associated with the items in the room, linking to concepts such as "Life events", "Hair styles", "Public education", "Deities", "Social class", "Worship", "Immortality" etc. The user makes the choice to retrieve items and narratives relating to the topic of "Worship". Three museum items are returned (we use here their item IDs): *MT0006* (a figurine of a woman wearing a veil), *MT0017* (bronze object – votive offering, probable earing) and *MT0018* (bronze object – votive offering, bracelet). The items *reflect* the reflective topic *rt_0000_0121*, which is about "Religion" and "Rituals". As shown in the diagram in Figure 6.1 below, all three items are located in the Room 9 and reflect the same reflective topic, which is referred by the CCCS concepts "Deities", "Worship", "Worshipers", "Religion" and "Arcadia". The reflective topic has a narrative, which is about worship and community life of Arcadia in antiquity.

The reflective topics in the CCKB can be composed by others, e.g., books are composed by chapters, which in turn can be composed by sections. The scenario presents the relation of three museum items to a reflective topic, which can be unfolded to a further composition of reflective topics. The reflective topic *rt_0000_0121* is composed of the reflective topics *rt_0000_0136*, *rt_0000_0137*, and *rt_0000_0146*, which are reflected in the museum items *MT0017*, *MT0018* and *MT0006*, respectively. Each reflective topic carries (has) a narrative, which presents a story of an object around a particular topic, in this case "Worship". For example, the museum item

MT0017, is a bronze object, possibly personal jewellery, which was offered as a votive and was found in Tegea. The museum item *MT0018* is also a votive offering found in Tegea, which according to the respective narrative *rn_0000_0137* "was a very important Arcadian city, known for the temple of Alea Athena". The item *MT0006* is a clay figurine found in Mantineia, the place of prehistoric Ptolis founded by "Mantineas, the mythical grandson of Pelasgos, the first parent of Arcadians".

This rich network of narratives and items fosters a rich user experience impossible to deliver without employing the CCKB metadata semantics. The example clearly demonstrates the added value that can be brought by the knowledge base, where three museum items, which in other cases might have gone unnoticed, deliver a rich interlinked narrative that enables users to find out more about worship and ritual in antiquity, particularly linked to the area of Arcadia, Greece.

The second scenario (Figure 6.2) demonstrates the retrieval of information and related narratives of artefacts across museums connected through a common subject or topic of interest. This extends the previous scenario by retrieving items located in different venues, which relate to common or similar reflective topics. For example, a visitor of the archaeological museum of Tripoli, having experienced its narratives and items, wishes to find more items that reflect topics relating to worship, which might be located elsewhere. The item *MT0017* is a votive offering reflecting the reflective topic *rt_0000_0121*, which is about religion and rituals in ancient Greece, and relates to the topic of "Worship". By semantically expanding on the topic through its broader concept "Religious Activities", the query retrieves the item *EP0014*, which is located in the Archaeological Museum of Asklepeion in Epidaurus. The item is a votive stele of M. Iulius Apellas, reflecting the Reflective Topic *rt_0000_0087* entitled "The night inside Abaton" and relating to the topic of "Rituals". The associated narrative is about Apellas experiencing the healing ritual of spending a night in the Abaton, a dormitory for those awaiting Asklepios' advice on healing. The second scenario demonstrates how meaningful and serendipitous connections between museum items of separate venues can be achieved through reflective topic associations. In this case, a votive offering located in the Archaeological Museum of Tripoli and a votive stele located in the Archaeological Museum of Asklepieion Epidaurus, can trigger reflections around the topics of ritual and worship in the relationships between religion and healing practices in antiquity (as well as providing a means by which to compare museum holdings and collection practices).

Conclusion

The Archaeological Museum of Tripoli case study demonstrated useful lessons regarding the adoption of the FAIR data principles in small heritage organisations. Practical challenges existed, such as the unwillingness and

scepticism towards the use of technology, the cumbersome bureaucracy procedures that delay the processes of digitisation and making the data open using appropriate licences and the difficult communication between humanities and computing experts. Other challenges included selecting the data modelling approach to take, setting up standardised procedures to the population of the ontology given differences in common understandings regarding original descriptions and terminology and balancing the needs of and relationships between the cultural heritage organisation staff, digital humanities researchers and computer scientists.

Despite these initial obstacles, through the CrossCult project the Archaeological Museum of Tripoli has finally received a wealth of technological tools, such as storytelling applications, games and augmented reality. Additionally, its new social media presence has allowed digital promotion, seeing it included in museum networks, becoming more widely known to the public and attracting new visitors. Furthermore, the network of CrossCult museums and sites allowed the museum to be connected to different sites around Europe, through dedicated narratives and the data-led infrastructure we describe here. For example, the Archaeological Museum of Tripoli content was connected to the content of the National Gallery in London and also to the content of the Epidaurus Archaeological site. Both these places attract vast numbers of visitors every year. The content of the Archaeological museum of Tripoli was digitally enhanced with objects from these venues and was also advertised to the visitors of these popular places. In doing so, we demonstrate how preparing collection data to align with standardised ontologies and FAIR principles can help smaller GLAM organisations reuse and repurpose their collection data, allowing their holdings to become accessible to a wider heritage audience.

This has ramifications for other organisations in the cultural heritage sector. Moving from static digitisation of collections, and the work of aggregators of digital collections such as Europeana, we now need to move forward in discovering connections and associations between objects, collections, venues and narratives. In doing so, the semantic data approaches described here (including data cleaning, preparation, aligning with standardised ontologies and thesauri and sharing this data widely) are necessary to structure data, reveal patterns and allow rich interoperability as well as analyses. Additionally, developing robust user testing will allow us to reflect upon where these approaches can be best deployed (user testing of the outcomes of this work is described elsewhere (Dahroug et al. 2019)). Allowing collections data to be as reusable as possible will also be beneficial to organisations at a time of continued austerity in the heritage sector, ensuring that the resources put into digitisation and cataloguing of their collections can be redeployed elsewhere. This is also, then a question of efficiency, expanding ideas regarding why collections are digitised, allowing the data to become more usable and therefore sustainable. The collections effectively become

"collections as data", allowing others to manipulate, analyse and reframe them (Padilla 2018).

Following the FAIR principles ourselves, we welcome others accessing and reusing the dataset described here (Vlachidis et al. 2018c), which is available under a Creative Commons 4.0 Attribution International license. However, we also identify the need to develop discovery mechanisms for other such datasets, allowing the work undertaken in creating these rich semantic structures to be easily available for others to build upon: the fractured nature of LAM sector work in this area means there is no one clear mechanism for sharing and disseminating semantically enriched collections data. Providing such a mechanism will allow others to see the benefits, and examples, of semantic cross walking of collections, but also avoid both waste and duplication of effort, while providing opportunities for data-led innovation between and across collections.

The processes described in the present work also require resources that are not always available especially for small- and medium-sized museums when the entire collection needs to be digitised. However, the present approach allows the digitisation of a few, representative and carefully selected items that will allow the museum to enter the networked world by also keeping the cost low. The present work, with the digitisation of only 36 items, gave the museum the opportunity to enter a community of connected venues, to promote its content and attract new audiences. We do not underestimate the work and skillsets necessary to successfully adopt semantic linking, recommendation and visualisation techniques, which requires interdisciplinary working groups to successfully navigate overlapping areas of expertise. We recommend that those working in semantic technologies look to heritage collections as a rich use case for development, and an area of deployment that can lead to social good. If those in collections and museums management can understand the benefits of the creation of open, rich, shareable datasets of collections, shareable under FAIR principles, then this should lead to added support for this semantically enriched approach across the sector. At a time of increased social distancing, encouraging open sharing of detailed, structured, collections data can support many across the sector in outreach, engagement and understanding.

Bibliography

Aloia, Nicola, Franca Debole, Achille Felicetti, Ilenia Galluccio, and Maria Theodoridou. 2017. "Mapping the ARIADNE catalogue data model to CIDOC CRM: Bridging resource discovery and item level access". *SCIRES–IT– SCIentific RESearch and Information Technology* 7 (1): 1–8.

Antoniou, Angeliki, et al. 2019. "Bringing a Peripheral, Traditional Venue to the Digital Era with Targeted Narratives". *Digital Applications in Archaeology and Cultural Heritage* 14: e00111.

APEF. 2019. "Archives Portal Europe Foundation." http://www.archivespor-taleuropefoundation.eu

ARIADNE 2017. "Advanced Research Infrastructure for Archaeological Dataset Networking in Europe". https://ariadne-infrastructure.eu/ (Date accessed 27/09/2021)

Barbuti, Nicola. 2020. "Creating Digital Cultural Heritage with Open Data: From FAIR to FAIR Principles". *In Digital Libraries: The Era of Big Data and Data Science. IRCDL 2020. Communications in Computer and Information Science*, vol. 1177, edited by Michelangelo Ceci, Stefano Ferilli, Antonella Poggi, 173–181. Cham: Springer.

Benjamins, V. R., J. Contreras, M. Blázquez, J. M. Dodero, Garcia, E. Navas, F. Hernández, and C. Wert, 2004. "Cultural Heritage and the Semantic Web". In *European Semantic Web Symposium*, 433–444. Berlin: Springer.

Beretta, F., 2020. A Challenge for Historical Research: Making Data FAIR Using a Collaborative Ontology Management Environment (OntoME). *Semantic Web* 12 (2): 279–294.

Berners-Lee, Tim. 2020. "Linked Data – Design Issues". https://www.w3.org/DesignIssues/LinkedData.html

Bonaccorsi, Andrea, Lucia Piscitello, and Cristina Rossi. 2007. "Explaining the Territorial adoption of new technologies. A spatial econometric approach." *Applied Evolutionary Economics and Economic Geography*, 256.

CIDOC. 2018. "Special sessions of CIDOC CRM". http://www.cidoc2018.com/special_sessions (Date accessed 27/09/2021)

CLARIN. 2021 "European Research Infrastructure for Language Resources and Technology". https://www.clarin.eu/ (Date accessed 27/09/2021)

Clough, Paul, Jennifer Marlow, and Neil Ireson. 2008. "Enabling Semantic Access to Cultural Heritage: A Case Study of Tate Online". In Proceedings of the ECDL. Workshop on Information Access to Cultural Heritage, 978–990.

CrossCult. 2019. "Empowering Reuse of Digital Cultural Heritage in Context-aware Crosscuts of European History". https://cordis.europa.eu/project/id/693150 (Date accessed 27/09/2021)

Dahroug, Ahmed, et al. 2019. "Using Dates as Contextual Information for Personalised Cultural Heritage Experiences". *Journal of Information Science* 47 (1): 82–100. https://doi.org/10.1177%2F0165551519871823

DARIAH. 2021. "Digital Research Infrastructure for the Arts and Humanities". https://www.dariah.eu/ (Date accessed 27/09/2021)

de Haas, Tymon, and Martijn van Leusen. 2020. "FAIR Survey: Improving Documentation and Archiving Practices in Archaeological Field Survey Through CIDOC CRM". Fasti Online Documents & Research.

Doerr, Martin. 2003. "The CIDOC Conceptual Reference Module: An Ontological Approach to Semantic Interoperability of Metadata". *AI Magazine* 24 (3): 75–92.

E-RIHS. 2020. "Europeana and the European Research Infrastructure for Heritage Science". http://www.e-rihs.eu/ (Date accessed 27/09/2021)

Estermann, Beat. 2015. "Diffusion of Open Data and Crowdsourcing among Heritage Institutions. Based on data from Finland, Poland, Switzerland, and The Netherlands". *Presented at the EGPA 2015 Conference, held on 26–28 August 2015 in Toulouse, France.* http://survey.openglam.ch/publications/EGPA2015_Estermann_Diffusion_of_Open_Data_and_Crowdsourcing_among_Heritage_Institutions_20150901.pdf

European Commision. 2007. "Communication from the Commission to the European Parliament, the Council, the European Economic and Social Committee and the Committee of the Regions on a European agenda for culture in a globalizing world {SEC(2007) 570}". https://eur-lex.europa.eu/legal

Tanacković Faletar, Sanjica, Koraljka Golub, and Isto Huvila. 2017. "The Meaning of Interoperability and its Implications for Archival Institutions: Challenges and Opportunities in Croatia, Finland and Sweden." *Information Research* 22 (1): 463–482.

Finnis, Jane, and Anra Kennedy. 2020. "The Digital Transformation Agenda and GLAMs – Culture24 Findings and Outcomes. Europeana". https://pro.europeana.eu/post/the-digital-transformation-agenda-and-glams-culture24-findings-and-outcomes

Gangemi, Aldo, Nicola Guarino, Claudio Masolo, Alessandro Oltramari, and Luc Schneider. 2002. "Sweetening Ontologies with DOLCE". In *International Conference on Knowledge Engineering and Knowledge Management*, 166–181. Springer: Berlin.

Gangemi, Aldo, Lehmann Jos, and Carola Catenacci. 2008. "Norms and Plans as Unification Criteria for Social Collectives". *Autonomous Agents and Multi-Agent Systems* 17: 70–112.

Go-Fair.org. 2020. "FAIR Principles". https://www.go-fair.org/fair principles/

Gombault, Anne, Allal-Chérif Oihab, Décamps Aurélien. 2016. "ICT Adoption in Heritage Organizations: Crossing the Chasm". *Journal of Business Research* 69 (11): 5135–5140.

Gruber, Thomas R. 1993. "A Translation Approach to Portable Ontologies". *Knowledge Acquisition* 5 (2): 199–220.

Heritage Data Reuse Charter. 2020. "Mission Statement of the Heritage Data Reuse Charter". https://datacharter.hypotheses.org/mission-statement

Hyvönen, Eero. 2012. "Publishing and using cultural heritage linked data on the semantic web". *Synthesis Lectures on the Semantic Web: Theory and Technology* 2 (1): 1–159.

Kontiza, Kalliopi, et al. 2020. "On How Technology-Powered Storytelling Can Contribute to Cultural Heritage Sustainability across Multiple Venues – Evidence from the CrossCult H2020 Project" *Sustainability* 12 (4): 1666. https://doi.org/10.3390/su12041666

Koster, Lukas, and Saskia Woutersen-Windhouwer. 2018. "FAIR Principles for Library, Archive and Museum Collections: A Proposal for Standards for Reusable Collections". *Code4Lib Journal* 40. Available from: https://journal.code4lib.org/articles/13427

Lewis, Rhiannon, and John Stack. 2020. "Sidestepping the Limitations of Collection Catalogues with Machine Learning and Wikidata. Heritage Connector Blog". *Science Museum Group*, accessed March 3 2021. https://thesciencemuseum.github.io/heritageconnector/post/2020/09/23/sidestepping-the-limitations-of-collections-catalogues-with-machine-learning-and-wikidata/

Lykourentzou, Ioanna, Yannick Naudet, and Luc Vandenabeele. 2016. "Reflecting on European History with the Help of Technology: The CrossCult Project". *GCH*, 67–70. http://dx.doi.org/10.2312/gch.20161384

Mendes, Pablo N., Max Jakob, Andrés García-Silva, and Christian Bizer. 2011. "DBpedia Spotlight: Shedding Light on the Web of Documents". In *Proceedings of the 7th International Conference on Semantic Systems (I-Semantics '11)*, 1–8. New York, NY: Association for Computing Machinery. https://doi.org/10.1145/2063518.2063519

Miles, Alistair, and Sean Bechhofer. 2009 "SKOS Simple Knowledge Organization System Reference". *W3C Recommendation.* https://www.w3.org/TR/skos-reference/

Mons, Barend. 2018. *Data Stewardship for Open Science. Implementing FAIR Principles.* Boca Raton, FL: CRC Press.

Museum-API. 2015. "Helping Cultural Heritage Organisations Make Content Re-Usable; Helping Programmers Access Cultural and Historic Content Through Open Cultural Cata". http://museum-api.pbworks.com

Nauta Jan Nauta, Wietske van den Heuvel, and Stephanie Teunisse. 2017. "D4.4 Report on ENUMERATE Core Survey 4". *Europeana DSI 2- Access to Digital Resources of European Heritage.* Europeana. https://pro.europeana.eu/files/Europeana_Professional/Projects/Project_list/ENUMERATE/deliverables/DSI-2_Deliverable%20D4.4_Europeana_Report%20on%20ENUMERATE%20Core%20Survey%204.pdf

Padilla, Thomas G. 2018. "Collections as data: Implications for enclosure". *College and Research Libraries News* 79 (6): 296–300.

PARTHENOS. 2019. "Pooling Activities, Resources and Tools for Heritage E-research Networking, Optimization and Synergies". https://www.parthenos-project.eu/ (Date accessed 27/09/2021)

Peacock, Darren. 2008. "Making Ways for Change: Museums, Disruptive Technologies and Organisational Change". *Museum Management and Curatorship* 23 (4): 333–51. https://doi.org/10.1080/09647770802517324

Sauermann, L., R. Cyganiak, and Völkel, M. 2008. "Cool URIs for the Semantic Web". https://www.w3.org/TR/cooluris/

Terra delle Gravine. 2017. "Percorso Partecipato per la Progettazione Culturale." https://terradellegravineprogettazioneperlacultura.wordpress.com/il-progetto/ (Date accessed 27/09/2021)

Terras, Melissa. 2012. "Being the Other: Interdisciplinary Work in Computational Science and the Humanities". In *Collaborative Research in the Digital Humanities: A Volume in Honour of Harold Short, on the Occasion of his 65th Birthday and his Retirement*, edited by Willard McCarty, and Marilyn Deegan, 213–230. London: Routledge.

van Reisen, Mirjam, Mia Stokmans, Mariam Basajja, Antony Otieno Ong, Christine Kirkpatrick, and Barend Monshidden. 2020. "Towards the Tipping Point of FAIR Implementation". *Data Intelligence* 2 (1–2): 264–275.

Vassallo, Valentina, and Achille Felicetti. 2020. "Towards an Ontological Cross-Disciplinary Solution for Multidisciplinary Data: VI-SEEM Data Management and the FAIR principles". *International Journal of Digital Libraries.* https://doi.org/10.1007/s00799-020-00285-5

VI-SEEM. 2018. "Virtual Research Environment in Southeast Europe and the Eastern Mediterranean". https://vi-seem.eu (Date accessed 27/09/2021)

Vlachidis, Andreas, and Douglas Tudhope. 2016. "A Knowledge-based Approach to Information Extraction for Semantic Interoperability in the Archaeology Domain." *Journal of the Association for Information Science and Technology* 67 (5): 1138–52.

Vlachidis, Andreas et al. 2017. "The CrossCult Knowledge Base: A Co-inhabitant of Cultural Heritage Ontology and Vocabulary Classification". In *New Trends in Databases and Information Systems. ADBIS 2017. Communications in Computer and Information Science*, vol. 767, edited by Mārīte Kirikova et al., 353–362. Cham: Springer. https://doi.org/10.1007/978-3-319-67162-8_35

Vlachidis, Andreas et al. 2018a. "CrossCult D2. 4 Refined Digital Cultural Resource Data & Data Structure". https://www.crosscult.lu/en/resources/deliverables/

Vlachidis, Andreas et al. 2018b. "Semantic Representation and Enrichment of Cultural Heritage Information for Fostering reinterpretation and Reflection on the European history". In *Digital Cultural Heritage. Lecture Notes in Computer Science*, vol. 10605 edited by Marinos Ioannides, 91–103.Cham: Springer. https://doi.org/10.1007/978-3-319-75826-8_8

Vlachidis, Andreas, et al. 2018c. "The CrossCult Knowledge Base (Version Final, v3.8 owl) [Data set]". Zenodo. http://doi.org/10.5281/zenodo.1209325

W3C. 2015. "World Wide Web Consortium – Semantic Web Standards." https://www.w3.org/standards/semanticweb/

Wilkinson, M. Dumontier, et al. 2016. "The FAIR Guiding Principles for Scientific Data Management and Stewardship". *Scientific data* 3: 160018. https://doi.org/10.1038/sdata.2016.18

From data to knowledge

7 Digital research, the legacy of form and structure and the ResearchSpace system

Dominic Oldman

Introduction

Data is present in ever expanding digital repositories, fuelled by new digital technologies. However, these infrastructures have contributed little to advancing adequate forms of knowledge representation let alone solving problems of knowledge fragmentation, and from many perspectives have made matters worse. To many technologists this sounds counter-intuitive but the underlying forms and structures of data that technology creates to serve its needs are highly problematic. While this data can be technically linked it inherently lacks the necessary expressiveness required for progressive, diverse and inclusive knowledge processes. It relies on reduction and simplification to operate, and fails to express real world relations producing connections with limited value, inequality and built-in obsolescence. This makes the decision of subject experts to invest in it also problematic (Agar 2006). However, while textual narratives provide intellectual weight they are also inherently difficult to digitally interrelate effectively because of their semantic complexity, style and variety. Textual narrative provides qualitative richness but is difficult to relate to the wider social systems that they exist within. These narratives find it difficult to describe and relate the overarching structures and complex relationships that impact on and situate lived experience.

Research is a dialectic process in that there is a constant dynamic between sources and materials, their ongoing historical relations, analysis and explanation, and their appropriate representation, but textual narratives limit this dynamic to within their static bindings. They create stand-alone publications from which the tracing and connected growth of knowledge over time, within and across communities, is increasingly impossible, and this cries out for some type of technological framework. Equally data models and structures, and the associated mindsets of artificial categorisation that they promote and protect, are fixed and static and fail to provide an effective and sustainable framework for the evolution of knowledge crucial to challenging established histories.

DOI: 10.4324/9781003131816-7

The modern database, developed after the Second World War, was created to meet the needs of efficient business and commercial information processing. It quickly became the workhorse of general computing. Most organisations use and maintain different institutional databases and the same database systems are also used on personal desktop computers. We interact with highly visual websites and web pages, but behind them sit database information systems that orchestrate content through inert structures and provide access to various competing datasets for which we, and the companies who provide them, have little long term intellectual investment in the content. Despite the imperative behind the original design vision for databases, they have also taken up a significant role in humanities and social science research, and their terms of use have been accepted with little resistance. There has been little investment in research to find appropriate structures and forms of data capable of supporting the full dynamic of historical research to unite both experience and thought. While relatively large amounts of time and money are ploughed into new data systems, they contribute little to the overall understanding of human history evidenced by their temporality. Repurposing the database from storing customer records, supply chain information and financial transactions, without rethinking how historical patterns and real-world abstractions should be represented, means they simply repackage old data and old thinking and propagate inequality and a lack of diversity in terms of sources of valid knowledge.

This chapter explains and contextualises the Andrew W. Mellon Foundation supported ResearchSpace project at the British Museum. ResearchSpace is an open source system designed to reflect the complexities of relational and processual approaches to knowledge generation, integration, dissemination and preservation. It enables researchers, cultural heritage professionals and other community groups to empirically investigate and represent history from different contextual vantage points providing objectivity through diversity. It can construct propositions and arguments so that different explanations can be transparently synthesised, compared, rejected, reconciled and adopted. It allows transparency across research programmes providing a means of identifying progressive branches of research while delivering a knowledge base with meaningful provenance. It creates internally related data narratives at different levels of generality. However, the history behind the traditional data systems that have and are adopted by the humanities is important in understanding the ResearchSpace project and how different professional and non-professional communities can re-imagine their relationship with data to produce a diverse, contextualised and historically driven contribution to wider information infrastructures (https://www.researchspace.org).

This chapter provides a background section linking the issue of neoliberal influence in the Digital Humanities to the structure and form of data and technological approach, creating an incompatibility with progressive research methods. The second section on related research sets out a short

history of databases and their effect on data-oriented research projects, again relating this to a conflation of commercial and scholarly objectives or structures that undermine the challenge of representing meaningful historical knowledge in data to achieve intellectual sustainability. The last section provides a brief case study of the ResearchSpace system itself, concentrating on describing its methodological approach rather than individual technical functions which have preoccupied data driven Digital Humanities projects.

Background: Data to represent knowledge

One significant element of the Digital Humanities – structured data – is burdened by a commercial history which may explain concerns about neoliberal influence (Allington, Brouillette, and Golumbia 2016). A burden because while many humanities scholars have ventured into digital methods asking new questions, they are forced to adopt structures and forms derived from commercial computing imperatives that were not designed to support historical research. This problem continues because of a lack of knowledge required to engage with an essential component of data orientated systems which is dominated by a different disciplinary tradition, computer science. Computer science, among other things, studies the structure and form of data including the meta-models of different systems of data representation. Humanists often examine the structure and form of textual narrative which plays an important part in conveying meaning, thinking and plausibility. However, when it comes to "data" the humanists' concerns with structure and form evaporates. There is little attempt to critically analyse a given data structure which is not simply accepted, but ignored. The assumption is that data is data, and its reductive raw form is fixed, neutral and immutable.

This reduction, usually based on physical characteristics and identity, is incompatible with representing the complex outputs of research methods, except as a relatively narrow quantitative index. While these indexes have utility they ultimately create fragmentation and build obsolescence. Databases constrain the use of data such that it can only operate as a poorly contextualised reference, statistical dataset or finding aid, and in doing so creates inequality by what it omits, resisting progressive forms of knowledge generation and tending towards the preservation of old knowledge, rather than extending knowledge to new sources and new knowledge categories. The Digital Humanities has focused on function above the data layer, for example, the preoccupation with scholarly primitives, and as a result experiences the effects of technology commodification (Unsworth 2000).

There are two main issues with the structure and form of data in conventional database approaches. It restricts what can be represented and therefore ensures that data cannot support abstractions from the "real concrete" world. Its artificiality contributes towards its own static nature, narrowness

of representation and lack of synthesis, providing a simple referential pointer to other sources and never seeking to represent wider relations. It ignores the researcher's need to continually grow knowledge and change the focus of research as it evolves. This makes data and databases disposable resources because the resulting stunted surrogate is always inadequate beyond a narrow design brief and restricted by our understanding of what structured data is and what it can provide.

The potential of data orientated computing in research is that it could, with the correct structures and forms, remove the fragmentation of scholarship; to represent and interconnect, *inventio (investigation of materials and sources), dispositio (explanation and argument) and elocutio (appropriate representation)* which are themselves not standalone linear processes but dynamically related (Ricoeur 1995). In other words, while text can perform all three tasks – but with significant limitations – the database, by design and convention, cannot. The second issue is its conformance to instrumentation built into computer databases and associated conventions of documentation that impede the creation of "patterns and linkages of facts" and resulting perspectives (Evans 2001, 252). Despite 20th-century modernist visions of a totality of world knowledge through technology, modern data systems, both through top-down human control but also technological instrumentation, filter out essential political, social and epistemology aspects (Day 2014, 566).

This picture is not true of all computer scientists. Some have also expressed dissatisfaction with forms of data representation that serve the technology more than the user, but these have been mostly confined to the 20th century. In the current era, criticism has centred on the quality of implementation. For example, in the use of alternative structures like Linked Data, which theoretically exerts, through computer ontology, improved semantics. Here, some computer scientists have asserted the need to apply classic scientific principles. They define a research object as, "a container for a principled aggregation of resources, produced and consumed by common services and shareable within and across organisational boundaries" (Bechhofer et al. 2013, Introduction). However, this is not enough for humanities scholars because it fails to consider data beyond the mechanical empiricism of reproduction and repeatability, or confront the issue of the artificiality of representation (Bechhofer et al. 2013). The humanities researcher must spend significant capacity conforming to predetermined data systems which force them to disconnect their abstractions from the real world that they investigate (Feenberg 2005). This means that the opportunity for researchers to use computers to meaningfully synthesise and reconcile different empirically-based histories – different vantage points or perspectives – is resisted by the fallacy of a single scientific reproducible neutrality, which persists in the ideology of data systems, and "vulgar" empiricism. This is not just an issue for researchers but also organisations that hold and disseminate historical materials and sources.

Related research

*Always historicize! (*Jameson 2002, *9)*

One of the main impediments to the mass commercial uptake of the computer after the second world war was the availability of an integrated information management system. Instead of creating all the different components themselves, something not feasible for most companies, a software system was needed that integrated operational and management tools into one package making it feasible for companies to adopt (Haigh 2016, 26). The first information or database management system was created by a commercial systems engineer, Charles Bachman (https://amturing.acm.org/award_winners/bachman_1896680.cfm). Bachman created the Integrated Data Store (IDS) at a time when there was no relevant academic community, "as a practical tool, not an academic research project". It had a straightforward objective, to provide, "efficient and flexible handling of large collections of structured data [which] was the central challenge for what we would now call corporate information systems departments, and was then called business data processing" (Haigh 2016, 26). Bachman's Integrated Data Store was the forerunner of all the subsequent database systems created by companies like IBM, and the database system that many desktop users would have used in the 1980s and 1990s, namely dBASE, as well as the subsequent relational database management system which still dominates today (Dbase, based on the xbase programming language, was produced by Aston Tate and later bought by Borland, specialists in programming tools, and it competed with other systems like FoxBase, purchased by Microsoft and used with the Windows operating system). These systems were aimed at commercial supply chains and customer record keeping (the prime example given in many of the database textbooks of the time), but the need to categorise and organise information was, and is, universal.

Personal computing made database systems like dBase accessible to everyone, and some humanities researchers made use of them, but mostly as statistical tools, or digital versions of their card file systems. The database system paradigm is not just one that demands technical conformity but engenders a particular mental approach to structured categorisation contrary to natural thinking which is based on sensory experience. Eleanor Rosch, the cognitive psychologist, showed that people naturally use experience or "prototypes" to best organise things rather than abstract definitions. In contrast, "[t]he classical theory...defines categories only in terms of shared properties of the members and not in terms of the peculiarities of human understanding" (Lakoff 1990, 8). Databases, founded on this classical view of categorisation, were not designed to support processes of human abstraction but to process transactions and keep track of commodities. Their design architecture, based on the Bachman tradition, was not based on social history, but margins and costs and efficient inventory.

Constructive challenges to established structures of data (as opposed to general rejection) have been rare (Stone 1979). Manfred Thaller, a historian often cited by digital humanists, concluded that relational (SQL) databases could not provide answers to historical questions. In his detailed analysis, they lacked support for the variability or "fuzziness" of historical knowledge (Thaller 2017). The process of "data normalisation" that removes redundancy from data schemas to obtain technical efficiency in quantity, as a side effect also removed, and continues to remove, the elements necessary to address the types of questions historians needed to ask, for which Thaller gave empirical examples (Thaller 2017, 196–199). While computer scientists in the 1960s, many of which had a psychological grounding, developed new ways of looking at computers from the perspective of augmenting human skills, these have not been the focus of mainstream computing (Thaller 2017, 199). These pioneering computer scientists were interdisciplinary and transdisciplinary, actively investigating the interaction and relationship between humans and machines in complex processes. This approach has been lost to mainstream Computer Science and is largely absent from data-oriented Digital Humanities. The computer industry has provided researchers with new and innovative functions, and different ways of visualising data, but underneath the bonnet little has changed in terms of what these tools ultimately operate on, bringing many humanities researchers to the conclusion that while computers may be useful for some quantitative tasks, they are mostly ancillary and disposable. Researchers and technologists seem to agree that data is not for asking complex "why" questions, but provides scalable storage, statistical processing and, through networking and aggregation, greater access to existing sources.

Practical examples

In practical terms, these limitations, both technological and mindset can be seen in a programme of digital projects from the 1990s that have focussed on existing cultural heritage sources used by humanities researchers. These include museums, galleries, archives and libraries, which in many countries are maintained with public funding, or are the traditional custodians of sources within universities. The EU, for example, has maintained a programme of projects designed to integrate the accumulated "knowledge" of cultural heritage institutions from their previously private collection databases. The first significant EU project was Remote Access to Museum Archives (RAMA) a project initiated in 1992 involving museums such as the Musée d'Orsay in Paris, the Uffizi Museum in Florence, the Ashmolean Museum in Oxford and the Goulandris Museum of Cycladic Art in Athens (European Commision (Cordis) 1994). Its Principal Investigator, Dominique Delouis was the Director of a French telecommunications company. His objective was to provide a single interface for retrieving data and images from remote museums. It would generate a commercial service, aimed at

schools, researchers and other audiences, as well as commercial enterprises. A source of knowledge greater than the sum of its parts, and at the same time, a one-stop shop to facilitate income generation based on a single point of access to cultural heritage assets.

Delouis' reflections at the end of the project indicate why his aims were unachievable and why databases have done little in terms of progressive knowledge representation. His pronouncement was, "can one hope for the 'virtual museum'? Yes, if one holds a universalist view of the world where different contents could be moulded into identical forms. No, if one thinks that each system of representation should keep its characteristics regarding form as well as contents" (Delouis 1993, 127). This approach to data goes back to the very first data management systems which serviced commercial processes, and which informed the design of the modern database.

In reality, aggregating museum inventory systems could never create a meaningful virtual museum and didn't represent their accumulated knowledge which remains fragmented and inaccessible. It only produced a secondary reduction to the ones already created by individual institutions adopting the database paradigm for their administrative purposes. A cynical reading might suggest that the data was simply a finding aid for licensing images, an explicit focus of many subsequent projects. This rationalisation of content to promote efficient data processing and the conflation of commercial objectives with academic purposes, works against knowledge development and sustainability, meaningful data preservation and collaborative knowledge building, and even efficiency – for the reasons provided above – but is an approach adopted by many funded projects investing considerable funds but rarely providing significant results. RAMA and its successors illustrated that these new computer data systems did not reveal new insight but demonstrated that even minor differences between museum catalogues constantly trip up database software developers. Rather than researching and understanding how to accommodate the complexity of humanities knowledge in data, the technological transformation from above simply repackaged old data and forms. Useful in the sense of improved technical access, but bypassing the deficiencies of the content itself.

We now acknowledge that the data systems that Delouis sought to integrate and transform were themselves preservations of old Empire ordering and acquisition record-keeping, activities with little interest in wider global perspectives. Many modern open data strategies host the same anachronistic and homogenised data suggesting that new technology in the modern period is about, "giving you today another version of what you had yesterday and never a different tomorrow" (Curtis 2021). Similarly, Alan Lui points to a lack of any "sense of history" in digital networks and identifies mashups of shallow fragmented information masquerading as sophisticated networks of interconnections (Liu 2011, 22). Databases and networked data avoid the meaningful relations and context required by serious scholarship

and community campaigns for greater diversity, limited by a particular *"structure and form"* statically optimised to preserve a status quo, a perfect system to document Fukuyama's end of history (Fukuyama 1989).

In this context, the open data movement's call for data reuse is bound up with this repackaging of an old commodity for use in new digital networks bypassing current social issues voiced through other mediums. The discourse of social justice is not matched by changes to back-office infrastructures. From the front office, cultural heritage organisations now engage in discussions of inequality whether race, culture or gender, but in the back-office data is divorced from this debate and is part of a perpetuated static infrastructure. Only in a computer database project could you deliver the statement made by Delouis (still replicated today) claiming at the same time to be promoting educational and scholarly aims, and not be challenged. Colonially derived record-keeping practices still have a cloak of digital invisibility created through data's reductive, hidden and deceptively innocuous state.

The trajectory of Delouis' project was clear. It collaborated with Computer Interchange of Museum Information (CIMI), a Museum Computer Network initiative, to replicate what had been produced in Libraries with Machine-Readable Cataloging (MARC) – a single standard for interchange that would lower costs and make bibliographic transactions more efficient – similar to a clearing bank system. Library systems show a particular disregard for wider knowledge and context precisely because of their proximity to it (Delouis 1995). The "stack itself offers seemingly limitless opportunities for the prepared mind to find conjunctions and synchronicities or wander productively. And yet those possible conjunctions among the books, however vast in number, are limited - not only by the size of the library... but by the catalog, by whatever ordering principle determines which books stand next to another on the shelves". Digital systems potentially provide, through a network of books, an interconnected map of world history and society, but instead we get a "tattered ruin" which keeps those networks of knowledge at arm's length (Schnapp and Battles 2014, 91). The largely unsuccessful aim was to transfer the library clearing house system of homogeneous data interchange and apply it to other aspects of cultural heritage, but perhaps because of the independent nature of other heritage organisations and the lack of resources compared to library infrastructures, this has never been enforceable, but is a constant short-sighted objective.

The data machine – H2

Data is an increasingly valuable form because it can be processed in vast quantities by global networks of computers that inject it, employing opaque algorithms, into large numbers of digital services. We see everyday evidence of old data or old forms of data, transported through new networked technology, for example, through our smart televisions and digital assistants,

mobile devices and particularly through social networks algorithms, underlying how data is controlled and distributed with no way of understanding its provenance. The "subsumptive process of the modern documentary tradition is, from a certain historical perspective, the dominant Zeitgeist of our age but one that leaves remainders, which are increasing - in not only epistemological and technical senses, but even more importantly, in political and social senses, left out of the literal counting, processing, and indexing of knowledge, technology, politics, and professional and everyday social and cultural being" (Day 2014, 566). It is the omission of these remainders in this subsumptive process that speaks to the question of a neoliberal undercurrent in the Digital Humanities, and the participation or acceptance of it. Regardless of good intentions the construction of these systems inevitably comes into contact with the legacy of commercially driven data structures – and lack of facility is not a defence.

Usually defended on the basis that researchers come to digital systems with progressive questions, many of the tools and associated data structures used to investigate these questions were not designed for the purpose. The inherent design parameters of structured data systems, and their influence on research, have not been fully appreciated (Allington, Brouillette, and Golumbia 2016). Researchers, as they might for any other method, need to pay attention to the underlying structures and forms on which their questions are pursued, rather than commission tools at a high functional level and leave these underlying data design questions to those not invested in the subject matter itself. It is this fundamental area that the Digital Humanities has consistently failed to address. Delouis set the scene for a series of global projects, including many in Europe and the United States, that repeated the same pattern, using different technologies and providing new functionality, but always glossing over the nature of data itself. This focus on function rather than subject and content has parallels in the Digital Humanities with its equally high-level concern for function through what is known as scholarly primitives (high-level academic functions), without any study of how these functions are affected by the form of content they are applied to (Oldman, Doerr, and Gradmann 2016, 266).

In software development "information hiding" refers to both the segregation of components to protect against the effects of design changes, but also to prevent the user from deviating from the prescribed parameters that might lead to greater development overheads. The same mindset that is applied to the data is extended to the user interface which becomes a tool of constraint as well as access. This is not simply about efficiency, but about control and costs. In database systems designed to fulfil specific tasks the greater the flexibility given to the user, the more involved the development of the user interface and the greater the problem of maintenance of software distributed at scale.

Just as Charles Babbage aimed to construct mechanisms with his knowledge locked in to create pre-determined processes (mechanical information

hiding) so that workers in a production line would not have to confront variables or rely on their own experience and knowledge, so his digital successors adhere to this Taylorist tradition, despite its inappropriateness for the design of a digital knowledge-oriented environment. Computer database systems are designed to scale technically, but not intellectually; however knowledge processes require the latter more than the former, which in any event has become less problematic with modern computing technology. Typically, a knowledge worker or researcher would naturally want to change the underlying model of their systems to adapt to new circumstances, processes and relationships. The greater the dependency between the data and software the less able it is in dealing with real-world abstractions and the more inappropriate it becomes as a knowledge ori- entated tool. A digital version of Taylorism. We are all aware from our daily work that dealing with the real world means that knowledge work- ers must actively find workarounds to "fixed model" systems, like the use of unstructured notes, the overloading of fields, the relaxation of valida- tion for data types and most clearly, the use of other disconnected sys- tems, which generate a much larger but hidden inefficiency compared to the business problem they were aimed at. In reality, most of our valua- ble knowledge is still represented in personal word processor documents, spreadsheets and notebooks.

This resulting inefficiency is only justifiable in the sense that it satis- fies the requirements of detached management information or regulatory requirements on which financial and organisational decisions are based. Conversely, the need for information systems that support knowledge-based processes relies on the ability to incorporate new knowledge and new catego- ries of knowledge regularly, and often spontaneously. The gap between the information system and real changing processes grows over time draining resources, constraining innovation and giving misleading organisational indicators. When this gap becomes too great either a change is made to the system, which is generally avoided if possible, or the organisation bears a greater resource overhead and manages around it with reduced capacity. This gap is directly experienced by the everyday users of the system and is invisible to those that deploy them. However, even changes to informa- tion systems are likely to focus more on function and updating technology rather than on improving the value of the underlying data. The additional function may allow knowledge workers to find more workarounds but stuck with a similarly fixed data model. In a corporate environment, legacy data- bases can be sustained for a long time, for example, banking systems, and similarly in cultural heritage organisations where collection systems have only just come under scrutiny. While these problems are also relevant to the modern business that increasingly rely on knowledge workers, they represent a significant barrier for progressing research methods in digital environments in which they can only provide a nominal role, but at great expense – financially and intellectually.

Research and general knowledge systems need to express semantics and logic and produce a "data narrative" that is responsive and effective. They need to provide a general ontological commitment, but not mechanical empiricism, and include social perspective and the ability to represent epistemology. Research is a process of abstraction from the real world, "the real concrete...the world in which we live, in all its complexity", and breaking it down into manageable parts, the "thought concrete", bearing in mind that it all belongs to one universal reality (Ollman 1990, 27). True interdisciplinary and transdisciplinary digital research is impossible if digital abstractions are not representations of the real world.

Since the real world cannot be unpacked all at once by any one person or body, different vantage points or historical perspectives are produced from different contextual starting points (Ginzburg 2014, 15). A museum may represent objects using an empirical base but they select from a set of facts and from a particular vantage point which increasingly requires wider enrichment. A museum visitor may get a different narrative from an independent tour compared to the official one, and while not incompatible, are nevertheless separated and disconnected, rather than mutually enhanced and reconciled. Cultural heritage information systems tell you more about the objects' place in the institution rather than their place in the wider world. From one perspective data projects that publish institutional data, like the one managed by Delouis, make the situation worse by transferring legacy data issues into wider networks, but from another perspective, they have made transparent the problems of the internal processes that maintain and perpetuate them. The question is now whether this realisation is confronted by reaching for the next generation of off-the-shelf technology and tweaking existing data vocabularies and standards, or whether we now aim the significant skills and experience of humanities scholars and community groups towards a critical analysis of the data structures that wash over and dilute richer representations, and radically redesign them to support the complexity of social history.

Contextualised representations that embrace variability and intellectual rigour solve issues of sustainability, value, longevity and inequality – but this is completely counter-intuitive to managers and technologists trained in efficient and scalable transactions but who dominate technical infrastructures defending the bedrock of the Babbage legacy. The tradition of professional archivists, curators and librarians, alongside their Academy counterparts is not one of simple physical characteristics, but about contextualisation – the dynamic interconnection of the physical and intellectual (Eastwood 2000). Even in commercial circles, business consultants like Peter Drucker advised against companies hanging on to modern forms of Taylorism which prevented innovation in a knowledge society – a phrase he coined. The computer systems which were developed after the two world wars to address commercial requirements never considered this intellectual element and raced to provide universal computing infrastructures targeting

managerial administration and quantitative transaction processing – not to encourage human creativity. Drucker himself separated the computer from the processes of knowledge calling computer systems, "morons", but as a result they required more intelligent operators. He never envisaged that computers would ever take up an active role in decision-making (Drucker 2012, chap. 10) However, from a business sector perspective he saw that in ignoring the shift from the physical production line to the new information and knowledge-driven economy, a great inefficiency and cost was being created in organisations (Wartzman 2014). In humanities research, this mindset also equates to a poor investment of research funds and intellectual fragmentation.

Babbage, considered by computer scientists as the founder of computing, was fascinated with Adam Smith's concept of division of labour and was concerned with reducing cost and gaining control over previously craft processes (Tinel 2013, 266). He laid the foundations for Taylor's, "scientific management", (Babbage 1971) and was interested in how technology could remove humans from sight (Schaffer 1994). He aimed to use his privileged knowledge to relegate people to the role of servicing technology rather than using technology to enhance and augment human skill. The psychologically oriented computer scientists of the 1960s challenged Babbage's approach to technology and researched on the basis that computers should enhance human intellect. Douglas Englebart's report to the Director of Information Sciences, Air Force Office of Scientific Research, Washington DC, was called, "Augmenting Human Intellect: *A Conceptual Framework*", setting out the potential of computers to help humans tackle ever greater complexity (Englebart 1962). However, much of modern data computing continues the tradition of the Babbage and Taylor vision, now in the form of machine learning that threatens a new stage of its development, never allowing true knowledge systems the space to dislodge the computers' traditional hard-coded role.

What is the complexity that modern humanities disciplines might need computers for to help them with? One answer came from historians, a discipline well known for its technological caution. In 1970, the historian Eric Hobsbawn outlined the major challenge for historians which he thought could only be answered by technology. In a conference on Historical Studies, he stated that "[t]he most serious difficulty may well be the one which leads us directly toward the history of society as a whole. It arises from the fact that class defines not a group of people in isolation, but a system of relationships, both vertical and horizontal. Thus it is a relationship of difference (or similarity) and distance, but also a qualitatively different relationship of social function, of exploitation, of dominance/subjection" (Hobsbawm 1998, 115). This system of relations at different layers marks a slow but fundamental change in progressive humanities methodologies but it is exactly this type of representation that computer systems prevent. More than 20 years later, sociologists also declared that they needed to

make a fundamental decision of "whether to conceive of the social world as consisting primarily in substances or in processes, in static 'things' or in dynamic, unfolding relations...increasingly, researchers are searching for viable analytic alternatives, approaches that...depict social reality... in dynamic, continuous, and processual terms" (Emirbayer 1997, 281). There are other examples of this new trajectory in other disciplines which need to address complexity, but to date, the provision of computer data systems with appropriate structures and forms that might address these fundamental requirements are not even on the radar of most information and computer scientists. While technologists see scholars as technologically conservative, it is the technologies offered to humanities scholars that are unsophisticated and regressive.

One of the most adventurous digital humanities projects of the 21st century was Project Bamboo, run by the University of California, Berkeley and the University of Chicago, initiated in 2008 (Dombrowski 2014). It aimed to solve the problems of previous projects and bridge the gap between humanists and technologists providing the tools that humanists "required" to address their questions and to resolve the continuing problem of fragmentation. The project spent 18 months travelling the world visiting different institutions listening to academics but with a predetermined notion of what technological frameworks were needed; ones that relied yet again on the same data structures and forms, but through a new technology architecture. They were shot down by scholars who approached the problem from the perspective (and defence) of their own knowledge systems and methods. Each new project, like Bamboo, fails to investigate the history and issues of previous ones. Bamboo's planning document included a phrase that sums up the technologists' blindness to serious historical and cultural heritage data representation. After considering the technical infrastructure and tools, which themselves had already been pre-selected from existing systems, the project reserved a paragraph revealing their approach to data. It asked the question; "[w]ho will do the data shovelling?" (Broughton and Jackson 2008, 7). There is no consideration of a need to address the limitations of traditional data structures and find a basis for academic scholarly communication in a structured form. The same data, data standards and vocabularies are preserved, but in new magical re-packaging based either on the traditional database and/or its worldview, which is transferred into the next new technology, like Linked Data (Langmead et al. 2018, 158). Project Bamboo failed to provide a solution and as a parting gesture also emphasised the importance of function over structure and form, again through the lens of "scholarly primitives", without considering the possibility and importance of combining real word abstraction, ontological commitment and human thinking. Project Bamboo rejected Linked Data as a viable technology, believing that it wouldn't technically scale. In reality, their results would have been the same regardless, indicated by their functional-technical priorities.

Case study

ResearchSpace background

The ResearchSpace project was initiated by the Andrew W. Mellon Foundation both out of frustration with, and interest in, digital humanities projects. The Foundation had set up a funding program called "Research into Technology" which operated between 2000 and 2010 working across Higher Education and Arts and Culture.[i] This programme made a significant contribution to open source higher education software developed and used across the world, and provided additional skills and experience to other Mellon programmes. In terms of scholarly communication and cultural heritage programmes, the Mellon Foundation was aware of a growing and significant problem in digital humanities research projects. They had funded a large number of digital projects allowing universities and cultural heritage organisations to build up digital data repositories, but expected to see these resources actively used and built upon by their beneficiaries. The Foundation funded particular data-driven pilot projects at different institutions that produced digital monographs – ones not easily reusable by others and lacking the qualities necessary for them to challenge traditional text-based sources or established methodologies. While the Mellon Foundation focused on the need to leverage computer networks to facilitate greater collaboration and sharing of knowledge between researchers and institutions and to provide accessibility of information to wider audiences, they were confronted with structural and organisational problems.

Each project used technical infrastructures that employed different flavours of database technology which, as argued above, didn't provide the necessary properties for the sustainable forms of scholarly communication that the Mellon Foundation sought. The projects either slotted into a traditional catalogue publishing model and were more about digitisation, or employed processes too reliant on particular software and data models which were impossible to share and build upon. While the former may have been incorporated into existing institutional catalogues and made available as static Web references, the latter was never institutionally supported beyond their external funding. Institutions were unwilling to invest in these new infrastructures. They had not bought into the Mellon's community-based vision and didn't understand the challenges and benefits of forging a different kind of collaborative paradigm in cultural heritage. Many institutions hadn't even considered the potential benefits of open source models and the concept of sharing the costs of developing mutually beneficial community software. In many organisations this represented a risk rather than an investment for the future. In the main, cultural heritage organisations

i Programme Managers, Ira Fuchs and Christopher Mackie

procure basic proprietary software which has a consistent cost and support model, and in theory a minimal impact on internal resources. However, in reality, this has meant a lack of choice, flexibility and innovation, both from the market and within the institutions themselves. It has generated a considerable hidden cost in terms of internal productivity and knowledge preservation, affecting traditional social and educational aims. A "degenerative" branch.

The progressive way forward was, and is still not, clear. The lack of cross-boundary terms of reference which fully explain the sensitivities regarding technology, clearly apparent in Project Bamboo, between the subject experts (the humanities scholars and curators) and the technologists, remains undefined. The dominance of function and efficient data processing, artificial categorisations and top-down control create apprehension, caution and disinterest in academic circles. While computers provide quantity they are not able, under traditional computing paradigms, to transfer the complexity taken for granted in textual narrative and, "situate a work within the many networks from which it gains meaning and value, and then present the results within complex visual arguments—the kind that were elaborately constructed on slide tables before being reduced to side-by-side comparisons for lectures or standard print publications" (Drucker 2013, 6).

The ResearchSpace project started life investigating one thing; the structure and form of data in digital environments. In a letter dated 25 August 2009, addressed to the Directors of the London National Museums, the Andrew W. Mellon Foundation proposed a "Shared Infrastructure". Like many digital infrastructure projects part of the rationale was to reduce costs, but not in the conventional sense. The infrastructure would aim to create intellectual and scholarly sustainability by building systems not bound to the conventions of traditional databases. It would concentrate on separating the dependency between software and information, using Linked Data as a way of representing all relevant meaning and logic. The infrastructure would allow projects with different aims to provide vantage points, authored and presented in multiple ways but which were naturally compatible, not through software or vocabularies, but true ontologies. The ontological model ensured a common framework based on reality, not artificial categorisation and escalating artificial standards. Such an approach needed a significant amount of research in its own right, funded in stages as inroads were made into understanding and solving the problem.

Design principles of ResearchSpace

Narrative is defined in the Oxford English Dictionary (OED) as, "[a]n account of a series of events, facts, etc., given in order and with the establishing of connections between them; a narration, a story, an account" (Oxford University Press 2021). Usually narrative is associated with textual, oral or visual accounts. Narrative is not usually associated with databases

that assume a referential role providing specific uncontextualised results to queries which may then be used to inform a narrative conducted elsewhere – although database content is not generally formally cited as another implication of their unsustainable form and short life. Database queries are rarely the same as the actual questions being investigated and the answer is similarly detached. Only the person making the query is aware of its potential significance concerning an investigation and a line of thinking. Understanding the context of a question is part of the systems of knowledge, but it is never divulged to the database and therefore to its community of users. It is a limited form of scholarly communication, often on purpose to protect an individualistic approach. For example, I search for a letter in a database based on a query of the sender, receiver and date, leading me to a letter that I read to only then determine its significance to the actual questions that form the basis of my research. There is no intellectual narrative in the structured data (although there may be some comments in unstructured text fields) and there is no potential for any ongoing, let alone multi-faceted, accounts. The interactions are only acknowledged at the system log level. The notion of structured data providing a narrative may seem alien, but that is the critical starting point for understanding how structured data might be re-imagined to confront the problem of providing a narrative in data. The ability to generate such a narrative and at the same time use the benefits of computers to read, support underlying processes (augment intellect), compare and traverse these patterns of data narrative, completely changes the nature of structured data environments.

In the distant past, some historians attempted to provide descriptive factual histories in the text without including an explanation, for fear of introducing subjective elements that would undermine their empirical scientific work. This type of account is commonly called a "chronicle" history. The OED defines chronicle as "[a] detailed and continuous register of events in order of time; a historical record, *esp.* one in which the facts are narrated without philosophic treatment, or any attempt at literary style" (Oxford University Press 2021). In modern scholarship these types of history, while having some historical use, generally have little benefit to ongoing scholarship and even the empirical information can be difficult to extract and understand in terms of its purpose and significance. What distinguishes historical narrative from historical chronicle is the construction of "patterns and linkages" (real processes and relations) which involve an element of judgement and imagination, but still grounded in empirical evidence (Evans 2001, 252). This process can be equated to general methodology in scientific research programmes, such as those described by Imre Lakatos, the influential philosopher of science and mathematics. According to Lakatos (summarised by Burawoy), "in a progressive program, the new belts of theory expand the empirical content of the program, not only by absorbing anomalies but by making predictions, some of which are corroborated. In a degenerating program, successive belts are only backward looking, patching up

anomalies in ad hoc fashion, by reducing the scope of the theory, or by simply barring counterexamples. In a degenerating program new theories do not anticipate new facts, and thus knowledge does not grow" (Burawoy 1990, 766).

The historian that, with others, pursues a single reality of the world and who rejects relativism, uses empirical research methods to uncover new facts. But to grow knowledge they must interpret this evidence which necessitates a selection of what they consider to be the most relevant facts and whose relations provide more than intrinsic insight (Schmidt-Glintzer, Mittag, and Rüsen 2005, 156). This provides a particular view of the world, an angle or a *vantage point*. These empirically based interpretations are a catalyst for further work and the discovery of new facts and thinking. Communities of professional humanities scholars read the latest research and contribute to it both in terms of countering facts and theories as well as developing them. In other words, the process of understanding the reality of history is dependent on an ongoing, dynamic and the collaborative scientific process of interpreting empirical evidence some of which will, through the integration and synthesis of the work of others, either be progressive, generating new investigation and evidence or be degenerative with a risk of preserving static and anachronistic knowledge. These "predictions" or interpretations through the analysis of facts are a necessary part of the process of objectivity which cannot be achieved through individual detachment but through the continual dynamic activity of community development and testing. This is not a three-year funded project, but a continuous everyday process that requires the different branches of a scientific programme to be recorded and preserved in a meaningful way, both progressive branches and the degenerative dead ends. *Therefore, digital systems that don't support this long term and ongoing scientific process are themselves part of degenerative branches and have short life-spans, or are artificially sustained and are damaging to research and the dissemination of contextual and diverse knowledge.*

While historians may come up with different conclusions, the ongoing task of research is to pursue progressive branches and deprecate degenerative ones (but maintaining the provenance) considering, comparing, reconciling and reaching new conclusions all devoted to understanding historical reality. Textual narratives even over relatively short periods are extremely difficult to synthesise, not least because of the different language and style that they use. The further away the reader is from the professional community that generates the content the harder it becomes to receive a complete understanding of the direction and flow of the different branches of particular programmes, which over time become fragmented across numerous publications. Only the professional historian has the time to follow it, but even within their discipline there is fragmentation across the many specialisations. Computers provide a potential answer. They do not have the same aesthetics and storytelling qualities of a textual narrative, but they can get very close with the right "relational" structures and capture the dynamic

relationship between *inventio, dispositio and elocutio.* Data, alongside the textual narrative, can solve one of the biggest problems that historians and humanities scholars face in a world overflowing with uncontextualised information. To precisely track the progress of different interpretations and explanations, based on different, overlapping and emerging empirical facts with a transparent and traceable provenance. Existing structures and form and associated mindsets prevent this.

As Hobsbawm put it, "the wider the range of human activities which is accepted as the legitimate concern of the historian, the more clearly understood the necessity of establishing systematic connections between them, the greater the difficulty of achieving a synthesis. This is, naturally, far more than a technical problem of presentation, yet it is that also. Even those who continue to be guided in their analysis by something like the 'three-tiered hierarchical' model of base and superstructures, may find it an inadequate guide to presentation, though probably a less inadequate guide than straight chronological narrative" (Hobsbawm 1998, 250). Current uses of technology in the humanities are used at arm's length to ensure that their reductive qualities do not affect the purity of research methods, but at the same time, this reluctance to engage in the details of computer information structures means that the impact and influence of humanities scholars are reduced and more importantly their scientific programmes become increasingly irrelevant.

The communities of knowledge in which scientific programmes of history are conducted, using traditional modes of authoring and publication are too narrow and immediately bring into question the validity of these research programmes. This is still, of course, a question and problem for natural sciences also. Without technology humanities researchers cannot resolve issues of fragmented research programmes let alone provide a sufficient synthesis of knowledge. In any event, history is not linear and cannot be presented as such if we value progressive research with social responsibility. Textual narratives hit a serious limitation in their ability to interconnect and communicate patterns across time and space and more particularly make the connection between past and present, or present and past, the dynamic from which we gain new insight. Computers provide a potential answer but only if they shake off their commercial constraints, provide the ability to establish "patterns and linkages" (or rather relations and processes) using new forms and structures that incorporate argument and explanation and allow subject experts to take control of how information and thinking are abstracted into structured environments.

Conclusion: ResearchSpace design dynamic

The ResearchSpace project was approached as a humanities research project, not an IT solution, using some aspects of a design approach described by Löwgren and Stolterman in the MIT book "Thoughtful Interaction Design: A Design Perspective on Information Technology" (Löwgren and

Stolterman 2007). The authors describe a dialectic design method that treats the process as a research project, requiring a full investigation and understanding of a given subject area, rather than simply the design medium. In addition, the products of design, "are not artefacts, but knowledge" (Löwgren and Stolterman 2007, 2). ResearchSpace is a knowledge building project investigating and understanding the processes and relations involved in aspects of humanities research and the ResearchSpace platform uses this knowledge to help researchers approach their own research dialectically (Löwgren and Stolterman 2007, 12). Löwgren and Stolterman saw that system design based on "useability and usefulness" created a narrow and limiting design position (Löwgren and Stolterman 2007, 131). The ResearchSpace project uses their concept of "thoughtful design" which is based on real research and experience, rather than rapid technological development which prevents researchers from "experimenting with and learning about all the new possibilities created by new technology and new knowledge... [and]...deal with a reality marked by complexity and change" (Löwgren and Stolterman 2007, ix). The next generation of humanities researchers need not be programmers, but they must be designers and modellers of their own data and systems just as they design the structures of textual narratives.

As such the ResearchSpace project has not been a linear process of requirements gathering, specification creation and build. It has been a dynamic process of research, communication, testing and collaborating with communities also progressing new relational and processual research methods, ones that create insurmountable challenges for textual narratives. One part of this community developed an ontology which supports the same contextual approach employed by ResearchSpace. The International Committee for Documentation of the International Council of Museums – Conceptual Reference Model (CIDOC CRM) is itself an evolving empirical research project with significant practical potential (http://www.cidoc-crm.org/). Its recent growth has resulted in different branches of development, some progressive while others less so. Its wider adoption means that its scope, the new specialisms of ontological commitment it addresses, places pressures to reassess its own scientific base (the sign of a true scientific research programme), particularly when addressing the issues of describing social ontology and grappling with the internal relations of social structure and agency. In contrast, many computer ontologies used in Linked Data are based on existing artificial schemas which transfer existing vocabulary and protect established models and standards, propping up degenerative programmes of research and outmoded professional standards.

The point of ResearchSpace is not simply to create tools that implement function but to provide forms of representation that are as close as possible to original research abstractions and enable data narratives. The adoption of ResearchSpace flows from the need to address complexity and wider community knowledge. As such the groups and individuals now using ResearchSpace transfer these methods into a digital environment to obtain

the benefits of computers without losing the provenance and semantics of abstractions and explanations – although in reality all systems, whether computers or pen and paper, always carry some constraints and limitations. One challenge is that many projects will be transferring data from existing platforms to ResearchSpace and therefore will be transferring elements of previous approaches and mindsets. For example, current projects like "Pharos" are bringing together art archives from institutions based in the United States and Europe to create an aggregated research resource. This initially equates to the migration of legacy data to, initially, simple ontological patterns based on the original records (Pharos Consortium 2021, http://pharosartresearch.org). The ongoing challenge, in contrast to projects like RAMA, is to encourage researchers to approach this data with a new mindset and assume a position of dynamic transformers of the information and its structures, changing it from a static reference to a living archive hosting new ideas, explanations and arguments. For new projects, a progressive approach can be adopted from the start. Other active ResearchSpace contributors like Villa I Tatti, The Harvard University Center for Italian Renaissance Studies, are now using ResearchSpace in various projects including, "Venice as an Archipelago" and the innovative, "Metapolis: Spatializing histories through archival sources". These projects use temporal-spatial layering in the study of early modern Venice (VIlla I Tatti 2021). They provide a detailed microcosm from which many other projects at different levels of generality (including global systems) can grow from and provide fresh insight building on the original research. Taking a microcosm and linking it to overarching historical social systems, is the type of research activity that ResearchSpace makes possible. Equally, the Linked Infrastructure for Cultural Scholarship (LINCS) consists of a network of researchers from various Canadian universities investigating socio-historical questions using and developing the ResearchSpace platform. Their particular objective is to create, "a smarter, 'semantic' web whose links will elucidate the diverse causes, effects, and significance of human action and expression" (LINCS 2021).

ResearchSpace is also aimed at organisational transformations, in particular long-term growth of knowledge and knowledge processes across different organisational departments and beyond the institutional walls – informing research and generating intellectual efficiencies which provide organisational and personal benefits. The inefficiencies created by the top-down deployment of fixed model technology (including non-digital) stifle knowledge-based processes (the branches of organisational research), circumvent back-office innovation, affect the long-term preservation of organisational knowledge and prevent the incorporation of community knowledge. Just as in commercial organisations, project-oriented management approaches which have no underlying knowledge infrastructure create informational and process fragmentation. However, traditional cultural heritage processes such as archiving, conservation, collection research and external engagement could be supported and interconnected through a

knowledge base structure that supports internal and external collaborative working. This type of transformation is crucial to organisation's ongoing relevance for research, education and social responsibility, effectively bringing meaningful knowledge to the surface which is accessible to wide audiences, rather than producing limited static catalogues and records.

The details of individual tools and functions can be found on the project's web site. They will evolve and change over time. The important factors are, the ability to use dynamic and dialectic data forms and structures, a progressive and collaboratively orientated community, a willingness to engage with innovation and assert new designs based on historical challenges, and a commitment to providing context and diversity in data. These aspects are increasingly important to confront the considerable issues of technology disruption and commercially led global information infrastructures.

Bibliography

Agar, Jon. 2006. "What Difference Did Computers Make?" *Social Studies of Science* 36 (6): 869–907. https://doi.org/10.1177/0306312706073450

Allington, Daniel, Sarah Brouillette, and David Golumbia. 2016. "Neoliberal Tools (and Archives): A Political History of Digital Humanities. Los Angeles Review of Books." 1 May 2016. https://lareviewofbooks.org/article/neoliberal-tools-archives-political-history-digital-humanities/

Babbage, Charles. 1971. *On the Economy of Machinery and Manufactures*. A. M. Kelley.

Bechhofer, Sean et. al. 2013. "Why Linked Data Is Not Enough for Scientists." *Future Generation Computer Systems* 29 (2): 599–611.

Bridle, James. 2018. *New Dark Age: Technology, Knowledge and the End of the Future*. London: Verso.

Broughton, Janet, and Gregory A. Jackson. 2008. "Bamboo Planning Project: An Arts and Humanities Community Planning project to Develop Shared Technology Services for Research: A Proposal to the Andrew W. Mellon Foundation." January, 1–39.

Burawoy, Michael. 1990. "Marxism as Science: Historical Challenges and Theoretical Growth." *American Sociological Review* 55 (6): 775. https://doi.org/10.2307/2095745

Curtis, Adam. 2021. *Can't Get You Out of My Head – Series 1: 1. Part One – Bloodshed on Wolf Mountain*. https://www.bbc.co.uk/iplayer/episode/p093wpgw/cant-get-you-out-of-my-head-series-1-1-part-one-bloodshed-on-wolf-mountain

Day, Ronald E. 2014. "Indexing It All: The Modern Documentary Subsuming of the Subject and Its Mediation of the Real." In *iConference 2014 Proceedings*. iSchools. https://doi.org/10.9776/14140

Delouis, Dominique. 1993. "TOIOsystixnes France." *International Cultural Heritage Informatics*, 117–127. http://www.archimuse.com/publishing/ichim93/delouis.pdf

Delouis, Dominique. 1995. "Standards for Cultural Heritage Information: The RAMA Perspective." *Archives & Museum Informatics (Selected Papers from the Third International Conference on Hypermedia and Interactivity in Museums (ICHIM 95/MCN 95)* vol. 2: 281–282.

Dombrowski, Quinn. 2014. "What Ever Happened to Project Bamboo? The Andrew W. Mellon Foundation." 1 September 2014. https://mellon.org/news-blog/articles/what-ever-happened-project-bamboo/

Drucker, Johanna. 2013. "Is There a "Digital" Art History?" *Visual Resources* 29 (1–2): 5–13. https://doi.org/10.1080/01973762.2013.761106

Drucker, Peter F. 2012. "The Manager and the Moron." In *Technology, Management and Society*. London: Routledge.

Eastwood, Terry. 2000. "Putting the Parts of the Whole Together: Systematic Arrangement of Archives." *Archivaria* 50 (1): 93–116.

Emirbayer, Mustafa. 1997. "Manifesto for a Relational Sociology." *American Journal of Sociology* 103 (2): 281–317. https://doi.org/10.1086/231209

Englebart, Doug. 1962. *Augmenting Human Intellect: A Conceptual Framework*. Menlo Park: Stanford Research Institute. https://www.dougengelbart.org/content/view/138

European Commision (Cordis). 1994. "Remote Access to Museum Archives | RAMA Project | FP3 | CORDIS | European Commission." https://cordis.europa.eu/project/id/R2043

Evans, Richard J. 2001. *In Defence of History*. London: Granta Books.

Feenberg, Andrew. 2005. "Critical Theory of Technology: An Overview." *Tailoring Biotechnologies* 1 (1): 47–64.

Fukuyama, Francis. 1989. "Have We Reached the End of History?" http://bev.berkeley.edu/ipe/readings/Fukuyma%20(corrected).rtf

Ginzburg, Carlo. 2014. "Distance and Perspective: Reflections on Two Metaphors." In *Historians and Social Values*, edited by Ann Rigney, and Joep Leerssen, 218–232. Amsterdam: Amsterdam University Press.

Haigh, Thomas. 2016. "How Charles Bachman Invented the DBMS, a Foundation of Our Digital World." *Communications of the ACM* 59 (7): 25–30. https://doi.org/10.1145/2935880

Hobsbawm, Eric. 1998. *On History*. London: Abacus.

Jameson, Fredric. 2002. *The Political Unconscious: Narrative as a Socially Symbolic Act*. 2nd ed. London: Routledge.

Lakoff, George. 1990. *Women, Fire, and Dangerous Things: What Categories Reveal About the Mind*. Chicago, IL: University of Chicago Press.

Langmead, Alison, Tracey Berg-Fulton, Thomas Lombardi, David Newbury, and Christopher Nygren. 2018. "A Role-Based Model for Successful Collaboration in Digital Art History." *International Journal for Digital Art History* no. 3. https://doi.org/10.11588/dah.2018.3.34297

LINCS. 2021. "LINCS Cyberinfrastructure Project | CWRC/CSEC." *Canadian Writing Research Collaboratory*. https://cwrc.ca/news/LINCS-CFI

Liu, Alan. 2011. "Friending the Past: The Sense of History and Social Computing." *New Literary History* 42 (1): 1–30. https://doi.org/10.1353/nlh.2011.0004

Löwgren, Jonas, and Erik Stolterman. 2007. *Thoughtful Interaction Design: A Design Perspective on Information Technology*. Cambridge MA: MIT Press.

Oldman, Dominic, Martin Doerr, and Stephan Gradmann. 2016. "ZEN and the Art of Linked Data New Strategies for a Semantic Web of Humanist Knowledge." In *A New Companion to Digital Humanities*, edited by Susan Schreibman, Ray Siemens, and John Unsworth, 2nd ed, 251–73. Holbroken NJ: John Wiley & Sons.

Ollman, Bertell. 1990. "Putting Dialectics to Work: The Process of Abstraction in Marx's Method." *Rethinking Marxism* 3 (1): 26–74. https://doi.org/10.1080/08935699008657901

Oxford University Press. 2021. "Chronicle, n." In *OED Online*. Oxford University Press. https://www.oed.com/view/Entry/32576

Oxford University Press. 2021. "Narrative, n." In *OED Online*. Oxford University Press. https://www.oed.com/view/Entry/125146.

Pharos Consortium. 2021. "PHAROS: The International Consortium of Photo Archives." http://pharosartresearch.org/

Ricoeur, Paul. 1995. "History and Rhetoric." In *The Social Responsibility of the Historian*, edited by François Bédarida, 7–24. Providence RI: Berghahn Books.

Schaffer, Simon. 1994. "Babbage's Intelligence: Calculating Engines and the Factory System." *Critical Inquiry* 21 (1): 203–227.

Schmidt-Glintzer, Helwig, Achim Mittag, and Jörn Rüsen, eds. 2005. *Historical Truth, Historical Criticism, and Ideology: Chinese Historiography and Historical Culture from a New Comparative Perspective.* Leiden Series in Comparative Historiography, vol. I. Leiden: Brill.

Schnapp, Jeffrey T., and Matthew Battles. 2014. *The Library Beyond the Book (Metalabprojects).* Cambridge, MA: Harvard University Press.

Stone, Lawrence. 1979. "The Revival of Narrative: Reflections on a New Old History." *Past & Present* 85 (1): 3–24.

Thaller, Manfred. 2017. "The Need for a Theory of Historical Computing [1991]." *Historical Social Research/Historische Sozialforschung. Supplement* 29: 193–202.

Tinel, Bruno. 2013. "Why and How Do Capitalists Divide Labour? From Marglin and Back Again through Babbage and Marx." *Review of Political Economy* 25 (2): 254–72. https://doi.org/10.1080/09538259.2013.775825

Unsworth, John. 2000. "Scholarly Primitives: What Methods Do Humanities Researchers Have in Common, and How Might Our Tools Reflect This?" http://people.lis.illinois.edu/~unsworth/Kings.5-00/primitives.html

VIlla I Tatti. 2021. "DigiTatti." https://dh.itatti.harvard.edu/#

Wartzman, Rick. 2014. "What Peter Drucker Knew about 2020." *Harvard Business Review* 16 October 2014. https://hbr.org/2014/10/what-peter-drucker-knew-about-2020

Part II
Information management

Management of textual resources

8 Research access to in-copyright texts in the humanities

Peter Organisciak and J. Stephen Downie

Introduction

In 2004, John Unsworth noted that the primary constraint to humanities in the digital age is the current copyright landscape, limiting which primary sources can be accessed, shared and studied. He argued that approaches "which deal with texts in the aggregate... provide a way around the copyright constraint" (2004). Since then, the emergence of massive digital collections has presented extensive opportunities for digital humanists and invigorated large-scale study of the published archive beyond the traditional canon. As predicted, though, the indexing, access and use of digital collections has remained limited by intellectual property challenges and legal frameworks, while beginning to address text mining, have been cautious and unassertive in adapting to such modes of inquiry.

Quantitative text analysis presents efficient and sometimes wholly new approaches to the study of culture and history, as seen in digital humanities work in stylometrics (e.g., Holmes 1985), culturomics (Michel et al. 2011), distant reading (Moretti 2013) and cultural analytics (Manovich 2009). However, access remains a problem, as the scale that makes digital methods promising is also untenable in current intellectual property systems. Due to information access issues, it is significantly more difficult to perform digital humanities work on the past century of text (Ross and Sayers 2014). This leads to a situation where some eras of study are more privileged in the digital humanities than others.

This chapter pursues the question, *what information access approaches can enable research use of privileged or sensitive corpora?* Increasingly, the solutions being pursued fall under the approach of non-consumptive access or non-expressive use (Jockers, Sag, and Schultz 2012), which describe uses that do not require a full text to be closely read or distributed. As Unsworth speculated, "if we don't have to republish work in order to do digital humanities, perhaps we can get at a greater portion of that record" (2004). This chapter will focus on text abstraction techniques, which represent a text through text patterns and statistics. The approach is viewed through the

DOI: 10.4324/9781003131816-8

efforts of the HathiTrust Research Center (HTRC) in providing mediating scholarly use of 17 million digitised library volumes.

Non-consumptive approaches to information access present some challenges. Texts can lose important context and not all scholarly uses are served by the particular choices made in preparing the intermediate resource. However, they also present a path towards the study of modern texts, where the alternatives are either highly restricted or none at all. As the text analysis subdomains of the digital humanities mature, striking a balance between access and expressiveness of research texts will be vital and the current landscape of work will inform those choices.

The remainder of this chapter considers the value that growing digital libraries hold for scholarship, and how that value is challenged by legal hurdles. First, we consider the broader landscape of digital library growth, large-scale study of primary sources and the role of copyright in shaping that scholarship. Then we turn to the instructive example of the HTRC, to consider how one centre is addressing these challenges. The HTRC supports research on the 17 million digitised bibliographic volumes of HathiTrust Digital Library, of which 10.5 million volumes cannot be distributed because of their copyright status. In aggregate, it is a massive resource for digital humanities research into historical, cultural and linguistic trends. The HTRC was founded to encourage that potential through non-consumptive uses of the corpus, and serves as a case study in how scholarship over in-copyright corpora may grow.

Background

Computational analysis of text has been a central method in the emergence of what came to be known as humanities computing and eventually, the digital humanities. If the humanities are primarily a discipline of appreciation and understanding of cultural production, computing has offered new lenses and reconfigurations through which we may view our primary sources.

Early in the history of humanities computing, text digitisation was done in service of analysis. Some of the earliest known digitised texts were the Revised Standard Version of the Bible and the works of Thomas Aquinas, for projects led by Rev. John W. Ellison and Fr. Busa (Burton 1981, Hockey 2004). Both cases were in service of concordances, time-intensive reconfigurations of texts that the leaders of both projects believed could be better done by computers. "By using means that no age before ours could afford", a review of Busa's *Index Thomisticus* noted, "we are able now to arrive at that complete knowledge of Aquinas" (Sprokel 1978).

Computational analysis of texts and other primary sources has branched into various subdomains. With *stylometrics* (e.g., Holmes 1985, Burrows 1987), scholars sought to quantify authorial style, both towards better

understanding the author's stylistic markers as well as to better appreciate their writing. With *distant reading* (Moretti 2013), scholars sought to position the value of broader, quantified analysis of corpora, as a complement to traditions of close reading. Such an approach has grown to massive scales in the context of *cultural analytics* for humanistic inquiry (Manovich 2009), and *culturomics* for inferential, corpus-driven analysis (Michel et al. 2011). These sub- and related domains have longer traditions in the humanities and social sciences (Underwood 2017), but in many cases have been invigorated by computational affordances, which excel in quantifying with consistency and scaling.

Accompanying the maturation of computation text analysis has been an emergence of large primary-text corpora, both born-digital and digitised. Contemporary materials are readily available from the digital age, with web archiving offering a new tool for historians (Milligan 2016, Milligan 2019) and user-generated content and social media providing material for cultural theory, ethnology and other social sciences (Manovich 2009, Lazer et al. 2009). Digital collections are large, and will continue to grow. As of late 2020, the Internet Archive, which preserves media as well as web pages, stores 70 petabytes of data and 475 billion web pages (Jessen 2020). Common Crawl, a repository of web data designed for programmatic access, contains 280 terabytes with 2.7 billion web pages in 2021 (Common Crawl 2021). The Library of Congress's Twitter Archive collected 12 years of messages before turning to more selective archive in 2018 (Osterberg 2017).

Given the effort involved, corpora of digitised materials have been slower to emerge, though with some notable standouts. LexisNexis has been providing electronic access to news and legal material since the 1970s (LexisNexis 2003) and JSTOR has digitised 12 million academic journals since 1994, for example. Through federated or consortial efforts, however, recent years have seen more collections of such scale become accessible for scholarship. In 2008, Europeana was launched as a cultural heritage digital library, starting with 4.5 million digital objects from over 1,000 European museums, archives and other institutions (Purday 2009). Similar efforts have been undertaken in the United States with IMLS Digital Collections and Content (Palmer, Zavalina, and Mustafoff 2007) and the Digital Public Library of America (Darnton 2013), both collecting cultural heritage materials from multiple institutions.

For years, the most notable bibliographic collection was Project Gutenberg. Founded at the University of Illinois in 1971, the project's volunteers have hand-transcribed 60,000 public domain works. The real inflection point, however, was with the Google Books project in the early 2000s. Unlike previous projects, which had to be selective for the costly and time-intensive process of digitisation, Google aimed to scan as many books as possible, partnering with predominantly academic, US-based libraries

to scan millions of books, sharing the scans with the institutions. They also showed willingness to partner with researchers, notably releasing the Google NGrams Viewer and Dataset while supporting founding research on culturomics (Michel et al. 2011).

In response to the Google Books project, other consortial digitisation projects were founded. The Open Content Alliance was conceived by the Internet Archive, with support from Yahoo and Microsoft (Suber 2005). The Internet Archive has continued with its own digitisation initiatives, which has grown to over 2 million books (Freeland 2021). Finally, the HathiTrust was founded as a non-profit consortium, to separately collect works from different institutions' collections – including a significant portion that had been digitised by Google.

In this chapter, we focus on access to the HathiTrust collection, so we first turn to characterising the collection.

About the HathiTrust

The HathiTrust is a consortium collecting scanned works of institutions around the world in the massive HathiTrust Digital Library. The library is bibliographic in nature, primarily consisting of scanned books, as well as pamphlets, serials and other text materials; here, we adopt the HathiTrust's general language referring to those scanned text materials as *volumes*. Related works, such as identified duplicates and parts of a multi-volume set, are represented together in *catalogue records*.

As of 2021, the HathiTrust contains 17.4 million scanned volumes, representing 8.9 million unique catalogue records and contributed from over a hundred institutions worldwide (HathiTrust 2021a). Its roots lie in the Google Books project, a large digitisation project which sought access to academic library collections for scanning in exchange for providing the libraries the scans of those works. As individual institutions' digital collections grew from this effort, the HathiTrust was founded to allow a central, non-profit place for preservation and access of digitised works, with the Google-digitised materials being a large component of that collection. Today, those materials are still a significant portion of the HathiTrust Digital Library and the HathiTrust still maintains an ongoing relationship with Google's effort.

While the US institutions and the English language are most notably represented in the collection, there is still broad coverage beyond them. A number of institutions from Australasia and Europe contribute to the HathiTrust, and about 50% of the collection is in languages other than English ("HathiTrust Languages" 2021c). Of these, 800,000 catalogue records are in German (8.6%), 650,000 are in French (7%) and 608,000 are in Spanish (6.5%), followed by Russian (3.3%), Chinese (3%), Japanese (2.6%), Italian (2.6%), Arabic (1.5%) and Portuguese (1.5%). Overall, there are 465 unique languages represented, 41 of which contain more than 10,000 volumes.

The HathiTrust Digital Library collection also has broad topical and temporal coverage. Among the 5.0 million catalogue records that have an assigned Library of Congress Classification number, all 21 classes are represented, with a median of 136,000 records per class. Temporally, the collection spans multiple centuries, with 1.75% of volumes from the 18th century or earlier, 14.25% from the 19th century, 74.36% from the 20th century and 9.65% from the 21st century.

Given that the collection spans eras, subjects and languages while still maintaining large sample sizes in various slices of the collection, the HathiTrust presents tremendous value for the digital humanities. In addition to its value for finding individual primary materials for scholarship, the pairing of scale with digital access can support emerging forms of large-scale, aggregate-level corpus scholarship. This type of work is embodied in overlapping and variant subdomains including culturomics (Michel et al. 2011), distant reading (Moretti 2013) and cultural analytics (Manovich 2009).

Challenges to computational text analysis at scale

The challenges to scholarly use of corpora such as Google Books, HathiTrust and the Internet Archive are curatorial and organisational. In some instances, making sense of what is in the collection is important for contextualising aggregate-level inferences. For example, given that the contributing institutions to the HathiTrust are predominantly academic, there is a higher representation of scientific works. It's been noted, for example, that the capital-F Figure occurs more than figure in Google Books (Pechenick, Danforth, and Dodds 2015) and in turn, the HathiTrust. Given that the digital library materials are associated with professionally catalogued metadata, it is possible to account for content biases by focusing on specific subject classes or subsampling from a balanced subset of them, but understanding the biases of the collection is the first step. A further curatorial challenge is simply sifting through the scale to find quality materials. For example, there is uneven but pervasive duplication in the collection, which can be detrimental to certain types of text analysis (Schofield, Thompson, and Mimno 2017) and is not a trivial problem to address (Organisciak et al. 2019).

Of the challenges facing scholars in working with digitised collections, however, the greatest is *legal*. In the largest collections, a great many of the works are still in copyright, in the United States and around the world, and cannot easily be distributed to scholars or – in some jurisdictions – even studied by them. While challenges of curation, access and scale are tractable with enough effort and resources, the legal problem is more pernicious. It presents a barrier which, short of copyright reform, needs to be worked around rather than overcome.

Case study

The HTRC was founded to address the varying challenges of scale, access, curation and copyright inherent to using the HathiTrust collection. This section focuses on how the HTRC uses non-consumptive access to navigate the primary issue of enabling research over sensitive documents. We consider the legal challenges to brokering access to the collection, then examine two approaches that the centre takes in working within those restraints: the Extracted Features (EF) Dataset and the exploratory data analysis tool HathiTrust+Bookworm (HT+BW). Finally, we consider how their model may apply to other digital libraries.

HathiTrust Research Center

While the HathiTrust Digital Library serves to meet traditional tenets of libraries, improving preservation and access to primary materials, the value of the collection as data was acknowledged with the founding of the HTRC, as a partnership between the University of Illinois and Indiana University. The Research Center was founded to support scholarship over the collection, particularly the type of large-scale study that the collection is uniquely positioned to support. As noted in their Non-Consumptive Use Policy, the HTRC "leverages the scope and scale of the repository to develop avenues for non-consumptive research of the HathiTrust Digital Library" (HathiTrust 2017).

Copyright considerations and non-expressive access

The HTRC's approach to in-copyright materials is motivated by two key considerations:

A substantial portion of the HathiTrust Digital Library is contemporary

According to the HathiTrust, nearly two-thirds of the digital library collection (63.6%) is composed of materials from 1950 onward (HathiTrust 2021b). This includes 9.8% of materials created in the 1960s, 12.1% from the 1970s, 13.8% from the 1980s, 13.1% from the 1990s and 9.6% from the new millennium. There are millions of works in the HTDL from earlier in that timeframe. Yet, the heavy representation in the latter 20th century suggests that use of the collection should support contemporary, as well as classical works. A research centre that focuses on older, out-of-copyright works is neglecting the majority of the collection.

The HathiTrust serves an international audience of patrons, scholars and researchers.

The HathiTrust's constituents and contributors are from around the world, a fact that may be overlooked when noting its home at the University of

Michigan. Further, the English materials comprise a bare majority, at about half of the full collection, with over 400 languages represented. As such, the HathiTrust requires international considerations, and in turn must navigate many different legal systems.

From a copyright standpoint, accommodating an international audience complicates any scholarly use mission. The US copyright system is restrictive to a degree, with longer copyright terms than many countries. Yet, it has two characteristics that simplify working with an era-spanning collection like the HTDL, at least in the near term. The first is in its fair use doctrine, which allows for certain use of in-copyright materials when their benefits to society outweigh the potential harm. Indeed, the HathiTrust collection's digitisation and maintenance has been successfully protected under the doctrine in *Authors Guild, Inc. v. HathiTrust* (S.D.N.Y.; Parker 2014) and Authors *Guild v. Google, Inc.* (S.D.N.Y.; Chin 2013). Notably, scholarly uses such as text analysis were noted as a transformative use in the Google case.

The second useful characteristic is a historical artefact of the United States' slow turn to copyright reform, resulting in copyright terms prior to 1978 that are determined by work publication date rather than author life. This means that copyright assessments are easier to do with the manifest publishing information contained within a book. There are a few aggregate-level generalisations that can be made. Prior to the Copyright Act of 1976, copyright was explicitly registered for 28 years, and renewable for a second term. We know that works published or registered before 1923 are almost certainly in the US public domain, because even with a renewal they would have lapsed into the public domain before copyright reform went into effect. Second, works published prior to reform in the 70s have terms of 95 years, so we know that works published prior to 1926 have entered the public domain (by 2021), with that window moving each year. Finally, it is safe to assume that post-1963 works are in-copyright, given that the mechanisms for those to have entered the public domain are sparse. Only the period from 1926 to 1963 is more complicated, as the copyright status is dependent on whether a work's copyright registration was renewed.

Serving an international audience makes copyright determinations much more difficult, not only because of the complexity of honouring a myriad of regional differences, but also because many countries have copyright terms based on the author's death. Indeed, that is the case in the United States for works created since 1978, but countries that ratified the Berne Convention of 1886 have had that form of copyright term for a longer time (the United States joined the agreement over a century later). The issue for copyright determinations is that nearly every single work requires a secondary source of information, not contained within the book's content or metadata, to determine the author's life. At a scale of millions of works, and with many lesser-known works with obscure authors, there is no simple rule like the "pre-1926" rule in an author-based system.

The HathiTrust addresses this issue by using a conservative worldwide public domain cutoff, maintaining that works published prior to 1881 are reasonably assumed to be in the public domain throughout the world. After that cutoff, while works may be public domain in various jurisdictions – for example, in Canada works by authors that died as recently as 1970 are in the public domain or 1950 for most European countries – making such determinations is a time-consuming process.

With over a century of works that the HathiTrust cannot assume to be globally available to the public, there is more of a burden to provide non-consumptive ways to benefit from the collection.

Non-consumptive access

Non-consumptive or *non-expressive*, access and use refers to use of materials in such a way that their use does not conflict with the rights of the material's copyright holders. In essence, the principle seeks to learn from text and disseminate those findings without making the original text available. In the case of non-consumptive access at the HathiTrust, the principle is further considered not only in the context of avoiding widespread dissemination of copyrighted work, but also in limiting the exposure between the library and the scholar.

Jockers, Sag and Schultz popularised the framing non-expressive use in an amicus brief filed on behalf of digital humanities scholars, in support of Google Books in *Authors Guild v. Google, Inc.* (2012). In that American litigation, the Authors Guild was challenging the legality of Google's right to digitise and maintain access to the scans of the Google Books project, similar to *Authors Guild v. HathiTrust*. Since the United States has a fair use doctrine, not explicitly laying out exceptions to copyright but defining criteria for judging when the benefits to society for use of copyrighted material outweigh the harm to the copyright holder, the amicus brief laid out the benefits to digital humanities.

The argument laid out by Jockers, Sag and Schultz was that non-expressive use is important to the "progress of science" in the digital humanities, that non-expressive aspects of works are not protected by copyright and finally, that the types of contributions that non-expressive text mining makes are precisely the types of advancements that fair use seeks to protect. The judge's opinion in that case made reference to this argument in a ruling in Google's favour, noting that "Google Books permits humanities scholars to analyze massive amounts of data – the literary record created by a collection of tens of millions of books. Researchers can examine word frequencies, syntactic patterns, and thematic markers to consider how literary style has changed over time" (The Authors Guild v. Google, Inc., S.D.N.Y.; Chin 2013).

Europe has no fair use doctrine protecting novel and productive uses of copyrighted material, making non-expressive use more critical (Hugenholtz 2013).

A 2019 European Union directive finally clarified copyright exceptions related to text and data mining, though with limitations. Article 3 of the Directive on Copyright in the Digital Single Market (DSM) protects the rights of research institutions and cultural heritage institutions to preserve and reproduce copyrighted material, as well as permitting their use for text and data mining, while article 4 allows for the same outside of those institutions, albeit with the ability for copyright holders to opt out (European Parliament 2019).

At the HathiTrust, non-consumptive access is the term of art, as it makes clear the role of the scholar in working with materials. With a mediated collection, there are two practical parties in the discussion of copyright: one is the digital library, and their right to maintain works for research purposes, and the other is the external scholars that may seek to study that library's collection. The legal precedents in the United States and directives in the EU have focused on the first-party right to use material for text and data mining. The HathiTrust considers the relationship with third-party or affiliated second-party scholars, using *non-consumptive access* to refer to the form of that access. Per the HathiTrust's "Non-Consumptive Use Research Policy" (2017):

> Non-consumptive Research (also called "non-consumptive analytics") means research in which computational analysis is performed on one or more volumes (textual or image objects) in the HT collection, but not research in which a researcher reads or displays substantial portions of an in-copyright or rights-restricted volume to understand the expressive content presented within that volume. Non-consumptive analytics includes such computational tasks as text extraction, textual analysis and information extraction, linguistic analysis, automated translation, image analysis, file manipulation, OCR correction, and indexing and search.

The HathiTrust outlines three of the modalities implemented by the HTRC: *derived downloadable datasets, web-accessible data analysis and visualisation tools* and *HTRC Data Capsule*. Datasets and analytic tools are described in detail over the next two sections.

Extracted features

The HTRC's *EF Dataset* is a dataset of all the books in the HathiTrust Digital Library, presented in a form that is useful for research but non-consumptive. The dataset shared a fingerprint of each page in the collection, such as which words occur and statistics on page layout such as line and character counts. Altogether, it shares information on 6.2 billion pages with 6.9 trillion words in a freely-available, openly-licensed dataset. To consider the value of this form of data, it is useful to consider its precedents.

An area of research where access is challenged by copyright limitations is music information retrieval (MIR). MIR seeks to analyse and retrieve music by various sonic properties, for purposes such as music recommendation. Unlike the published word, there is little history for music that has lapsed into the public domain, given its relatively recent technological advent. Instead, the datasets of audio recordings collect from work where the artist has voluntarily dedicated their work to the public domain or, more commonly, given the work a permissive Creative Commons licence. The Free Music Archive, for example, has 106,000 tracks, comprising nearly one terabyte of date (Defferrard et al. 2017). Due to the limits on what can be distributed, however, larger music datasets are not distributed as audio recordings. Instead, datasets such as the Million Song Dataset (Bertin-Mahieux et al. 2011) share *features* of audio tracks.

A *feature* is an agnostic term for a countable property in machine learning. To analyse any sort of dataset, it needs to speak the quantified language of computing. Text and music are both examples of *unstructured data*, with no naturally countable structure. To a machine, a sentence is a string of characters, but there is no sense of what that sentence may communicate. In order to make sense of unstructured data, it first needs to be interpreted into one or a set of countable features. This process is called feature extraction. For music, extracted features may include properties such as the timing of all the beats in a song or the timbre, pitch and loudness of smaller segments of the song.

Feature extraction is a necessary step of working with unstructured data: researchers first need to derive a malleable representation of the document, then they may look to analytic processes such as classification, clustering, tagging, generation etc. The clever approach taken by the Million Song Dataset is in distributing already extracted features, with songs segmented and counted in useful ways (Bertin-Mahieux et al. 2011). This allows distribution of useful information about songs – in many cases the very information that a researcher would have extracted from an audio file – without actually distributing a listenable track that can be enjoyed in a way that may be seen as harmful to the original creator. While there is value in the mechanics of extraction – for example, a scholar may want a different algorithm for finding beats or splitting texts into words –this type of dataset benefits a large proportion of uses. Further, it enables access to data that might otherwise not be distributable.

Inspired by datasets from the field of MIR, the HTRC developed and released the HTRC EF Dataset (Organisciak et al. 2017, Jett et al. 2020). The EF Dataset distributes book-level and page-level features for each of the volumes in the HathiTrust Digital Library. The derived dataset approach has also been implemented for other massive-scale text digital libraries: Google's Ngrams Viewer offered datasets of term counts at the full collection level (Michel et al. 2011) and JSTOR's Data for Research service "includes metadata, n-grams, and word counts" for the majority of JSTOR's articles, chapters and reports.

In text mining and analysis, one feature stands above all others: the token count. Commonly, a text is split up, or tokenised, into sentences and those sentences into individual words, or more generally *tokens*, which may be counted. Page-level token counts are the cornerstone feature in the EF Dataset. For every page of every book, the text is tokenised, the tokens are tagged by part of speech, and the count of each type of use for each word is provided. The part of speech tagging will differentiate between the verb rose (to rise) and the noun rose (flower). Further, counts are provided for their original casing, so the name Rose will be differentiated from the lower-cased flower, except when the flower is used at the start of a sentence; in that instance, the part-of-speech tagging will still differentiate between a proper noun and noun.

Token counts are a type of representation known as bag-of-words. The intuition is that words represent a topical fingerprint of what a text is about. This simplifying assumption fails in certain contexts, such as negation; for example, "not good" is a phrase that would lose its meaning when the words are considered independently of each other. Yet, when paired with language models that can represent similarity between words (e.g., that "dog" and "canine" discuss similar topics) and term weighting approaches that acknowledge that not all words are equally informative, they can effectively support many text classification, clustering and analysis workflows. For example, Underwood and Sellers used the HathiTrust data to identify the emergence of a style associated with prestigious literature, noting an increased tendency for work reviewed by prominent periodicals to exaggerate stylistic features from prestigious work before it (2016).

With respect to non-consumptive *access*, the lack of positional information is an asset, enabling access to works that would otherwise be too legally risky to distribute otherwise. Yet, the token count approach does not satisfy all scholarly needs, such as text modelling approaches that learn text based on a word's context in a larger sequence, like BERT (Devlin et al. 2018) or ELMO (Peters et al. 2018). Further, artificial neural network-based approaches are challenged by the use of "words" as their token unit. Counting every unique word can result in counts for hundreds of thousands or millions of words, a large *vocabulary*. Since neural network approaches generally allow for improved performance to be eked out from larger, more parameter-heavy models, the cost of supporting a large vocabulary may be seen as a less favourable way to allocate computing resources. Rather, words are often encoded using *sub-word* representations such as byte-pair-encoding (Gage 1994, Sennrich et al. 2016), which has a smaller vocabulary of character sequences and a word may be represented through multiple tokens. In the context of feature datasets, the trade-off may be necessary, as the lack of positional information is a central contributor towards enabling non-consumptive access. Yet, given the direction of natural language processing research, which often precede trends in information science, information retrieval and eventually the digital humanities, a productive area

of future research would be in exploring new forms of practical but non-consumptive features for text.

Beyond token counts, the EF Dataset includes other valuable features, including:

- key metadata for each volume, including author, date, publisher and place, language, classification numbers, control numbers and volume enumeration information. Descriptive metadata is available from other HathiTrust sources, but is included with the EF Dataset for convenience;
- disambiguation of headers and footers from content. This allows researchers to easily ignore text that repeats on multiple pages, which may confound a text mining model;
- counts of sentences in the text as well as the number of lines from the top to bottom of a page. This can be useful information for determining the type of content on a page. For example, front matter – content like title pages and dedications, which researchers may be less interested in – tends to have fewer lines of text;
- counts of characters on the leftmost and rightmost side of a page. This feature speaks to the physical structure of a page and how the written word interacts with it, and may be useful for identifying what type of page is being dealt with. A title page will have statistically more capitalised characters on the left, a table of content will have the same as well as roman or Arabic numerals on the right. Poetry is laid out with more regard for layout than prose so some types of poetry may be identifiable through this feature;
- algorithmically inferred language per page. Sometimes cataloguing metadata is incorrect or incomplete, other times books contain multiple languages and a finer approach for language is needed; this feature provides a second guess of each page's language.

The limitations of a feature dataset are that it takes the flexibility of parameterising and choosing feature representations away from the scholar. It may also be, as Samberg and Hennesy note, "puzzling" for scholars hoping to work with a txt or PDF file (2019), or those that work with fully automated tools that internally expect to do feature extraction and analysis all at once. Yet, its ability to open the door to scholarship over sensitive data should not be overlooked, and it is seeing adoption in other digital library spheres.

HathiTrust+Bookworm

While the EF Dataset frees a scholar from part of a typical text analysis workflow, it's use is still burdened by economies of scale and exploration and inference require technical expertise, time and computational resources. At the same time, for a scholar that is new to text analysis the

abstracted nature of the EF Dataset may be off-putting, as not being able to review the original texts may lend a sense of lost sensitivity to the underlying materials.

With HT+BW, the HTRC seeks to promote non-consumptive use of the collection for a different set of uses and users. HT+BW is built as a tool for exploratory data analysis (Tukey 1977) over the HathiTrust collection, allowing quick, flexible and robust queries to be made of the corpus and visualized.

Underlying HT+BW is *Bookworm*, a tool for visualising language trends and corpus trends at large scale. It is best to understand Bookworm as a quantitative API (application programming interface), a tool that allows you to form complex queries and receive a structured data response. Paired with the scale and the professionally catalogued metadata of the Hathitrust, Bookworm becomes a powerful way of studying history, language and culture in the published word.

Bookworm queries are comprised of a few components:

- Faceting: Faceting is the disambiguation of results by a specific property of result. Consider a question of "how many books are in the collection?" This query would have one number as a result. Now, consider a facet such as date. For a question such as "how many books are in the collection, by year", our results would have a count for every single year seen in the collection. This type of facet can be applied for many properties, such as Library of Congress Classification System class or subclass, publication country, publication state (for USA, United Kingdom or the former USSR), author, copyright status and so on. This can be very powerful, especially when multiple facet groups are used.
- Examples: "how many books are in the collection, by subject class and by publication year?"; "how often is the word 'gender' used in different publication countries?"
- Filtering: Filtering similarly uses book or document metadata, though for selecting texts of interest, rather than for disaggregating results. You can still facet on the results, for example, seeing the prevalence of "data" by year, but unlike Bookworm's precedent Google NGrams Viewer, you are not limited to searching over the entire corpus.
- Examples: "How often is the word 'data' used in the Library Sciences?"; "How has 'creativity' emerged in the 20th Century?"
- Word Searching: A scholar can specify a word to look for in the full or filtered collection. In essence, this is a type of filter, applied on the *content* of the underlying corpus rather than the *metadata*. While word search is optional – without it a scholar can still observe bibliographic metadata trends – this is the functionality that truly enables scholars to glimpse inside books in a non-consumptive manner.
- Example: "When did the word 'Inuit' replace the non-preferred 'Eskimo' in Canadian books?"

- Output Statistics: A query can ask for results in various ways. These include "words per million", a ratio of how much a specified word occurs out of every million words; "text percent", a percentage of books in the facet that have a specified word; and "text count", which is the nominal number of books in each facet of the query, including a word if it was specified.
- Examples: "How many books discuss 'freedom'?", "Proportionally, how often in the language is 'freedom' used?"

With these components, HT+BW is able to answer complex queries, returning raw data results or visualizing them. The "main" view of HT+BW, the Bookworm GUI (http://bookworm.htrc.illinois.edu), visualises word trends with a time-series line chart. In this view, the faceting group is "date", so that all results are disaggregated by year, and the word filter is specified by the user, as with a related preceding tool, Google Ngrams Viewer. Where the Bookworm GUI view differentiates itself is in allowing more detailed filtering. Rather than only asking a question of the form, "how has the usage of X changed over time", it is possible to ask questions such as "how has the usage of X changed in a specific country/subject class/literary form/etc.". This also allows the same term to be compared in two settings, such as "how has the usage of 'cookie' changed in general texts vs. technology texts".

While the Bookworm GUI includes faceting by date, it is not the only way to query the collection, and the HTRC offers other tools to visualize the responses to those types of questions. For example, it may be necessary to facet by two groups – perhaps date and class. For such queries, the Bookworm Advanced interface (https://bookworm.htrc.illinois.edu/advanced) offers modules for graphics such as heatmaps – a two-dimensional grid where each x–y grid square is coloured – or stacked line charts. Bookworm Advanced also offers scatter plots, maps, and bar charts, using a *declarative* style where a scholar can bind data elements to visual elements (Wilkinson 1999), specifying which data is bound to the x-axis, y-axis, colour, fill or size of an element. For a template-based alternative, maps and heatmaps may also be customised in the Bookworm Playground (https://bookworm.htrc.illinois.edu/app).

These interfaces provide different ways to work with the same underlying API. Their intent is to balance expressiveness, conciseness and accessibility for visualising the data. To make the system work for complex cases as well as playful, exploratory ones, the interfaces offered by HT+BW vary in how many decisions have been made in the interface and how many decisions are left to the user. The non-consumptive "masking" of sensitive data is designed into the core API, so these interfaces do not require special considerations in their implementation. This approach also allows for the API to be the most advanced option for scholarship. The HT+BW API is entirely open, and researchers can craft their own custom queries through a web browser or by using a statistical programming library like Python or R.

HT+BW is a specific implementation of an open-access tool, Bookworm, against the HathiTrust collection. Bookworm was founded at the Harvard Cultural Observatory by Erez Lieberman Aiden and Jean-Baptiste Michel, following from their earlier work on the Google Ngrams Viewer (Aiden and Michel 2014). The Google Ngrams Viewer does not offer the same flexibility and metadata richness as HT+BW, primarily allowing a single view – time series line chart – over the entire collection. However, it *is* non-consumptive, an early and enlightening example of how massive datasets can be shown to people, and not only described. It is still being maintained, with an update in 2020, and serves as a good additional case of this form of exploratory data analysis tool. It has one primary strength over HT+BW: the inclusion of longer phrases (*n*-grams), whereas HT+BW is focused on unigrams. Its notable approachability has been influential, such as with FiveThirtyEight's tool for exploring a data dump of the *reddit* online community, "How the Internet Talks" (King and Olson 2015). Bookworm development has been led by Benjamin M. Schmidt (2011) for the past few years, and HT+BW's large-scale improvements were funded by the National Endowment for the Humanities (#HK-50176-14) and led by Schmidt and this chapter's authors.

HT+BW is a demonstrative example of Bookworm's functionality, but not the only one. Other institutions can freely make use of Bookworm, including the large-scale improvements developing for supporting a collection at the scale of the HathiTrust collection. This may be especially appropriate for institutions working to make their own collections of sensitive data accessible, whether they are copyrighted texts or simply texts that for various reasons a group may not want to distribute fully.

Other approaches

As we see with the multi-pronged approach to interfacing with HT+BW, so goes the broader HTRC strategy. In resolving to provide non-consumptive access and eluding direct access to raw text, the Center faces a challenge: that the scholars they serve have varied methodological approaches and research questions, and no single approach outside can meet that litany of needs. Practically, solutions such as a feature dataset or exploratory data analysis tool may meet enough needs to allow institutions or researchers to mediate access to sensitive materials. However, given its broad mission, the HTRC implements multiple strategies in order to minimise the use cases that cannot be met. As such, it is an interesting case study, offering different views of how non-consumptive research may be performed and the strengths and weaknesses of each.

Beyond the EF Dataset and HT+BW, the HTRC's other non-consumptive offerings are the *Portal*, a web interface for text mining tools; the *Data Capsule*, a secure virtual machine for research and *Advanced Collaborative Support (ACS)*, a program for partnering Center staff with scholars.

The HTRC Portal is a web-based toolkit that implements analytic tools in-browser. A scholar may select a custom subset of the HathiTrust Digital Library and apply an out-of-the-box algorithm to it in a custom job, such as named entity recognition and token counting. A user of the Portal specifies what they want and how, then receives the processed output.

A Portal approach has some advantages. It is easy to use and, in existing solely on the web, does not require much effort to learn. However, it is challenging to maintain and heavily restricts the types of uses on the data – each classifier, tokeniser, analyser needs to be explicitly prepared. To address this challenge, HTRC early on implemented a module-based platform, Software Environment for the Advancement of Scholarly Research (SEASR). SEASR uses a piped workflow paradigm (Ács et al. 2010), where a developer creates an algorithm by connecting modules, from input through to preprocessing, feature extraction, analysis and output. Still, user demand for more flexibility combined with the person-power required to manage the system has led to a partial deemphasizing of the Portal, which functions most prominently as an educational tool and an entryway to other non-consumptive tools.

Providing greater flexibility is the Data Capsule, which provides a secure, sanitised virtual machine for working with original, sensitive texts. The Data Capsule runs a Linux desktop environment on HTRC servers, into which an approved scholar connects. Once there, the system runs in two modes: maintenance mode and secure mode. In maintenance mode, the server is connected to the web and can install software or download datasets from the internet. However, no HathiTrust data is accessible, beyond a small sample set. When a scholar flips to secure mode, web connectivity in the virtual machine is blocked, so nothing can be brought in or taken out, but the HathiTrust Digital Library book data is mounted and accessible. The intent is for maintenance mode to be where research code and workflows are developed and secure mode where they are run.

The Data Capsule requires a stronger partnership with researchers as well as more supervision of their work. Only researchers from institutions with a legal partnership with the HathiTrust may process in-copyright texts, and all results that are intended to be removed from the data capsule must undergo a manual human review, to ensure that only non-expressive outputs are taken out. In essence, the Data Capsule is a digital version of a restricted research study or archive, where materials can only be handled on "location". The Data Capsule has some obstacles to adoption by other institutions, including time, manpower and computational costs. It needs to be hosted somewhere, is a complex paradigm engineering-wise, and requires staffing for moderation of exported results. In exchange for those hurdles, it offers the most flexibility for advanced scholarship, such as work on understanding gendered language in literature (Underwood, Bamman, and Lee 2018), and the study of books through the lens of critical reviews (Underwood 2020).

Each non-consumptive strategy taken by the HTRC balances a trade-off between access and flexibility. If these approaches are not sufficient, the HTRC offers a more bespoke approach through its ACS program. ACS is a series of grants of HTRC staff time. Scholars apply with projects that may not be tractable using publicly available tools and datasets and, if awarded, the HTRC will work with them on the research, including being the intermediary between the researcher and any in-copyright data. The program has supported a number of digital humanities and information science projects, such as a study of the influence of the Chicago school of architecture (Baciu 2019) and work into automated segmentation of book structure (McConnaughey, Dai, and Bamman 2017).

Broader impact

Non-consumptive or non-expressive use is a principle of scholarly research that considers ways for a work to be studied without revealing the original, copyrighted text. It can refer both to the product of research and primary source for research. In some jurisdictions, text mining applications that disseminate non-expressive results are explicitly or implicitly exempted from copyright law. However, this is complicated when multiple parties are involved. Whereas a scholar can perform text analysis on personally-obtained raw text, they cannot disseminate the original texts for reproducibility, nor can digital libraries share it in the name of access for scholars. For institutions and scholars seeking to improve access to privileged or sensitive materials, *non-consumptive by design* offers a path forward.

The HTRC has a mission to support research access to the extremely rich HathiTrust Digital Library collection, but that collection is two-thirds in-copyright. By the nature of that conundrum, the HTRC's services have had to be non-consumptive by design. Digital libraries and other research collections continue to grow, while text and data mining mature as methods in the digital humanities, computational social sciences and information science. If that growth continues – as the increasing investment in data as a service by academic publishers would suggest – it will be important for scholarly infrastructures to adapt to the increased value and demand for aggregate-level access to archival collections. The HTRC provides a template on how collections with privileged materials can balance ease of access with legal, ethical or proprietary restrictions.

Bibliography

Ács, Bernie, Xavier Llorà, Loretta Auvil, Boris Capitanu, David Tcheng, Mike Haberman, Limin Dong, Tim Wentling, and Michael Welge. 2010. "A General Approach to Data-Intensive Computing Using the Meandre Component-Based

Framework." In *Proceedings of the 1st International Workshop on Workflow Approaches to New Data-Centric Science (WANDS 10)*, 1–12. New York, NY: Association for Computing Machinery. https://doi.org/10/dv3j3s

Aiden, Erez and Jean-Baptiste Michel. 2014. *Uncharted: Big Data as a Lens on Human Culture*. New York, NY: Riverhead Books.

Baciu, Dan C. 2019. "Chicago Schools: Large-Scale Dissemination and Reception." *Prometheus* 2 (2). 20–43.

Bamman, D., M. Carney, J. Gillick, C. Hennesy, and V. Sridhar. 2017. "Estimating the Date of First Publication in a Large-Scale Digital Library." In *ACM/IEEE Joint Conference on Digital Libraries (JCDL)*, 1–10. https://doi.org/10.1109/JCDL.2017.7991569

Bertin-Mahieux, Thierry, Daniel PW Ellis, Brian Whitman, and Paul Lamere. 2011. "The Million Song Dataset." In *Proceedings of the 12th International Society for Music Information Retrieval Conference*, 2:10. Miami, FL.

Burrows, J. F. 1987. "Word-Patterns and Story-Shapes: The Statistical Analysis of Narrative Style." *Literary and Linguistic Computing* 2 (2): 61–70. https://doi.org/10.1093/llc/2.2.61

Burton, D. M. 1981. "Automated Concordances and Word Indexes: The Fifties." *Computers and the Humanities* 15 (1): 1–14. https://doi.org/10/btssqs.

Chin, Denny. 2013. *The Authors Guild v. Google, Inc.* S.D.N.Y.

Common Crawl. 2021. "Common Crawl." https://commoncrawl.org/

Darnton, Robert. 2013. "The National Digital Public Library Is Launched." *The New York Review of Books* 25. https://nybooks.com/articles/2013/04/25/national-digital-public-library-launched

Defferrard, Michaël, Kirell Benzi, Pierre Vandergheynst, and Xavier Bresson. 2017. "FMA: A Dataset for Music Analysis." In *International Society for Music Information Retrieval Conference (ISMIR)*.

Devlin, Jacob, Ming-Wei Chang, Kenton Lee, and Kristina Toutanova. 2018. "BERT: Pre-Training of Deep Bidirectional Transformers for Language Understanding," October. https://arxiv.org/abs/1810.04805v2.Archiv.org

European Parliament. 2019. "Directive (EU) 2019/790 of the European Parliament and of the Council of 17 April 2019 on Copyright and Related Rights in the Digital Single Market and Amending Directives 96/9/EC and 2001/29/EC." *Official Journal of the European Union*, May. https://eur-lex.europa.eu/eli/dir/2019/790/oj

Freeland, Chris. 2021. "Internet Archive's Modern Book Collection Now Tops 2 Million Volumes." *Internet Archive Blogs (blog)*. February 3, 2021. https://blog.archive.org/2021/02/03/internet-archives-modern-book-collection-now-tops-2-million-volumes/

Gage, Philip. 1994. "A New Algorithm for Data Compression." *C Users Journal* 12 (2): 23–38.

Geiger, Christophe, Giancarlo Frosio, and Oleksandr Bulayenko. 2018. "The Exception for Text and Data Mining (TDM) in the Proposed Directive on Copyright in the Digital Single Market - Legal Aspects." *SSRN Scholarly Paper ID 3160586*. Rochester, NY: Social Science Research Network. https://doi.org/10.2139/ssrn.3160586

HathiTrust. 2017. "Non-Consumptive Use Research Policy." *HathiTrust Digital Library*. https://www.hathitrust.org/htrc_ncup

HathiTrust. 2021a. "About." HathiTrust Digital Library. https://www.hathitrust.org/about

HathiTrust. 2021b. "HathiTrust Dates." HathiTrust Digital Library. https://www. hathitrust.org/visualizations_dates

HathiTrust. 2021c. "HathiTrust Languages." HathiTrust Digital Library. https:// www.hathitrust.org/visualizations_languages

Hockey, Susan. 2004. "The History of Humanities Computing." In *Companion to Digital Humanities*, edited by Susan Schreibman, Ray Siemens, and John Unsworth. Oxford: Blackwell Publishing Professional. http://www.digitalhumanities.org/ companion/

Holmes, D. I. 1985. "The Analysis of Literary Style – A Review." *Journal of the Royal Statistical Society: Series A (General)* 148 (4): 328–41. https://doi.org/10/ bghv3t

Hugenholtz, P. Bernt. 2013. "Fair Use in Europe." *Communications of the ACM* 56 (5): 26–28. https://doi.org/10/gjfvd3

Jessen, Jenica. 2020. "Looking Back on 2020." *Internet Archive Blogs (blog)*. December 19, 2020. https://blog.archive.org/2020/12/19/looking-back-on-2020/

Jett, Jacob, Boris Capitanu, Deren Kudeki, Timothy W. Cole, Yuerong Hu, Peter Organisciak, Ted Underwood, Eleanor Dickson Koehl, Ryan Dubnicek, and J. Stephen Downie. 2020. "The HathiTrust Research Center Extracted Features Dataset (2.0)." https://doi.org/10.13012/R2TE-C227

Jockers, Matthew, Matthew Sag, and Jason Schultz. 2012. "Brief of Digital Humanities and Law Scholars as Amici Curiae in Authors Guild v. Google." *SSRN Scholarly Paper ID 2102542*. Rochester, NY: Social Science Research Network. https://doi.org/10.2139/ssrn.2102542

JSTOR. n.d. "JSTOR Data for Research." JSTOR. Accessed February 5, 2020. https://www.jstor.org/dfr/

King, Ritchie, and Randy Olson. 2015. "How the Internet* Talks." FiveThirtyEight. Last updated September. 22, 2017. https://projects.fivethirtyeight.com/reddit-ngram/

Lazer, David, Alex (Sandy) Pentland, Lada Adamic, Sinan Aral, Albert Laszlo Barabasi, Devon Brewer, Nicholas Christakis, et al. 2009. "Life in the Network: The Coming Age of Computational Social Science." *Science* 323 (5915): 721–23. https://doi.org/10/c9w2g3

LexisNexis. 2003. "The LexisNexis Timeline." http://www.lexisnexis.com/anniversary/30th_timeline_fulltxt.pdf

Manovich, Lev. 2009. "Cultural Analytics: Visualising Cultural Patterns in the Era of 'More Media.'" Domus (March 2009). Milan.

McConnaughey, Lara, Jennifer Dai, and David Bamman. 2017. "The Labeled Segmentation of Printed Books." In *Proceedings of the 2017 Conference on Empirical Methods in Natural Language Processing*, 737–47. Copenhagen, Denmark: Association for Computational Linguistics. https://doi.org/10/ggc2kq

Michel, Jean-Baptiste, Yuan Kui Shen, Aviva Presser Aiden, Adrian Veres, Matthew K. Gray, Joseph P. Pickett, Dale Hoiberg, et al. 2011. "Quantitative Analysis of Culture Using Millions of Digitized Books." *Science* 331 (6014): 176–82. https:// doi.org/10.1126/science.1199644

Milligan, Ian. 2016. "Lost in the Infinite Archive: The Promise and Pitfalls of Web Archives." *International Journal of Humanities and Arts Computing* 10 (1): 78–94. https://doi.org/10/gjgnw7

Milligan, Ian. 2019. *History in the Age of Abundance? How the Web Is Transforming Historical Research*. Montreal, QC: McGill-Queen's University Press.

Moretti, Franco. 2013. *Distant Reading.* London: Verso Books.

Nelson, Laura K. 2014. *"The Power of Place: Structure, Culture, and Continuities in U.S. Women's Movements."* PhD diss. UC Berkeley. https://escholarship.org/uc/item/8794361r

Organisciak, Peter, Boris Capitanu, Ted Underwood, and J. Stephen Downie. 2017. "Access to Billions of Pages for Large-Scale Text Analysis." In *iConference 2017 Proceedings* Vol. 2. Wuhan, China: iSchools. https://doi.org/10.9776/17014

Organisciak, Peter, Summer Shetenhelm, Danielle Francisco Albuquerque Vasques, and Krystyna Matusiak. 2019. "Characterizing Same Work Relationships in Large-Scale Digital Libraries." In *International Conference on Information,* 419–25. Cham, Switzerland: Springer.

Osterberg, Gayle. 2017. "Update on the Twitter Archive at the Library of Congress. Library of Congress Blog." Last updated December 26, 2017.//blogs.loc.gov/loc/2017/12/update-on-the-twitter-archive-at-the-library-of-congress-2/

Palmer, Carole L., Oksana L. Zavalina, and Megan Mustafoff. 2007. "Trends in Metadata Practices: A Longitudinal Study of Collection Federation." In *Proceedings of the 7th ACM/IEEE-CS Joint Conference on Digital Libraries,* 386–95. JCDL '07. New York, NY: Association for Computing Machinery. https://doi.org/10/djcbw8

Parker, Barrington Daniels Jr. 2014. *Authors Guild, Inc. v. Hathitrust.* S.D.N.Y.

Pechenick, Eitan Adam, Christopher M. Danforth, and Peter Sheridan Dodds. 2015. "Characterizing the Google Books Corpus: Strong Limits to Inferences of Socio-Cultural and Linguistic Evolution." *PLoS One* 10 (10): e0137041. https://doi.org/10.1371/journal.pone.0137041

Peter Suber. 2005. "The Open Content Alliance." *SPARC Open Access Newsletter,* November 2, 2005. https://dash.harvard.edu/bitstream/handle/1/4552008/suber_oca.htm?sequence=1

Peters, Matthew E., Mark Neumann, Mohit Iyyer, Matt Gardner, Christopher Clark, Kenton Lee, and Luke Zettlemoyer. 2018. "Deep Contextualized Word Representations." ArXiv:1802.05365 [Cs], February. http://arxiv.org/abs/1802.05365

Purday, Jon. 2009. "Think Culture: Europeana.eu from Concept to Construction." *The Electronic Library* 27 (6): 919–37. https://doi.org/10/c4mkkp

Ross, Stephen, and Jentery Sayers. 2014. "Modernism Meets Digital Humanities." *Literature Compass* 11 (9): 625–33. https://doi.org/10/gmxdw9

Samberg, Rachael Gayza, and CodyHennesy. 2019. "Law and Literacy in Non-Consumptive Text Mining: Guiding Researchers Through the Landscape of Computational Text Analysis." In *Copyright Conversations: Rights Literacy in a Digital World*, Sara R. Benson, ed. Chicago, IL: Association of College and Research Libraries. https://escholarship.org/uc/item/55j0h74g

Schmidt, Benjamin M. 2011. "Bookworm." *Beta Sprint Competition Selection presented at the Digital Public Library of America Plenary Meeting*, Washington, DC, October 21: Digital Public Library of America.

Schofield, Alexandra, Laure Thompson, and David Mimno. 2017. "Quantifying the Effects of Text Duplication on Semantic Models." In *Conference on Empirical Methods on Natural Language Processing.* Copenhagen, Denmark. http://www.cs.cornell.edu/~xanda/textduplication2017.pdf

Sennrich, Rico, Barry Haddow, and Alexandra Birch. 2016. "Neural Machine Translation of Rare Words with Subword Units." ArXiv:1508.07909 [Cs], June. http://arxiv.org/abs/1508.07909

Sprokel, Nico. 1978. "The 'Index Thomisticus.'" *Gregorianum* 59 (4): 739–50.

Tukey, John W. 1977. *Exploratory Data Analysis*. Reading, MA: Addison-Wesley Publishing Company. http://www.ru.ac.bd/wp-content/uploads/sites/25/2019/03/102_05_01_Tukey-Exploratory-Data-Analysis-1977.pdf

Underwood, Ted. 2017. "A Genealogy of Distant Reading." *Digital Humanities Quarterly* 011 (2). http://www.digitalhumanities.org/dhq/vol/11/2/000317/000317.html

Underwood, Ted, and Jordan Sellers. 2016. "The Longue Durée of Literary Prestige." *Modern Language Quarterly* 77 (3): 321–44. https://doi.org/10.1215/00267929-3570634

Underwood, Ted. 2020. "There's No Such Thing as Bad Publicity: Toward a Distant Reading of Reception." Paper Presented at *MLA 2020*. Seattle, USA: Modern Language Association.

Underwood, Ted, David Bamman, and Sabrina Lee. 2018. "The Transformation of Gender in English-Language Fiction." *Journal of Cultural Analytics* 1 (1) (February 13, 2018): 11035. https://doi.org/10/gjjz7h

Unsworth, John. 2004. "Forms of Attention: Digital Humanities Beyond Representation" In *Third Conference of the Canadian Symposium on Text Analysis (CaSTA)*, Hamilton, ON: McMaster University. https://johnunsworth.name/FOA/

Wilkinson, Leland. 1999. *The Grammar of Graphics*. New York, NY: Springer-Verlag.

9 SKOS as a key element for linking lexicography to digital humanities

Rute Costa, Ana Salgado, and Bruno Almeida

Introduction

The humanities, where traditionally dictionaries fit into, have undergone significant changes in recent years regarding the production, research, publication, dissemination, preservation and sharing of information. Nowadays, the concept of "digital humanities" is characterised by associating the field of traditional humanities with computational methods, encompassing computation for the humanities, computational linguistics (Hockey 2004; Gold and Klein 2019) and ontologies, among others. Like digital humanities and lexicography, information science is contributing to the effort of sharing information, transferring its reference objects, thesauri, into digital versions in SKOS format. In the introduction to ISO 25964-1, 2011 one can read: "Today's thesauri are mostly electronic tools, having moved on from the paper-based era when thesaurus standards were first developed." (6). Historical dictionaries are going in the same direction – from paper to digital – requiring standards and tailored software to ensure effective interoperability.

The research is relevant because we believe that this project will contribute significantly to the analysis and annotation of Portuguese lexical resources using computer-assisted processes. It will allow us to rethink how to design new lexicographical products that are not merely a simple reproduction of paper editions, which will respond more effectively to the needs of the end-users. While digitisation signalled the modification of a paradigm, the spread of the Web has shaped a new concept for lexicographic works. Today we can create dynamic, more robust lexicons enriched with semantic, conceptual and statistical information and take advantage of Linked Data, highlighting the notion of content models and data mining by joining digital humanities and lexicography. Generating or re-digitising lexicographic products has linguistic, heritage and historical relevance, contributing to the establishment of the lexicon of a language at a given time, around which the identity of a linguistic and cultural community is built and preserved.

VOLP-1940, an ongoing project, is the first of a series of orthographic vocabularies published by the Lisbon Academy of Sciences (ACL) to be

DOI: 10.4324/9781003131816-9

digitised to create a lexicographical corpus. The digitisation of VOLP-1940 aims to allow its computational processing by creating a lexicographical resource encoded in Text Encoding Initiative (TEI P5), with structured information in Simple Knowledge Organisation System (SKOS), and in line with the Findable, Accessible, Interoperable, Reusable (FAIR) principles (see FAIR Principles). This will serve to guarantee its future connection to other systems and resources, in particular in the Portuguese-speaking world. This research also aims to fill a gap in Portuguese lexicography, given that legacy dictionaries are still rare online (Williams 2019, 83). These resources need to be encoded and published on the web, based on current standards and methodologies that enable data sharing and harmonisation as well as their alignment with existing lexical resources.

This chapter falls within the domain of the application of digital lexicography in the context of a scholarly editing project and is based on a set of methodological and theoretical assumptions for which we will make some considerations. We will focus on the organisation of linguistic information of a lexicographical nature within the field of digital humanities, emphasising the development of a cross-disciplinary methodology that combines lexicography and information science. Our goal is to attest the strong relationship between lexicographic practice, dictionaries and digital humanities, where we include information science (Robinson, Priego, and Bawden 2015).

We aim to build a digital lexicographical corpus bringing together the publicly available printed versions of ACL vocabularies (1940, 1947, 1970, 2012), and improving multiple search functionalities, as a source of scientific research and cultural heritage, especially on the evolution of Portuguese language and culture. Underlying this goal, we have a central research question: how could digital humanities integrate annotated dictionaries in a wider community, contributing and intervening in collaborative information organisation, search and retrieval in digital cultural heritage collections? The second main question related to the previous one concerns the standards: how could we join efforts to make different standards coming from different communities, such as SKOS and TEI, becoming more effective, contributing to the operationalisation of vocabularies?

This rest of this chapter is organised as follows. The section titled Background provides an overview on the relation between lexicography and information science as part of the digital humanities and existing standards. The section titled Case Study is dedicated to the *Vocabulário Ortográfico da Língua Portuguesa* (VOLP-1940; Orthographic Vocabulary of the Portuguese Language; see Academia das Ciências de Lisboa, 1940). After presenting our lexicographical case study, we describe the structure of the vocabulary, focusing on the macrostructural and microstructural main components and continue with a proposal of modelling in SKOS(-XL) and encoding in TEI Lex-0. Finally, we highlight our future work and present concluding remarks.

Background

Lexicography and information science as part of digital humanities: A brief overview

The field of lexicography, currently defined as the "total of all activities directed at the preparation of a lexicographic reference work" (Wiegand et al. 2020, 224 Wiegand et al. 2020, 224), aims to produce a great variety of resources, namely, dictionaries, vocabularies, glossaries and encyclopaedias. However, while a variety of lexicographical works were still being published on paper at the start of the 21st century, this scenario has changed radically over the past two decades. This is especially due to the ongoing transition to digital, the downfall of many renowned publishers and the changes introduced to editorial business models (Rundell 2010, 170). Terms such as "online dictionaries" and "e-lexicography" started to appear but were soon replaced by "digital dictionaries" and "digital lexicography". This change in terminology has led to a paradigm shift directly related to the advancement of the field of digital humanities, which has quickly become a catalyst for academic research in the interface between humanities and computation. While early definitions of digital humanities were limited to the humanities computing (Terras et al. 2013), today, its definition is far from reaching a consensus (Gold and Klein 2019). This is because it covers a wide variety and assortment of works from different branches of knowledge that are characterised by the use of tools, digital methods and standards to ensure the long-term growth of the Web, primarily implying a new look at the humanities in general.

Within digital humanities, we can find lexicography and its products, that is, lexicographical reference works. Dictionaries must be converted into digital resources to enable information retrieval on the Web. This transformation must be adequately addressed to optimise access to linguistic and lexicographical information until the dictionaries become actual digital resources. On the other hand, dictionaries are also cultural objects whose heritage must be preserved and made available to the entire community. Our research focus is to undertake a precise linguistic analysis and description of the object-language, that is, a language that is the object of study in various fields, and to organise linguistic data (e.g., linguistic variants, grammatical information and domain labels, among others) according to the microstructure of the lexicographical articles, namely the dictionary entry (the part of a dictionary that contains information related to one lemma and its variants (ISO 1951 2007)) specific to each dictionary model.

Another field that stands out within digital humanities, and is of interest to our research, is information science, an interdisciplinary field concerned with "the origination, collection, organisation, storage, retrieval,

interpretation, transmission, transformation and use of information"
(Borko 1968, 3). Information includes all encoded representations (in natural
language or other modalities) that can be transmitted, stored and organised
for subsequent retrieval. As Saracevic (1999) noted, the study of informa-
tion involves not only the encoded messages and their interpretation and
processing but also the wider social context in which information is used.
Born out of the so-called "information explosion" of the post-WW2 period,
information science became a necessity in the newly formed information
and knowledge societies, wherein information retrieval methods and tech-
nologies are paramount.

The ties between terminology science and information science were
noted from the beginnings of terminology as a contemporary subject of
inquiry. As one of the early proponents of terminology as a discipline in
its own right noted, terminologies are fundamental for "the storage and
retrieval of scientific and technical information" (Felber 1984, 1), inclu-
ding applications such as thesauri and the classification schemes. The
ties between information science and lexicography remain less obvious.
Lexicography has traditionally been understood as the art and craft of
compiling general language dictionaries (Landau 2001) and is often seen as
a branch of applied linguistics. However, there is a more holistic approach
that embraces lexicography's relationships with lexicology, terminology,
encyclopaedias and information science. According to this broader view,
metalexicography "should be regarded as part of information science"
(Wiegand 2013, 14). More than describing the lexicon of languages, the
purpose of lexicography is to "resolve specific types of information needs
detected in society" (Tarp 2018, 22). Indeed, it can be argued that lexico-
graphy is aimed "in a more general way at the production of informa-
tion tools" (Bergenholtz and Gouws 2012, 40), that is, reference works
currently focused on "enhanced information retrieval" (ibid.). The ties
between lexicography and information science have also been noted in
the latter community, especially in the context of digital lexicographi-
cal research based on end-user information needs and access to lexico-
graphical data (Bothma 2018). Knowledge organisation (KO), a subfield
of information science, is especially relevant for drawing relationships
between information science and lexicography. KO is concerned with the
activities of document description, indexing and classification (usually
referred to as KO processes) carried out in information services, such as
libraries and archives, as well as with the knowledge organisation systems
(KOS) employed to carry out such activities (Hjørland 2008). The latter
include widely different resources, ranging from flat term lists to struc-
tured resources, such as thesauri and ontologies (Hodge 2000; Zeng 2008).
Contrary to KOS, the traditional products of lexicography and termino-
logy are not aimed at facilitating information retrieval through the KO
processes mentioned above. Instead, the structuring of knowledge present
in lexicographical products aims to facilitate the retrieval of information

about the words and senses of one or more languages, e.g., through the use of lists of abbreviations representing lexicographical categories (as will be shown in the section titled Case Study with VOLP-1940). Terminological products, on the other hand, structure knowledge through concept systems based on generic, partitive and associative relations between concepts in specialised domains (ISO 1087, 2019). Therefore, terminologies are very similar to thesauri for information retrieval (ISO 25964-1, 2011; ISO 25964-2, 2013), although the former aim at improving specialised communication, while the latter are focussed on retrieving indexed information resources. Despite these differences, dictionaries, glossaries and other terminological products may also play a role in information retrieval, e.g., for extending thesauri (as a source for concepts, terms and scope notes) or complementing them in full-search applications (ISO 25964-2, 2013 §22.3).

Standards

Conceiving digital lexicographical resources increasingly requires the application of adapted standards and tools capable of guaranteeing the availability of structured data and ensuring interoperability between systems. To change a raw document into a structured one, it is necessary to define the different types of data that make up the document for modelling it according to a standardised data model, which makes interoperability feasible. Interoperability is (from manuscripts to poems, dictionaries, culinary recipes, corpora annotation and many others) despite not having the legal status of a standard (Stührenberg 2012). Interoperability is the "capability to communicate, execute programs, or transfer data among various functional units in a manner that requires the user to have little or no knowledge of the unique characteristics of those units" (ISO/IEC 2382, 2015). While the conversion of printed dictionaries signalled a paradigm shift, the dissemination of the Web has forced us to rethink the concept of lexicographical work. More than ever, we must learn how to take advantage of and explore the possibilities of the digital environment (Trap-Jensen 2018) by creating dynamic and robust lexicons augmented with semantic, conceptual and statistical information, wherein data from different resources can be interconnected (Linguistic Linked Open Data Cloud 2021). Although a reasonable number of Portuguese lexicographical works can currently be consulted online, these resources end up being static; hence, there is a need for some sort of icebreaker.

As Tasovac (2010, 1) stated, "we cannot think of dictionaries any more without thinking about digital libraries and the status which electronic texts have in them". Keeping in mind this new reality, we propose to apply new principles, that is, computational methods, interoperable standards and semantic technologies that facilitate the organisation of large amounts of lexical data. These methods, standards and technologies will be further described below.

De facto standard: Text encoding initiative (TEI) and TEI Lex-0

For lexical data annotation, TEI has become a *de facto* international standard for the encoding of different types of documents (manuscripts, poems, dictionaries, culinary recipes, annotated corpora and many others). TEI was created in 1987 by a consortium of several institutions, the TEI Consortium, to develop a standardised format for the electronic edition of textual content in multiple formats. It presents a metalanguage comprising a vocabulary (a set of elements and attributes) and a grammar (a schema) to annotate, structure and validate documents, whose specific syntax and semantics in Extensible Markup Language (XML) make it a textual analysis method for digital processing.

The current version of the *TEI Guidelines* (TEI Consortium) continues to be the subject of constant updates. In our case study, we chose to follow this standard format because it is commonly used to share lexicographical data and ensures the digital preservation of the dictionaries and their interoperability. The complexity of lexicographical resources has been recognised by the scientific community (Salgado et al. 2019), both because of the diversity of its structural components and as different resources follow different criteria for the representation and processing of lexicographical information.

The most recent version of the *TEI Guidelines* is known as P5. These guidelines have a specific module for dictionaries: Chapter 9. Here too, the word "dictionaries" is taken in its most general sense, that is, encompassing not only dictionaries but also, as previously mentioned, vocabularies, encyclopaedias and glossaries. Since the *TEI guidelines* are characterised by their highly flexible annotation potential – several encoding possibilities for the same elements, which poses an obstacle for interoperability – TEI Lex-0, a new, simplified TEI sub-format for dictionaries (in the broad sense of the term) is being developed specifically to encode lexical resources, the application of which will be detailed later in this chapter.

The groundwork for this format started in 2016 and is currently led by the Digital Research Infrastructure for the Arts and Humanities (DARIAH n.d.) Lexical Resources Working Group. TEI Lex-0 aims to define a clear and versatile annotation structure, albeit not too permissive, to facilitate the interoperability of heterogeneously encoded lexical resources. TEI Lex-0 should be regarded as "a format that existing TEI dictionaries can be unequivocally transformed to, in order to be queried, visualised or mined uniformly" (Tasovac et al. 2018). As the layout of this format has not been finished yet, we have been actively contributing to its development by raising issues on GitHub.

W3C recommendation for the semantic web: SKOS

SKOS is a model for sharing and linking KOS, such as thesauri, taxonomies, classification schemes and other structured and controlled vocabularies available on the Web (Baker et al. 2013). The model is expressed as

an ontology in Web Ontology Language (OWL), which enables the modelling of controlled vocabularies as Resource Description Framework graphs (RDF), as well as their mapping to external resources and integration in the Linguistic Linked Open Data Cloud (Linguistic Linked Open Data Cloud n.d.). The early developments that have led to SKOS started in the late 1990s and early 2000s in the context of several European projects focused on improving the browsing and discoverability of Web resources. SKOS answered the need for a common RDF schema for modelling thesauri, a type of knowledge organisation system and defining inter vocabulary mappings. The model became a World Wide Web Consortium (W3C) recommendation in 2009 (Miles and Bechhofer 2009). SKOS is widely used by the information science community for publishing KOS in the Semantic Web though its mostly suited for thesauri. A few notable examples include the EU Vocabularies (EU Vocabularies n.d.) and the Getty Art and Architecture Thesaurus (Art & Architecture Thesaurus Online).

The central units of SKOS are concepts, which are informally defined as ideas or notions, typically represented in thesauri, taxonomies and other KOS for information retrieval. Among other possibilities, the model allows for concepts to be identified with URIs, lexicalised with multilingual labels (preferred, alternative, and hidden), documented with notes, linked to other concepts through conceptual relations (broader, narrower or associative) and mapped to concepts in external resources. While the core SKOS model only allows for relations between concepts, the SKOS-XL extension has brought support for modelling relations between concept labels. The latter include the relations between abbreviations and their full forms (e.g., between "EU" and "European Union"), which will be exemplified later in this chapter concerning the modelling of lexicographical information.

Both standards, TEI and SKOS, have been applied to the VOLP-1940 following a precise methodology described below based on the relationship between linguistic and lexicographical knowledge and information science.

Case study: Vocabulário ortográfico da língua portuguesa (VOLP-1940)

This section is structured around research issues related to VOLP-1940. After presenting our lexicographical case study, we describe the structure of the vocabulary, focusing on the macrostructural and microstructural main components. The next subsection is devoted to front matter analysis. The two subsequent subsections are dedicated to modelling in SKOS(-XL) and encoding in TEI Lex-0.

General considerations on the VOLP-1940

The case study presented in this chapter is the digital conversion of the paper edition of the first Portuguese Academy vocabulary of a series of subsequent vocabularies – 1947, 1970 and 2012 – published in 1940. The

document is named *Vocabulário Ortográfico da Língua Portuguesa* (VOLP-1940), published by Imprensa Nacional de Lisboa with the seal of the ACL in a volume of 821 pages.

The spelling proposed in this work was governed by the 1911 spelling reform, backed by two other elements: the 1920 spelling reform, which changed some provisions of the 1911 reform, and the 1931 Portuguese-Brazilian Orthographic Agreement, signed by the Portuguese and Brazilian academies. This lexicographical work has immense historical and linguistic value since it served as the basis for the ACL and the Brazilian Academy of Letters to discuss a new orthographic measure that came to result in the Portuguese-Brazilian orthographic convention of 1945, commonly known as the Orthographic Agreement of 1945, which was in force until 2011.

We aim to do the following: (i) create a new online lexicographical resource, accessible to the entire scientific community and the general public; (ii) work on the metadata providing consistency, following an exact linguistic annotation strategy in line with TEI recommendations, while ensuring the data are accessible and reusable; (iii) organise metadata information according to SKOS; (iv) describe the linguistic annotation for further semantic enrichment of the database and (v) add new metadata information, namely, domain names and information that will be recovered from other lexicographical works that contain this annotation, and make the connection between several synonymous units that are included in the work's word list. The tasks described above are necessary for improving information retrieval within VOLP-1940 by scholars in linguistics and digital humanities, as well as for ensuring the interoperability of our dataset with third-party systems.

With the publication of the VOLP-1940, the ACL intended to establish the official spellings of Portuguese words in their national variety, having become a "referência normalizadora para a fixação da nomenclatura em quase todos os dicionários escolares e práticos publicados após a sua divulgação" (standardising reference to establish the [Portuguese] vocabulary in almost every academic and practical dictionary published after its dissemination; Verdelho, 2007).

Since the VOLP-1940 is organised around two structures, its macrostructure and microstructure, our research also focuses on these two parts separately. Rey-Debove (1971) envisioned the macrostructure as the list of every word that is described in a dictionary, while the microstructure refers to the information provided about each lexical unit, that is an "unit of language, belonging to the lexicon of a given language and which is described or mentioned in a dictionary" (ISO 1951, 2007).

The VOLP-1940 macrostructure

In macrostructural terms, the list of entries "covers only the modern Portuguese language, i.e., the linguistic period that runs from the 16th

century to the present time [i.e., 1940]" (Academia das Ciências de Lisboa, 1940, p. XII), registering lexical units that entered the language after 1500 and leaving out units "pertencentes ao período arcaico do idioma" (that belong to the archaic period of the language; Academia das Ciências de Lisboa, 1940, 12).

The preliminary pages present a dedication and an "Introdução" (Introduction; 9–86), prefaced by Francisco Rebelo Gonçalves (1907–1982), one of the great Portuguese philologists of the 20th century in Portugal. The introduction consists of three chapters: "Preliminares" (Preliminaries), "Normas da escrita portuguesa" (Standards of Portuguese spelling) and "Comentários ortográficos" (Spelling comments).

The VOLP-1940 is further divided into three main parts, namely 1) common vocabulary, 2) onomastic vocabulary and 3) registration of abbreviations.

1 COMMON VOCABULARY (3–713) of the "léxico geral da língua des-contados os nomes próprios" [general lexicon of the language excluding proper names], including elements of composition (9);
2 ONOMASTIC VOCABULARY (717–809), "nomes próprios de várias categorias" [proper names of various categories] (9), such as anthropo-nyms, toponyms and patronyms, as well as ethnonyms, hieronyms (sacred names), mythonyms, chrononyms (calendar names) and biblionyms;
3 REGISTRATION OF ABBREVIATIONS (appendix), commonly used at the end of the 1930s (813–819): "portuguesas e ainda de outras não portuguesas que são empregadas na nossa escrita [...] as abreviaturas de maior importância para os usos correntes e de maior curiosidade geral para os dois países de língua portuguesa" [Portuguese and other non-Portuguese abbreviations that are used in our writing [...] the abbreviations of greatest importance for current uses and of greatest general interest for the two Portuguese-speaking countries] (9).

The lexical units that comprise the entry words of the VOLP-1940 are orga-nised into three columns per page, listed alphabetically, and are followed by various classifications, such as grammatical information and pronunciation information, among others, as we will demonstrate in the next subsection.

The microstructure of the VOLP-1940

In microstructural terms, a lexicographical article from the VOLP-1940 may, as a rule, include the following elements:

1 Lemma: It is a "lexical unit, chosen according to lexicographical conventions to represent the different forms of an inflection par-adigm" (ISO 1951, 2007). In this vocabulary, it corresponds to the singular form of the noun or adjective and the masculine form when there is gender inflection in variable words. In the case of verbs, it

corresponds to the form of the impersonal infinitive. It should be noted that the elements of composition, that is, "todo o elemento que se baseie etimologicamente num tema nominal, pronominal, ou verbal, qualquer que seja o seu lugar no composto" (any element that is etymologically based on a nominal, pronominal, or verbal base, whatever its place in the compound) (21), for instance, "mono-" and "-grafia", also appear in the word list. In this case, the base is followed by a hyphen (geo-) or preceded by a hyphen (-mente), followed by the indication "el. comp." (composition element) and a descriptive text of the employment of this element, providing examples at the end to illustrate the application of the spelling rule that is usually stated. There are also notes on spelling variants, for instance, "cenoura" and "cenoira" (carrot). Variants of the canonical form do not normally feature in the word list, e.g., "cenoira" does not appear in the list of entries but can only be found in the lexicographical article "cenoura". There are some exceptions to this criterion that are explained in the Introduction (18), such as "cousa" and "coisa" (thing). In such cases, whenever the variant is more usual than the basic form, it also features in the word list.

2 Orthoepy: The standard indication of the pronunciation of a lexical unit, which appears in parentheses after the base, and only in words of doubtful pronunciation. When it is not marked graphically, the pitch of the closed stressed vowels "e" and "o" can also be provided. Additionally, particular stressed vowels that are often pronounced incorrectly will also be marked. On the matter of orthoepy in Portuguese, see section 4 of the paper "Orthography and Orthoepy" (Gonçalves 2020, 651–677).

3 Part of speech: "A category assigned to a lexical unit based on its grammatical and semantic properties" (ISO 1951, 2007), which appears after the base or orthoepy when marked and is indicated in abbreviated lowercase. In the part corresponding to proper names, the classifications are onomastic, for instance, anthroponym (antr.) and toponym (top.). Further, although they are not parts of speech, this information is provisionally encoded in this field for practical reasons; this issue is being debated by the "Lexical Resources" DARIAH Working Group.

4 Gloss: Understood as "a textual description of a sense's meaning" (Salgado et al. 2020), it appears only to disambiguate cases of homonymy, to which a number is added (1, 2 etc.), superscripted on the right-hand side of the base as a way of distinguishing them. Consider, e.g., "afecto[1] (*ét*) s. m.: afeição" [affection] and "afecto[2] (*ét*) adj.: afeiçoado" [attached].

There is also information about words that are almost exclusively used in phrases. For example, when a particular word is only used in a particular

phrase, this indication appears as an entry in what is considered the core word of that phrase – for instance, "cavalitas, el. nom. f. pl. na loc. adv. mod. às cavalitas" (riding piggyback, plural feminine noun element).

Another indication of a prescriptive nature concerns constructions that begin with the expression "Melhor que" (Better than). The forms indicated as preferable are those that are considered to be closest to their origin or more correct for certain reasons, such as "canon" and "cânone" – "cânone, s. m. Melhor que canon" (cânone [canon], s. m. better than canon [Portuguese orthographic variant of the first form]). So far, we have identified the essential and most relevant elements of the VOLP-1940's microstructure. This analysis is crucial for the linguistic annotation phase discussed below.

The list of abbreviations and conventional signs

Now, we move on to the analysis of the front matter, specifically, the list of abbreviations. First, we describe the content and then, we focus on the modelling of the lexicographical data using SKOS. To conclude, we exemplify the encoding of a lexicographical article with TEI Lex-0.

On the initial pages of the VOLP-1940, in the front matter materials, a "Lista de abreviaturas e sinais convencionais" (List of abbreviations and conventional signs; 89–92) can be found. In this study, we focus on organising this list for computational processing using SKOS and TEI Lex-0 to ensure the interoperability that will be necessary, in the future. In the paper version, this list is sorted alphabetically and divided into two parts: (i) List of abbreviations and (ii) List of conventional signs. The list shows the abbreviations or conventional signs followed by their full form. Our analysis is anchored on the first part, from which we draw up a classification of the 220 abbreviations that comprise the list. Although this list is well organised into two columns, it is static and has some limitations inherent to the paper format. From this simple alphabetical list, whose original page is retained on the website of this project, we proceeded to its organisation and representation for the digital environment as well as its linguistic annotation.

After a thorough analysis of the abbreviations that make up the list of abbreviations in the VOLP-1940, the following types have been identified: part of speech; onomastic classification; grammatical gender; grammatical number; language; register; tense; etymology; word-formation and others (see Appendix). Thus, these categories constitute what we call the typological organisation of the list of abbreviations. In the transition from paper to digital, we had to reorganise the content of this list to be able to process it and ensure its future interoperability. Therefore, from the total list of abbreviations, we isolated those related to word classes. Based on this list, and for interoperability with other lexicographical resources,

Table 9.1 Sample matches between the VOLP-1940 word classes and Universal Dependencies Part-of-Speech values

VOLP-1940	Universal dependencies Part-of-speech	Universal POS tags
OPEN CLASS WORDS		
adjetivo (adj.)	*adjective*	ADJ
advérbio (adv.)	*adverb*	ADV
interjeição (inter.)	*interjection*	INTJ
substantivo (s.)	*noun*	NOUN
verbo (v.)	*verb*	VERB
CLOSED CLASS WORDS		
artigo (art.)	*determiner*	DET
conjunção (conj.)	*coordinating conjunction*	CCONJ
	subordinating conjunction	SCONJ
numeral (num.)	*numeral*	NUM
preposição (prep.)	*adposition*	ADP
pronome (pron.)	*pronoun*	PRON

we made the correspondence between word classes and the values of the Universal Dependencies Part-of-Speech (Universal Dependencies n.d.), a framework for consistent annotation of grammar, which will be exemplified in Table 9.1. The indication of *part of speech* (morphological categories and subcategories) is used in the "Common vocabulary" part. This indication provides information not only concerning the category of a lexical unit (e.g., pronoun, numeral, adverb or conjunction) but also its subcategory; for instance, there are specific labels for adverbs, such as "adv. af." (assertion adverb) or "adv. conf." (confirmation adverb). Sometimes, there is also some classifying information in this part, such as "phrase", that does not belong to a part of speech. On the other hand, in "Onomastic vocabulary", to differentiate the onomastic forms that make up the word list of this part according to the type of entities they apply to, traditional labels are used, which constitute what we call onomastic classification.

Abbreviations are also used, which are related to the indication of grammatical gender, namely, "m." (masculine), "f." (feminine) or "2 gen." (both genders); the indication of grammatical number, namely, "pl." (plural), "sing." (singular) or "2 núm." (both numbers); tense indications; etymology; word formation and abbreviations related to word-formation processes; and others. The last element is a set of abbreviations that we have not classified because they are not particularly interesting for the present research.

In addition to the abbreviations used to mark word classes, we also found abbreviations that refer to the language. This information is used in the

VOLP-1940 to identify the source language of a particular word; therefore, we also mapped these abbreviations to Tags for Identifying Languages (IETF BCP 47 n.d.), which is a set of codes to identify human languages. Tags are generally used to indicate the language of the content in a standardised way; e.g., "croché" is identified as the Portuguese version of the French "crochet", and the code used for the abbreviation "fr." (of French) in this case matches the abbreviation used in the VOLP-1940. The *register* label, defined by the standard (ISO/TR 20694, 2018, the ISO standard that gives the general principles for language registers in both descriptive and prescriptive environments) as "language register, language variety used for a particular purpose or in an event of language use, depending on the type of situation, especially its degree of formality", is also used; e.g., "ant." (old), "arc." (archaic) and "pop." (popular).

Modelling in SKOS(-XL)

After a careful analysis of the structure of the VOLP-1940, we will now move on to the first stage of modelling the list of abbreviations in SKOS. Figure 9.1 below shows the overall model of the lexicographical categories used for organising the list of abbreviations. In the examples shown

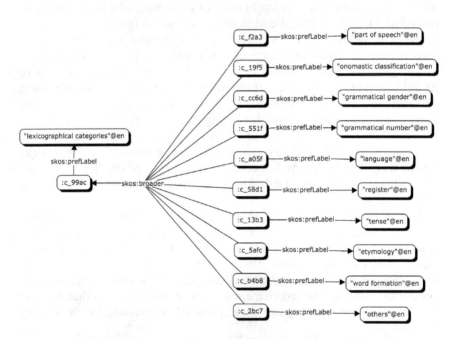

Figure 9.1 Lexicographical categories for modelling the list of abbreviations in SKOS.

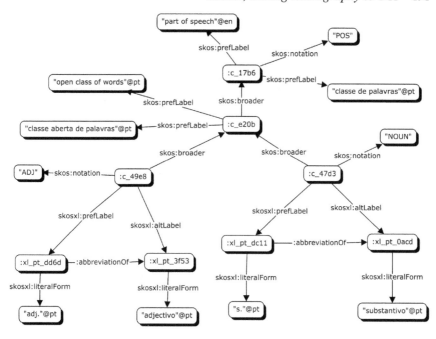

Figure 9.2 Part of speech abbreviations in SKOS (noun and adjective).

in this subsection, SKOS concepts and SKOS-XL labels are identified with URI placeholders (e.g., ":c_17b6", ":xl_pt_3f53"). We have specified the above-mentioned categories based on examples of part of speech and language concepts.

Figure 9.2 below shows the modelling of the noun and adjective concepts ("substantive" and "adjective" in Portuguese), both open classes of words. SKOS-XL is used for modelling lexical units as classes with their own URIs. This allows for the use of an abbreviation relation (abbreviationOf), which holds between the abbreviations and the full forms. For example, the label "s." (URI:xl_pt_dc11) is modelled as an abbreviation of the full form "substantivo" in Portuguese (URI:xl_pt_0acd). In this model, abbreviations are preferred labels, while the full forms are alternative labels for the concepts. The Universal Dependencies Part-of-Speech tags are modelled via the skos:notation property, which allows for the identification and retrieval of each concept regardless of language. For example, the tag for nouns (NOUN) is represented as a notation of the noun concept in our model (URI:c_47d3).

Figure 9.3 below shows the modelling of the Portuguese and French language labels. Here, abbreviations are also declared as preferred labels ("port." and "fr."), while the full forms are alternative labels ("português"

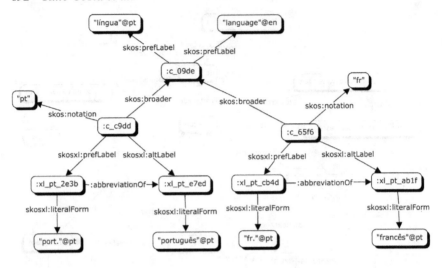

Figure 9.3 Language abbreviations in SKOS (Portuguese and French).

and "francês", respectively). For example, the label "port." (URI:xl_pt_2e3b) is declared as an abbreviation of the full form "português" in Portuguese (URI:xl_pt_e7ed). Language codes are also added through the skos:notation property, corresponding to IETF BCP 47 codes. For example, the language code for Portuguese (pt) is represented as a notation of the noun concept in our model (URI:c_c9dd).

These examples show how a model originating in the information community can be applied in the modelling of lexicographical resources More specifically, this approach will be used to annotate the TEI-encoded entries of the VOLP-1940 with URIs corresponding to elements of our SKOS model of the list of abbreviations. For example, the URI of the "s." element can be associated with all noun entries in the TEI encoding of the VOLP-1940. Furthermore, an information system will be able to interpret that all nouns in the VOLP-1940 correspond to an open class of words.

The approach outlined facilitates the retrieval of structured lexicographical information from VOLP-1940 and its interoperability with external systems. This approach also facilitates the use of VOLP-1940 for NLP and information retrieval applications, e.g., for word-sense disambiguation and analysis of semantic change.

Encoding in TEI Lex-0

As already mentioned, a lexicographical article in the VOLP-1940 starts with a base corresponding to the entry, followed by the grammatical information about that unit. This is the basic and regular structure of a VOLP-1940 entry to which the TEI Lex-0 annotation was applied (see Example 9.1):

Example 9.1

Basic and regular structure of a VOLP-1940 entry.

```
<entry xml:id="..." xml:lang="pt" type="...">
<form type="lemma">
<orth>...</orth>
</form>
<gramGrp>
<gram type="pos">...</gram>
<gram type="gen">...</gram>
</gramGrp>
</entry>
```

While the `entry` element encompasses all the information contained in the lexicographical article, the `form` element is used to note the information relating to the base, detailing its `type` attribute as `"lemma"`, and the orthographic form is provided in the `orth` element. It is important to note that in TEI Lex-0, the `entry` element requires the attributes `@xml:id`, the entry identifier and `@xml:lang`, the appropriate language code according to IETF BCP 47, which, in turn, is based on ISO 639 standards. Since we are dealing with vocabulary entries, we use the `form type=lemma`.

In the particular case of homonymous words, as in Example 9.2, "afecto", the lemma is split. In TEI Lex 0, avoiding possible structural ambiguities,

Example 9.2

Encoding of the entry "afecto¹" of the VOLP-1940 in TEI Lex-0.

```
<entry xml:lang="pt" xml:id="afecto_1" n="1"
"type="monolexicalUnit"> <form type="lemma">
<orth>afecto</orth>
<lbl>1</lbl>
<pc>(</pc>
<pron extend="part">ét</pron>
<lbl>)</lbl>
</form>
<pc>,</pc>
<gramGrp>
<gram type="pos" norm="NOUN">s.</gram>
<gram type="gen">m.</gram>
</gramGrp>
<pc>:</pc>
<sense>
<def>afeição</def>
<pc>.</pc>
</sense>
</entry>
```

the `superEntry` element (which groups a sequence of entries, such as a set of homographs) is no longer allowed, and we use `entry` systematically. To mark the numeric index, the element `lbl` preserves the digit of the original. The attribute `n` of the entry will, in turn, prove important for the further processing of the entry by computational tools.

We now focus on the TEI Lex-0 encoding word classes, that is, the "designação geral dos conjuntos distintos nos quais se agrupam as palavras do léxico, diferenciados pelas suas propriedades gramaticais e semânticas" (general designation of the different sets in which the words in the lexicon are grouped, differentiated by their grammatical and semantic properties; Raposo 2013, 326–327). We also look at how to present information about the language of origin of a lemma using language codes.

The grammatical properties of a lemma are specified in `entry/gramGrp/gram`. This `gram` element typically specifies the part-of-speech of the entry. In TEI Lex-0, specific elements of the *TEI Guidelines* for grammatical properties are dispensed with. We annotated the word classes using `@type="pos"`, e.g., `<gram type="pos">s.</gram>`, also marking the gender as `@type` `"gen"`, e.g., `<gram type="gender">f.</gram>`. We also considered using the `@norm` attribute for the Universal Dependencies Part-of-Speech values, as mentioned above. To ensure the accuracy of this correspondence, a complete list of possibilities for the contents of this label was calculated, and the annotation was added manually. In Table 9.1, we present a sample of the survey performed.

Considering the goals of TEI Lex-0 to serve as a common baseline and target format for transforming and comparing different lexical resources, the authors of the new guidelines decided to do away with the specific elements for grammatical properties, recommending the use of typed elements. The attribute values for `gram/@type` are a semi-closed list and the possibility of adding a new value, `"pos-sub"`, to annotate subcategories is currently being discussed. For instance, adverbs are grouped according to their function and value (subclasses), following the traditional Portuguese grammatical classification, which is obsolete. In this case, we decided to encode the part of speech with the `"pos"` value and a subcategory in the new value, `<gram type="pos" norm="ADV">adv.</gram>`, followed by `<gram type="pos-sub" expand="de afirmação">af.</gram>`.

Information about the language of origin of a lemma was encoded through the `etym` element (etymology) as a `"borrowing"`. Language information was provided in two different places. In the `lang` tag, it is presented as shown to the user, while the `@xml:lang` attribute encodes the language information as an IETF BCP 47 value. This is shown in Example 9.3, where the lemma "croché" is the Portuguese form of the French lemma "crochet".

Upon illustrating the encoding of some lexicographical articles in TEI, the examples show that this process is more detailed in TEI Lex-0 and more structured and accurate, allowing systems to better process the annotated data. TEI Lex-0 should be seen primarily as a format in which the existing

Example 9.3

Encoding of the entry "croché" of the VOLP-1940 in TEI Lex-0.

```
<entry xml:lang="pt" xml:id="croché" n="1"
"type="monolexicalUnit">
<form type="lemma">
 <orth>croché</orth>
 <pc>(</pc>
 <pron extend="part">è</pron>
 <lbl>)</lbl>
 </form>
<pc>,</pc>
<gramGrp>
<gram
type="pos" norm="NOUN">s.</gram>
<gram
type="gen">m.</gram>
</gramGrp>
<pc>:</pc>
<etym
type="borrowing">
<lbl>aportg. do</lbl>
<lang>fr</lang>
<mentioned xml:lang="fr">crochet</mentioned>
</etym>
</entry>
```

TEI dictionaries can be annotated and exploited more uniformly, with features that will include, among others, basic and advanced search capabilities. Alongside this, SKOS will play an important role in the organisation of lexicographical data as well as in ensuring its interoperability.

Conclusion: Breaking the ice – the benefits of an interdisciplinary action

In the course of our work, we invested in an effective trans-disciplinary approach that combines theories and methods of lexicography and information science, placing the TEI and SKOS standards at the very core of our research. We therefore contributed to the creation of the linguistic digital heritage that is at the heart of digital humanities. We implemented two standards with different but complementary goals, given that TEI specifies "encoding methods for machine-readable texts, chiefly in the humanities, social sciences and linguistics" (TEI Consortium) and SKOS, in turn, "is a common data model for knowledge organization systems such as thesauri, classification schemes, subject heading systems and taxonomies" (W3C 2009).

In the context of VOLP-1940, TEI encodes contents acting primarily on the microstructure of the dictionary, whereas SKOS allows the modelling of KOS, acting on macrostructural information and enabling the connection to other existing systems and resources. The modelling of lexicographical categories and their linguistic realisations (i.e., abbreviations and full forms) in SKOS facilitates the future exploration of VOLP-1940 as Linked Data. For example, through the language category, it opens the possibility for a system to extract all entries that are adopted from other languages (e.g., "croché" in Portuguese, borrowed from the French "crochet"), which would be an important application for linguistics scholars interested in borrowing and word-formation processes. For interoperability purposes, the lexicographical categories modelled in SKOS should be aligned to external vocabularies and ontologies, such as the widely used LexInfo ontology of lexical categories (LexInfo n.d.). For example, our class for nouns should be mapped to LexInfo's noun class, which would facilitate the reuse of VOLP-1940's subset of nouns as Linked Data. We aim to foster open access to resources that have a recognised heritage value, conceived from the start as dynamic searchable resources. This is a task of linguistic, heritage and historical relevance that will certainly contribute to the establishment of the Portuguese lexicon at the time – until 1940 – around which the identity of a linguistic and cultural community has been built and preserved.

With the work we have done so far, we believe we have highlighted the need to change traditional lexicographical practices. Many of the principles now defined and adopted will be used as a guide for the annotation of the remaining entries and application to subsequent bodies of work since they share several typographic conventions that have now been identified. With this process of retro-digitisation of lexicographical reference works and the application of this methodology, we intend to represent the ever-increasing synergy between lexicographers, terminologists, computational linguists, information experts and digital humanists that we so keenly advocate.

This methodology has already proved fruitful, as the Portuguese Foundation for Science and Technology (FCT) has financed the project MOR Digital – Digitisation of *Diccionario da Lingua Portugueza* by António de Morais Silva. The main goal of MOR Digital is to encode the selected editions of *Diccionario de Lingua Portugueza* by António de Morais Silva (MOR), first published in 1789. MOR Digital aims to promote accessibility to cultural heritage while fostering reusability and contributing towards a greater presence of digital lexicographical content in Portuguese through open access tools and standards. The methodology applied to MOR will have an enormous impact in Portuguese-speaking countries. MOR represents a great legacy, since it marks the beginning of Portuguese dictionaries, having served as a model for all subsequent lexicographical productions throughout the 19th and 20th centuries.

The strength of the methodology applied to the VOLP-19 lies in the fact that it is reproducible and reusable. In the near future, we will expand our method, link different monolingual legacy dictionaries (Portuguese, French, Spanish) and interconnect them through the "skosification" of the macro-structural elements. TEI Lex-0 will be used to encode the microstructural information of the monolingual dictionaries in the three languages, thus increasing multilingual lexicographical repositories.

One of the main challenges raised by the methodology proposed in this chapter is to combine the skills of the various scientific disciplines that make up the humanities in connection with information science. This is because the standards are cross-disciplinary tools that help build a joint methodology that benefits everyone. At the end of the project, we expect to have codified a vocabulary with a significant heritage value, compatible with the most advanced standards for academic and open-access digital editions.

We believe that this project will contribute significantly to the analysis and annotation of Portuguese lexical resources using computer-assisted processes. It will allow us to rethink how to design new lexicographical products that are truly digital and not merely a simple reproduction of paper editions, which will respond more effectively to the needs of the end-users.

In the next few years, the challenge lies in creating new profiles for the humanities. Universities must create multidimensional profiles that associate the skills of linguistics, computing, and information science. That is what defines digital humanities.

Acknowledgements

This paper is supported by the Portuguese National Funding through the FCT – Fundação para a Ciência e Tecnologia as part of the project Centro de Linguística da Universidade NOVA de Lisboa – UID/LIN/03213/2020 and the European Union's Horizon 2020 research and innovation programme under grant agreement No 731015 (ELEXIS; European Lexicographic Infrastructure).

Bibliography

Academia das Ciências de Lisboa. 1940. *Vocabulário Ortográfico da Língua Portuguesa* (VOLP-1940). Lisboa: Imprensa Nacional. Accessed December 1, 2020. https://volp-acl.pt/index.php/vocabulario-1940/projeto.

Art & Architecture Thesaurus Online. 2017. https://www.getty.edu/research/tools/vocabularies/aat/

Baker, Thomas, Sean Bechhofer, Antoine Isaac, Alistair Miles, Guus Schreiber and Ed Summers. 2013. "Key Choices in the Design of Simple Knowledge Organization System (SKOS)." *Journal of Web Semantics*, 20: 35–49. https://doi.org/10.1016/j.websem.2013.05.001

Bergenholtz, Henning and Rufus H. Gouws 2012. "What is lexicography?" *Lexikos* 22: 31–42. https://doi.org/10.5788/22-1-996

Borko, Harold. 1968. "Information Science: What Is It?" *American Documentation* 19 (1): 3–5. https://doi.org/10.1002/asi.5090190103

Bothma, Theo J. D. 2018. "Lexicography and Information Science." In *The Routledge Handbook of Lexicography*, edited by Pedro A. Fuertes-Olivera, 197–216. London: Routledge.

DARIAH. n.d. "Lexical Resources." Accessed March 12, 2021. https://www.dariah.eu/activities/working-groups/lexical-resources/

EU Vocabularies. n.d. Accessed March 12, 2021. https://op.europa.eu/en/web/eu-vocabularies/

FAIR PRINCIPLES: Findable, Accessible, Interoperable, Reusable. 2016. Accessed March 12, 2021. https://www.go-fair.org/fair-principles/.

Felber, Helmut. 1984. *Terminology Manual*. Paris: UNESCO.

Gold, Matthew K. and Lauren F. Klein, eds. 2019. *Debates in the Digital Humanities*. Mineápolis: University of Minnesota Press.

Gonçalves, Maria Filomena. 2020. "Orthography and Orthoepy." In *Manual of Standardization in the Romance Languages, Manuals of Romance Languages (MRL)*, edited by Franz Lebsanft and Felix Tacke, 24, 649–677. Berlin/Boston: De Gruyter.

Hjørland, Birger. 2008. "What is Knowledge Organization (KO)?" *Knowledge Organization* 35 (2/3): 86–101. https://doi.org/10.5771/0943-7444-2008-2-3-86

Hockey, Susan. 2004. "The History of Humanities Computing." In *A Companion to Digital Humanities*, edited by Susan Schreibman, Ray Siemens, and John Unsworth. Oxford: Blackwell.

Hodge, Gail. 2000. *Systems of Knowledge Organization for Digital Libraries: Beyond Traditional Authority Files*. Washington, DC: The Digital Library Federation. Council on Library and Information Resources.

IETF BCP 47. n.d. Tags for Identifying Languages. Accessed March 12, 2021. https://tools.ietf.org/html/bcp47.

ISO 1087. 2019. *Terminology Work and Terminology Science – Vocabulary*. Geneva: ISO.

ISO 1951. 2007. *Presentation/representation of Entries in Dictionaries – Requirements, Recommendations and information*. Geneva: ISO.

ISO 25964-1. 2011. *Information and Documentation – Thesauri and Interoperability with other Vocabularies—Part 1: Thesauri for Information Retrieval*. Geneva: ISO.

ISO 25964-2. 2013. *Information and Documentation – Thesauri and Interoperability with other Vocabularies—Part 2: Interoperability with Other Vocabularies*. Geneva: ISO.

ISO/IEC 2382. 2015. *Information Technology – Vocabulary*. Geneva: ISO.

ISO/TR 20694. 2018. *A Typology of Language Registers*. Geneva: ISO

Landau, Sidney I. 2001. *Dictionaries: The Art and Craft of Lexicography*. 2nd ed. Cambridge: Cambridge University Press.

LexInfo. n.d. Accessed March 12, 2021. https://www.lexinfo.net/.

Linguistic Linked Open Data Cloud (LLOD). n.d. Accessed March 12, 2021. https://linguistic-lod.org/llod-cloud.

Miles, Alistair, and Sean Bechhofer. 2009. *SKOS Simple Knowledge Organization System Reference*. 18 August 2009. http://www.w3.org/TR/skos-reference.

Raposo, Eduardo Buzaglo Paiva. 2013. Estrutura da frase. In *Gramática do Português*, edited by Eduardo Buzaglo Paiva Raposo, Maria Fernanda Bacelar do Nascimento, Maria Antónia Coelho da Mota, Luísa Segura, and Amália Mendes, 303–398. Vol. I. Lisboa: Fundação Calouste Gulbenkian.

Rey-Debove, Josette. 1971. *Étude Linguistique et Sémiotique des Dictionnaires Français Contemporains*. Paris: The Hague.

Robinson, Lyn, Ernesto Priego, and David Bawden. 2015. "Library and Information Science and Digital Humanities: Two Disciplines, Joint Future?" In *Re:Inventing Information Science in the Networked Society*, edited by Franjo Pehar, Christian Schlögl, and Christian Wolff, 44–54. Glückstadt: Verlag Werner Hülsbusch.

Rundell, Michael. 2010. "What Future for the Learner's Dictionary?" In *English Learners' Dictionaries at the DSNA 2009*, edited by Ilan J. Kernerman and Paul Bogaards, 169–175. Jerusalem: Kdictionaries.

Salgado, Ana, Rute Costa, Toma Tasovac, and Alberto Simões, A. 2019. "TEI Lex-0 In Action: Improving the Encoding of the Dictionary of the Academia das Ciências de Lisboa." In *Electronic lexicography in the 21st century. Proceedings of the eLex 2019 conference*, edited by. Iztok Kosem, Tanara Zingano Kuhn, Margarita Correia, José Pedro Ferreira, Maarten Jansen, Isabel Pereira, Jelena Kallas, Miloš Jakubíček, Simon Krek, and Carole Tiberius, 417–433. Brno: Lexical Computing CZ, s.r.o. https://elex.link/elex2019/wpcontent/uploads/2019/09/eLex_2019_23.pdf

Salgado, Ana, Sina Ahmadi, Alberto Simões, John Philip McCrae, and Rute Costa. 2020. "Challenges of Word Sense Alignment: Portuguese Language Resources." In *Proceedings of 7th Workshop on Linked Data in Linguistics (LDL 2020) Building Tools and Infrastructure*, edited by Maxim Ionov, John P. McCrae, Christian Chiarcos, Thierry Declerck, Julia Bosque-Gil, and Jorge Gracia, 45–51. France: Marseille. https://www.aclweb.org/anthology/2020.ldl-1.0.pdf

Saracevic, Tefko. 1999. "Information Science." *American Documentation* 50(12): 1051–1063. https://doi.org/10.1002/(SICI)1097-4571(1999)50:12%3C1051::AID-ASI2%3E3.0.CO;2-Z.

Stührenberg, Maik. 2012. "The TEI and Current Standards for Structuring Linguistic Data." *Journal of the Text Encoding Initiative* [Online] issue 3, (November). https://doi.org/10.4000/jtei.523

Tarp, Sven. 2018. "Lexicography as an Independent Science." In *The Routledge Handbook of Lexicography*, edited by Pedo A. Fuertes-Olivera, 19–33. London: Routledge.

Tasovac, Toma. 2010. "Reimagining the Dictionary, or Why Lexicography Needs Digital Humanities." *Digital Humanities 2010*. http://dh2010.cch.kcl.ac.uk/academic-programme/abstracts/papers/pdf/ab-883.pdf

Tasovac, Toma, et al. 2018. "TEI Lex-0: A Baseline Encoding for Lexicographic Data. Version 0.8.5." DARIAH Working Group on Lexical Resources. https://dariah-eric.github.io/lexicalresources/pages/TEILex0/TEILex0.html

TEI Consortium, eds. 2021. "TEI P5: Guidelines for Electronic Text Encoding and Interchange. 4.2.1." Last modified March 1, 2021. TEI Consortium. http://www.tei-c.org/Guidelines/P5/

Terras, Melissa, Julianne Nyhan, Edward Vanhoutte, eds. 2013. *Defining Digital Humanities: A Reader*. Londres: Ashgate.

Trap-Jensen, Lars. 2018. "Lexicography between NLP and Linguistics: Aspects of Theory and Practice." In *Proceedings of the XVIII EURALEX International Congress: Lexicography in Global Contexts*, edited by Jaka Čibej, Vojko Gorjanc, Iztok Kosem, and Simon Krek, 25–37. Ljubljana: Ljubljana University Press, Faculty of Arts. https://e-knjige.ff.uni-lj.si/znanstvena-zalozba/catalog/view/118/211/3000-1.pdf

Universal Dependencies. n.d. Accessed March 12, 2021. https://universaldependencies.org/

Verdelho, Telmo. 2007. "Dicionários Portugueses, Breve História." In *Dicionarística Portuguesa: Inventariação e Estudo do Património Lexicográfico*, edited by Telmo Verdelho, and João Paulo Silvestre. Aveiro: Universidade de Aveiro.

W3C. 2009. "SKOS Simple Knowledge Organization System Reference." https://www.w3.org/TR/skos-reference/

Wiegand, Herbert Ernst. 2013. "Lexikographie und Angewandte Linguistik." *Zeitschrift Für Angewandte Linguistik* 58 (1): 13–39. https://doi.org/10.1515/zfal-2013-0002

Wiegand, Herbert Ernst, Rufus H. Gows, Matthias Kammerer, Michael Mann and WernerWolski. 2020. *Dictionary of Lexicography and Dictionary Research*. Vol. 3 I-U. Berlin/Boston: Walter de Gruyter.

Williams, Geoffrey. 2019. "The Problem of Interlanguage Diachronic and Synchronic Markup." In *The Landscape of Lexicography*, edited by Alina Villalva and Goeffrey Williams. Lisboa–Aveiro: Centro de Linguística da Universidade de Lisboa–Universidade de Aveiro.

Zeng, Marcia. 2008. "Knowledge Organization Systems (KOS)." *Knowledge Organization* 35 (2/3): 160–182. https://doi.org/10.5771/0943-7444-2008-2-3-160

Appendix

VOLP-1940 list of abbreviations (typological organization)

Part of speech

OPEN CLASS WORDS

adj. (adjectivo) [adjective]

adv. (advérbio) [adverb]adv. af. (advérbio de afirmação) [affirmation adverb]

adv. conf. (advérbio de confirmação) [confirmation adverb]

adv. design. (advérbio de designação) [designation adverb]

adv. dúv. (advérbio de dúvida) [adverb of doubt]

adv. excl. (advérbio de exclusão) [exclusion adverb]

adv. interr. (advérbio interrogativo) [interrogative adverb]

adv. lug. (advérbio de lugar) [adverb of place]

adv. mod. (advérbio de modo) [mode adverb]

adv. neg. (advérbio de negação) [negation adverb]

adv. num. (advérbio numeral) [numeral adverb]

adv. rel. (advérbio relativo) [relative adverb]

adv. temp. (advérbio de tempo) [adverb of time]
interj. (interjeição) [interjection]interj. excl. (interjeição exclamativa) [exclamatory interjection]
interj. voc. (interjeição vocativa) [vocative interjection]
s. (substantivo) [noun]
v. (verbo) [verb]

CLOSED CLASS WORDS

art. (artigo) [determiner]
conj. (conjunção) [conjunction]conj. adv. (conjunção adversativa) [adversative conjunction]
conj. caus. (conjunção causal) [causal conjunction]
conj. comp. (conjunção comparativa) [comparative conjunction]
conj. conc. (conjunção concessiva) [concessive conjunction]
conj. concl. (conjunção conclusiva) [conclusive conjunction]
conj. cond. (conjunção condicional) [conditional conjunction]
conj. cons. (conjunção consecutiva) [consecutive conjunction]
conj. cop. (conjunção copulativa) [copulative conjunction]
conj. disj. (conjunção disjuntiva) [disjunctive conjunction]
conj. fin. (conjunção final) [final conjunction]
conj. int. (conjunção integrante) [integral conjunction]
conj. temp. (conjunção temporal) [temporal conjunction]
num. (numeral) [numeral]num. card. (numeral cardinal) [cardinal numeral]
num. distr. (numeral distributivo) [distributive numeral]
num. fracc. (numeral fraccionário) [fractional numeral]
num. mult. (numeral multiplicativo) [multiplicative numeral]
num. ord. (numeral ordinal) [ordinal numeral]
pron. (pronome) [pronoun]pron. dem. (pronome demonstrativo) [demonstrative pronoun]
pron. ind. (pronome indefinido) [indefinite pronoun]
pron. interr. (pronome interrogativo) [interrogative pronoun]
pron. pess. (pronome pessoal) [personal pronoun]
pron. pess. compl. (pronome pessoal complemento) [personal pronoun complement]
pron. pess. suj. (pronome pessoal sujeito) [subject personal pronoun]
pron. poss. (pronome possessivo) [possessive pronoun]
pron. refl. (pronome reflexo) [reflex pronoun]
pron. rel. (pronome relativo) [relative pronoun]
prep. (preposição) [adposition]

Grammatical gender
f. (feminino) [feminine]
m. (masculino) [masculine]
2 gén. (2 géneros) [dual gender]

Grammatical number
 sing. (singular) [singular]
 2 núm. (2 números) [dual number]
 pl. (plural) [plural]

Language
 al. (alemão) [Deutsch]
 ár. (árabe; arábico) [Arabic]
 din. (dinamarquês) [Danish]
 esp. (espanhol) [Spanish]
 finl. (finlandês) [Finnish]
 fr. (francês) [French]
 gr. (grego) [Greek]
 hebr. (hebraico) [Hebrew]
 hol. (holandês) [Dutch]
 ingl. (inglês) [English]
 it. (italiano) [Italian]
 jap. (japonês) [Japanese]
 lat. (latim) [Latin]
 lat. vulg. (latim vulgar) [Vulgar Latin]
 lit. (lituano) [Lithuanian]
 nor. (norueguês) [Norwegian]
 pol. (polaco) [Polish]
 port. (português) [Portuguese]
 rom. (romano) [Roman]
 scr. (sânscrito) [Sanskrit]

Register
 ant. (antigo) [old]
 arc. (arcaico) [archaic]
 pop. (popular) [popular]

Onomastic classification
 antr. (antropónimo; antroponímico) [anthroponym; person name]
 astr. (astrónimo) [astronomical name]
 bibl. (bibliónimo) [renowned book name]
 cogn. (cognome) [cognomen]
 cron. (cronónimo) [chrononym; calendar name]
 etn. (etnónimo) [ethnonym]
 heort. (heortónimo) [holiday name]
 hier. (hierónimo) [sacred name]
 mit. (mitónimo) [mythonym; mythological name]
 patr. (patronímico) [patronymic]
 pros. (prosónimo) [nickname]
 top. (topónimo) [toponym; place name]

Tense
fut. conj. (futuro do conjuntivo) [future subjunctive]
fut. ind. (futuro do indicativo) [future indicative]
ger. (gerúndio) [gerund]
imper. (imperativo) [imperative]
imperf. conj. (imperfeito do conjuntivo) [imperfect subjunctive]
imperf. ind. (imperfeito do indicativo) [imperfect indicative]
inf. (infinitivo) [infinitive]
inf. pess. (infinitivo pessoal) [personal infinitive]
m. q. perf. ind. (mais-que-perfeito do indicativo) [pluperfect indicative]
part. pass. (particípio passado) [past participle]
part. pres. (particípio presente) [present participle]
perf. ind. (perfeito do indicativo) [perfect indicative]
pres. cond. (presente do condicional) [conditional present]
pres. conj. (presente do conjuntivo) [present subjunctive]
pres. ind. (presente do indicativo) [present indicative]

Etimology
lat. (latino) [latin]
or. gr. (origem grega) [greek origin]
or. lat. (origem latina) [latin origin]

Word formation
adapt. (adaptação) [adaptation]
agl. (aglutinação) [agglutination]
aportg. (aportuguesamento) [adapted Portuguese form]
contr. (contracção) [contraction]
el. comp. (elemento de composição) [composition elemento]
inf. (infixo) [infix]
pref. (prefixo) [prefix]
red. (redução) [reduction]
red. pop. (redução popular) [popular reduction]
rad. (radical) [radical]
suf. (sufixo) [suffix]

Others
alf. (alfabeto) [alphabet]
át. (átono) [unstressed]
ax. (axiónimo) [honorific]
cat. morf. (categoria morfológica) [morphological category]
cf. (confira) [compare; consult]
cons. (consoante) [consonant]
constr. (construção) [construction]
dif. (diferente) [different]
diss. (dissilábico) [disyllabic]

dit. (ditongo) [diphthong]

el. (elemento) [element]

el. art. (elemento articular) [joint element]

el. nom. (elemento nominal) [nominal element]

el. part. (elemento participial) [participial element]

el. prot. (elemento protético)

[prothetic element] el. top. (elemento toponímico) [toponymic element]

equiv. (equivalente) [equivalent]

f. (forma) [form]

flex. (flexão) [inflection]

form. port. (formação portuguesa) [portuguese formation]

f. paral. (forma paralela) [parallel form]

f. verb. (forma verbal) [verbal form]

hipoc. (hipocorístico) [hypocoristic]

lig. (ligação) [connection]loc. (locução) [phrase]

loc. adj. (locução adjectiva) [adjetive phrase]

loc. adv. mod. (locução adverbial de modo) [adverbial phrase]

loc. adv. temp. (locução adverbial de tempo) [temporal phrase]

loc. prep. (locução prepositiva) [adposition phrase]

loc. pron. pess. (locução pronominal pessoal) [personal pronominal phrase]

loc. s. (locução substantiva) [noun phrase]

loc. s. f. (locução substantiva feminina) [feminine noun phrase]

loc. s. m. (locução substantiva masculina) [masculine noun phrase]

n. (nome) [name]

pal. (palavra) [word]

part. apass. (partícula apassivante) [passive particle]

part. aux. (partícula auxiliar) [auxiliary particle]

part. expl. (partícula expletiva) [expletive particle]

pess. (pessoa) [person]

p. ex. (por exemplo) [for example]

p. ext. ou abrev. (por extenso ou abreviadamente) [in full or abbreviated]

sent. (sentido) [sense]

sup. (superlativo) [superlative]

term. (terminação) [ending]

tón. (tónico) [stressed]

v. (veja) [see]

var. (variação) [variation]

vog. (vogal) [vowel]

Preserving DH research outputs

10 Linked data strategies for conserving digital research outputs

The shelf life of digital humanities

Florian Kräutli, Esther Chen,
and Matteo Valleriani

Introduction

The digital humanities struggle with the challenge of long-term usability and accessibility of digital research outputs. Research data and digital artefacts in the form of databases and websites constitute essential results of digital research projects, yet they are typically not maintained in ways that can be reused, cited and accessed in the long term. Our main questions are, therefore: how can we maintain digital humanities research outputs so that they remain accessible and usable? What requirements must the research data infrastructures of cultural heritage institutions meet in order to fulfil this task? How can research outputs be linked to the primary sources being studied and how closely do central library infrastructures and individual research projects have to be aligned?

These questions have been posed for some time now. Since the early 2000s, the European Union has established large funding programs to develop transnational research infrastructures in various disciplines. This funding aimed to address these open questions and to increase the development and competitiveness of Europe as a research space. The projects included in the term "research infrastructures" diverge as widely as the expectations and hopes for them, especially in the humanities. In her paper "What are research infrastructures?", Anderson (2013) examines a wide range of research infrastructures, taking into account big funding programs such as the European Strategy Forum on Research Infrastructures as well as many different national projects such as the French Biblissima project or Oxford's Cultures of Knowledge. She emphasises the role of research infrastructures as an experiential presence that is embedded in the practices and experience of research, claiming that the strong collaboration of scholars, librarians and archivists is a major key to success (Anderson 2013, 10):

> Infrastructure development and take up is far more successful if it emerges from researchers' own practices: if it fills gaps in existing provision, or it is a solution to identified problems and perceived difficulties.

In her book Scholarship in the Digital Age: Information, Infrastructure, and the Internet (Borgman 2007), Borgman underlines the significance of

DOI: 10.4324/9781003131816-10

research data while examining what she calls information infrastructures. She claims that no framework exists for research data comparable to that for publishing, while at the same time the output of such data increases rapidly. Looking back at this statement from today's perspective, we still cannot regard this problem as being solved, even though digital research data is deeply embedded in the day-to-day practices of humanities research.

At the Max Planck Institute for the History of Science, we draw from a comparatively long history of digital scholarship, notably through the ECHO initiative that began to digitise historical sources and publish them on the Web as early as 2002 (Renn 2002). Since then and to date, research projects have been studying, annotating and contextualising digital sources, which have become increasingly available in recent years. In addition to common scholarly outputs such as books or journal articles, these projects produce digital outputs such as websites, databases or virtual exhibitions: typical artefacts of digital humanities research. Maintaining these artefacts has, however, proven to be challenging. Unlike their physical counterparts, e.g., books, monographs and journal publications, they do not end up in the library and instead live on scattered servers and ageing software systems. This makes maintaining long-term access to these resources difficult and ensuring that they are usable and interoperable with evolving digital technologies is nearly impossible.

Our ambition is to complete the digital research life cycle: to make sure that digital research outputs can be discovered, accessed and reused within one integrated environment. We seek to achieve this by adopting a common model to represent our digital knowledge and by implementing Linked Data technologies for data storage and exchange. In this chapter, we outline the challenges surrounding the preservation of digital humanities research outputs and present how we address them, both within the scope of an individual research project and at scale, as libraries take on new responsibilities in managing digital research outputs. First, we outline some of the main challenges in the preservation of digital humanities research as identified by the scholarly community. We then present two of our projects as case studies in which we tackle these challenges. We propose to look at digital humanities research outputs as consisting of two layers: a presentation layer and a data layer. We suggest that there is a need to focus on the data at the expense of its presentation if we are to seek to preserve these research outputs in reusable and sustainable ways.

Current challenges in maintaining digital humanities research outputs

The challenge of creating reusable data

With the increasing adoption of digital methods, the need for reproducibility of research is no longer confined to the natural sciences but has become relevant for the humanities too (Peels and Bouter 2018). As O'Sullivan (2019)

writes: "Humanities scholars are increasingly expected to accept the findings of their peers without access to the data from which discoveries are drawn. Access to data is just part of the problem." The other part of the problem that O'Sullivan discusses is a lack of documentation and transparency about the applied methods, which often make reproducing digital humanities research impossible. We prefer to keep our focus, however, on the problem of access to data. Beyond mere access, the problem lies in making and keeping data usable, i.e., "not to archive data, but to keep them alive" (Kilchenmann, Laurens, and Rosenthaler 2019). Thorough data curation is therefore not only a necessity, but due to the richness of humanities data, also a substantial challenge (Henry 2014). Archives and libraries employ a range of standard models to describe their holdings in a common and reusable way, such as Machine Readable Cataloguing (MARC, MARBI, 1996), Encoded Archival Description (EAD, LOC, 2002) or Bibliographic Framework (BIBFRAME, LOC, 2016). While these models allow for rich descriptions of digital collections data, they are not necessarily compatible with each other, which complicates data sharing and reuse. In addition, although they are meant to be broadly applicable, they may not support research in the wider framework of humanities research. As Oldman et al. (2014) write: "Cultural heritage data provided by different organisations cannot be properly integrated using data models based wholly or partly on a fixed set of data fields and values, and even less so on 'core metadata'".

Scholars may not only need to describe a wide range of material but also events, actors and the relationships between them, as well as observations, conflicting information, beliefs and inferences. The conceptual reference model CIDOC-CRM[1] was developed to address the problem of incompatibility between standards (Doerr and Crofts 1999; Crofts et al. 2011) and to allow the description of humanities data to a high level of accuracy. It has therefore emerged as a general-purpose model for the cultural heritage domain (Oldman, Doerr, and Gradmann 2016). CIDOC-CRM defines a basic set of entities such as actors, places, concepts and, most importantly events. This approach allows for things to be described not through a vocabulary of terms, whose meaning might be ambiguous, but through events that create or transform things and can happen at a particular place or time and through actors. In comparison to existing approaches, these generic and minimal building blocks allow for a "less complex, more compact and sustainable model, but with far richer semantics" (Oldman, Doerr, and Gradmann 2016). Instead of using potentially ambiguous terminologies such as "author", e.g., the model allows for a detailed digital representation of events that lead to the creation of a particular cultural artefact along with relationships to the actors involved.

1 CIDOC stands for the International Council for Documentation, under whose patronage the CIDOC-CRM Special Interest Group maintains and develops the reference model.

Extensions of CIDOC-CRM have been and continue to be developed where a consensus about the material and events that are represented allow for greater specificity of the data model. This includes FRBRoo (Doerr et al. 2013; Bekiari et al. 2015), a CIDOC-CRM extension of the bibliographic standard FRBR (the "oo" in FRBRoo stands for "object-oriented"; Functional Requirements for Bibliographic Records, IFLA 1998) and CRMdig (Doerr, Stead, and Theodoridou 2016) for capturing digitisation and provenance information. Each of these extensions introduces new entity types, which are derived from the basic set specified in CIDOC-CRM but cater to the individual needs of their subject domains. CIDOC-CRM provides a generic class for describing physical carriers of information, which FRBRoo extends to allow for distinguishing specific types of information carriers such as printed books, audio CDs or videotapes.

The absence of suitable interfaces and platforms for the user-friendly creation of semantically rich data according to the CIDOC-CRM model has previously been a major obstacle for their adoption. By now, a growing number of solutions have been created, e.g., WissKi (Goerz et al. 2009), ResearchSpace (Oldman 2016) and Metaphacts Open Platform (Metaphacts 2019). These platforms allow researchers to create semantically rich data according to the CIDOC-CRM model without necessarily having to be familiar with all its intricacies.

Besides the conceptual representation of data according to a standard such as CIDOC-CRM, the file format in which data is ultimately stored is a deciding factor in its reusability. As the PARTHENOS project, an EU-funded initiative for enabling interoperable digital humanities research, states: "There will never be one standard format for all data. Rather, we must find means to translate between them" (PARTHENOS, n.d.). A file format that facilitates translation across data schemas, as well as interlinking of data, is the Resource Description Framework (W3C 2014). In this format, "Meaning is expressed by RDF, which encodes it in sets of triples, each triple being rather like the subject, verb and object of an elementary sentence" (Berners-Lee, Hendler, and Lassila 2001, 38). Due to its flexibility, RDF has emerged as common ground on the data format level to create, preserve and exchange digital humanities research data. The Swiss Data and Service Center for Humanities (DaSCH) caters to a variety of needs in humanities research through an RDF-based data infrastructure (Kilchenmann, Laurens, and Rosenthaler 2019): "RDF allows great flexibility of data modelling, which enables the DaSCH to use one single infrastructure for data, metadata, models and structures for any project regardless of the data concept used. Thus, the DaSCH has to maintain only one single infrastructure to provide sustainability. Data from any one project can be analysed and compared with data from other projects".

RDF is also a central building block of the Semantic Web. The Semantic Web and the application of Linked Data principles seek to make data reusable by focussing on machine readability and dense interconnectedness

through the technical principles of the Internet. As a concept, the Semantic Web is almost twenty years old (Berners-Lee, Hendler, and Lassila 2001). Since the inception of the World Wide Web, and to a great extent until today, its basic building block has been text documents connected by hyperlinks. These are documents that are intended for people, which need to be interpreted, and which may contain various pieces of information. The Semantic Web, by contrast, connects data instead of documents, for the use of computers. Data is here understood as a single piece of information that is machine readable. In contrast to documents, data cannot rely on human interpretation and therefore need to represent all meaning explicitly. The concept of Linked Data constitutes the mechanisms, technologies and frameworks for publishing data on the Semantic Web (Bizer, Heath, and Berners-Lee 2009). In RDF, each component of a triple can be a URI. Each piece of data, therefore, becomes globally addressable and reusable. Certain databases, such as relational databases, usually rely on their internal identifiers for database entries and use text labels to identify database fields. Using URIs instead means that both the entities in a database and what we say about those entities can be universally interpreted. Querying RDF data can be done through the SPARQL query language (W3C 2014). SPARQL queries can be stored as text files along with the RDF data for later reuse. Merely applying Linked Data principles is, however, no guarantee of reusable data. Linked Data is "not enough for scientists" (Bechhofer et al. 2013) without "a common model for describing the structure of our Research Objects including aspects such as lifecycle, ownership, versioning, etc." (Bechhofer et al. 2013, 569). Conceptual models such as the CIDOC-CRM described above are therefore crucial for creating truly reusable data, as are feasible methods for putting them into practice.

The challenge of maintaining digital humanities research outputs

Digital humanities produce a variety of digital artefacts that constitute the outcome of a research project: databases, websites, digital editions, virtual exhibitions, just to name a few. Such artefacts are often not only static files that can be stored but constitute pieces of software that must run and must be maintained for them to keep running as digital systems change and evolve. Technical debt is accumulated, as digital research outputs should remain reusable for future research (Hughes, Constantopoulos, and Dallas 2016, 161): "The use of ICT methods requires good practice in all stages of the digital life cycle to ensure effective use and reuse of data for research. Building digital collections of data for research involves consideration of the subsequent use and reuse of these collections for scholarship, using a variety of digital methods and tools".

Building a website constitutes not just a one-time effort but a long-term commitment, as Crymble (2015) observes: "Websites are expensive and a lot

of work. Committing to building a website is like committing to build and maintain a library for the foreseeable future".

The disappearance of websites from the internet is a common phenomenon. Sampath Kumar and Manoj Kumar (2012) reviewed the decay of online citations in open access journals and found that almost a third of the cited articles were no longer accessible. This is a serious problem when those websites constitute valuable research outputs that are often also the result of significant financial investment. When funding stops, websites disappear (Bicho and Gomes 2016): "Most current Research & Development (R&D) projects rely on their websites to publish valuable information about their activities and achievements. However, these sites quickly vanish after the project funding ends".

The commitment required in maintaining online publication and research outputs is often overlooked in digital humanities scholarship (Reed 2014): "[...] coursework and publications related to DH project management tend to focus heavily on the difficulties of planning and launching a new project rather than the challenges of maintaining an established one [...]"

As Bethany Nowviskie (2012) writes, digital humanities tend to emanate a feeling of "Eternal September", referring to the September influx of new students where all is new and fresh and everything can be built from scratch. This feeling ignores the fact that the digital artefacts that we build require maintenance and conveniently overlooks everything that is already available and needs taking care of. The notion of an "Eternal September", as Ashley Reed writes, "can also give the mistaken impression that digital humanities projects are inherently disposable: that long-term project management is unnecessary because creating a project is more important than developing or sustaining it" (Reed 2014, para. 2).

As the Web became commonplace, digital humanities researchers started to use more "sophisticated" tools. With this, the likelihood that digital research artefacts would become defunct increased significantly, either because they depend on the operation of underlying infrastructures such as databases and web servers (e.g., in content management systems such as WordPress or Drupal) or because the technology itself became obsolete (e.g., Flash). Sperberg-McQueen and Dubin (2017) describe a layered dependence of research artefacts on digital infrastructure: "In existing computer systems there is typically a long chain of relations connecting the physical phenomena by which data are represented with the data being represented. Each link in the chain connects two layers of representation: each layer organizes information available at the next lower level into structures at a higher (or at least different) layer of abstraction, and in this way provides information used in turn by the next higher level in the representation".

The layers ascend from the physical representation of data on storage devices to application-specific data structures and then to the presentation layer. With increasing numbers of layers, the long-term availability of digital research outputs becomes more difficult, as each layer depends on the

previous ones and requires dedicated maintenance. It is due to such observations that a shift towards "the application of minimalist principles to computing" under the framework of minimal computing (Go::DH 2014; Varner 2017) is being promoted by some scholars (Gil and Ortega 2016). Minimal computing refers to "computing done under some set of significant constraints of hardware, software, education, network capacity, power, or other factors" (Go::DH 2014). In practice, this can mean publishing a website not through a database server that requires constant maintenance, upkeep and an internet connection but instead as a set of static documents that could be distributed on a USB stick in communities where internet access is scarce. Using the analogy of Sperberg-McQueen and Dubin (2017), minimal computing aims to reduce the layers of data representation that must be maintained, thereby making the challenge of producing digital research outputs that remain usable in the long term more realistic to achieve.

The challenge of long-term preservation

When facing the challenges of long-term preservation of research data, it is worth taking a closer look at the GAMS infrastructure of the University of Graz (Stigler et al. 2018). Their situation is in some ways comparable to the one we face at our institute and which we discuss below. After maintaining a proprietary pool of research-supporting software projects and technology, which became more costly and difficult over time, all projects then existing were transferred to a single environment for long-term archiving and provision of scientific data and content. The goal is to ensure sustainable availability and flexible (re-)use of digitally annotated and enriched scientific content. This is achieved through a largely XML-based content strategy based on domain-specific data models. Separation of the content and its presentation is an integral part of the infrastructure's architecture. Using recognised international standards like TEI, LIDO, SKOS, EDM or Dublin Core, Stigler et al. (2018) emphasise in their paper that the challenges of long-term preservation of research data cannot be solved without strong commitment from academic institutions, which have to perceive them as their central responsibility.

In her paper Research Data Management Instruction for Digital Humanities, Dressel (2017) states that, despite the interest in data curation in the digital humanities, little attention has been paid to providing instruction in research data management for the digital humanities: "Data curation represents a full range of actions on a digital object over its lifecycle and includes the basics of data management" (Dressel 2017, 8). To achieve successful long-term research data preservation, she emphasises the importance of the strong collaboration between librarians, researchers and IT staff.

In their book Cinderella's Stick: A Fairy Tale for Digital Preservation, Tzitzikas et al. (2018) point out the great importance of digital preservation,

describing at the same time the challenges that come with it, which are different for all different types of digital artefacts. "While on the one hand, we want to maintain digital information intact as it was created; on the other, we want to access this information dynamically and with the most advanced tools" (Tzitzikas et al. 2018, 2). With regard to research data, they claim the usage of semantic web technologies such as RDF and the existing ontologies are beneficial: "Overall, we could say that the Semantic Web technologies are beneficial for digital preservation since the 'connectivity' of data is useful in making the semantics of the data explicit and clear. This is the key point for the Linked Open Data initiative, which is a method for publishing structured content that enables connecting it" (Tzitzikas et al. 2018, 65).

Case study: Self-contained research data at scale

At the Max Planck Institute for the History of Science (hereafter the Institute) we know all too well the amount of effort involved in maintaining digital research outputs (as well as the consequences of not being able to do so). The Islamic Scientific Manuscripts Initiative (ISMI, Daston et al. 2006), e.g., is one of the longest-running digital projects at the Institute. It constitutes a database catalogue of Islamic scientific manuscripts, including digitised sources where available (Daston et al. 2006). At its conception in 2006, a custom database was developed because no existing solution permitted the representation of the manuscripts and their scholarly and social connections at the level of detail that the scholars required. Currently, the data is being migrated into a CIDOC-CRM data model stored in an RDF triple store, as these models and technologies have matured and become widely available (Kuczera 2018). The ability to keep this unique source accessible has, however, hinged on both the availability and funding of a dedicated IT specialist throughout the project's lifetime up until today.

This has not been possible for the large majority of digital projects that have been developed, e.g. in collaboration with visiting researchers who have since left the Institute. An internal survey has unearthed 125 digital projects (and counting) residing on the Institute's servers. While many of them are surprisingly still operational – largely in cases where they have been built as static HTML websites – this is neither to be taken for granted nor relied on.

About a fifth of the 125 projects we identified at our own Institute have by now been either retired or stabilised, some of them as isolated run-time environments in which a project's state is conserved while the security risk of running outdated software is mitigated. This solution is acceptable if we want to preserve a website as an outcome of a research project. It is insufficient, however, when our goal is to allow future researchers to build on and reuse the digital artefacts that have been created.

When we regard digital projects as research outputs that should be shared and reused, our focus is therefore not on the presentation layer in the form of

a website or an interactive data visualisation; instead, it is on the data that have been collected and curated to realise the presentation, i.e., the research data. This shift from presentation-centred digital scholarship towards an awareness of the value of data-driven approaches can be seen in recent calls for thinking of digital collections as collections of data and for a rethinking of cultural institutions as data-brokers (Ziegler 2020).

In shifting from presentation to data-centred digital humanities projects, though, we encounter two main problems for preservation. Firstly, many projects do not delineate a presentation layer from a data layer. This has been the case especially in projects employing technologies such as Adobe/Macromedia Flash, which allow a project to be published as a single file. The situation slightly improved with the adoption of content management systems, where data is stored in a database. But the underlying database generally remains inaccessible to users who are only able to access it through predefined views or search interfaces. The second problem is that not everything that constitutes research data is expressed in data. A more recent digital project completed at the MPIWG is Sound & Science: Digital Histories (Tkaczyk et al. 2018). This website collects digital sources related to the history of acoustics and presents them through a search interface and in thematic sets, while also contextualising them in many written essays. It is based on the content management system Drupal and everything is stored in a database. Nevertheless, it is only through the presentation layer, where objects, images and texts are drawn together through customised views and database queries, that meaningful contexts are established. In a relational database model such as the one on which Drupal relies, individual entities are stored in separate tables. For example, the database entry describing a particular source and the database entry describing the person who authored that source reside in two different tables. And while these entities are linked together through an identifier on the database level, it is only through a database query and subsequent visual presentation that, e.g., the meaning of a relationship between a person and a text as that of "authorship" becomes evident to the user.

This is a central problem that we identified in several digital humanities projects, both of our own making and within the field: the full value of a digital research output manifests itself only through the combination of data and business logic (in the form of database queries and custom views). Research outputs rely on several layers of abstraction, as we outlined above with reference to Sperberg-McQueen and Dubin (2017). The upper layers provide meaning to the former. How, then, can we create research data that can live on its own, separate from software interfaces that might provide context to human users, but that we are unable to maintain?

From a library perspective, the transition to new digital publication environments and (micro)formats for publication as described above have changed the traditional workflows of collecting, cataloguing and archiving research outputs. Libraries have reliably accumulated publications over

centuries and thus secured the functioning of the research life cycle. The life cycle is based on scholarly publications, which build on existing publications and flow back into retrieval and archival systems. This previously well-functioning life cycle of creating, publishing, evaluating, disseminating, archiving and retrieving has long since cracked: research data, the content of databases, websites and data visualisations do not flow back reliably into retrieval mechanisms anymore and are at risk of vanishing.

In our case study, we present two projects that have been developed in parallel for four years beginning in 2016: the Max Planck Digital Research Infrastructure and the research project The Sphere: Knowledge System Evolution and the Shared Scientific Identity of Europe. The goal of the Max Planck Digital Research Infrastructure is to establish conceptual workflows and technical infrastructure for storing semantically rich research data, linking it with relevant digital sources and providing user interfaces and APIs to keep data usable even after a project has ended. Within the Sphere research project, we tested conceptual and technical approaches for creating self-contained Linked Data according to the CIDOC-CRM standard, which in turn informed the design of the Max Planck Digital Research Infrastructure, the second project we present in this case study.

The Sphere: Knowledge system evolution and the shared scientific identity in Europe

The Sphere project revolves around the history of a single text: the *Tractatus de Sphaera* written by Johannes de Sacrobosco (Valleriani 2017, 2020). Sacrobosco's *Tractatus* is a short treatise on geocentric cosmology written during the 13th century, which gave rise to a very successful commentary tradition. It was usually published together with other texts taken from different disciplines that were seen as relevant for the study of cosmology. Within the project to date we have collected digital copies of 356 editions in which this particular text appears. The corpus begins with the earliest printed edition published in 1472 and spans a timeframe of roughly 180 years until the mid-17th century when the relevance of the *Tractatus* rapidly declined. What the project seeks to investigate based on this corpus is how certain texts and the knowledge that they conveyed have been disseminated, and what the contributing factors were that supported or hindered the spread of certain kinds of knowledge. The project has resulted in new findings on epistemic communities within the corpus (Valleriani et al. 2019; Zamani et al. 2020).

To identify the possible influence of certain factors such as individual publishers, the composition of each book, the location of printers or the language in which an edition was published, we need to store relevant data in a way that allows us to identify and trace arbitrary connections between them. This is the issue that we outlined in the first part of our chapter: meaning is found not in the individual entities but through how relationships are

established between them. While the project began collecting bibliographic data about the corpus in a relational database, it was clear that a change of architecture would be required and that semantically Linked Data would be a crucial element for realising this research project.

Using the CIDOC-CRM ontology and the FRBRoo extension for bibliographic records (Bekiari et al. 2015), we created an initial data model for representing the bibliographic records of our corpus. Following the FRBR paradigm (Madison et al. 1997), an individual book is represented as separate components representing the physical copy (item), the printing template (manifestation) and the included text (expression). Using RDF, we can represent each component, as well as the events and actors that are associated with them, as individually addressable entities. Treating the content of a book as an entity on its own, which can, in turn, include other entities, allowed us to model a detailed representation of the individual texts that each edition contains. We could adapt and extend the data model as our understanding of the corpus grew and as new research questions arose. For instance, we could identify when individual texts were derived from other texts through processes of annotation or translation, thereby modelling entire genealogies of texts.

Representing the corpus in semantically rich RDF allows for a self-contained dataset, so that meaning is encoded in the data itself and not only at the point of retrieval via appropriate queries and presentation through suitable user interfaces. However, the meaning that is no longer being extracted at data output, therefore needs to be made manifest at data input, increasing the complexity of data entry. For the Sphere project, we built a data entry platform based on the Metaphacts system (Metaphacts 2019). This platform supports form-based data entry and image annotation as well as query and visualisation tools. From the perspective of a researcher, the platform's interface does not therefore significantly differ from common database-entry forms, preventing researchers from having to interact with the RDF data directly. A public instance of the platform can be found online and is documented in Kräutli and Valleriani (2018).

While the platform features a visual interface for composing custom queries, we found the availability to query RDF data directly via SPARQL to be the most useful for our research. We can query the data from Jupyter Notebooks (Project Jupyter 2020). Jupyter Notebooks are a text-based file format in which code can be combined with textual explanations, creating executable notebooks or even scholarly articles with embedded executable code. In the Sphere project, we employed Jupyter Notebooks to combine data query, analysis and visualisation in a shareable and self-contained format. Once we can no longer maintain our data entry platform, it will still be possible to download a copy of the project's research data. The notebooks can still be used locally to analyse the data. Instead of creating software that needs to be maintained and hosted, we create static artefacts that can be stored.

In the Sphere project, we applied several ideas that have been suggested for addressing the challenges of data reusability and preservation, such as Linked Data and the CIDOC-CRM data model. Implementing practical realisations of these paradigms gave us valuable insights into how we can address the issue of research data preservation at scale and create workable solutions for maintaining access to digital research outputs. Designing those solutions was the goal of the Max Planck Digital Research Infrastructure Project.

The Max Planck Digital Research Infrastructure

The ambition of the Max Planck Digital Research Infrastructure is to complete the digital research life cycle and to address the problems outlined above. We therefore designed an infrastructure to address an immediate need: the ability to maintain digital humanities research outputs so that they remain accessible and usable in the long term.

The most crucial realisation for achieving this is that most of what has been created at the Institute for digital humanities projects, and what we called databases, websites or visualisations at the time, is in fact software. Software needs to run, needs to be kept running and therefore needs constant maintenance. Lacking the resources for this, we need to separate data from software, creating self-contained datasets as demonstrated in the Sphere project. The painful consequence of this reality is that most of the user interfaces we create, most of the interactive visualisations that provide engaging access to research outputs, will not be around forever. Creating digital research outputs that remain usable also means designing the end of life of many artefacts that we create.

Our infrastructure comprises four main components: a repository, working environments, a data archive and a knowledge graph. The repository is a store of digitised sources, the Institute's digital collection. Scholars conduct their research within working environments that contain project-specific tools and artefacts. While researchers are working on a project, they use specific software and custom interfaces that may not be usable and maintainable in the long term and that will therefore be switched off at the end of a project. What remains after a project has ended is the research data, which is stored in the data archive. From there, it is fed into an institute-wide knowledge graph, where it is combined with sources in the repository as well as with data from previous research projects.

The knowledge graph becomes a central access point for all our digital artefacts, be they digitised sources, annotations or the datasets created within research projects. For this heterogeneous data to be compatible with other data, they need to be aligned to a common data model. This is where Linked Data principles come into play, namely the use of unique identifiers (URIs) to represent the same objects, together with the CIDOC-CRM ontology. We have successfully employed these principles in previous

research projects. However, applying them at scale to all our research data is a new challenge that we have yet to face. Aside from the technical hurdles, working with these models requires a new set of skills in data modelling and knowledge representation, for which librarians and digital humanities developers need to be prepared.

Discussion: Implications and future challenges

What are the lessons learned in these projects and what are the next steps? Which changes and developments do we envisage in the field of digital humanities and digital data curation in the future?

What we have found is that we are not alone in the challenges that we face. The issues and unsolved questions surrounding data legacy that we are struggling with are the same as those confronting many research and cultural heritage institutions worldwide. In every presentation we gave in recent years, we received a great deal of feedback along with many questions and requests for further exchange of expertise. It seems that most of these institutions have reached a point where the number of legacy projects has become so significant, and the danger of vanishing data so pressing, that the search for a solution has become a considerable priority and the appetite for change, along with its disruptive implications, is increasing. This also explains why a growing community is evolving around Linked Data front ends, as described above. Linked Data, as we were able to show in the previous section, is certainly a suitable solution that can separate research data from software, interlink research data with the sources to which it refers, and, most importantly, let the data flow back into the digital research life cycle. Yet we must also acknowledge that there remain problems to be solved.

In addition to the technical challenges, we faced organisational stumbling blocks when we sought to follow an agile development approach within the administrative framework of a public institution. Since we started the digital research infrastructure project with a full set of open questions that needed to be solved along the way, an agile approach was unavoidable. Unfortunately, the administrative guidelines of public institutions are not entirely compatible with agile approaches, in the case of Germany, at least. These require the project to specify the exact software requirements and individual stages of development in detail before a contract with any company can be made. It took us some weeks to do this and many workarounds with colleagues from the Institute's administration needed to be sorted out in order to make our agile approach possible.

Another challenge is the undoubtedly steep learning curve that all project members face in gaining practice with data modelling using CIDOC-CRM or other compatible models such as FRBRoo. While Linked Data has been widely adopted by libraries over the last decade to describe their bibliographic data and interlink it with authority data, our projects aim to model

not only the bibliographic records in a Linked Data format but the research data as well. This contributes to sustainably securing the data and – in the longer term – to being able to turn the "web of documents" into a "web of data".

Significant and long-term commitment and investment from all participants is therefore crucial for the successful outcome of these kinds of projects: librarians have to build up expertise in data modelling, ontologies and domain-specific vocabularies and take the lead in these fields within the research projects. Especially in the humanities, librarians must adjust more and more to new paradigms of research outcomes such as research data and other micro-publications. In order to address the question of how collaborations between information studies and digital humanities will progress and deepen, we argue that a broader knowledge of data modelling and existing ontologies will need to form a part of the curriculum for information studies. Librarians have always been experts in metadata; becoming experts in data modelling is nothing but the necessary next step. The significant difference is that their work must now become part of the research process at a much earlier stage and not only once the work is finished. Only as part of the project team can librarians advise scholars on how to express their research data using controlled vocabularies and ontologies, while also showing them the benefits of doing so. This approach will enable and require new ways of collaborating and stronger interactions between library professionals, IT experts and researchers. It can be said in general that the growth of digital approaches in the humanities is inevitably leading to more teamwork since different kinds of expertise are needed. In our experience, all sides benefit immensely from this collaboration.

While it will be the responsibility of the librarians to provide guidance, to maintain library data in ways that interconnect with research projects, and to establish standard interfaces for the exchange of research data, humanities scholars have to face the challenge of developing their projects within a digital framework and exploring digital methods from the very beginning. Using Linked Data paradigms at an early stage opens up many opportunities to exploit the data later. This will have a profound impact on research processes and methodologies. Following this approach represents a step towards genuine digital research in the humanities: digital research that rightly deserves the name "digital humanities". These approaches also need to be reflected in curricula within the humanities.

Last but not least, this deep collaboration between research projects and research infrastructures will lead to a shift of responsibilities, especially between the institution's academic staff in the digital humanities, IT specialists and the library. In our case, we are still in the process of (re)defining workflows, tasks and duties between the units as the projects evolve further. A central idea within this is to roll out every DH project in small teams consisting of the researchers, IT research staff and a librarian to provide support for data modelling.

When we started our infrastructure project, it was mainly driven by questions of maintenance and sustainability from the perspectives of the library and of IT staff: these are very practical questions about library infrastructures and about how to avoid falling into the same traps again, migrating and securing research projects and their data and finding a solution to make solving these challenges easier in future. We discovered early on that the data should be produced in certain formats, following certain data policies and using suitable ontologies. That required much closer interaction with the researchers and the research process itself than we initially expected. What seemed at first to be a sort of by-product became the centre of our attention and of enormous benefit to all parties involved: the close collaboration with the research project had a significant impact on the research methods that were employed, which enabled the researchers to work in a genuinely digital manner from the very beginning of their project. This led us to another important insight: in aiming for stable workflows and infrastructures, for clear structures and responsibilities, we had to accept the fact that the whole field that we work in is constantly developing and changing. Its fluidity is not only a result of the fact that each of the different disciplines engaged in the process (humanities, information science and IT) is very much in transition in terms of DH tools and methods, but also because the nature and degree of collaboration required in this framework are new to all three of them within this paradigm. Developing our project further than this is something we have to take into consideration. A certain level of flexibility is required not only throughout the project but also in more general terms, since we cannot initially predict all of the demands that will be placed upon our infrastructure and workflows. Our pilot project The Sphere provides a clear example: having been built on Linked Data principles and using CIDOC-CRM from the start, it provided an excellent use case for our digital research infrastructure. As the project evolved, it developed in a highly innovative direction, using methods of machine learning, identifying certain clear patterns throughout the history of the printing of the *Tractatus de Sphaera*. Using our data framework as a basis, the project went in a direction that we could not have predicted. This constant openness to changing paradigms is undoubtedly a challenge for research units and their infrastructures. At the same time, a constant dialogue between all participants is required, namely between humanities researchers and the supporting infrastructures for their research. We certainly intend to continue developing these in the future and, in our view, herein lies enormous potential for the development of digital tools and methods in the humanities.

Bibliography

Anderson, Sheila. 2013. "What are Research Infrastructures?" *International Journal of Humanities and Arts Computing* 7 (1–2): 4–23.

Bechhofer, Sean et al. 2013. "Why Linked Data is not Enough for Scientists." *Future Generation Computer Systems* 29 (2): 566–611.

Bekiari, Chryssoula, Martin Doerr, Patrick Le Boeuf and Pat Riva, eds. 2015. *Definition of FRBRoo: A Conceptual Model for Bibliographic Information in Object-Oriented Formalism.* International Federation of Library Associations and Institutions (IFLA). https://www.ifla.org/files/assets/cataloguing/FRBRoo/frbroo_v_2.4.pdf

Berners-Lee, Tim, James Hendler, and Ora Lassila. 2001. "The Semantic Web." *Scientific American* 284 (5): 34–43.

Bicho, Daniel, and Daniel Gomes. 2016. "Preserving Websites of Research & Development Projects." IPRES.

Bizer, Christian, Tom Heath, and Tim Berners-Lee. 2009. "Linked Data: The Story So Far." *International Journal on Semantic Web and Information Systems* 5 (3): 1–22.

Borgman, Christine L. 2007. *Scholarship in the Digital Age: Information, Infrastructure, and the Internet.* Cambridge, MA: MIT Press.

Champion, Erik Malcolm. 2014. "Researchers as Infrastructure." In *Proceedings of the Digital Humanities Congress 2012: Studies in the Digital Humanities,* edited by Clare Mills, Michael Pidd, and Esther Ward. Sheffield: The Digital Humanities Institute. https://www.dhi.ac.uk/openbook/chapter/dhc2012-champion

Champion, Erik Malcolm. 2018. "Introduction: A Critique of Digital Practices and Research Infrastructures." In *Cultural Heritage Infrastructures in Digital Humanities,* edited by Agiatis Benardou, Erik Champion, Costis Dallas, and Lorna M Hughes, 1–14. London: Routledge.

Crofts, Nick, Martin Doerr, Tony Gill, Stephen Stead, and Matthew Stiff, eds. 2011. *Definition of the CIDOC Conceptual Reference Model.* Heraklion: ICOM/CIDOC CRM Special Interest Group.

Crymble, Adam. 2015. "Does Your Historical Collection Need a Database-Driven Website?." *Digital Humanities Quarterly* 9 (1). http://www.digitalhumanities.org/dhq/vol/9/1/000206/000206.html

Daston, Lorraine, Jamil Ragep, Sally Ragep, and Robert Casties. 2006. "Islamic Scientific Manuscript Initiative." https://ismi.mpiwg-berlin.mpg.de/

Dierig, Sven, Jörg Kantel, and Henning Schmidgen. 2000. "The Virtual Laboratory for Physiology." Preprint 140. Max Planck Institute for the History of Science.

Doerr, Martin, and Nicholas Crofts. 1999. "Electronic Esperanto: The Role of the Object Oriented CIDOC Reference Model." In Proceedings of the ICHIM '99, Washington DC.

Doerr, Martin, Stefan Gradmann, Patrick LeBoeuf, Trond Aalberg, Rodolphe Bailly, and Marlies Olensky. 2013. *Final Report on EDM - FRBRoo Application Profile Task Force.* Europeana. http://pro.europeana.eu/taskforce/edm-frbroo-application-profile.

Doerr, Martin, Stephen Stead, and Maria Theodoridou. 2016. Definition of the CRMdig. FORTH.

Dressel, Willow. 2017. "Research Data Management Instruction for Digital Humanities." *Journal of EScience Librarianship* 6 (December): e1115. https://doi.org/10.7191/jeslib.2017.1115

Gil, Alex, and Élika Ortega. 2016. "Global Outlooks in Digital Humanities: Multilingual Practices and Minimal Computing." In *Doing Digital Humanities,* edited by Constance Crompton, Richard J. Lane, and Ray Siemens. London: Routledge.

Go::DH. 2014. "Minimal Computing." 2014. https://go-dh.github.io/mincomp/

Goerz, Guenther, Martin Scholz, Dorian Merz, Siegfried Krause, Mark Fichter, Kerstin Reinfandt, Peter Grobe, and Maria AnnaPfeifer. 2009. "What is WissKI?" http://wiss-ki.eu/what_is_wisski

Henry, Geneva. 2014. "Data Curation for the Humanities." In *Research Data Management: Practical Strategies for Information Professionals*, edited by Joyce M. Ray, 347–374. DGO-Digital original. West Lafayett: Purdue University Press. https://doi.org/10.2307/j.ctt6wq34t.20

Hughes, Lorna, Panos Constantopoulos, and Costis Dallas. 2016. "Digital Methods in the Humanities: Understanding and Describing Their Use across the Disciplines." In *A New Companion to Digital Humanities*, edited by Susan Schreibman, Ray Siemens, and John Unsworth, 150–170. Hoboken, NJ: John Wiley & Sons.

IFLA. 1998. *Functional Requirements for Bibliographic Records.* Munich: K. G. Saur Verlag. https://www.ifla.org/publications/functional-requirements-for-bibliographic-records

Kilchenmann, Andre, Flavie Laurens, and Lukas Rosenthaler. 2019. "Digitizing, Archiving... and Then? Ideas about the Usability of a Digital Archive." In *Archiving Conference, Archiving 2019 Final Program and Proceedings* (5): 146–150. Society for Imaging Science and Technology. https://doi.org/10.2352/issn.2168-3204.2019.1.0.34

Kräutli, Florian, and Matteo Valleriani. 2018. "CorpusTracer: A CIDOC Database for Tracing Knowledge Networks." *Digital Scholarship in the Humanities* 33 (2): 336–346. https://doi.org/10.1093/llc/fqx047

Kuczera, Andreas. 2018. *Graphentechnologien in den digitalen Geisteswissenschaften.* GitHub. https://kuczera.github.io/Graphentechnologien/

LOC. 2002. "EAD: Encoded Archival Description (EAD Official Site, Library of Congress)." https://www.loc.gov/ead/

LOC. 2016. "Overview of the BIBFRAME 2.0 Model (BIBFRAME – Bibliographic Framework Initiative, Library of Congress)." https://www.loc.gov/bibframe/docs/bibframe2-model.html

Madison, Olivia, John Byrum, Suzanne Jouguelet, Dorothy McGarry, Nancy Williamson, Maria Witt, Tom Delsey, Elizabeth Dulabahn, Elaine Svenonius, and Barbara Tillett. 1997. "Functional Requirements for Bibliographic Records." *International Federation of Library Associations and Institutions.* https://www.ifla.org/files/assets/cataloguing/frbr/frbr_2008.pdf

MARBI. 1996. "The MARC 21 Formats: Background and Principles." https://www.loc.gov/marc/96principl.html

Metaphacts. 2019. "Metaphacts-Community." https://bitbucket.org/metaphacts/metaphacts community

Nowviskie, Bethany P. 2012. "Eternal September of the Digital Humanities." In *Debates in the Digital Humanities*. Minneapolis: University of Minnesota Press. https://dhdebates.gc.cuny.edu/read/untitled-88c11800-9446-469b-a3be3fdb36bfbd1e/section/4aaed3b0-07ed-4c4e-ad49-8f7ceecf740a.

O'Sullivan, James. 2019. "The Humanities Have a "Reproducibility" Problem." *Talking Humanities.* 9 July 2019. https://talkinghumanities.blogs.sas.ac.uk/2019/07/09/the-humanities-have-a-reproducibility-problem/

Oldman, Dominic. 2016. "ResearchSpace." https://public.researchspace.org/resource/Start

Oldman, Dominic, Martin de Doerr, Gerald de Jong, Barry Norton, and Thomas Wikman. 2014. "Realizing Lessons of the Last 20 Years: A Manifesto for Data Provisioning and Aggregation Services for the Digital Humanities (A Position Paper)." *D-Lib Magazine* 20 (7/8). https://doi.org/10.1045/july2014-oldman

Oldman, Dominic, Martin Doerr, and Stefan Gradmann. 2016. "Zen and the Art of Linked Data: New Strategies for a Semantic Web of Humanist Knowledge." In *A New Companion to Digital Humanities*, edited by Susan Schreibman, Ray Siemens and John Unsworth, 251–273. Hoboken, NJ: John Wiley & Sons.

Peels, Rik and Lex Bouter. 2018. "The Possibility and Desirability of Replication in the Humanities." *Palgrave Communications* 4 (1): 95. https://doi.org/10.1057/s41599-018-0149-x

PARTHENOS. n.d. "The Data Heterogeneity Problem – Parthenos Training." Accessed 23 March 2021. https://training.parthenos-project.eu/sample-page/formal-ontologies-a-complete-novices-guide/what-is-data-heterogeneity/.

Project Jupyter. 2020. "Project Jupyter." https://www.jupyter.org.

Reed, Ashley. 2014. "Managing an Established Digital Humanities Project: Principles and Practices from the Twentieth Year of the William Blake Archive." *Digital Humanities Quarterly* 8 (1). http://www.digitalhumanities.org/dhq/vol/8/1/000174/000174.html

Renn, Jürgen. 2002. "Echo: Ein Virtueller Marktplatz für das Kulturelle Erbe." *Max-Planck-Forschung*, (2): 68–74.

Sampath Kumar, B. T., and K. S. Manoj Kumar. 2012. "Decay and Half-Life Period of Online Citations Cited in Open Access Journals." *International Information & Library Review* 44 (4): 202–11. https://doi.org/10.1080/10572317.2012.10762933

Sperberg-McQueen, C. M., and Dubin, David. 2017. "Data Representation." In *Digital Humanities Data Curation*. Accessed 19 March 2021. https://guide.dhcuration.org/contents/data-representation/.

Stigler, Johannes Hubert, and Elisabeth Steiner. 2018. "GAMS–An Infrastructure for the Long-Term Preservation and Publication of Research Data from the Humanities." *Mitteilungen der Vereinigung Österreichischer Bibliothekarinnen und Bibliothekare* 71 (1): 207–16.

Tkaczyk, Viktoria, Joeri Bruyninckx, Fanny Gribenski, Xiaochang Li, Kate Sturge, Robert Casties, and Florian Kräutli. 2018. "Sound & Science: Digital Histories." https://soundandscience.de/

Tzitzikas, Yannis and Yannis Marketakis. 2018. *Cinderella's Stick: A Fairy Tale for Digital Preservation*. Cham: Springer. https://doi.org/10.1007/978-3-319-98488-9

Valleriani, Matteo. 2017. "The Tracts on the Sphere: Knowledge Restructured over a Network." In *The Structures of Practical Knowledge*, edited by Matteo Valleriani, 421–473. Cham: Springer. https://doi.org/10.1007/978-3-319-45671-3_16

Valleriani, Matteo, Florian Kräutli, Maryam Zamani, Alejandro Tejedor, Christoph Sander, Malte Vogl, Sabine Bertram, Gesa Funke, and Holger Kantz. 2019. "The Emergence of Epistemic Communities in the Sphaera Corpus." *Journal of Historical Network Research* 3 (November): 50–91. https://doi.org/10.25517/jhnr.v3i1.63

Valleriani, Matteo, ed. 2020. *De Sphaera of Johannes de Sacrobosco in the Early Modern Period: The Authors of the Commentaries*. Cham: Springer. https://doi.org/10.1007/978-3-030-30833-9

Varner, Stewart. 2017. "Minimal Computing in Libraries: Introduction." https://godh.github.io/mincomp/thoughts/2017/01/15/mincomp-libraries-intro/

W3C. 2014. "RDF – Semantic Web Standards." https://www.w3.org/RDF/

Zamani, Maryam, Alejandro Tejedor, Malte Vogl, Florian Kräutli, Matteo Valleriani, and Holger Kantz. 2020. "Evolution and Transformation of Early Modern Cosmological Knowledge: A Network Study." *Scientific Reports* 10: 19822. https://doi.org/10.1038/s41598-020-76916-3

Ziegler, S. L. 2020. "Open Data in Cultural Heritage Institutions: Can We Be Better Than Data Brokers?" *Digital Humanities Quarterly* 14 (2). http://www.digitalhu manities.org/dhq/vol/14/2/000462/000462.html

Part III

Platforms and techniques

Specific platforms

11 Heritage metadata

A digital *Periegesis*

Anna Foka, Kyriaki Konstantinidou, Nasrin Mostofian, Linda Talatas, John Brady Kiesling, Elton Barker, O. Cenk Demiroglu, Kajsa Palm, David A. McMeekin, and Johan Vekselius

Introduction: *Periegesis Hellados* as heritage data

Thinking of literature as spatial information with Geographic Information System (thereon GIS) is emerging into a science known as Geographic Information Science (Harris, Bergeron, and Rouse 2010). The geospatial information community has been contributing methods, ontologies, use cases and datasets compatible to GIS as means of enabling research in the humanities and social sciences. In praxis, the application of GIS for spatial narratives means essentially unfolding their historical, non-cartesian complexity into layers of meaning-making; it can even facilitate a deeper thinking of place *both* as the locus for exploring human activity particularly as a contested terrain of competing definitions *and* as a linking mechanism for information from disparate sources, e.g., the compatibility of text to the actual archaeological data on the ground.

This chapter provides a novel perspective on GIS as both an epistemic device and a method for information organisation by focusing on the process of creating a digital cartographic edition, essentially a GIS of Pausanias's 2nd century CE ten-volume travellers' guide, the *Description of Greece*. The ten volumes comprise a narrative time machine that binds together *place* and *artefact* with its notional *origin* and *purpose*. Methodical but inconsistent in listing temples, statues, hero shrines, altars and other spaces as "Greek" places, Pausanias constructs an idiosyncratic view of Greek cultural heritage. His method, which he mentions in passing, is overtly personal and selective:

"Such in my opinion are the most famous legends (*logoi*) and sights (*theorêmata*) among the Athenians, and from the beginning my narrative has picked out of much material the things *that deserve to be recorded*". Pausanias, *Description of Greece* HYPERLINK "https://scaife.perseus.org/reader/urn:cts:greekLit:tlg0525.tlg001.perseus-grc2:1.39.3/" 1.39.3

To create a contemporary GIS out of a 2nd century CE non-cartesian, literary description of Greek heritage is a challenging scholarly endeavour

DOI: 10.4324/9781003131816-11

with importance beyond the field of classical studies. To start with, Pausanias's reputation as an actual guide for Greek heritage and archaeological finds has fluctuated over the centuries. Recent work, however, suggests that at least some of his descriptions are compatible with the archaeological record, as demonstrated at Delphi by the École Française d'Athènes and in the Athenian Agora by the American School of Classical Studies (Cundy 2016). Indeed, Pausanias's description of place does not always map easily to the archaeology. However, the gaps and disjunctions can be revealing of biases in his description as well as in contemporary scholarship. Examining the compatibility of Pausanias's ten volumes to the archaeological data on the ground is an important gap that the Digital Periegesis project seeks to fill in relation to the humanistic disciplines of classical studies and archaeology.

Moreover, Pausanias's ten volumes provide an excellent case study for additional research gaps that ought to be addressed in relation to GIS – and information organisation more generally – both from an epistemological and a technical perspective. Identifying and describing heritage, artefacts and objects and their association to cultures and space is never a straightforward task. The description of heritage in Pausanias is nearly two thousand years old and it is a "thick" narrative with a lot of disorganised information. It is a representation of material and immaterial culture and its multiple articulations over time. It constitutes an archive of sorts that, in order to be implemented in the technical environment of a GIS, first needs to be sorted in contemporary information organisation terms. From a technical perspective, GIS, with its ability to enrich and to combine layers of information, provides a possibility of combining disparate data, literary, historical and archaeological information. The project applies GIS as a means to organise heritage information to a deeper understanding of the spatial idiosyncrasies of ancient Greek culture, while responding to the broader epistemological and technical questions arising in the intersection between information organisation and digital humanities (DH).

This chapter's purpose is to highlight how GIS can help gather, organise and present heritage information (Dunn 2019; Foka et al. 2020). However, notions of heritage often concern culture and memory related to a given geographical space. Seeing as space becomes a place through the people and stories associated with it, objective heritage information organisation ideally comes with the responsibility of cultural sensibility. Geographic information, spatial data and their organisation are bound with humanistic inquiry and concepts such as ethnicity, cultural memory, conflict and provenance naturally come to the fore (Dunn et al. 2019). The project imbricates the digital and the humanistic thus opening up to the possibility of a deeper understanding of Greek heritage and archaeology, while posing the additional epistemological and technical challenges concerning the humanistic dimensions of information organisation.

In answering the essentially DH research question – how Pausanias's literary heritage information can be best organised and connected to the archaeological record on the ground – the Digital Periegesis project is charting and analysing the relevant digital tools and methods by which extensive semantic annotation and Linked Open Data (LOD) can facilitate the organisation of heritage information in Pausanias's text and its connection to actual archaeological finds. This chapter also discusses the potential application of GIS for such complex pre-cartesian narrative analysis. Finally, it emphasises the importance of building geo-spatially enriched digital editions collaboratively, involving discipline specialist researchers and information organisation experts, with the aim of holistically interpreting histories of place.

This chapter aims to review the state-of-field for using digital heritage metadata in the context of GIS mapping and LOD and to identify key challenges from both theoretical and practical perspectives. The chapter illustrates these challenges and how they can be dealt with a case study of a project using cutting-edge methodologies, the Digital Periegesis project. This allows us to answer research questions about how to organise and link textual data in relation to archaeological material culture, generally, and with regard to Pausanias's *Description of Greece* and places mentioned by him, specifically. This endeavour makes it possible to approach an overarching purpose and address larger issues related to information organisation from epistemological and technical perspectives.

In what follows, we assess Pausanias's ten books from the perspectives of DH and information organisation and in relation to the Wallenberg Foundation project: Digital Periegesis (2018–2021). We begin by drawing together previous scholarship on information organisation in relation to heritage, literature and archaeology. We then proceed to address specifically contemporary heritage initiatives that are preoccupied with spatial information organisation; we describe our case study, more precisely the process of applying computational methods to extract, to organise and to enrich heritage information, monuments and artefacts mentioned in the text. Using the open-source semantic annotation platform Recogito (2021), we record the different aspects that make up "Greek heritage" – the built environment, objects, people, events and stories and how their spatial information is organised. With a focus on marking the location of heritage information, we use Recogito to align Pausanias's places and objects in space to records in global authority files (gazetteers), as well as archaeological databases. As an example of the kind of complexity enabled by Recogito's "free tagging" capability, we discuss the use of relational tags to generate formal data statements that can enrich a broader corpus of organised heritage information. We conclude with reflections on the new knowledge gained by interdisciplinary endeavours at the intersection of information organisation and DH.

Background and related research

Heritage is essentially information organisation in praxis and has come to mean the events, materials or processes that have a special meaning for the memory and identity of certain groups of people. While definitions may vary, heritage is understood as present cultural production that has a resource to the past (Kirshenblatt-Gimblett 1998). As such, heritage springs from modernity's ambitions in information organisation: selecting, ordering, classifying and categorising the world, and simultaneously from threats that force humanity to recognise identities and their tangible or intangible representation (Harrison 2013). With the advent of the nation state in the 19th century, heritage became a challenging and a contested subject. The constant transformation of cultural identities globally due to conflict, migration and colonisation has further contributed to a complexity in understanding what heritage is and if it belongs to someone. Concepts such as a "transnational heritage" or even a "difficult heritage" have not always been specified but are present in disciplines like anthropology, archaeology, history, geography, architecture, urbanism and tourism, constituting a framework that drives applied research internationally (Silverman 2011). Heritage is thus not so much a selection of values as it is a contested subject. Who values what, where and why? And how can these values be described, organised and represented as objectively as possible through the lens of the peoples, places and stories associated with them?

In relation to the organisation of geographic information concerning peoples and cultures, heritage institutions and collections have a legacy in representing complex layers of place, before the utilisation of digital technology. Analogue information such as museums and museum catalogues have a long history of organising, curating and representing place. Spatial information is a part of nearly any curatorial practice or exhibition, more recently addressing questions of complex provenance of fragmented and disembodied artefacts as object "biographies" or "itineraries". The negotiation, organisation and representation of spatial information has always been central to the mission of any heritage institution from their early modern period origins to the Internet (Dunn et al. 2019). The increasing use of digital methods and tools in heritage information management has merely reinvigorated these questions. Indeed, the stark transformation in the way cultural heritage information is now described, communicated and experienced, especially in relation to spatial information raises complex issues pertaining to ownership and authenticity.

Over the past decades the extraordinary growth of new technologies has made it possible to aggregate, organise and analyse archaeological spatial information with GIS (Conolly and Lake 2006; Landeschi 2019; Foka et al. 2020; Trepal, Lafreniere, and Gilliland 2020; Rajani 2021). In praxis, and concerning the information organisation work of heritage institutions, this idea of organising geographic information has been utilised by large

archaeology, architecture, art and heritage stakeholders and their associated entities, most notably, the Getty Thesaurus for Geographic Names (TGN; Getty Thesaurus of Geographic Names 2017). The purpose of the TGN as a structured and organised resource for spatial data is to improve access to geographic information about art, architecture and material culture more generally. The Getty Thesaurus is in essence an organised information system aimed at providing rich spatial metadata descriptions for digital art history and related disciplines. TGN is constructed using national and international standards for thesaurus construction; its hierarchy has tree structures corresponding to current and historical worlds; it is validated by use in the scholarly art and architectural history community; and it is compiled and edited in response to the needs of the user community. All releases are available under Open Data Commons Attribution License (ODC-By). The focus is on historical art architecture and archaeological information and organisation including more recently 1 archaeological sites, lost sites, and other historical sites and 2 building concept hierarchies for historical nations and empires, where a concept hierarchy defines a sequence of low-level concepts to higher-level, more general concepts, e.g., ancient Greece (a country concept) – Peloponnese (a regional concept) – Sparta (a town concept). Thus, information organisation for monuments and artefacts is a well-articulated and documented activity in both scholarly terms and implementation in praxis.

Since the 2010s, the discipline of Geographic Information Science has focused on information organisation and visualisation of non-cartesian textual narratives. The need to combine the organisation of information with complex historical humanistic reasoning has been iterated as a necessary approach: thinking broadly in terms of Geographic Information Science and the complex epistemological concepts of space rather focusing on GIS as a system: "it is in the arena of GISc that the more substantive intellectual engagement and reciprocity between geography, GIS and the humanities will emerge" (Harris, Bergeron, and Rouse 2010). Similarly, the geospatial semantics community has contributed information organisation methods such as folksonomies, use cases and datasets targeting Semantic Web principles and LOD (Janowicz et al. 2012; Mai et al. 2019)

Research on geographic information and its organisation, focusing on traveling literature in particular, has been conducted on historical texts. Examples include the Corpus of Lake District Writing project (CLDW), a corpus of digitised and annotated texts (from 1622 and 1900), in which geographic information was aggregated and organised using automated approaches such as Named Entity Recognition (NER). The project has led to a new methodology, called Geographical Text Analysis. This methodology combines GIS applications with corpus linguistics and Natural Language Processing (NLP), targeting aesthetics, literature and physical geography used in writing about the English Lake District (Rayson et al. 2017; cf. Foka et al. 2020). The organisation of information about place names in novels

published between 1800 and 1914, working with street names in Paris, is another similar project, albeit focused at an urban context. The project combined NLP and NER with textometric tools thus facilitating automated geoparsing of street names (Moncla et al. 2017). Related work focusing on traveling itineraries is the Ben Johnson Walk project focusing on narratives concerning travels in the summer of 1618 (Ben Jonsons Walk 2020) and the City of Edinburgh project – an intra-city geographic information project collecting and organising narratives about the city of Edinburgh (Alex et al. 2019). Finally, according to Barker's Hestia Project (Barker, Isaksen, and Ogden 2016, 181–224), network graphs, by which places were organised and visualised relationally in terms of their action and influence, were a better means of identifying the links and the underlying spatial structure of the narrative, than topographic representation.

Thus, literary narratives seen through the prism of GIS, highlights human complexity, pluralism and the ambiguity of historical concepts of space and time (Foka et al. 2020). In what follows we address how the Digital Periegesis project tackles archaeology on the ground, contemporary technological frameworks for geographic information organisation and exceptionally complex ancient narratives about place and culture. We also reiterate the purpose and aims of the project focusing on methodology, results and discussion. We show how our information organisation schema is rather similar to that used by cultural heritage curators, however, categories and hierarchies are based on the concepts and terminology found in Pausanias.

Case study: Purpose and aims, methodology, results, discussion

Purpose and aims

The purpose of laying out the case study is to demonstrate the application of GIS for documents in praxis, while its central aim is to show how Pausanias's literary heritage information can be best organised and connected to the archaeological record on the ground. In doing so, the team performed an extensive semantic annotation of the volumes and applied LOD principles to facilitate the organisation of heritage information in Pausanias's text and its connection to actual archaeological finds.

Text, methodology and the technical environment

In creating a heritage-data rich version of Pausanias's *Periegesis*, we have focused on (re)using materials and resources already established in the DH community. The text we have used is available in open-license (CC-BY) (in both Greek and English) from the Scaife Digital Library (2021), a reading environment for premodern text collections in both original languages and in translation. The text itself is prepared for organising and linking

information. Documents in the Scaife Library follow the Text Encoding Initiative (TEI), the industry standard for digital texts, which uses a robust interoperable XML-schema to provide enriched and organised information, metadata, such as provenance, edition, book structure and named entities; places and peoples e.g., (for TEI and its evolution, see Burnard 2013). To be able to organise spatial information throughout the ten volumes and in collaboration, Recogito, an open-source web browser platform for semantic annotation was selected, which enables users, without coding expertise, to semantically annotate place information with Uniform Resource Identifier (URI)-based gazetteers to produce annotations as LOD. Recogito is particularly effective in collaborative work, since it keeps track of version history and edit provenance, as well as supporting the downloading of annotations in a range of different data formats.

The method of semantic geo-annotation in Recogito is twofold: (a) reading the document and manually locating and annotating the words that denote heritage in the online document and (b) then resolving and connecting annotations to a digital authority file with organised information about space (a gazetteer) that provides the means to identify and disambiguate between different places. This process is carried out entirely by the annotator who has the opportunity to review the alignment of a word denoting heritage in a document to a global gazetteer URI. The annotators can choose what they consider the appropriate URI and disambiguate that place and map, according to the Web Annotation Data Model (Web Annotation Data Model 2017). Thanks to global gazetteer initiatives, the procedure for identifying and disambiguating ancient place information from documents in Recogito is relatively robust, and can greatly assist comparison and further analysis.

One obstacle that we needed to overcome was where Recogito draws on a suite of established global gazetteers, including Pleiades, the gazetteer for the ancient world. Usually, Pleiades would be sufficient when working on a text from the ancient world, since its coverage spans the Roman Empire (and beyond into Persia). Pausanias's *Description of Greece*, however, presents a challenge, because so much of the narrative takes place within settlements – the place (city, town, village) being the customary baseline for Pleiades (2021). Pausanias's deep dive into places includes descriptions of areas within a city (e.g., the Athenian agora, the Acropolis), and, above all, its heritage monuments – buildings (e.g., temples) and objects (e.g., statues). Very few, if any, of these places or *objects in space* have a record in Pleiades. To address this obvious omission that for reasons unrelated to this study where not an option in the global instance, we hosted a local instance of Recogito, to which we could then upload custom gazetteers in addition to Pleiades and the Digital Atlas of the Roman Empire (DARE 2019). To have more granular topographic and heritage data identifiers, we generated and imported three additional gazetteers. From ToposText.org, an indexed collection of ancient texts and mapped places relevant to the history and

mythology of Greece from the Neolithic period to the 2nd century CE, we collected identifiers for ancient Greek sanctuaries and buildings not yet in Pleiades. For art historical artefacts and monuments in Athens, we derived identifiers and extrapolated coordinates from the late J. Binder's *The Monuments and Sites of Athens: A Sourcebook*, as digitised by J. B. Kiesling for the project, Dipylon (2020). Finally, we utilised a detailed database of ancient art objects mentioned by Pausanias, compiled by T. Hölscher et al., *Bildwerke bei Pausanias*, and included in the database of the Deutsches Archäologisches Institut (DAI). Once these additional resources had been added to our instance of Recogito, we then uploaded the Scaife TEI Greek text of Pausanias, dividing it into the ten books that correspond to the ten volumes of the work which were then assigned to different members of the team, reflecting their disciplinary expertise.

The manual process of digital semantic annotation that is used for the project's case study is extensively described elsewhere (Barker, Foka, and Konstantinidou 2020, 195–202) and hence, is only briefly presented here. The general practice is to manually identify and mark up a word that denotes "heritage" in the broader sense, as a tangible or an intangible manifestation of Greek throughout Pausanias's ten volumes. For example, it could be a word for an architectural monument or an artefact, or even a word that denotes a group of people who carry a specific story of origin or culture, e.g., the Spartans, as proxies to a geographic location, e.g., Sparta.

In addition to manual annotations that require specialised knowledge, Recogito offers a NER option, an automated mechanism for the identification and annotation of named entities, as part of a first, automated sweep of the document, before each annotation is checked and verified by the annotator. NER is currently restricted to European languages, with the default (Stanford CoreNLP) trained models for NER for English language texts.

Since the team is working with the Greek text, NER cannot be applied, therefore we focus on manual annotation only. The annotator then remains in full control – a critical feature in a text where a place may be referred to in terms that are clear only in context, e.g., "the temple" ('ναός'), where the annotator must perform the disambiguation by reading above and below to identify the Temple of Hera at Olympia. In Recogito's annotation screen, the user identifies a character string as a monument or an object in space and then aligns that reference to a suitable gazetteer entry. By virtue of this two-step process, the user not only disambiguates their individual place information and links it to an authority record; by using a gazetteer URI, they also produce LOD annotations by which the place referenced in Pausanias can be linked to other resources mentioning the same place. Selecting a gazetteer entry also has the added benefit of automatically providing coordinates (where available) to map the place. An annotator can also provide additional information in a "comment" field or as "tags". Figure 11.1 shows the working interface for semantic annotation in Recogito. In the figure the word eikōn, is marked up and tagged in the Greek version of *Description*

Section 12

Καυλωνία δὲ ἀπωκίσθη μὲν ἐς Ἰταλίαν ὑπὸ Ἀχαιῶν, οἰκιστὴς δὲ ἐγένετο αὐτῆς Τύφων Αἰγιεύς· Πύρρου δὲ τοῦ Αἰακίδου καὶ Ταραντίνων ἐς τὸν πρὸς Ῥωμαίους πόλεμον καταστάντων ἄλλαι τε τῶν ἐν Ἰταλίᾳ πόλεων ἐγένοντο αἱ μὲν ὑπὸ Ῥωμαίων, αἱ δὲ ὑπὸ τῶν Ἠπειρωτῶν ἀνάστατοι, κατέλαβε δὲ ἐς ἅπαν ἐρημωθῆναι καὶ τὴν Καυλωνίαν ἁλοῦσαν ὑπὸ Καμπανῶν, οἳ Ῥωμαίοις μεγίστη τοῦ συμμαχικοῦ μοῖρα ἦσαν.

Section 13

ἐπὶ δὲ τῷ Δίκωνι ἀνάκειται μὲν Ξενοφῶν Μενεφύλου παγκρατιαστὴς ἀνὴρ ἐξ Αἰγίου τῆς Ἀχαιῶν, ἀνάκειται δὲ Πυριλάμπης Ἐφέσιος λαβὼν δολίχου νίκην. τοῦ μὲν δὴ τὴν εἰκόνα ἐποίησεν Ὄλυμπος, Πυριλάμπει δὲ ὁμώνυμος καὶ ὁ πλάστης, γένος δὲ οὐ Σικυώνιος, ἀλλὰ ἐκ Μεσσήνης τῆς ὑπὸ τῇ Ἰθώμῃ.

Section 14

Λύσανδρον δὲ τὸν Ἀ
ἐν καλυβαίτῳ τεμένι
ἔστηκ᾿ ἀνθέντων ὃης
τοῦτο μὲν δὴ τοὺς τὸ
ἀθάνατον πάτρα καὶ
Λύσανδρ᾿, ἐκτελέσα
δῆλοι οὖν εἰσιν οἵ τε

Q⁺ Place ▲⁺ Person ★⁺ Event

Portrait statue: Xenophon (athlete) Olym...
dai:3586540

JBradyK 9 months ago

Add a comment...

object eikōn Add tag

Cancel OK & Next OK

τὸ μὲν πρότερον τῶν ἐπιγραμμάτων ἐστὶν

ὑσανόρον·

Figure 11.1 Semantic annotation in Recogito of the word eikōn (meaning inter-
changeably icon, painting, likeness or image) in Pausanias's *description
of Greece* 6.13.11, including gazetteer entry and organised free-text tags.

of Greece 6.13.11. As it appears by the interface the user disambiguates and
aligns the word with a specific entry. As the bottom line shows the annotator
also adds hierarchical free-text tags, object and eikōn, in this case.

Tags in particular have the potential to be an extremely powerful means of
organising the data. The pros and cons of collaborative, social and coherent
tagging (cf. Golub, Lykke, and Tudhope 2014) were considered. The research
expertise of the annotating team and initial research questions of the pro-
ject, however, guided the choices. After some trial and error and multiple
presentations to external reference groups, the research team developed a
tagging schema that, while based on Pausanias's own description, helped
organise and structure place information as a heuristic tool in a way that
could be consistently applied. The scheme is as follows: The first two tags are
loosely inspired by FISH, the Forum of Information Standards in Heritage
Vocabularies (http://www.heritage-standards.org.uk/fish-vocabularies/),
and more precisely their three thesauri: the Object Material Thesaurus, the
Monument Material Thesaurus and the Archaeological Objects Thesaurus.
The point is to identify different types of heritage objects and monuments
(an "ontology" or "typology"). That is to say, while being aware of con-
temporary modes of organising, e.g., heritage or art historical knowledge,
the project group chose the original vocabulary that Pausanias uses in the
Greek language (and in expert translation) as far as possible, and generated
a schema based on his description, rather than impose one from our own
culture which would be culture-insensitive and anachronistic.

Therefore, the annotators decided to adhere to the following tagging
guidelines. The first tag establishes broad analytical categories to make

entities easier to group and filter: for large structures such as a city, temple, theatre etc., we use the tag "built" (for the "built environment"); for natural features of the landscape, the tag "physical"; for smaller items (in space), like a statue, artwork, dedication, column etc., "object"; and, if the place represents an inherently unmappable space like Hades, we use the tag "mythical". A second tag is used to capture a key element of the description, using vocabulary driven by Pausanias's own word choice: e.g., a *"naos"* (temple), *"hieron"* (sanctuary), *"bomos"* (altar') or an *"agalma"* (statue as divine offering), *"xoanon"* (roughly carved old wooden image), *"anathēma"* (offering) etc. The third set of tags corresponds directly to the research question of the project. We use the tag "Paus" to signify that Pausanias is writing as if he is physically present at the place at this moment of his narrative. We use the tag "opsis" (sight/sighting) when Pausanias writes about a place he knows from direct experience but is outside the geography of his current narrative – when he does not appear present at the time. This data enrichment allows Pausanias's nominal itinerary to be visualised programmatically and defines a set of actual places of which Pausanias gives a more complex historical and geographical account than the mere record of visiting one ancient temple after another.

Tagging persons, tagging time

It is worth mentioning two other features beyond place information that we have also annotated. Recogito's flexibility allows us to markup prosopographical (referring to persons) and temporal information in addition to spatial data, the difference being the lack of an authority file for the latter two. That is to say, where marking a place is a two-step process – identify the reference in the text; align to the gazetteer record – marking people or time only involves the initial step. This is because, at the time of writing, there is no global authority standard for ancient people or for temporal information in the same way as there are with places. The original vocabulary that Pausanias uses in the Greek language (and in expert translation) comes with variations and discrepancies as well as added complexity, e.g., it could be "Dionysos" in one gazetteer and "Dionysus" in another and they may not even be the same person; also, the temporal metric systems from our own culture do not necessarily map onto contemporary dating classifications (e.g., "323 BCE" or "the Hellenistic period").

Still, it seemed to us that it was also important to mark both entities in Pausanias, not least because of their associations with place and their impact on how those places are viewed. In addition, in a similar way to how have approached the challenge of meeting Pausanias's thick place description by incorporating more granular place-based resources in Recogito to align our references, we developed lightweight, practical measures to disambiguate and authorise our prosopographical and temporal data so far as possible. For the former, this has meant manually aligning named persons in

Pausanias to their Wikidata identifier, by which we will be able to track the gods, heroes, artists, athletes and politicians whose names recur throughout the narrative. For efficient workflow, we annotate personal names in Recogito simply as "person" rather than align them individually. We export these annotated names in Greek as batches, match to their English/Latin forms and align to Wikidata using Excel. We then import again to the final annotation file which is enriched with structured data extracted from Wikidata using OpenRefine, a free and open access data cleaning and information organisation tool.

As for time Pausanias's narrative moves rapidly back and forth in time, from the Golden Age of Greek myth, to the wars between Hellenistic monarchs, to his own period. Capturing these varied chronological elements as one moves through the narrative is challenging. Even more difficult is rendering Pausanias's time descriptions as year dates. Again, there is a need to be sensitive and alert to the nuances of Pausanias's description: how he talks about time – as, say, an event like "the Trojan War", or else through the figure of a mythical/historical person, like "Ptolemy Soter" – is an important aspect to investigate for the reader and there needs to be an informed annotation in place that signifies the time and/or the temporal information of that event.

On the other hand, it is useful if we can also translate those periods into date stamps for visualisation purposes, with which one will be able to explore how the chronological structures of the events described relates to, intersects with, and works against the chronotope of the narrative (e.g., Book 1, chapter 2, paragraph 3). Rich libraries of chronological expressions have been compiled, most noteworthy being the structured authority files for time periods of PeriodO (period.o 2020), a public domain gazetteer of historical, art-historical and archaeological periods. While linking among datasets that define periods differently may be an interesting exercise, the resource is at the time of writing by no means complete, although it helps scholars and students see where period definitions overlap or diverge. However, such terms and their associated date ranges seldom map neatly to Pausanias's narrative which tends to establish a working chronology by using known events such as battles or Olympiads. Fortunately, Wikidata is rich in such items. We can thus annotate the 102nd Olympia mentioned by Pausanias with its Wikidata ID, Q57337793, and extract the year date as a temporal expression, "tx:372 BCE". We can then use relation annotations to link persons, places and events in Pausanias's narrative to a year we can place on a visualisation timeline.

Tagging relations

The aim of the Periegesis project is to not simply catalogue and organise Hellenic heritage according to Pausanias but rather to delve deeper into the meaningful semantic relationships between objects, monuments, people

and events. As noted above, Recogito allows annotations to be linked to one another by any relationship term (e.g., "origin") the project members are interested in defining. The end product of the annotation process is a downloadable nodes and edges CSV format file download that is compatible with social network visualisation platforms such as e.g., Gephi that can be shared and reused on many platforms.

A particularly relation-information rich section is Pausanias's description of the monuments in the sanctuary of Olympian Zeus at Olympia in Books five and six. The Olympic Games brought together elite audiences and performers from the entire Greek-influenced world. Preeminent Greek artists memorialised preeminent personalities there. The relative placement of portrait statues and other dedications within the Altis, the sacred enclosure, in Pausanias's ten volumes is a testimony to dynamic semantic relations of heritage and memory as connected to political power and patronage over the centuries. Pausanias draws distinctions between divine images offered to the gods (*agalma*, *xoanon*) and statues of men (*andrias*, *eikôn*), but the true significance of such terms is not made explicit. Tagging relations using Pausanias's precise nomenclature is thus vital to understanding his description, since it allows us to derive important semantic data from systematic analysis of who is depicted under what circumstance. It is particularly interesting to contrast the role of human portrait statues and divine statues at Olympia, where objects were given a particularly high exposure and had strong social and political implications.

The number of historically charged art objects Pausanias describes, well over three hundred at Olympia alone, and the number of artists, teachers and patrons he mentions, is too large and complex for rigorous organisation without computer assistance. Often, whether through his historical knowledge or the inscriptions he reads on the statue bases, Pausanias provides us with a complete genealogy of the person portrayed. Our relatively basic annotations of the Altis section of Book 6 harvested almost 2,500 instances of 1,110 unique named entities.

Our annotation efforts were designed to distil Pausanias's description into a series of consequent machine-readable statements in Subject -> Verb -> Object form. For the 160 or more portrait statues and statue groups Pausanias lists, the annotations of relations are complex and long and tend to follow the following model: Object A, offered to Zeus by Person B, depicts Person C son of Person D from Place E, in honour of Event F, created by Person G, the student of Person H, at Temporal/Event I, using Material J from Place K, is contained in Place L and located in spatial relation M to Object N and O (which have their own set of similar properties).

Each letter above represents a recognisable Named Entity as the subject or object of our annotation statements: artwork from the Arachne database (DAI 2017); places from ToposText/Pleiades/DARE; persons, events (e.g., Olympiads, battles) and materials from Wikidata. Relationship labels need to be short, to save typing effort, but also unambiguous in their

directionality, since in Recogito they are drawn as arrows from subject to object/target. A tag like "father" is inherently ambiguous, because the relationship could easily run in either direction: is father of, or has as father. To reduce that uncertainty, we regard relationship labels as active verbs, e.g., "father" as "he fathered", "dedicates" (person that dedicates an artwork) and "depicts" (artwork that depicts a person). In most cases, the extracted relations translate directly into Wikidata properties. Our "depicts" maps to Wikidata P180 (https://www.wikidata.org/wiki/Property:P180) "depicts", while "creates" is the inverse of Wikidata P170, "has creator", but in practice can map directly to P800 "has notable work".

When it comes to spatial relationships, to ensure maximum precision and granularity, we elected to retain Pausanias's own terms, transliterated but not translated. Thus, portrait statue A is *"pros"* statue B, that is, close up against it, while statue C is *"ephexes"* statue B, that is, comes next in a series. These relationship tags give us a better understanding of the multiple layers of information that lay within the text: they draw spatial links between monuments on a map, while by referring to space, they illustrate links between people, events and places, thus drawing a lively picture of movements and exchange, and improving our understanding of social, economic and geopolitical relations in Greek antiquity.

Conclusion: Extending disciplines, extending data ecosystems

The Digital Periegesis project set out to create a contemporary GIS out of an ancient non-cartesian, literary description of Greek heritage. While the project at the time of writing is in its final, there are important observations and conclusions to be made from a DH research perspective. First, the validation of the description of Greek heritage by connection to the archaeological information record. To this date, numbers are approximate, subject to change as repeat mentions are integrated and slips are continuously corrected. Of 20,081 identified and marked up place mentions, real place information and coordinates can be assigned to 15,670 of them. A key part of the annotation process is to provide an exportable database of all the 4,113 mentions of places or large objects that are not yet catalogued/mapped in any gazetteer. These can be verified in geographical terms by proximity to another verified spatial entity. The latter include many of Pausanias's 366 or so temple mentions, 174 altars, 304 tombs/memorials and 1,058 sanctuaries. Second, the ultimate result will be a densely annotated digital edition, available in several formats, that can be downloaded, reused and re-explored on its own or integrated into a much broader universe of cultural heritage information describing the ancient world through the eyes of the 2nd century traveller Pausanias.

Heritage items, digitised or not, are often built as manifestations of dominant historical and linguistic approaches; as a consequence, thesaurus and vocabulary standards are following anglophone models and thus may fail to encapsulate the meaning of heritage artefacts, including their original uses

and contexts. Another issue is that information organisation standards and classifications are more generally used (see e.g., TGN) but in praxis, and with case studies as specific as Pausanias's description of Greek cultural heritage, there are additional research specific inquiries to take into consideration. The description of heritage in Pausanias is not only a "thick" narrative with a lot of disorganised information, but much of the original language had to be part of the descriptive parameters of each word denoting heritage. With heritage monuments and cultural data in particular, it is important that information organisation is thus embracing the original context with humanistic sensibility. Using GIS to organise a century long narrative may have a similar issue – places and monuments change names and territories change hands over time. Again, geographic information vocabularies need to be often case specific looking at information concerning space as a conjunction of spatial and temporal information. In other words, while a heritage monument or an artefact may seem as a static point on a map, in reality it comes with a flurry of often disparate information, actual, temporal, cultural that needs to be thought through, compartmentalised and organised in a holistic, culturally-sensible and inclusive way.

Tackling technological concerns is equally important: as disciplines and ideas evolve, so does technology, especially pertaining to information organisation. For example, the Pleiades structure continues to evolve as a robust foundation for place data, with ToposText attempting to follow in its wake. Recogito currently supports a range of export formats, which is likely to be expanded. Assigning coordinates taken from authority structured files such as gazetteers is relatively easy to do manually, but the lesson is that one needs to hold the relevant humanistic expertise to implement.

Finally, perhaps the most important lesson to be learnt concerns interdisciplinarity. The Digital Periegesis project is based on interdisciplinary collaboration, involving discipline specialist researchers such as archaeologists and classical philologists, but also geographers and computational linguists alongside information technology and information organisation experts. The feasibility of the open access platform for easy collaborative annotation facilitated interdisciplinary thinking and implementation. In that sense, one of the important lessons to take with is that while subject and case study specific, the Digital Periegesis project aims to be generative and to be used by the wider communities of classicists, archaeologists and heritage experts and institutions. As such, it corresponds to a more general issue rather than being confined to the study of Pausanias – and in doing so, it makes an ancient traveling narrative thought through technology, relevant to this digital day and age.

Bibliography

Alex, B., C. Grover, R. Tobin, and J. Oberlander. 2019. "Geoparsing Historical and Contemporary Literary Text Set in the City of Edinburgh." *Language Resources and Evaluation* 53 (4): 651–675. https://doi.org/10.1007/s10579-019-09443-x

Arachne database (DAI). 2017. https://arachne.dainst.org/

Barker, Elton, Anna Foka, and Kyriaki Konstantinidou. 2020. "Coding for the Many, Transforming Knowledge for All: Annotating Digital Documents." *PMLA/Publications of the Modern Language Association of America* 135 (1). Cambridge University Press: 195–202. doi:10.1632/pmla.2020.135.1.195

Barker, Elton, Leif Isaksen, and Jessica Ogden. 2016. "Telling Stories with Maps: Digital Experiments with Herodotean Geography." In *New Worlds Out of Old Texts: Revisiting Ancient Space and Place*, edited by Elton Barker, Stefan Bouzarovski, Leif Isaksen, and Chris Pelling, 181–224. Oxford: Oxford University Press. https://doi.org/0.1093/acprof:oso/9780199664139.001.0001

Ben Jonsons Walk. 2020. https://www.blogs.hss.ed.ac.uk/ben-jonsons-walk/map/

Burnard, Lou. 2013. "The Evolution of the Text Encoding Initiative: From Research Project to Research Infrastructure." *Journal of the Text Encoding Initiative* 5, 1–15.

Conolly, James and Mark Lake. 2006. *Geographical Information Systems in Archaeology*. Cambridge: Cambridge University Press.

Cundy, J. E. 2016. "Axion Theas: Wonder, Space, and Place in Pausanias' Periegesis Hellados." PhD diss., Toronto: University of Toronto Press.

Digital Atlas of the Roman Empire (DARE). 2019. https://dh.gu.se/dare/

Dipylon organization. 2020. https://dipylon.org/en/

Dunn, S., G. Earl, A. Foka, and W. Wooton, 2019. "The Birth of the Digital Object Itinerary." In *Museums and Digital Culture: New Perspectives and Research*, edited by Tula Giannini and Jonathan P. Bowen, 253–271. Berlin, Heidelberg: Springer.

Dunn, Stuart. 2019. *A History of Place in the Digital Age*. Routledge: London https://doi.org/10.4324/9781315404462

Foka, Anna, Elton Barker, Kyriaki Konstantinidou, Nasrin Mostofian, Osman Cenk Demiroglu, Brady Kiesling, and Linda Talatas. 2020. "Semantically geo-annotating an ancient Greek" travel guide" Itineraries, Chronotopes, Networks, and Linked Data." In *Proceedings of the 4th ACM SIGSPATIAL Workshop on Geospatial Humanities*, edited by Ludovic Moncla, Patricia Murrieta-Flores, Carmen Brando, 1–9. New York, NY: Association for Computing Machinery.

Foka, Anna, Coppélie Cocq, Phillip I. Buckland, and Stefan Gelfgren. 2020. "Mapping Socio-Ecological Landscapes: Geovisualization as Method." In *Routledge International Handbook of Research Methods in Digital Humanities*, edited by Kristen Schuster and Stuart Dunn, 203–217. London: Routledge.

Getty Thesaurus of Geographic Names. 2017. https://www.getty.edu/research/tools/vocabularies/tgn/index.html

Golub, Koraljka, Marianne Lykke, and Duglas Tudhope. 2014. "Enhancing Social Tagging with Automated Keywords from the Dewey Decimal Classification." *Journal of Documentation* 70 (5): 801–828. http://dx.doi.org/10.1108/JD-05-2013-0056

Harris, Trevor M., L. Jesse Rouse, and Susan Bergeron 2010. "The Geospatial Semantic Web, Pareto GIS, and the Humanities." In *The Spatial Humanities: GIS and the Future of Humanities Scholarship*, edited by David J. Bodenhamer, John Corrigan, and Trevor M. Harris, 124–142. Indiana: Bloomington University Press.

Harrison, R. 2013. *Heritage: Critical Approaches*. London: Routledge.

Janowicz, K., S. Scheider, T. Pehle, and G. Hart. 2012. "Geospatial Semantics and Linked Spatiotemporal Data. Past, Present, and Future." *Semantic Web* 3 (4): 321–332. https://doi.org/10.3233/SW-2012-0077 (accessed May 8, 2021).

Kirshenblatt-Gimblett, B. 1998. *Destination Culture*, Berkeley, CA: University of California Press.

Landeschi, Giacomo. 2019. "Rethinking GIS, Three-Dimensionality and Space Perception in Archaeology." *World Archaeology* 51(1), 17–32.

Mai, Gengchen Krzysztof Janowicz, Bo Yan, Simon Scheider. 2019. "Deeply Integrating Linked Data with Geographic Information Systems." *Transactions in GIS* 23 3: 579–600. https://doi.org/10.1111/tgis.12538

Moncla, Lodovic, Mauro Gaio, Thierry Joliveau and Yves-François Le Lay. 2017. "Automated Geoparsing of Paris Street Names in 19th Century Novels." In *Proceedings of the 1st ACM SIGSPATIAL Workshop on Geospatial Humanities*. 1–8. https://doi.org/10.1145/3149858.3149859

Pleiades. 2021. https://pleiades.stoa.org/.

Pretzler, Maria. 2007. *Pausanias: Travel Writing in Ancient Greece*. London: Duckworth.

Rajani, M. B. 2021. "GIS: An Array of Tools for Archaeology." In *Patterns in Past Settlements: Geospatial Analysis of Imprints of Cultural Heritage on Landscapes*. 83–110. Singapore: Springer.

Rayson, Paul, Alex Reinhold, James Butler, Chris Donaldson, Ian Gregory, and Joanna Taylor. 2017. "A Deeply Annotated Testbed for Geographical Text Analysis: The Corpus of Lake District Writing." In *Proceedings of the 1st ACM SIGSPATIAL Workshop on Geospatial Humanities*. 9–15. New York, NY: Association for Computing Machinery. https://doi.org/10.1145/3149858.3149865

Recogito. 2021. https://recogito.pelagios.org/

Scaife Digital Library. 2021. https://scaife.perseus.org/

Silverman, H. 2011. "Contested Cultural Heritage: A Selective Historiography." In *Contested Cultural Heritage*, edited by Helaine Silverman, 1–49. New York, NY: Springer.

Stanford CoreNLP. 2020. https://stanfordnlp.github.io/CoreNLP/

ToposText. 2019. https://topostext.org/

Trepal, Dan, Don Lafreniere, and Jason Gilliland. 2020. "Historical Spatial-Data Infrastructures for Archaeology: Towards a Spatiotemporal Big-Data Approach to Studying the Postindustrial City." *Historical Archaeology* 54: 424–452. https://doi.org/10.1007/s41636-020-00245-5

Web Annotation Data Model. 2017. https://www.w3.org/TR/annotation-model/

Data analysis techniques

12 Machine learning techniques for the management of digitised collections

Mathias Coeckelbergs and Seth Van Hooland

Introduction

If we believe media such as the New York Times, artificial intelligence (AI) and machine learning techniques have the potential to automate a wide range of societal challenges, from the detection of cancer to self-driving cars (Lohr 2016). Given enough content to analyse and practice on as a training set, algorithms can develop statistical models to replace decision-making ordinarily perceived as requiring human intelligence, such as driving a car in traffic or interpreting an X-ray scan. There is no lack of content to analyse. There is too much of it to be handled manually.

In this context, automation is no longer seen as a feature that is "nice to have", but is a necessity. However, there are a lot of misunderstandings and false hope circulating in the archives and records management community. We use the terms information management and archives and records management interchangeably throughout this paper. A complex debate could be had on the exact boundaries and definitions of these two fields, but automation has a role to play in both. However, we decided not to focus on the exact definitions of each field. This chapter therefore seeks to give professional users such as researchers and students a better understanding both of the possibilities and the limits of automation.

The first half of the chapter develops a typology of the different methods and tools which have been in use for decades to automate particular aspects within the life cycle of information in archives. We believe that machine learning methods can greatly contribute to the life cycle of information, as they can perform manipulations on the raw data, unmediated by previous selection mechanisms. This overview also includes a review of the relevant current literature. The latter half of the chapter then focusses on a more detailed description of one specific technique which can be applied by virtually any records manager or archival collection holder: topic modelling (TM). In the context of this chapter, we consider TM as a "gateway drug" for the information management community. Once you get "hooked" on easily implemented, unsupervised analyses, it opens the door to more enhanced machine learning techniques. It is easy to get

DOI: 10.4324/9781003131816-12

quick results and it may trigger insights into the implementation of more complex and resource-intensive machine learning methods and tools. To make the introduction to TM as pragmatic as possible, we present the technique with the help of a real-life, large-scale case study. In the study, TM was applied on an archival corpus of the European Commission (EC) using a statistically significant sample. Having presented the results of the case study, the chapter concludes with some remarks on how the information management community can develop a more pragmatic view on automation.

The remainder of this chapter will first provide an overview of the state of the art of both automation for information management and how machine learning was introduced in the text mining field in general and in records management in particular. Then, we discuss the usefulness of one specific topic modelling algorithm, Latent Dirichlet Allocation (LDA) and how it can help us give an initial assessment of the applications of machine learning in an archival setting. This will allow us to develop a case study in which we use LDA to link documents to entries of the EuroVoc thesaurus. The chapter ends with a discussion and conclusion of the above.

A short history of automation in information management

Electronic records management may seem to be a tautology, since records management is traditionally associated with archives that keep track of their records without the use of information technology. The term electronic records management is used more and more often as the field is shifting almost exclusively to digital methods. A complex debate could be had on the exact boundaries and definitions of the two fields, but automation has a role to play in both. However, we decided not to focus on the exact definition of the boundaries of each field. Archival documents can also include e-mails, for example. But, as Bailey pointed out almost a decade ago, the status or role of automation within the professional community remains a "somewhat ill-defined and rather arbitrary one" (Bailey 2009, 91). Take, for example, the principles underpinning virtually every electronic document and records management system on the market today: records must exist within a container of some kind (as if they were a physical item). Here we understand records as the documents we want to archive and containers as the smallest unit in which they are collected. They can only exist in one place within the system (again, as if they were a physical item) and are allocated this location within a hierarchical classification scheme that organises content as if physically arranging it. We add additional metadata to records to enable multiple search routes in the same way as subject-based index cards (cards sorted according to a pre-defined list of subjects) did for our paper-holdings in the days before databases; and we define retention and destruction periods according to when the file was opened or closed or the record was created, in a way that

would have been immediately familiar to a registry officer from the 1960s. In short, we try to manage electronic records as we have always managed paper records: and this is why we are failing. For in doing so we have missed the crux of the issue, which is that the real challenge is not the fact that records are now electronic: it is the sheer volume with which they are now being produced. That requires an entirely different approach to their management.

It seems that a new wave of enthusiasm emerges every decade. With hindsight, three different stages can be identified, each of which can be roughly mapped to a particular decade. On each occasion, the archivist community puts its hope in the arrival of new hardware and software paradigms:

- In the 90s began the ubiquitous usage of desktops and client-server architecture. The popularity of monolithic EDRMS (electronic document and records management systems) applications, such as Documentum reached a maximum.
- At the end of the 90s and the beginning of the century there developed the global usage of the Web and the introduction of Web-based software.
- From 2010 onwards, cloud computing started to take off commercially at a large scale. The period is marked by major advances in natural-language processing (NLP) and increased interest in Linked Data for the creation and sharing of virtual authority files. For example, the Social Networks and Archival Context (SNAC) Project demonstrates how existing descriptions in the Encoded Archival Context – Corporate bodies, Persons, Families (EAC-CPF) format can be leveraged as Linked Data. During the same period, interest in the use of Machine Learning to extract meaning from non-structured text also rose.

While it is relatively straightforward to draw up a typology of methods, as we have just described, it can be more of a challenge to describe the various aspects of the life cycle of documents and files to be automated. In many cases, it is more accurate to talk about semi-automation, since human intervention is often still required in the life cycle of documents. Elements of this semi-automated cycle include the following:

- appraisal and record declaration, based on worth: in a paper-based environment, records managers and archivists were responsible for identifying the business value of documents. In an electronic environment, this task has been shifted onto staff members. A large body of literature documents the inadequacy of such an approach, as described by (Vellino 2016);
- classification of a record into a file;
- development of a controlled vocabulary and its application;
- identification of personally identifiable information.

The process of appraisal establishes the value of information, qualifying its value and determining the retention period (Duranti 1994, 329). A recent thorough study on the possibilities and limits of automatically appraising e-mail was conducted by Vellino (2016). He describes the need to formalise the organisational context, which requires considerable effort.

In the first step, a qualitative study of the e-mail appraisal behaviour of records management experts is performed based on semi-structured interviews and cognitive inquiries, followed by data analysis. Based on this input, an abstract classification model was built, consisting of two top-level categories: "e-mails of business value" and "e-mails of no business value", which were further divided into 13 sub-categories. The insights of eight records management experts were used as training data for a support vector machine (SVM), one of the most widely used machine learning methods for classification. The trained model was then tested on a collection of 846 e-mails, taken from two of these experts' mailboxes. The main result of this experiment was that, although it is very complex to establish a consensus within an organisation on what is "business value", machine classification models nevertheless achieve a high degree of accuracy. The most important criteria appeared to be the keywords in the subject field and the textual features from the e-mail body. This result shows that a smart textual representation, based on machine learning, together with insight into the indexing of these emails by their subject field, gives promising results for automatic methods of classifying e-mails for long-term preservation as an on-demand service.

At this point we are confronted with one of the central problems of metadata: they are infinitely extendable. Boydens has pointed out this danger by referring to Friedrich Nietzsche's "Vom Nutzen und Nachtheil der Historie fuer das Leben" ("About the benefits and disadvantages of history for life", in which Nietzsche aims to demonstrate that we need to *serve history only insofar as it serves living*" [Boydens 1999]). The different layers of metadata that are added, one on top of another, result in highly complex documentation practices that are difficult to maintain. The ability to comment on a user review of an Amazon product provides an illustrative example. The user comment, which can be considered a form of metadata on the book that a customer bought, is turned into data itself by attaching metadata to it in the form of a review of the comment.

Metadata evolve through time, but so do the objects and realities that they describe. Boydens and Hooland (2011) explained that the notion of the *lead department* is one of the conceptual building blocks of a records management policy. Throughout the entire life cycle of a record, it should be clear who has responsibility for a file. However, as Desrochers says, "the properties of organizational structures have shifted from a hierarchical command and control structure – a Weberian state – to one where an organization exists and interacts in a network with other institutions" (Desrochers et al. 2011). Phenomena such as mergers, acquisitions, take-overs and bankruptcies also

challenge the notion of having an established entity responsible for a file. In the aftermath of the Fortis and Dexia bankruptcies, questions arise regarding their management, based on the information decisions that were taken. If no clear records management policy was implemented at the time of these crises, it will be impossible to present legally sound information in about who was aware of what information and when.

The National Archives and Records Administration (NARA) has identified five different approaches to automation. Based on their typology, three distinct methods can be differentiated:

- Rule-based automation: Based on prior established rules, documents can be assigned records, filed and given retention rules. These rules can vary widely in their complexity. An example of a relatively simple rule is the approach promoted in the "capstone" method of managing e-mail. This records management method requires organisations to designate specific inboxes for accounts that are likely to receive crucial e-mails. In this case, an organisation might, for example, declare the rule that, starting from a certain level in the hierarchy of an organisation, all e-mail accounts are ingested as records unless the user specifies the contrary. Rules might also be triggered by certain types of metadata that indicate a certain type of document (e.g., a contract). More complex rules can be composed by combining formal and contextual elements of a document with actual content by making use of regular expressions. For example, all documents which contain the string "final'" can be grouped, as they probably indicate all finalised documents in a collaboration workflow.
- Business processes and automated workflows: Most organisations use process-driven software to manage specific workflows such as procurement. This approach consists of assigning specific metadata within these applications in an automated manner. For example, in an application that allows citizens to apply for permits, each document can be assigned a record when the application file is finalised and the file is transferred to the digital archive. Currently, most workflow packages can be connected to other applications, making this scenario relatively easy to implement for structured documentation. If an organisation only uses this model, it should be aware that the unstructured documentation must also be managed and brought into context with the automated records from workflow applications.
- Auto-classification: This is the most complex and advanced way to automate workflows, using the content of documents to convert them into records and assign them the necessary metadata. These processes often use machine learning software, where a training corpus is used to configure the software iteratively. The more formal and repetitive the content of the documents, the better the results of this approach. It can also be combined with rule-based methods and workflow automation based on those rules. The software and methodology that are

available in the field of auto-classification are relatively new but offer many advantages over traditional classification, based on keywords or functions, rather than using generic rules that do not take into account the actual content of the documents. The raw data of these documents contain valuable information that is left untouched by these methods. They usually require making highly specific and granular classification schemes more general and evolving towards a "big bucket" method of classification. In this case, the rule-based system becomes too detailed to still be efficient, given the complexity of the system. The difficulty of this method lies in the fact that there are currently no satisfactory benchmark studies available that objectively compare the performance of different methods and tools.

The premise for auto-classification is having existing categories based on a classification scheme that is already in place, which can be used to manually label a training set. The data, together with this set of labels, can then be used to train an algorithm. Here we can also refer to the essential caveat in the NARA report (Automated Electronic Records Management Report, Plan of the NARA). It points out in the introduction that "All the automated approaches described in this report and plan depend on having a solid records management policy in place. Automation is a tool, not a replacement for a professional records and information management program" (NARA 2014, 4).

The starting point of this section was to know what the worst-case scenario is: a large collection of non-structured documents with little to no manually pre-assigned metadata offers a significant challenge for the implementation of machine learning methods. In the remainder of this chapter, we will discuss a workflow for tackling this issue together with some preliminary results.

Rise of machine learning and its introduction in records management

The history of Machine Learning can be traced back to the 1950s, with the inception of Turing's Learning Machine and stochastic neural analog reinforcement calculator (SNARC), the first neural network algorithm, built by Marvin Minsky and Dean Edmonds. These early, statistics-based algorithms laid the groundwork for the subsequent development of important machine learning tools such as the perceptron by Frank Rosenblatt in 1958 (Rosenblatt 1958), the nearest neighbour algorithm in 1967 (Mack and Rosenblatt 1979), backpropagation in 1986 (Rumelhart 1986) and the random forest algorithm in 1995 (Tin-Kam 1995). All these discoveries form an important part of the current machine learning landscape, even though at the time of their discovery and immediately thereafter they were not as widely used as they are today.

The computational underpinnings of the discovery of these algorithms were still in an embryonic stage, meaning that the available data were to a certain extent structured, allowing the rules to be deduced on which to build a system. Of course, these rules were not able to deal with all conceivable situations, but the exceptions could be measured. Since encoding explicit rules was easier both computationally as well as conceptually than using machine learning, rule-based systems have been very popular until fairly recently. It is only with the advent of big data methods and the computational power associated with them that investigations into machine learning methods could begin.

Even though the recent popularity of neural networks, as the most successful branch of machine learning methods, moves the goalposts for state-of-the-art research, they are still considered to be a black box. Although their results are changing the way we think about the treatment of data, it is still impossible to grasp what exactly is going on inside. Together with these algorithmic advances during the last two decades, we have seen a rise in not only the amount of data and documents available but also in the variety of data types, the complexity of resources and the unstructured nature of information. This shift in the landscape has made the rule-based methods that thrived in the 20th century outdated at best and often even obsolete in the context of the surge of big data.

In summary, we may claim that we are witnessing a shift from knowledge-driven methods (rule-based) to data-driven methods. This means that traditional rules are generally left behind, so that statistics-based machine learning systems can provide structure in the wealth of information available today. The danger of the rule-based approach is that, if the rules miss a scenario, noise is generated as output, which requires ever more rules to describe every possible scenario. In the machine learning approach, on the other hand, the user has to feed the system good examples of input data with the desired labels, which allows the system to learn the relationships between input and output in this training phase. The system then learns to classify data according to the thresholds that it acquires during training. Of course, this method is also not without its problems, since noise can arise from bad training data or overfitting, the learning deficit where the algorithm does not abstract well from the data. Nevertheless, the main asset of this approach is that it is based on the data themselves and not on knowledge input from the user. Chiticariu (2013) has noted that, although machine learning seems to be a more advanced method of dealing with data, this is a phenomenon mainly demonstrated in academia, whereas industry still heavily relies on rule-based applications. Industrial users are among the many voices declaring that the distinction between the two does not have to be that strong; and several hybrid methods have been proposed, for example, by Villena-Román (2011). Many, however, are often more reluctant to admit their use of rules, disguising them with euphemisms such as "dependency restrictions" (Schmitz Mausam et al. 2012) or "entity type constraints" (Yao 2011).

Topic modelling

The field of unsupervised machine learning, where an algorithm is designed to find clusters in the data without predetermined labels provided by humans, has proven to be important in providing a first analysis step in big data pipelines. Supervised machine learning, where labelled data is readily provided, can occur further down the pipeline, or else as a stand-alone technique that is focussed more strongly on specific NLP tasks such as text classification using pre-defined categories. Since our starting point of this chapter is raw textual data, we shall proceed with a primary focus on unsupervised machine learning. In this field, TM has gained momentum within the Humanities over the last few years in analysing topics represented by large volumes of full text. Within the digital humanities (DH) community, TM has attracted a fair amount of interest and is increasingly being used to access and explore large corpora of full-text documents (Chang 2009; Goldstone et al. 2012; Klein et al. 2015).

In this specific implementation of TM we use the famous LDA algorithm (Blei 2003), which forms the basis of several derived TM algorithms. Applied to large textual datasets, it shows great promise in successfully clustering similar texts, i.e., determining features based on patterns found in the raw data. This approach, along with other text-mining algorithms, has gained momentum in document classification based on features learned by a machine learning system, as pointed out by Suominen et al. (2016) in the specific field of bibliometrics or by Newman (2010) in a library context. Similarly, Roe (2016) uses LDA to draw a map of all human knowledge contained in the French *Encyclopédie* of *d'Alembert and Diderot*. This application of LDA indicates how this taxonomy of human knowledge, contained in their encyclopaedia, can be approximated automatically.

TM can be considered as a "plain vanilla" approach to text mining, since it is developed in the context of information retrieval. The main goal of this field is to retrieve the most relevant documents corresponding to a query. This can be compared to word embeddings, for example, which are equally famous but have been developed within the field of computational linguistics, where the main goal is not the retrieval of relevant documents but the correct modelling of the semantics. TM can be applied in any context where there is a large volume of non-structured documents (e-mail, social media, reports, etc.) and the outcomes can be used for different goals.

To investigate the value of TM for the archival community, this chapter seeks to critically assess its potential for the "distant reading" of archival data. Developed by Moretti (2007), distant reading practices make use of statistics and computational linguistics to extract specific features automatically from large corpora, providing a means to spot trends and shifts over time. This is in contrast to close reading, which uses only human understanding and classification to identify the relatedness of texts and the relevance of features in order to achieve a classification. Traditionally, historians explore

archives based on an inventory, which contains metadata at the fonds, series or file level. Only very rarely do historians have access to metadata on a document level. However, within the current context of mass digitisation of archival holdings, institutions often end up with millions of OCRed text files, having only minimal "tombstone" metadata at either the fonds, series, file or document level. In the absence of traditional access paths, based on metadata that are often not available or limited, innovative distant reading methods such as TM can provide alternative ways to explore large archival holdings and immediately drill down to the content at a document level.

Case study

When and how did environmental considerations start to influence agricultural policy development by the EC? What are the key documents to analyse the debate on nuclear energy production from the 1960s onwards? These are two examples of research questions that historians might frame. In this context, the mass digitisation of the EC's archives offers exciting new ways to query and analyse the archival corpus in an automated fashion. However, there is a large gap between the promises made by "big data" advocates, who rely on statistics to discover patterns and trends in large volumes of non-structured data, and how historians can derive value from automatically generated metadata to explore archives and find answers to their research questions.

Currently, millions of scanned and OCRed files are available that hold the potential to significantly change the way historians of the construction and evolution of the European Union can carry out their research. However, due to a lack of resources, only minimal metadata are available at the file and document levels, severely undermining the accessibility of this archival collection.

This chapter explores the capabilities and limits of TM empirically in order to automatically extract key concepts from a large body of documents spanning multiple decades. By mapping the topics to headings from the EUROVOC thesaurus, this proof of concept offers the future opportunity to represent the topics thus identified with the help of a hierarchical search interface for end users.

Data collection and pre-processing

Based on a subset of the EC archives, this section presents how TM can be implemented and discusses the results. After signing a non-disclosure agreement (NDA), the MaSTIC research group[3] of the Université libre de Bruxelles (The French-speaking Free University of Brussels) obtained a 138.3 GB corpus of 24,787 documents from the European Commission Archives. The dataset was created following the issuance of the Council Regulation (EEC, Euratom) No. 354/83 of 1 February 1983 concerning

opening the historical archives of the European Economic Community and the European Atomic Energy Community to the public. Classified documents within the files were declassified in conformity with Article 5 of the regulation. These files can be consulted by European citizens but are not currently made electronically available by the historical archives service of the EC, as little to no metadata are attached to the files.

The dataset is multilingual, spanning a period ranging from 1958 to 1982: it contains documents in French, Dutch, German, Italian, Danish, English and Greek, as those were the official languages of the European Economic Community of the time. As noted above, the dataset provides almost no metadata: apart from an XML file corresponding to each PDF, which contains basic information such as a unique identifier, a creation date, the number of a reference volume and the language and title of the document, little additional information is given. Although the metadata provides limited cues for classifying the documents, for example, the year of publication, none of these is related to the contents of the documents. There is no insight into what the documents encompass in terms of topics and themes, which makes the dataset nearly unusable for end users. This observation is reinforced by the fact that the original files contain several versions of the same document in different languages, making the automatic indexing of its content very difficult and effectively creating a lot of noise for the purposes of a classical, full-text information retrieval system.

To work with as many as 24,787 PDF files, a few preprocessing steps were needed. These steps, described below, include the creation of *.txt (raw text) files and the language detection of their content. Whilst PDF files are often the standard for storing historical documents and archives, the format does not allow for easy use within other, readily available applications. Using a small script in the programming language Python, a *.txt file was created for each of the existing PDF documents, making the dataset easily readable by other software. The script kept the existing folder structure as well as the filenames, ensuring that only the format of the data was changed. To create a file for each existing language version of a document, a Python script based on langid.py (Lui et al. 2012) was used, a language detection Python library that achieves 98.7% and 99.2% accuracy on the EuroGov (Sigurbjörnsson et al. 2005) EuroParl (Koehn 2005) corpora, respectively (which are two multilingual, parallel corpora that deal with EU-related matters). This process brought the total number of text files to 205,370, or 7.4 GB, an estimated 835,717,292 words or 1,671,434 pages.

Methodology

It should be noted that the number of topics for TM must be determined in advance. Following the work of Suominen et al. (2016), we used several configurations of the algorithm before choosing a total of 100 topics. LDA produces a list of keywords for each of the topics present in a textual dataset.

These keywords are supposedly the most representative tokens for that topic. When these are combined, a human operator must be able to deduce the underlying theme: for example, keywords such as *countries, coopera-tion, developing, trade, development, community, international, states, asso-ciated* and *aid* most probably refer to the topic of *international cooperation*. While this might often be considered straightforward, research shows that it is often more of an art than a science (Chang 2009), even though the automation of topic deduction (Lau 2014) seems possible. Nevertheless, deducing a list of top keywords selected by an algorithm remains a diffi-cult task. This problem should thus not be taken lightly, especially in the case of large archival fonds whose content is not completely known. With that in mind, we resorted to matching the most prominent entries with EuroVoc terms, allowing us to base our work on a solid, well-documented foundation on the one hand and to harness the power of a hierarchical, multilingual thesaurus on the other. EuroVoc (http://eurovoc.europa.eu/) is the EU's multilingual thesaurus, which we use here as the gold standard for indexing documents. Even though LDA provides a *distribution* of topics for each document, i.e., a collection of topics, where a probability is assigned to each document indicating to what extent each topic occurs in that doc-ument, we resorted to hard partitioning in this case study, i.e., assigning a single topic to every document. This choice was made because hard parti-tioning is a proof-of-concept approach to a semi-automatic classification of historical archives (Suominen et al. 2016); the alternative soft-partitioning approach, in which several topics are assigned to a document, would have proven too time-consuming while achieving only a small refinement of the results.

Evaluation metrics for TM are an important consideration, focussing mostly on a quantitative assessment of topics based on coherence meas-ures. An implementation of these measures can be found in the Palmetto Toolbox, a detailed discussion of which is beyond the scope of this chapter. In general, these measures are based on metrics that score the related-ness of the words for each topic. Although these measures are important for the interpretability of topics, and the assurance that the clusters found in the data are semantically realistic, they are not that important for our current purposes. They are discussed in more detail in our previous work (Coeckelbergs et al. 2020). Rather than verifying whether the clusters them-selves reveal the semantics of the underlying document collection, which can be achieved using the Palmetto Toolbox, we seek to evaluate whether top terms from topics can be matched to strongly related concepts from the EuroVoc thesaurus. To allow for a more precise and qualitative evaluation, the results of which can be found in Table 12.1, we selected a subset of the whole archival fonds: for this proof-of-concept we used three subsets of the dataset, consisting of the three EU Commissions for which English texts were available: the Ortoli presidency (73–77), the Jenkins presidency (77–81) and the Thorn presidency (81–85, but our data stops at 82).

Table 12.1 Examples of the results: URIs, labels and tokens for topics

URI	Label	Tokens			
http://eurovoc. europa.eu/2965	agricultural aid	agricultural	areas	aid	measures
http://eurovoc. europa.eu/852	ECSC aid	Coal	steel	ECSC	aid
http://eurovoc. europa.eu/1418	textile industry	Fabrics	textile	woven	knitted

Instead of manually querying the EuroVoc website, we used the built-in IMPORTXML (https://support.google.com/docs/answer/ 3093342) and IMPORTHTML (https://support.google.com/docs/answer/3093339) functions of Google Sheets. These functions allow us to query EuroVoc automatically and easily from within Google Sheets, where we had previously stored the output of TM; and, once the correct term has been selected, to keep its URI and preferred term (PT).

Results

Three examples of the results are illustrated in Table 12.1, each line corresponds to a topic, where the first and second column show the URI and the label of the topic, respectively, and the following columns give some of the tokens deemed representative of the topic by the algorithm. For clarity's sake, only the first four out of ten tokens are displayed.

However, it is important to emphasise that we were unable to attach a label to around 30% of the clusters, either due to the very general nature of the tokens (e.g., *agreement, community, parties, negotiations*) or to the fact that we did not manage to find a semantic link between them (e.g., *lights, bmw, brazil, eec, coffee*). For some topics, OCR noise (e.g., *cf, ii, ir*) was the main cause. While the OCR errors cannot be corrected automatically, the other unmatchable output could be reduced by using a smaller number of topics in the LDA configuration. In practice, we discovered that OCR errors tend to cluster into a single topic, which can then be left out of consideration.

The evaluation of the annotated LDA output was carried out by three different people, and the work of each annotator was verified by another. During this evaluation, there was no discrepancy between annotators based on Cohen's kappa coefficient, a well-known method of quantifying inter-annotator agreement. This indicates that the matching between LDA output and EuroVoc terms is consistent between people. We plan to submit our findings for expert evaluation to a domain expert, i.e., an archivist of the EC. Our approach differs from the one described by Newman (2010), which relied on semi-automatic evaluation of results using word pairs which serve as a base line for strongly correlated words (from Wikipedia, among other sources). Since the aim of this work is to evaluate how LDA can be used to

help annotate corpora with an existing controlled vocabulary and not to evaluate the human interpretation of LDA itself, our approach thus prevents an additional step which might introduce noise. Relying on an expert review helps in this process.

While there is a need for agreement between annotators for the controlled vocabulary matching, there is no indication of where LDA has correctly assigned topics to documents, only that it is possible to match LDA output to an existing thesaurus. With that in mind, we resorted to three topics selected randomly from each presidency and manually checking all documents for which this topic is the primary subject. Other means of evaluating LDA output exist, including the *topic intrusion* task introduced by Chang (2009): humans are given a document and four lists of words, each list amounting to a topic, and have to decide which one list out of the four is incorrect for that document. Given the clear and comprehensive results of a close manual inspection, such a method was not used. In the course of this close inspection of several hundred text files, no discrepancy between an actual document and its assigned topic could be found, even though it is clear that some documents are more relevant than others: this is the only logical and expected outcome, as LDA results in soft partitioning (a document is about several topics) and we considered only the primary topic of our documents.

From this dual approach to the manual evaluation of our results, it is clear that LDA offers a relatively fast and undeniably cheap alternative to manual metadata creation. Clear examples of success include the documents specified by LDA as part of the ECSC aid topic: the algorithm returned documents whose respective titles are "Memorandum on the financial aid awarding [sic] by the Member States to the coal industry in 1976", "Introduction of a Community aid system for intra-community trade in power-station coal", etc. After an extensive search of the results, the authors have failed to detect any document that was not directly or indirectly related to the topic deduced. Nonetheless, as noted earlier, around 30% of the clusters were not successfully matched with a label, mainly because of bad OCR.

Relevance of the research and future perspectives

In this chapter, we have discussed the results of applying TM on a large archival corpus to assess the potential of this statistical approach to the exploration of large collections of full text. The analysis yielded results scoring high in precision, but for which recall is unavailable.

Based on these results, what are the wider implications of this research for the overall archival community?

The tools and methodology described in this chapter can be of interest to any archival holder interested in adding a subject-based access to digitised full-text holdings. As document-level subject indexing is often out of scope, the automated and low-cost approach of TM can offer an interesting extra

access path for end-users. Typical use-cases would include digitised newspapers, journals or meeting reports, etc. The fact that the methodology is language independent offers also an important additional advantage, as it can be applied to archives in a multitude of languages.

What our methodology currently lacks is the ability to determine the depth of the term from a thesaurus to which an extracted term should be mapped, i.e., how precise a thesaurus term should be. Work in that direction is planned, enabling practitioners and end users alike to better visualise the documents collaboratively within the wider context of the whole thesaurus. By doing so, this research will help historians and archivists to develop a better understanding of how large volumes of full-text documents can be made more accessible.

Bibliography

Bailey, David J. 2009. *The Political Economy of European Social Democracy: A Critical Realist Approach.* London: Taylor Francis Ltd.

Blei, David M., Andrew Y. Ng, and Michael I. Jordan. 2003. "Latent Dirichlet Allocation." *Journal of Machine Learning Research* 3: 993–1022.

Boydens, Isabelle 1999. *Informatique, Normes et Temps.* Bruxelles: Bruylant (Emile).

Boydens, Isabelle, and Seth Van Hooland. 2011. "Hermeneutics Applied to the Quality of Empirical Databases." *Journal of Documentation* 67 (2): 279–289.

Chang, Jonathan, Sean Gerrish, Chong Wang, Jordan Boyd-Graber, and David Blei. 2009. "Reading Tea Leaves: How Humans Interpret Topic Models." In *Advances in Neural Information Processing Systems*, edited by Yoshua Bengio, D. Schuurmans, J. D. Lafferty, Christopher Kenneth Ingle Williams, Aron Culotta, 288–296. New York, NY: Curran Associates.

Chiticariu, Laura, Yunyao Li, and Frederick R. Reiss. 2013. "Rule-based Information Extraction is Dead! Long Live Rule-based Information Extraction Systems!" In *Proceedings of the 2013 Conference on Empirical Methods in Natural Language Processing (EMNLP)*, edited by David Yarowsky, Timothy Baldwin, Anna Korhonen, Karen Livescu, and Steven Bethard, 827–832. Seattle, WA: Association for Computational Linguistics.

Coeckelbergs, Mathias, and Seth Van Hooland. 2020. "Concepts in Topics. Using Word Embeddings to Leverage the Outcomes of Topic Modeling for the Exploration of Digitized Archival Collections." In *Proceedings of the first EAI Data and Information in Online Environments (DIONE) Conference*, edited by Rogério Mugnaini, 41–52. Cham: Springer.

Desrochers, Donna M., and Jane V. Wellman. 2011. *Trends in College Spending 1999–2009.* Washington, DC: Delta Cost Project. https://deltacostproject.org/sites/default/files/products/Trends2011_Final_090711.pdf

Duranti, Luciana, 1994. "The Concept of Appraisal and Archival Theory." *American Archivist* 57, 328–344.

Goldstone, Andrew, and Ted Underwood. 2012. "What Can Topic Models of Pmla Teach Us about the History of Literary Scholarship." *Journal of Digital Humanities* 2 (1): 40–49.

Hofmann, Thomas. 1999. "Probabilistic Latent Semantic Indexing." In *Proceedings of the 22nd Annual International SIGIR Conference on Research and Development*

in Information Retrieval, edited by Fredric Gey, Marti Hearst, and Richard Tong, 50–57. New York, NY: Association for Computing Machinery.

Kelemen, Jozef. 2007. "From Artificial Neural Networks to Emotion Machines with Marvin Minsky." *Acta Polytechnica Hungarica* 4 (4): 5–16.

Kerr. Sara J. 2016. "Jane Austen in Vector Space: Applying Vector Space models to 19th century literature." In *Proceedings of the Japanese Association for Digital Humanities 2016 Conference*, 19–22. Tokyo: The Historiographical Institute.

Klein, Lauren F., Jacob Eisenstein, and Iris Sun. 2015. "Exploratory Thematic Analysis for Digitized Archival Collections." *Digital Scholarship in the Humanities* 30 (suppl 1): i130–i141.

Koehn, Philipp. 2005. Europarl: A Parallel Corpus for Statistical Machine Translation. MT Summit, 79–86. https://homepages.inf.ed.ac.uk/pkoehn/publications/europarl-mtsummit05.pdf

Lau, Jey Han, David Newman, and Timothy Baldwin. 2014. "Machine Reading Tea Leaves: Automatically Evaluating Topic Coherence and Topic Model Quality." In *Proceedings of the 14th Conference of the European Chapter of the Association for Computational Linguistics (EACL)*, 530–539. Stroudsburg: The Association for Computational Linguistics.

Lohr, Steve. 2016. "IBM Is Counting on Its Bet on Watson, and Paying Big Money for It." New York Times, October 17, 2016. https://www.nytimes.com/2016/10/17/technology/ibm-is-counting-onits-bet-on-watson-and-paying-big-money-for-it.html

Lui, Marco and Timothy Baldwin. 2012. "langid.py: An Off-the-shelf Language Identification Tool." In *Proceedings of the 50th Annual Meeting of the Association for Computational Linguistics (ACL 2012), Demo session*, edited by Min Zhang, 25–30. Stroudsburg: The Association for Computational Linguistics.

Mack, Y.P., and Murray Rosenblatt. 1979. "Multivariate k-Nearest Neighbor Density Estimates." *Journal of Multivariate Analysis* 9 (1): 1–15.

Moretti, Franco. 2007. *Graphs, Maps, Trees: Abstract Models for a Literary History*. London: Verso.

National Archives and Records Administration. 2014. "Automated Electronic Records Management Report/Plan." September 2014. https://www.archives.gov/files/records-mgmt/prmd/A31report-9-19-14.pdf

National Archives and Records Administration. 2015. "White Paper on the Capstone Approach and Capstone GRS." April 2015. https://www.archives.gov/files/records-mgmt/email-management/final-capstone-white-paper.pdf

Newman, David, Youn Noh, Edmund M. Talley, Sarvnaz Karimi, and Timothy Baldwin. 2010. "Evaluating Topic Models for Digital Libraries." In *Proceedings of the 10th Annual Joint Conference on Digital Libraries*, 215–224. New York, NY: Association for Computing Machinery.

Roe, Glenn, Clovis Gladstone, and Robert Morrissey. 2016. "Discourses and Discipline in the En lightenment: Topic Modeling the French Encyclopédie." *Frontiers in Digital Humanities* 2: 2297–2668.

Rosenblatt, Frank 1958. "The Perceptron: A Probabilistic Model for Information Storage and Organization in the Brain." *Psychological Review* 65 (6): 386–408.

Rumelhart, David E., Geoffrey E. Hinton, and Ronald J. Williams.1986. "Learning Representations by Back-Propagating Errors." *Nature* 323: 533–536.

Schmitz Mausam, Michael, Robert Bart, Stephen Soderland, and Oren Etzioni. 2012. "Open Language Learning for Information Extraction." In *Proceedings of*

the 2012 Joint Conference on Empirical Methods in Natural Language Processing and Computational Natural Language Learning (EMNLP/CoNLL), edited by Jun'ichi Tsujii, James Henderson, and Marius Paşca, 523–534. Stroudsburg: The Association for Computational Linguistics.

Sigurbjörnsson, Börkur Jaap Kamps, and Maarten de Rijke. 2005. "EuroGOV: Engineering a Multilingual Web Corpus." In *Accessing Multilingual Information Repositories, Workshop of Cross-Language Evaluation Forum for European Languages (CLEF)*, Lecture Notes in Computer Science, vol 4022, edited by Carol Peters et al., 825–836. Berlin, Heidelberg: Springer. https://doi.org/10.1007/11878773_90

Suominen, Arho, and Hannes Toivanen. 2016. "Map of Science with Topic Modeling: Compari Son of Unsupervised Learning and Human-Assigned Subject Classification." *Journal of the Association for Information Science and Technology (JASIST)* 67 (10): 2464–2476.

Tin-Kam, Ho. 1995. "Random Decision Forests." In *Proceedings of 3rd International Conference on Document Analysis and Recognition*, 278–282. Montreal, QC: Institute of Electrical and Electronics Engineers.

Van Hooland, Seth, Max De Wilde, Ruben Verborgh, Thomas Steiner, and Rik Van de Walle. 2015. "Exploring Entity Recognition and Disambiguation for Cultural Heritage Collections." *Digital Scholarship in the Humanities* 30 (2): 262–279.

Vellino, André, and Inge Alberts. 2016. "Assisting the Appraisal of e-mail Records with Automatic Classification." *Records Management Journal* 26: 293–313.

Villena-Román, Julio, Sonia Collada-Pérez, Sara Lana-Serrano, and José C. González Cristóbal. 2011. "Hybrid Approach Combining Machine Learning and a Rule-Based Ex pert System for Text Categorization." In *Proceedings of the Twenty-Fourth International Florida Artificial Intelligence Research Society Conference (FLAIRS)*, 323–328. Palm Beach, FL: Association for the Advancement of Artificial Intelligence.

Yao, Limin, Aria Haghighi, Sebastian Riedel, and Andrew McCallum. 2011. "Structured Relation Discovery using Generative Models." In *Proceedings of the 2011 Conference on Empirical Methods in Natural Language Processing (EMNLP)*, 1456–1466. Edinburg: Association for Computational Linguistics.

User interfaces

13 Exploring digital cultural heritage through browsing

Mark M. Hall and David Walsh

Introduction

Digitisation of our cultural heritage by galleries, libraries, archives, and museums (GLAM) has created vast digital archives, many of which are publicly accessible via the web. These archives should, in theory, widen access to our digital cultural heritage (DCH), however, in practice, GLAM websites frequently experience bounce rates of over 60%, meaning they lose more than half of their visitors after the first page (Hall, Clough, and Stevenson 2012; Walsh et al. 2020). This mirrors a common complaint in the wider field of digital libraries: "So what use are the digital libraries, if all they do is put digitally unusable information on the web?" (Borgman 2010).

Users visit GLAM websites for a wide range of reasons, ranging from professional work goals to pure leisure activities. They may be planning a physical visit to the GLAM, to find out about the institution itself, to buy something from its online shop, or to explore the GLAM's digital holdings. Some may be visiting to find something specific; some may be looking for more general inspiration, and some purely to spend some time. The visitors' degrees of background knowledge and expertise will also vary significantly. Supporting this vast range of potential visitor requirements is of course very difficult, however the very high bounce rates experienced by GLAM websites indicates that there is a significant fraction of the potential visitors, for whom the current provisions do not work.

Out of the range of user characteristics and goals for visiting GLAM websites this chapter will focus on supporting access to the GLAM's digital holdings, in particular for users who have a less focused goal or less domain expertise. The reason for this is that focused search and high-expertise users are already served quite well by the most common interface for accessing the digital holdings: the search box. However, Koch et al. (2006), Ruecker, Radzikowska, and Sinclair (2011), and Walsh et al. (2020) show that the majority of users prefer to use browsing a navigation structure as the way to access the information they are seeking. Browsing, as a concept, covers a wide range of behaviours (Bates 1989; Rice, McCreadie, and Chang 2001; Bates, 2007), but for the purposes of this chapter we use a very broad

DOI: 10.4324/9781003131816-13

definition of a browsing-based interface as one that allows the user to interact with a collection without having to explicitly enter a search keyword. A search system may be running in the background, but this must either not be visible to the user or interaction with the search system must be an optional extra.

Our focus is on browsing because for users with less domain expertise or less focused goals the blank search box is a known and significant barrier (Belkin 1982; Whitelaw 2015). These kinds of users are also more likely to visit in a leisure, rather than a work context (Wilson and Elsweiler 2010) and thus tend to follow more exploratory behaviour (Mayr et al. 2016). Supporting these more open-ended goals and less experienced users in their interactions with search interfaces in general is traditionally seen as the domain of exploratory search (Marchionini 2006; White and Roth 2009). Exploratory search interfaces are generally designed to provide the user with guidance as to which keywords will produce search results and to help them narrow down their search, using features such as query suggestion and search facets. While these provide some indications as to which search terms will produce results, they generally do not provide an overview of the collection as a whole and still assume that users come to the system with at least a partially defined goal. Addressing this gap has been the task of exploratory interfaces developed under the labels of rich prospect browsing (Ruecker, Radzikowska, and Sinclair 2011) and generous interfaces (Whitelaw 2015). While they differ in some aspects, which will be explored in more detail later, both labels place a strong focus on providing the user with an initial overview over the collection and on allowing the exploration of said collection without having to enter a search query. These ideas have spurred the development of a range of interesting and innovative interfaces, however none of these have seen any major uptake outside the institutions they were developed for. This is in part because developing or even just adapting such interfaces is significantly more complex than deploying an off-the-shelf search interface (Ruecker, Radzikowska, and Sinclair 2011), but also because, particularly for museums, the question of what a digital, virtual or online presentation should be is still a contested area (Biedermann 2017; Meehan 2020).

The remainder of the chapter is structured as follows: first we will investigate the current state of interfaces for accessing GLAM's digital holdings in more detail. We will look at the kind of data available to users, the boundaries experienced by users in accessing the data, the types of interfaces that have been developed to overcome these boundaries, and techniques for automatically structuring collections to support access. The second major section will introduce the Digital Museum Map (DMM). The DMM demonstrates how to address the issues with exploring large, digital collections, by providing a generous, browsable interface, that is based on an automatically generated organisational hierarchy, and that can be applied to any collection without major human input.

Background

Many GLAMs house large heterogeneous collections and, through digitisation, have created digital collections covering parts of their physical collections. In many cases, the GLAMs have then made these digital collections available online. One limitation of the digitisation process is that it is very resource intensive, and as a result, most institutions have an ongoing, rolling digitisation programme (Denbo et al. 2008). This continuous digitisation process means that any curated online presentation of the collections needs to be continuously updated, creating an ever-growing digital environment.

Where these digital collections have been made available online, they generally consist of images of the items together with meta-data describing the item. The meta-data is typically drawn from the institution's own catalogues. In the case of libraries, these catalogues are generally created to enable access to the holdings by the reader, however in galleries, museums, and archives the catalogues focus primarily on providing museum staff or professional researchers (Eklund 2011; Vane 2020) with details of the artefacts such as provenance, descriptive, and organisational information (such as dates, condition, material, style, rights, acquisition, genre ...). These meta-data were generally created when the institution acquired the object, and while in the digitisation process, the data are sometimes cleaned and standardised; Agirre et al. (2013) show that the meta-data of items are often limited and incomplete. This represents less of a technical issue for off-the-shelf faceted search systems, which easily deal with limited or missing data, although lower meta-data quality will obviously impact how successfully users can use the search system. However, for more complex interfaces that go beyond search, preprocessing the data-set is necessary. This preprocessing ranges from simpler tasks, such as normalising spellings or date formats, to automatically structuring the collections, where no or no consistent structuring is available.

Accessing the collections

The GLAM websites that house the online collections also provide other types of information, including information about the institution, how to visit the physical institutions, selected items from the institution's holdings, and potentially an online gift shop. Due to GLAMs continued focus on their physical spaces, these other information services tend to receive the majority of attention, with the full collections access often treated as more of an afterthought.

Initially, where collections were made available, the interface for accessing the collection tended to be either a single white search box (basic search) or a set of search boxes, where each supported search in a specific meta-data field (advanced search). These search interfaces provided a fast and efficient entry point into the collection for the users familiar with either the collection itself or with the kind of data the collection contained. These users

generally have a high degree of both specific and general CH knowledge (Academics, Museum Staff, Research professionals ...) and typically have a particular information need, which enables them to successfully convert their need into the appropriate search terms to find what they are looking for (Marchionini 2003; Skov and Ingwersen 2008; Falk 2016).

For users who have lower levels of CH knowledge (Marchionini 2003; Falk 2016; Walsh et al. 2020) or have a less focused information need (Casual users, General public, Non-professional users ...), the blank search box represents a significant barrier to accessing the collection (Belkin 1982; Whitelaw 2015). For online collections, this is a particular problem, as Walsh et al. (2020) showed that the majority (almost 70%) of a national museum's online audience was from this lower CH knowledge group. Additionally, users from this group are less likely to be frequent visitors (most are first-time visitors) and have a strong preference for browsing based access. The lack of prior experience means that these users need more help and information when getting started with the collection. Without this supporting information, this group of users is likely to give up and move on relatively quickly (Hall, Clough, and Stevenson 2012).

To help those users who have less knowledge of the collection or who have less clear information needs, White and Roth (2009) suggested exploratory search systems. The most common interface for supporting exploratory search is the faceted search interface mentioned earlier. The advantage of the faceted search interface is that, in addition to the search box, for a selection of the collection's meta-data fields, the interface shows the user a choice of the most common values. Instead of being required to enter a search term, the user can select a value from the facet list and see results for that value. The exact facets used depend on the available meta-data, but commonly available facets include dates, locations, categories, materials and techniques. Letting the user select from these facets reduces the chance of getting a zero-result (Hearst 2006; Russel-Rose and Tate 2012), which particularly aids non-expert users, who can, in that way, learn what search terms will lead to results.

The main limitation of faceted search interfaces is that the number of different values that can be shown in the facets is restricted by the space available in the interface (Lang 2013). This is problematic for collections access, as the heterogeneous nature of DCH collections means that every facet tends to have a long tail of values that do not occur very frequently. As faceted search interfaces will generally only show 10 or 20 of the most common values, none of these infrequent values will be accessible through the facet interface and thus remain undiscoverable to the user. Nevertheless, faceted search systems represent the most common interface for collection level access in DCH.

From searching to browsing

Faceted search, while assisting users with determining appropriate search keywords and thus reducing the barriers to using these interfaces for

non-expert users, is still designed around search, even though non-expert users prefer browsing-based interfaces (Walsh et al. 2020). When developing browsing-based interfaces, there are two main requirements. First, they need to provide an initial overview of the collection (Greene et al. 2000; Hibberd 2014). Second, through the browsing and visualisation interface, they must support the user in exploring the collection and gradually building up a more detailed understanding of the content (Giacometti 2009; Mauri et al. 2013).

Where a browsing-based interface is provided by the GLAM institution, currently the most common interface is the manually curated digital exhibition (Coudyzer and van den Broek 2015), although some libraries also provide browsing access via existing classification systems such as Dewey Decimal Classification (DDC; Vizine-Goetz 2006; Lardera et al. 2018). The manually curated exhibitions generally provide an overview of the collection and very detailed information on a curated set of high-importance items. The main issue with these is that they require manual curation and creation and this does not scale to the amount of data in modern collections and struggles to keep up with the ongoing digitisation processes. While there have been attempts at automatically combining explanatory text with items selected from the collections (Hall, Clough, and Stevenson 2012) to overcome the scaling limits and dynamically create exhibitions on a topic selected by the user, the results have not seen widespread uptake.

Rich prospect browsing and generous interfaces

Instead the focus has been on more informative, supportive and scalable browsing interfaces labelled as either "Rich Prospect Browsing" (Ruecker, Radzikowska, and Sinclair 2011) or more recently "Generous Interfaces" (Whitelaw 2015). The two terms were developed independently, but essentially describe the same core idea of providing an interface that does not require a-priori expertise of either the interface or the collection in order to use the interface successfully.

The driving principle behind Ruecker, Radzikowska, and Sinclair's (2011) rich prospect browsing is Schneiderman (2003)'s interaction pattern of "overview first, zoom and filter, then details on demand." The core requirement of rich prospect browsing is that upon entering the collection, the user should be provided with a meaningful representation of every item in the collection. The user should then be able to manipulate this representation to explore the collection.

> An example that tries to get as close to the meaningful representation of every item is Foo's (2016) interface for a public-domain release of about 1,78,000 items from the New York Public Library. The initial screen shows a grid with a small thumbnail of every item, as expected from a rich prospect browsing interface. Users can click on the images to get more detail about them and navigate between them. The images on the

initial screen are organised by time, but can also be arranged by genre, collection or colour. The big question the interface raises is whether the tiny thumbnails, each thumbnail is only a few pixels large, represent a meaningful representation of the individual items, as, apart from colour differences, it is very difficult to discern anything about the items.

Whitelaw's (2015) generous interface is a slightly more generic concept, which is less prescriptive regarding specific interface elements. A generous interface should also provide an initial view of the collection. Unlike with rich prospect browsing, the assumption is that the initial screen shows a sample drawn from the collection, rather than all the items. The sample provides the starting point and clues that assist the user in then exploring the collection.

An interesting example of a generous interface is Coburn's (2016) "Collections Dive", using items from the Tyne and Wear museum's archive (http://www.collectionsdivetwmuseums.org.uk/). Here the user is initially presented with a random sample of related items and can then, by scrolling down, request more items. Depending on the speed at which the user scrolls, the additional items are more (slow scrolling) or less (fast scrolling) similar to the previously visible items. In this way, the user can explore the collection. The user can then also select items to see further details about them. As Speakman et al. (2018) show, the interface is very engaging, but because the user can only scroll and has no control over what kind of items are shown next, only how similar they are to what they saw previously, it does not achieve extended engagement.

Visualisations for browsing

The two interfaces nicely demonstrate that to develop browsing-based interfaces that scale to the size of current GLAM collections, the display of items has to be augmented with controls that allow the user to move between different parts of the collection. The most common approaches to this are visualisations and hierarchical navigation structures. Of the two, visualisations are used more frequently and Windhager et al. (2018) provide a detailed overview of the possible visualisation methods. Common visualisation methods include timelines, spatial (map) displays, network diagrams and word clouds. The main advantage of these is that while they may require the collection's meta-data to contain specific fields (e.g., time or location information), if these requirements are met, they can be used to visualise and provide access to any kind of collection.

Timeline visualisations work by showing the user a horizontal or vertical timeline and the items in the collection are then placed on this timeline based on their date(s). By interacting with the timeline the user can easily restrict the items they see based on the time-period they are interested in. Glinka et al. (2017) demonstrate the use of a timeline as the primary method for organising and browsing a collection, where all or at least the vast majority

of items have temporal meta-data. Their timeline visualisation shows not only when the items in the collection were created, but also shows how many items can be found at each point in time, providing additional guidance to the user. The interface also includes the functionality to restrict the timeline by keyword. This illustrates one limitation of timelines, which is that time on its own is a very limited organisational principle, and that an additional structuring principle is often required. While timelines are usually shown as linear features, Hinrichs et al. (2008) demonstrate that other displays are also possible, using concentric "tree-trunk" visualisation that represents a range of time periods.

Düring et al. (2015) demonstrate the use of network diagrams as a visual interface to a collection. In a network diagram, the items and meta-data values are shown as nodes, with edges between items and their meta-data values. DCH collections are generally well suited to network diagrams, as items often share where they were created, who created them, or what kind of thing they are, predisposing them to a network display. The power of network diagrams is that they allow for very efficient horizontal navigation through the collection. At the same time, the main limitation of network diagrams is that they do not scale that well. In particular, as the number of edges increases, it becomes difficult to visually distinguish which nodes are linked, as the network diagram degenerates into a black mess of lines.

Spatial displays are the most varied visualisation method. In the most common case, a 2-dimensional map is used to visualise the spatial meta-data (Simon et al. 2016). The advantage of this kind of map is that the user can zoom out to see an overview over the collection and zoom back in to see individual items. They can also easily be combined with a temporal visualisation. The most significant limitation of maps is that they require that the items have spatial meta-data and that it is in a computer-readable form that gives an exact location, as current web-based maps cannot handle vague spatial information. Where spatial meta-data is only available as complex natural language descriptions such as "found next to the river Nile" or very imprecise descriptions such as "printed in Germany", current map interfaces are not able to represent these locations accurately or at all, making these items inaccessible via the map visualisation.

The 2-dimensional map can also be used to display other information. For example, Descy (2009) describes the use of map interfaces to visualise search result clusters. Similarly, Hall and Clough (2013) present an interactive map visualisation that enables the exploration of a hierarchical structure used to organise a collection of about 500,000 items taken from Europeana. In that interface, the elements on the map no longer represent real-world geography, but instead a virtual geography, where the map elements are concepts from the hierarchy. This combines the value of a hierarchy for structuring things and the map as a known interface for exploring the world.

Word clouds (Feinberg, 2010) represent another visualisation technique. A word cloud is generated by extracting keywords from all items in the collection and then displaying the most frequent keywords (Sinclair and Cardew-Hall 2008; Wilson, Hurlock, and Wilson 2012). Users can then select keywords in the word cloud and see the items associated with that keyword. Various visual modifications, such as font size or colour, can be applied to the displayed keywords and used to provide additional information such as the relative frequency of the displayed keywords (Lohmann et al. 2009), guiding users in their exploration. They are relatively similar to the facets in a faceted search system and share many of their advantages, such as ease of generation and disadvantages, such as not scaling well to the large number of diverse keywords common in heterogeneous DCH collections.

Browsing navigational structures

The alternative to the use of visualisations is the provisioning of a navigation structure. This is generally provided in the form of a hierarchy or taxonomy of concepts. The hierarchical structure can either be used directly for browsing, displaying the hierarchy as a tree or can be visualised in another way, e.g., tag-clouds or a map, as demonstrated in the PATHS project (Hall et al. 2014). The difficulty with these is that they require the items to be mapped into an existing hierarchy, either manually or automatically. Libraries are often at an advantage in this, as their collections tend to use a standardised classification hierarchy, which can be browsed on its own or integrated into the search process to enable a mixed search and browse interface (Golub 2018).

Organising collections

For many browsing-based interfaces, the items in the collection need to be placed into an organisational structure of some kind. The structure then provides the links that the users use to browse the collection. Methods for undertaking this curation of items can be classified along three primary axes: manual vs. automatic methods, flat vs. hierarchical structures and purely data-driven methods vs. methods that include external data.

Manual organisation of collections

Manual curation (Rao et al. 1995) of an organisational hierarchy is likely to produce the highest quality and most domain-specific curation of the collection. However, it is also the most resource-intensive approach and in general for most GLAM institutions, not a viable approach, even though there is work ongoing on improving tool support for the process (see e.g., Rehm et al. (2019)). Libraries represent an exception in this case, as most

use a standardised classification scheme, such as DDC (https://www.oclc. org/en/dewey.html), Universal Decimal Classification (http://www.udcc. org/), Library of Congress Subject Headings (https://id.loc.gov/authorities/ subjects.html) or BISAC (Book Industry Standards and Communications) Subject Headings (https://bisg.org/page/BISACEdition) to organise their collections. An in-depth discussion of these schemes is outside the scope of this chapter, but they are generally hierarchical in nature and as such can be used to support a browsing-based interface.

When it comes to manually adding a hierarchical classification scheme to collections that do not use one or do not consistently use one, rather than relying on in-house expertise, crowdsourcing is often seen as a solution to scaling up the process (Sun et al. 2015; Yagui et al. 2019), but as Yagui et al. (2019) show, evaluation and input by domain experts are still required, which means that while the resource bottleneck is reduced, it is not removed.

Automatic organisation of collections

Automatic methods for organising collections offer a way of overcoming this bottleneck. At the simplest level, these methods employ basic clustering algorithms to create a flat partition of the collection (Hall et al. 2012). The limitation of such a pure flat partitioning is that for larger collections, the number of partitions quickly grows to such a degree that navigating these becomes difficult. Algorithms that organise the collection into a hierarchical structure offer to address this. Such algorithms can either be purely data-driven or be based on an existing hierarchy or taxonomy.

The pure data-driven algorithms can use a variety of methods including hierarchical Latent Dirichlet Allocation (LDA; Blei et al. 2003), multibranch clustering (Liu et al. 2012), co-occurrence (Sanderson and Croft 1999) or word embeddings (Luu et al. 2016). The advantage of these algorithms is that they do not require any external data and will place all of the concepts and items into a hierarchy. The downside is that while the arrangement of the concepts in the generated hierarchy will be "correct" as far as the algorithm is concerned, the resulting hierarchy is not guaranteed to match what people would consider an appropriate hierarchy. Depending on the algorithm, adding new data may also lead to significant changes to the hierarchy structure, which makes it harder for users to refind things after such a change. The pure data-driven approaches are also not capable of generalising concepts, so would, for example, be unlikely to group plates and cups under the concept of crockery, unless that concept also existed in the meta-data.

Using existing hierarchies addresses these issues and in previous work a range of hierarchies have been used, including WordNet (Navigli et al. 2003; Stoica et al. 2007), Wikipedia (Milne et al. 2007; Fernando et al. 2012) and DDC (Lin et al. 2017). Other approaches have combined concepts drawn from multiple, existing hierarchies including Library of Congress Subject

Headings, DBPedia, Wikidata or the Art and Architecture Thesaurus (AAT; Hall et al. 2014; Charles et al. 2018). While the use of existing hierarchies ensures that the structure follows patterns that are closer to people's expectations of such a hierarchy, if the concepts used in the collection do not exist in the chosen hierarchy, then the affected items cannot be mapped into the hierarchy. The algorithm we present in this chapter addresses these issues and by using a mix of pure data-driven hierarchy creation together with an existing hierarchy (the AAT) to create an organisational hierarchy that is based on the existing hierarchy, but also includes more specific concepts derived from the items' meta-data.

The Digital Museum Map

The DMM addresses some of the issues raised above, in particular providing an interface that is amenable to the kind of open-ended browsing discussed earlier, that scales to large collections, and that requires only minimal human input into the curation and visualisation process (https://github.com/scmmmh/museum-map, https://museum-map.research.room3b.eu/). The core idea behind the DMM's exploration interface is that the museum floor plan is an established and well-known method for exploring a physical museum and the DMM uses the same visualisation, but this time for a virtual museum, that is automatically generated for a specific collection. Naturally such an interface is more suited for museums' and archives' collections and for a library-shelves-inspired interface see Hall (2014).

The DMM is a complete redevelopment of the initial algorithms and interface (Hall 2018), based on the experience of developing and deploying the initial DMM. In particular the new algorithm scales more easily and is less tailored to the collection used in the development process. The browsing interface has also been revised to take into account informal observations of how non-specialist users interacted with the initial DMM. It does, however, retain the main metaphor of exploring a physical museum, with different rooms, floors and buildings.

Data

The initial version of the DMM was based on a selection of objects from National Museums Liverpool. For the new version presented here, the DMM uses a collection of 14,351 objects from the Victoria & Albert (V&A) museum's digital collection (https://collections.vam.ac.uk/). The items were acquired using the V&A's API and then loaded into a relational database for all further processing. The collection is representative of the kind of heterogeneity that characterises most GLAM collections and contains amongst other things pottery, paintings, prints, clothing, jewellery, designs for various types of objects, sculptures and photographs.

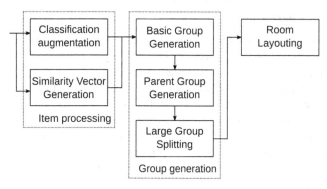

Figure 13.1 The DMM generation process. The two steps in the item processing stage can be parallelised, but the remainder of the processing workflow is linear.

Each item has a number of meta-data fields attached to it. The ones that are relevant to the DMM are the "object" field, which contains each item's primary classification (jug, earring ...), the "concepts", "subjects", "materials", "techniques", "year_start" and "year_end" fields, which are used in the group generation process, and the "title", "description", "physical_description" and "notes" fields, which are used to determine similarity between items. We only use the free-text fields for the similarity calculation, as these provide the most nuanced description of the items. All of these are also displayed in the interface.

The DMM generation process

The DMM generation process is shown in Figure 13.1. Its aim is to transform the unstructured set of item meta-data into a set of "rooms", distributed over one or more "floors", where each "room" contains a group of similar items. It starts with an initial processing of all the items in the collection, which extends the meta-data with values required to organise the items (Classification augmentation & Similarity Vector Generation). The processed items are then grouped (Basic Group Generation) and the groups arranged into a hierarchical structure (Parent Group Generation & Large Group Splitting). Finally, the groups are placed into the floor layout (Room Layouting), which is what the users will then use to explore the collection.

Item processing

In order to organise the items into cohesive groups based on their meta-data, the DMM has to generate two pieces of information for each item. The first is the hierarchy of classification values used to create the groups. The second is a similarity vector, which is used in the group creation and item layouting steps.

Classification augmentation

Each item's primary classification is defined by the value in the "object" field (e.g., "drawing of a wedding dress"). The values are often very specific to the individual item and if only those values were used to group the items, then a significant fraction of the collection would remain ungrouped or the resulting groups would only include a few items. To ensure the generated groups have an appropriate size, from past experience this lies between 15 and 120 items, the DMM initially employs natural language processing (NLP) techniques to extract more generic concepts from the item meta-data and then pulls in additional hierarchy information from the Getty AAT (https://www.getty.edu/research/tools/vocabularies/aat/) (Petersen 1990).

To extract the more generic concepts the DMM uses a series of heuristics that extract more generic concepts from the existing meta-data (Table 13.1). These are applied greedily in the order shown in Table 13.1 and recursively to the extracted concepts. For example, for the primary classification "drawing of a wedding dress", the "A of B" heuristic would be the first one that applies and "drawing" and "wedding dress" would be the two extracted concepts. The heuristics are then applied recursively to both the extracted concepts, resulting in the concept "dress" being extracted from "wedding dress" (using the final "A B" heuristic). The more generic concepts are added to the primary classification value to create a list of classification values ["design for a wedding dress", "wedding dress", "design", "dress"].

While the NLP augmentation extracts additional information from the classification value, higher level classification concepts need to be added from an external source and we use the AAT for this purpose. The AAT contains over 71,000 concepts (with over 400,000 terms for these concepts),

Table 13.1 The NLP heuristics. The "Heuristic" column shows the heuristic pattern, where A and B are one or more words. The "Extracted" column shows the extracted concepts and the order in which they are added to the classification value. The final column shows an example for each heuristic

Heuristic	Extracted	Example
A for B	B, A	Design for brooch -> brooch, design
A (B)	A, B	Cap (headgear) -> cap, headgear
A with B	A, B	Cup with stand -> cup, stand
A of B	B, A	Drawing of a dress -> dress, drawing
A from B	B, A	Page from a sketchbook -> sketchbook, page
A & B	A, B	Cup & saucher -> cup, saucher
A and B	A, B	Cup and saucer -> cup, saucer
A, B	A, B	Bowl, fragment -> bowl, fragment
A or B	A, B	Screen or balustrade -> screen, balustrade
A B	B	Tea cup -> cup

arranged into eight faces (associated concepts, physical attributes, styles and periods, agents, activities, materials and objects) to support catalogue and retrieve items from art, architecture and other visual cultural heritage. In addition to a search system, it provides a search API (http://www.getty.edu/research/tools/vocabularies/obtain/download.html) and each term in the augmented classification list is sent to the API and the parent hierarchy information extracted from the result. The DMM uses caching to reduce the number of requests sent to the AAT and to improve processing speed.

Where concepts are ambiguous and thus there are multiple hierarchies, the concepts from all hierarchies are added to the classification list. We then apply some post-processing on the concepts from the hierarchies. Duplicate concepts are only added once to the classification list. Concepts that end in "genre" or "facet" have that suffix stripped and are then added to the classification list, if not already present. Finally, purely organisational sub-division concepts such as "X by Y" (e.g., "containers by function") are filtered. This is because while they help with organising the AAT, they are not appropriate labels for use in the DMM. The resulting augmented list of classification values is added to the item's meta-data in an additional field.

Similarity vector generation

When creating the groups and when arranging individual items in a group for display, the items are ordered so that similar items are placed together. There are a range of similarity measures that could be used, but here we use a very simple approach introduced in Aletras, Stevenson, and Clough (2013). The similarity measure first creates a LDA model (Blei, Ng, and Jordan 2003) for all items in the collection and then calculates the topic vector for each item. Item similarity can then be calculated using cosine – similarity between pairs of topic vectors.

The LDA model is created based on the contents of the "title", "description", "physical_description" and "notes" fields. For each item the four fields are concatenated and then tokenised using the open-source NLP library Spacy (https://spacy.io). Punctuation and space tokens are filtered and the remaining tokens stored in the item's meta-data. Using these tokens, we generate a 300 topic LDA model using the Gensim topic-modelling library (Rehurek and Sojka 2010). We use Gensim's default dictionary extremes filtering settings of removing all tokens that occur less than 5 times or in more than 50% of all items. However, we use all remaining tokens, rather than the default setting of keeping only the 1,00,000 most frequent tokens. This is necessary as some items have very little text and thus very few tokens. Filtering infrequent tokens would lead to these items not having any topics assigned to them. We then calculate the topic vector for each item and store the resulting vector with the item.

Group generation

The second step is the creation of groups, where each group has between 15 and 120 items in it. The limits are based on experience, but are fully configurable. In particular, the lower boundary can be increased, if the collection is more homogenous and there are fewer uncommon classification values. As shown in Figure 13.1, generating the groups consists of a number of steps. First, the basic groups are generated and post-processed, then they are arranged into a hierarchy, which is then cleaned, before splitting any remaining, large groups.

GENERATING THE BASIC GROUPS

Unlike the initial DMM, which took a top-down approach, in the current DMM we take an iterative, greedy, bottom-up approach to grouping the items. The generation is based on the lists of classification values created earlier during the item processing. In each iteration the algorithm first calculates the frequencies for all classification values of those items that have not yet been assigned to a group. We filter all values that occur less than 15 times and from the remaining values the algorithm selects the value with the fewest occurrences. A new group is created for this value and all unassigned items that have that value are assigned to the new group. The algorithm then moves on to the next iteration, until no values remain that occur at least 15 times.

The reason for selecting the classification value with the fewest occurrences is that this is likely to create more cohesive and size-wise more displayable groups of items. At the same time the greedy, bottom-up approach can lead to a situation, where some items are not allocated to any group, even though they share a concept with at least 15 other items. This is because the other items may have been allocated to another group, based on another concept, reducing the number of unallocated items with the first concept to below 15. For the current collection, the algorithm fails to allocate 101 (0.7%) items. A manual analysis of these items indicates that the majority fall into three categories: items with very specific classifications that neither the NLP nor the AAT processing can group (e.g., "copy of the hedda"), items where there are only one or two of that type in the collection (e.g., "gun"), or concepts for which the AAT API does not return a result (e.g., "Tea-urn").

For future work it may be worth considering whether the similarity vectors could be used to assign the unallocated items to groups. Alternatively, the items may be placed in the "corridors" of the visualisation or simply grouped together in an "Odds & Ends" group.

In the original source data, the classification value is generally in the singular form, while the AAT generally uses the plural form. Because the data-driven generation algorithm does not take this into account, there is the potential for one group to exist with the singular form of a concept and

a second one with the plural form. In a post-processing step, we identify all singular–plural pairs, re-assign the items from the singular to the plural form group, and delete the singular form group. We retain the plural form, as this form is more appropriate when labelling rooms.

ADDING PARENT GROUPS

The DMM does not use the hierarchical structure for navigation by the user. However, when organising the groups into the 2-d layout, we want related groups to be placed close to each other and to achieve that, we need to organise the groups into a hierarchy. In practice, because the AAT is organised into eight facets that do not have a shared parent, there will not be a single hierarchy, but initially up to eight hierarchies.

To create these hierarchies, we first determine the AAT hierarchy for each group's concept. Then for each concept in the hierarchy, a group is created, unless that group already exists and the parent-child relationship between the hierarchy concepts is set. If no match is found in the AAT, then the NLP augmentation, as described earlier, is applied to the group's concept. If for any of the new concepts identified by the NLP augmentation, there is already a group, then the current group is added as a child under that group. If no group exists for any of the concepts identified by the NLP augmentation, then each concept is looked up in the AAT. The current group is then assigned to the first hierarchy that is found in the AAT.

After the hierarchies have been created, two post-processing steps are applied. First, any groups that have only a single child group and no items are pruned, as they don't add any useful information. Second, for any group that has both child groups and items, the items are added into a new group that has the same label as the original group and the new group is added as a child to the original group. This ensures that items are only placed in the leaf nodes, which makes the layouting algorithm simpler.

SPLITTING LARGE GROUPS

At this point there will be a small set of topics with more than 120 items. For the room layouting we have defined 120 items as the maximum number of items per room. These groups thus need to be split into smaller sub-groups, before they can be placed into rooms. When splitting these we treat groups with between 120 and 300 items separately from those with over 300 items. For groups of the first type, we first attempt to split them by time and if that does not produce a split, then they are split by similarity. For the larger groups, we first attempt to split them by one of four attributes ("concepts", "subjects", "materials", "techniques"). If that does not work, then we attempt to split by time and if that does not work, then by similarity.

When splitting by attribute, the approach is similar to that used when generating the basic groups. First we calculate the frequency of all attribute

values, filtering those attribute values that occur less than 15 times or cover more than two-thirds of the items, as neither are appropriate for splitting the group. Next, we check that the remaining attribute values cover at least 90% of the items. We then sort the attribute values by increasing frequency and then iterate over the sorted attribute values, assigning items to the first value that they have. The new groups are all labelled with the label of the original group plus their attribute value. Finally, any items that are not allocated to an attribute value group are placed into a new group with the same label as the original group.

If no attribute can split the group, or if the group has less than 300 items, then an attempt is made to split the group by time. In order to split the group by time, at least 95% of items in the group must have a temporal attribute set. Then the number of items per year is counted and the earliest and latest year determined. If the time span defined by the earliest and latest year is greater than 10 years and less than or equal to 100, the group is split by decade. If the time span is greater than 100, it is split by century. In either case the items are then sorted by the temporal attribute and placed into decade or century bins. Where temporally adjacent bins have less than 100 combined items, the bins are merged. For each unmerged bin, a new sub-group is created, labelled by the name of the parent group and the time period it covers. Any items that do not have a temporal attribute are placed in a new sub-group, with the same label as the original group, as is done when splitting by attribute case.

Finally, if neither attribute nor temporal splitting are possible, then the large groups are split into smaller groups using the item similarity. In this approach the items are first sorted using a greedy algorithm. The first item is copied from the input list to the sorted list and set as the current item. Then the current item's similarity to all unsorted items is calculated, using cosine similarity of the topic vectors calculated earlier. The most similar item is added to the sorted list and set as the current item. This is repeated until all items have been sorted. The sorted list is then split evenly into bins, with the number of bins calculated as the number of items in the group divided by 100. For each bin a new sub group is added, with the same label as the original group.

> Overall, for the 14,351 items, the algorithm generates a total of 390 groups in 7 hierarchies. Of these 286 are leaf groups, which contain items, and which are used in the next layouting step.

Room layouting

Unlike the group generation, which is completely automatic, the room layouting requires some manual input: a 2-d floor layout, a list of rooms with their maximum sizes, and the order in which the rooms should be processed. Each room has a set maximum number of items that it can contain. In the hierarchies created in the previous step, only the leaf nodes contain

items, so only those are fed into the room layouting algorithm. To ensure that related leaf nodes are placed as closely as possible, the list of leaf groups to layout is generated by walking the trees in a depth-first manner.

To assign the groups to rooms, the algorithm loops over the list of rooms. It then checks if the next unassigned group has less items than the room can contain. If this is the case, then the group is assigned to the room. Then the algorithm repeats this process for the next unassigned group. If the next unassigned group has more items than the current room can contain, then that room is left "unused".

If, after all rooms have been assigned one or more groups, there are still unassigned groups, a new "floor" is created with a new list of rooms and the assignment algorithm restarts with the new list of rooms. This process is repeated until all groups have been assigned to rooms. In the case of the example collection, the 286 leaf groups are assigned to 286 rooms, spread over 5 floors (an example of a single floor's layout is shown in Figure 13.2). The rooms, spread across the floors, together with the assigned groups are then used by the browsing interface to let the user explore the collection.

Browsing interface

Figure 13.2 shows the main floor plan interface the users use to explore the collection. As the screenshot shows, because the floorplan is provided, the resulting layout looks very natural and similar to a physical museum's layout. Using the arrows next to the floor number, the user can move between

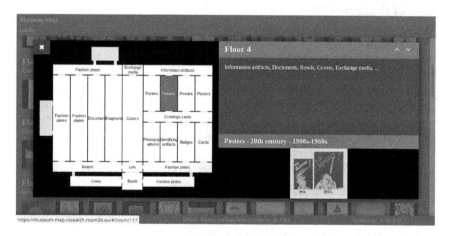

Figure 13.2 The Museum Map browsing interface showing the floorplan interface for exploring the collection in the foreground and the grid of items for a single room in the background. The currently visited room is highlighted, as is the room the user has moved their mouse over. For the room the user's mouse is hovering over, a preview is shown in the bottom-left corner.

the different floors. When moving the mouse over the floorplan, the user is shown a sample image taken from the items in that room. We are currently experimenting with how many samples to show and how to generate a brief textual summary of the items, to give the user a better idea of what the room contains.

When viewing a room, the items are arranged based on the similarity vectors calculated earlier and sorted using the greedy algorithm described earlier. To navigate between the rooms the user can always show the floorplan. Additionally, where the map shows "doors" between the current room and another room, a link is shown in the room view, allowing the user to move from room to room, exploring the museum. By clicking on a single item, the user can show a relatively standard detail-view of the item and its meta-data.

Conclusion

The digital cultural heritage collections created through the digitisation of GLAMs' holdings have made available vast numbers of digital items to everybody. However, non-specialist users generally lack the expertise needed to access these successfully. Various approaches have been made to open the digital collections of GLAMs to wider audiences. From improving simple search boxes by adding facets to the search interface, all the way to browsable, visual interfaces under the label of rich prospect browsing or generous interfaces designed to overcome the inadequacies of the search-only and faceted search interfaces (Vane 2020). However, none of the browsable, visual interfaces have seen any widespread uptake, in part because they are time-consuming and expensive to design and develop and are usually built for one specific collection (Haskiya 2019). As a result, they tend not to be applied to collections other than the one they were made for.

The open-source DMM system presented in this chapter addresses this limitation by providing a generous, browsing-based interface that can be applied to any collection and that generates the interface with minimal manual input (https://github.com/scmmmh/museum-map, https://museum-map.research.room3b.eu/).

This chapter illustrates that while there has been some work looking at moving beyond search as the interface for exploring large DCH collections, the area is still in its infancy and has a large number of open questions that need investigation, some of which are discussed below.

The biggest is how to evaluate the success of an interface designed for open-ended exploration. As such an interface is designed for users with no or at most a very vague information need, how does one judge to what degree the interface has worked for them? Is it a success if the users are engaged with the system? If they spend longer exploring than with standard search systems? If they return at a later point? If they show an increase in

knowledge of some kind? Developments in this area are particularly crucial, as they will enable comparisons between solutions, transforming research in this area from the current more exploratory approach into a more formal structure.

Another major direction for future work highlighted by this chapter is how to generate an overview or summary of the items in the collection. Such an overview would always be based on a sample drawn from the collection and the sample would have to be both representative of the whole collection and also enticing enough that it engages users and encourages exploration. This requires developing an understanding of what makes a "good" sample, what makes an "interesting" item to sample from the collection, and how these items should be tied together and presented to the user. It is also necessary to investigate whether such an overview sample should be static, change with each viewing or mix static and dynamically selected items.

How to make browsing interfaces scale not just to tens of thousands of items, but to millions of items, is another open research question for browsing systems. The DMM interface enables one possible approach, which is grouping together the "floors" into "wings", "galleries" or "museums" to create a navigation hierarchy, allowing the visual metaphor to scale. Scaling to this size also requires the addition of some kind of horizontal browsing support, most likely in the form of recommendations. While there has been much work on recommendation in general, little is known about what type of recommendation users would like to see in a DCH context, in particular how interested and open users are towards recommendations that have the potential to surprise them.

While there has been some work on integrating search and browse functionality into one combined interface (Hall 2014; Golub 2018), in general they are often treated as separate interaction modes. How to integrate the two more deeply and allow for the user to seamlessly switch between them remains an open question.

Finally, in addition to evaluating the system as a whole, we are also in the process of setting up evaluations for individual parts of the DMM, including the classification augmentation, similarity calculation, and group generation, in order to develop an in-depth understanding of how to create a high-quality structure for exploration.

Bibliography

Agirre, Eneko, Nikolaos Aletras, Paul Clough, Samuel Fernando, Paula Goodale, Mark Hall, Aitor Soroa, and Mark Stevenson. 2013. "Paths: A System for Accessing Cultural Heritage Collections." In *Proceedings of the 51st Annual Meeting of the Association for Computational Linguistics: System Demonstrations*, 151–156. Madison, WI: Association for Computational Linguistics, Omnipress, Inc.

Aletras, Nikolaos, Mark Stevenson, and Paul Clough. 2013. "Computing Similarity between Items in a Digital Library of Cultural Heritage." *Journal on Computing and Cultural Heritage (JOCCH)* 5 (4): 1–19.

Bates, Marcia J. 1989. "The Design of Browsing and Berrypicking Techniques for the Online Search Interface." *Online Review* 13 (5): 407–424.

Bates, Marcia J. 2007. "What is Browsing-Really? A model Drawing from Behavioural Science Research." *Information Research* 12 (4). http://InformationR. net/ir/12-4/paper330.html

Belkin, Nicholas J., Robert N. Oddy, and Helen M. Brooks. 1982. "Ask for Information Retrieval: Part I. Background and Theory." *Journal of Documentation* 38 (2): 61–71. https://doi.org/10.1108/eb026722

Biedermann, Bernadette. 2017. "'Virtual Museums' as Digital Collection Complexes. A Museological Perspective Using the Example of Hans-Gross-Kriminalmuseum." *Museum Management and Curatorship* 32 (3): 281–297.

Blei, David M., Andrew Y. Ng, and Michael I. Jordan. 2003. "Latent Dirichlet Allocation." *The Journal of Machine Learning Research* 3: 993–1022.

Blei, David M., Thomas L. Griffiths, Michael I. Jordan, and Joshua B. 2003. Tenenbaum. *Hierarchical Topic Models and the Nested Chinese Restaurant Process.* NIPS 16, Cambridge, Masachusetts: MIT Press.

Borgman, Christine L. 2010. "The Digital Future is Now: A Call to Action for the Humanities." *Digital Humanities Quarterly* 3 (4).

Charles, Valentim, Hugo Manganinhas, Antoine Isaac, Nuno Freire, and Sergiu Gordea. 2018. "Designing a Multilingual Knowledge Graph as a Service for Cultural Heritage–Some Challenges and Solutions." In *International Conference on Dublin Core and Metadata Applications*, 29–40, Dublin Core Metadata Initiative [Online].

Coburn, John. 2016. "I Don't Know What I'm Looking for: Better Understanding Public Usage and Behaviours with Tyne & Wear Archives & Museums Online Collections." *MW2016: Museums and the Web 2.* https://mw2016. museumsandtheweb.com/paper/i-dont-know-what-im-looking-for-better-understanding-public-usage-and-behaviours-with-tyne-wear-archives-museums-online-collections/

Coudyzer, Eva, and Anna van den Broek. 2015. "Europeana Exhibitions: A Virtual Trip through Europe's Cultural Heritage, Interview with Anna van den Broek." *Uncommon Culture* 6(11): 47–54.

Denbo, Seth, Heather Haskins, and David Robey. 2008. "Sustainability of Digital Outputs from AHRC Resource Enhancement Projects." *Arts and Humanities Research Council.* www.ahrcict.rdg.ac.uk/activities/review/sustainability08.pdf

Descy, Don E. 2009. "Grooker, KartOO, Addict-o-Matic and More: Really Different Search Engines." *TechTrends* 53 (3): 7–8.

Düring, Marten, Lars Wieneke, and Vincenzo Croce. 2015. "Interactive Networks for Digital Cultural Heritage Collections-Scoping the Future of Historiography." [JV1] In *Engineering the Web in the Big Data Era. ICWE 2015. Lecture Notes in Computer Science,,* edited by Philipp Cimiano, Flavius Frasincar, Geert-Jan Houben, and Daniel Schwabe, 9114: 613–616. Cham: Springer. https://doi. org/10.1007/978-3-319-19890-3

Eklund, Janice L. 2011. "Cultural Objects Digitization Planning: Metadata overview." *Visual Resources Association Bulletin* 38 (1).

Falk, John H. 2016. *Identity and the Museum Visitor Experience.* London: Routledge.

Feinberg, Jonathan. 2010. "Wordle". *Beautiful Visualization Looking at Data through the Eyes of Experts*, 37–58. Sebastopol, CA: O'Reilly Media.

Fernando, Samuel, Mark Hall, Eneko Agirre, Aitor Soroa, Paul Clough, and Mark Stevenson. 2012. "Comparing Taxonomies for Organising Collections of

Documents." *Proceedings of COLING 2012*, edited by Martin Kay, and Christian Boitet, 879–894. Mumbai: Indian Institute of Technology Bombay.

Foo, B. 2016. "NYPL-publicdomain/pd-visualization". *GitHub Repository*. San Francisco, CA: GitHub. https://github.com/nypl-publicdomain/pd-visualization

Giacometti, Alejandro. 2009. *"The Textiles Browser. An Experiment in Rich-Prospect Browsing for Text Collections."* *Master's* thesis. Edmonton Canada: University of Alberta.

Glinka, Katrin, Christopher Pietsch, and Marian Dörk. 2017. "Past Visions and Reconciling Views: Visualizing Time, Texture and Themes in Cultural Collections." *DHQ: Digital Humanities Quarterly* 11 (2).

Golub, Koraljka. 2018. "Subject Access in Swedish Discovery Services." *Knowledge Organization* 45 (4): 297–309.

Greene, Stephan, Gary Marchionini, Catherine Plaisant, and Ben Shneiderman. 2000. "Previews and Overviews in Digital Libraries: Designing Surrogates to Support Visual Information Seeking." *Journal of the American Society for Information Science* 51 (4): 380–393.

Hall, Mark M. 2014. "Explore the Stacks: A System for Exploration in Large Digital Libraries." In *IEEE/ACM Joint Conference on Digital Libraries*, 417–418. NJ: IEEE.

Hall, Mark Michael, Oier Lopez de Lacalle, Aitor Soroa, Paul Clough, and Eneko Agirre. 2012. "Enabling the Discovery of Digital Cultural Heritage Objects Through Wikipedia." In *Proceedings of the 6th Workshop on Language Technology for Cultural Heritage, Social Sciences, and Humanities*, 94–100. PA: Association for Computational Linguistics.

Hall, Mark Michael. 2018. "Digital Museum Map." In *Digital Libraries for Open Knowledge. TPDL 2018. Lecture Notes in Computer Science*, vol. 11057, edited by Eva Méndez, Fabio Crestani, Cristina Ribeiro, Gabriel David, João Correia Lopes, 304–307. Cham: Springer. https://doi.org/10.1007/978-3-030-00066-0_28

Hall, Mark, and Paul Clough. 2013. "Exploring Large Digital Library Collections Using a Map-Based Visualisation." In *International Conference on Theory and Practice of Digital Libraries, TPDL 2013. Lecture Notes in Computer Science*, vol. 8092, edited by Trond Aalberg, Christos Papatheodorou, Milena Dobreva, Giannis Tsakonas, and Charles J. Farrugia, 216–227. Berlin: Springer. https://doi.org/10.1007/978-3-642-40501-3_21

Hall, Mark, Paul Clough, and Mark Stevenson. 2012. "Evaluating the Use of Clustering for Automatically Organising Digital Library Collections." In *International Conference on Theory and Practice of Digital Libraries, TPDL 2012. Lecture Notes in Computer Science*, vol. 7489, edited by Panayiotis Zaphiris, George Buchanan, Edie Rasmussen, and Fernando Loizides, 323–334. Berlin: Springer.

Hall, Mark, Paula Goodale, Paul Clough, and Mark Stevenson. 2014. "The PATHS System for Exploring Digital Cultural Heritage." In *Proceedings of the Digital Humanities Congress 2012*. In Studies in the Digital Humanities, edited by Clare Mills, Michael Pidd, and Esther Ward. Sheffield: The Digital Humanities Institute. https://www.dhi.ac.uk/openbook/chapter/dhc2012-hall

Haskiya, David. 2019. "An Evaluation of Generous Interfaces." *EuropeanaTech Insight*, vol. 11. https://pro.europeana.eu/page/issue-11-generous-interfaces#an-evaluation-of-generousinterfaces

Hearst, Marti A. 2006. "Clustering Versus Faceted Categories for Information Exploration." *Communications of the ACM* 49 (4): 59–61.

Hibberd, Georgina. 2014. "Metaphors for Discovery: How Interfaces Shape Our Relationship with Library Collections." *The Search Is Over. International Workshop in Conjunction with DL2014, 11-12 Sep 2014 in London.* https:// searchisover.org/papers/hibberd.pdf

Hinrichs, Uta, Holly Schmidt, and Sheelagh Carpendale. 2008. "EMDialog: Bringing Information Visualization into the Museum." *IEEE Transactions on Visualization and Computer Graphics* 14 (6): 1181–1188. doi: 10.1109/TVCG.2008.127

Koch, Traugott, Koraljka Golub, and Anders Ardö. 2006. "Users Browsing Behaviour in a DDC-Based Web Service: A Log Analysis." *Cataloging & Classification Quarterly* 42 (3–4): 163–186.

Lang, Bo, Xianglong Liu, and Wei Li. 2013. "The Next-Generation Search Engine: Challenges and Key Technologies." In *Recent Progress in Data Engineering and Internet Technology, Lecture Notes in Electrical Engineering*, vol. 156, edited by Ford Lumban Gaol, 239–248, Berlin: Springer.

Lardera, Marco, Claudio Gnoli, Clara Rolandi, and Marcin Trzmielewski. 2018. "Developing SciGator, a DDC-Based Library Browsing Tool." *Knowledge Organization* 44 (8): 638–643.

Lin, Xia, Michael Khoo, Jae-Wook Ahn, Doug Tudhope, Ceri Binding, Diana Massam, and Hilary Jones. 2017. "Mapping Metadata to DDC Classification Structures for Searching and Browsing." *International Journal on Digital Libraries* 18 (1): 25–39.

Liu, Xueqing, Yangqiu Song, Shixia Liu, and Haixun Wang. 2012. "Automatic Taxonomy Construction from Keywords." In *Proceedings of the 18th ACM SIGKDD International Conference on Knowledge Discovery and Data Mining*, edited by Qiang Yang et al., 1433–144. https://doi.org/10.1145/2339530.2339754

Lohmann, Steffen, Jürgen Ziegler, and Lena Tetzlaff. 2009. "Comparison of Tag Cloud Layouts: Task-Related Performance and Visual Exploration." In *IFIP Conference on Human-Computer Interaction*, 392–404, Berlin: Springer.

Luu, Anh Tuan, Yi Tay, Siu Cheung Hui, and See Kiong Ng. 2016. "Learning Term Embeddings for Taxonomic Relation Identification Using Dynamic Weighting Neural Network." In *Proceedings of the 2016 Conference on Empirical Methods in Natural Language Processing*, 403–413. PA: Association for Computational Linguistics.

Marchionini, Gary, Catherine Plaisant, and Anita Komlodi. 2003. "The People in Digital Libraries: Multifaceted Approaches to Assessing Needs and Impact." In *Digital Library Use: Social Practice in Design and Evaluation*, edited by Ann Peterson Bishop, Nancy A. Van House, Barbara P. Buttenfield, and Bruce Schatz, 119–160. Cambridge, MA: MIT Press.

Marchionini, Gary. 2006. "Exploratory Search: From Finding to Understanding." *Communications of the ACM* 49 (4): 41–46.

Mauri, Michele, Azzurra Pini, Daniele Ciminieri, and Paolo Ciuccarelli. 2013. "Weaving Data, Slicing Views: A Design Approach to Creating Visual Access for Digital Archival Collections." In *Proceedings of the Biannual Conference of the Italian Chapter of SIGCHI*, edited by Antonella De Angeli, Fabio Paternò, Franca Garzotto, and Massimo Zancanaro, 1–8. New York, NY: Association for Computing Machinery.

Mauricio Yagui, Marcela Mayumi, Luís Fernando Monsores Passos Maia, Jonice Oliveira, and Adriana Vivacqua. 2019. "A Crowdsourcing Platform for Curating Cultural and Empirical Knowledge. A Study Applied to Botanical Collections." In *IEEE/WIC/ACM International Conference on Web Intelligence-Companion Volume*, 322–326. New York, NY: Association for Computing Machinery. https://doi.org/10.1145/3358695.3360920

Mayr, Eva, Paolo Federico, Silvia Miksch, Günther Schreder, Michael Smuc, and Florian Windhager. 2016. "Visualization of Cultural Heritage Data for Casual Users." In *IEEE VIS Workshop on Visualization for the Digital Humanities*, 1.

Meehan, Nicole. 2020. "Digital Museum Objects and Memory: Postdigital Materiality, Aura and Value." *Curator: The Museum Journal*. https://doi.org/10.1111/cura.12361

Milne, David N., Ian H. Witten, and David M. Nichols. 2007. "A Knowledge-based Search Engine Powered by Wikipedia." In *Proceedings of The Sixteenth ACM Conference on Conference on Information and Knowledge Management*, 445–454. New York, NY: Association for Computing Machinery.

Navigli, Roberto, Paola Velardi, and Aldo Gangemi. 2003. "Ontology Learning and its Application to Automated Terminology Translation." *IEEE Intelligent systems* 18 (1): 22–31.

Petersen, Toni. 1990. *Art & Architecture Thesaurus*. Oxford: Oxford University Press.

Rao, Ramana, Jan O. Pedersen, Marti A. Hearst, Jock D. Mackinlay, Stuart K. Card, Larry Masinter, Per-Kristian Halvorsen, and George C. Robertson. 1995. "Rich Interaction in the Digital Library." *Communications of the ACM* 38 (4): 29–39.

Rehm, Georg, Martin Lee, Julián Moreno-Schneider, and Peter Bourgonje. 2019. "Curation Technologies for Cultural Heritage Archives: Analysing and Transforming a Heterogeneous Data Set into an Interactive Curation Workbench." In *Proceedings of the 3rd International Conference on Digital Access to Textual Cultural Heritage*, 117–122. New York, NY: Association for Computing Machinery.

Rehurek, Radim, and Petr Sojka. 2010. "Software Framework for Topic Modelling with Large Corpora." In *Proceedings of the LREC 2010 Workshop on New Challenges for NLP Frameworks*, 45–50. Valletta, Malta: ELRA.

Rice, Ronald E., Maureen McCreadie, and Shan-Ju L. Chang. 2001. *Accessing and Browsing Information and Communication*. Cambridge, MA: MIT Press.

Ruecker, Stan, Milena Radzikowska, and Stéfan Sinclair. 2011. *Visual Interface Design for Digital Cultural Heritage: A Guide to Rich-Prospect Browsing*. Farnham: Ashgate Publishing.

Russell-Rose, Tony, and Tyler Tate. 2012. *Designing the Search Experience: The Information Architecture of Discovery*. Burlington: Morgan Kaufmann.

Sanderson, Mark, and Bruce Croft. 1999. "Deriving Concept Hierarchies from Text." In *Proceedings of the 22nd Annual International ACM SIGIR Conference on Research and Development in Information Retrieval*, 206–213. New York, NY: Association for Computing Machinery.

Shneiderman, Ben. 2003. "The Eyes Have it: A Task by Data Type Taxonomy for Information Visualizations." In *The Craft of Information Visualization*, edited by Benjamin B. Bederson, and Ben Shneiderman, 364–371. Burlington: Morgan Kaufmann.

Simon, Rainer, Leif Isaksen, Elton TE Barker, and Pau deSoto Cañamares. 2016. "Peripleo: a Tool for Exploring Heterogenous Data through the Dimensions of Space and Time." *Code4Lib Journal* 31. https://journal.code4lib.org/articles/11144

Sinclair, James, and Michael Cardew-Hall. 2008. "The Folksonomy Tag Cloud: When is it Useful?" *Journal of Information Science* 34 (1): 15–29.

Skov, Mette, and Peter Ingwersen. 2008. "Exploring Information Seeking Behaviour in a Digital Museum Context." In *Proceedings of the second international symposium on Information interaction in context*, edited by Pia Borlund, Jesper W. Schneider, Mounia Lalmas, Anastasios Tombros, John Feather, Diane Kelly, and Arjen P. de Vries, 110–115. New York, NY: Association for Computing Machinery.

Speakman, Robert, Mark Michael Hall, and David Walsh. 2018. "User Engagement with Generous Interfaces for Digital Cultural Heritage." In *International Conference on Theory and Practice of Digital Libraries*, vol. 11057, edited by Eva Méndez, Fabio Crestani, Cristina Ribeiro, Gabriel David and João Correia Lopes, 186–191. Cham: Springer.

Stoica, Emilia, Marti A. Hearst, and Megan Richardson. 2007. "Automating Creation of Hierarchical Faceted Metadata Structures." In *Human Language Technologies 2007: The Conference of the North American Chapter of the Association for Computational Linguistics; Proceedings of the Main Conference*, edited by Candace Sidner, Tanja Schultz, Matthew Stone, and ChengXiang Zhai, 244–251. Rochester, NY: Association for Computational Linguistics.

Sun, Yuyin, Adish Singla, Dieter Fox, and Andreas Krause. 2015. "Building Hierarchies of Concepts via Crowdsourcing." *arXiv preprint arXiv:1504.07302*.

Vane, Olivia. 2020. *Timeline Design for Visualising Cultural Heritage Data*. PhD diss. London, United Kingdom: Royal College of Art.

Vizine-Goetz, Diane. 2006. "Dewey Browser." *Cataloging & Classification Quarterly* 42 (3–4): 213–220.

Walsh, David, Mark M. Hall, Paul Clough, and Jonathan Foster. 2020. "Characterising Online Museum Users: A Study of the National Museums Liverpool Museum Website." *International Journal on Digital Libraries* 21 (1): 75–87.

White, Ryen W., and Resa A. Roth. 2009. "Exploratory Search: Beyond the Query-Response Paradigm." *Synthesis Lectures on Information Concepts, Retrieval, and Services* 1 (1): 1–98.

Whitelaw, Mitchell. 2015. "Generous Interfaces for Digital Cultural Collections." *Digital Humanities Quarterly* 9 (1): 1–16.

Wilson, Mathew, Jonathan Hurlock, and Max Wilson. 2012. "Keyword Clouds: Having Very Little Effect on Sensemaking in Web Search Engines." In *CHI'12 Extended Abstracts on Human Factors in Computing Systems*, edited by Joseph A. Konstan, Ed H. Chi, and Kristina Höök, 2069–2074. New York, NY: Association for Computing Machinery.

Wilson, Max L., and Elsweiler, David. 2010. "Casual-leisure Searching: the Exploratory Search Scenarios that Break Our Current Models". *HCIR 2010*, 28–31. New York, NY: Association for Computing Machinery.

Windhager, Florian, Paolo Federico, Günther Schreder, Katrin Glinka, Marian Dörk, Silvia Miksch, and Eva Mayr. 2018. "Visualization of Cultural Heritage Collection Data: State of The Art and Future Challenges." *IEEE Transactions on Visualization and Computer Graphics* 25 (6): 2311–2330.

Index

AAT (Getty Arts and Architecture Thesaurus) 75, 90, 94, 96, 98, 100, 117, 118, 184, 270, 272–275
accountability 48
Acerbi, Alberto 8
ACL (Lisbon Academy of Sciences) 178, 179, 185
ADCM (ARIADNE Catalogue Data Model) 111
Agency for Cultural Affairs 41
aggregation of objects 58
aggregation services 106
Agirre, Eneko 263
Aiden, Erez Lieberman 171
Aletras, Nikolaos 273
Anderson, Sheila 206
Andrew W. Mellon Foundation 132, 144
annotation process 235 – 236
APEF (Archives Portal Europe Foundation) 108
approaches to automation in archives 248–249
Aquarelle (project) 137
Aquinas, Thomas 8
Arachne database 238
Archaeological Museum of Asklepeion, Epidaurus 123
Archaeological Museum of Tripoli (case study) 106, 112–124
Archaeological Objects Thesaurus 235
archaeological spatial information 230–231
archival description 47
archival research: knowledge-driven methods (rule-based) 250; machine learning techniques 244; topic modelling 244; unsupervised machine learning 251

ARIADNE (Advanced Research Infrastructure for Archaeological Dataset Networking in Europe) 110–111
artificial neural network-based approaches 167
Aston Tate (software company) 135
Authors Guild v. Google, Inc. 163–164
automatically appraising e-mail 247

Babbage, Charles 139, 141, 142
Bachman, Charles 135
Bailey, David 245
Bamboo (project) 143, 145
Barbuti, Nicola 108
Barker, Elton 232
Ben Johnson Walk (project) 232
Beretta, Francesco 111
Berners-Lee, Tim 65
BERT 167
BIBFRAME (Bibliographic Framework) 208
Biblissima (project) 206
Binder, Judith 234
Blei, David M. 8
Bookworm 169–171
Borgman, Christine L. 17, 206
Borland (software company) 135
Boydens, Isabelle 247
British Museum 132
Burawoy, Michael 146
Busa, Fr. *Index Thomisticus* 158
Busa, Roberto 7, 8

C.DnS (Constructive Descriptions and Situation) 111
CCCS (CrossCult Classification Scheme) 118–122

CCKB (CrossCult Knowledge Base), 121–123
CDWA (Categories for the Description of Works of Art) 91, 97
CH (cultural heritage) 87, 88
CH knowledge 264
China Biographical Database 98
CHIs (Cultural heritage institutions) 69, 70
Chiticariu, Laura 250
CIDOC-CRM 48–49, 60, 73, 74, 78, 106–107, 110–111, 115–120, 149, 208–210, 213, 215–218
CIMI (Computer Interchange of Museum Information) 138
City of Edinburgh (project) 232
CLARIN (European Research Infrastructure for Language Resources and Technology) 108, 137
CLDW (Corpus of Lake District Writing project) 231
Clough, Paul 267, 273
CNKI (China National Knowledge Infrastructure) 95, 98
Coburn, John 266
Cohen's kappa coefficient 255
collaborative research projects 220
collection-level description 58
Common Crawl 159
computation text analysis 159
copyright issues of digitized materials 163–164
CQL (Contextual Query Language) 75
cross-collection connections 122
CrossCult Classification Scheme 117
CrossCult project 113, 115–119, 121, 124
Crymble, Adam 210
Cultures of Knowledge (project) 206
Cutter, Charles Ammi 46

DAI (Deutsches Archäologisches Institut) 234
Dai Nippon Printing 41
DARE (Digital Atlas of the Roman Empire) 233
DARIAH (Digital Research Infrastructure for the Arts and Humanities) 108, 183
DaSCH (Swiss Data and Service Center for Humanities) 209
data-driven methods in archiving 250
datafication 89–90
dBASE 135
DBpedia 91, 98, 270

DBpedia concepts 121
DBpedia Spotlight tool 121
DCH (digital cultural heritage) 261, 264
DDC 269
DDP (Digital Dunhuang Project) 92–93
de Haas, Tymon 111
de Morais Silva, Antonio 196
de Sacrobosco, Johannes 215
Delouis, Dominique 136, 137, 138, 139, 141
DEN (Dutch knowledge centre for digital heritage and culture) 108
Descy, Don E. 267
Desrochers, Donna M. 247
Digital Humanities data 108
Digital Periegesis (project) 228, 229, 232, 237, 239–240
Digital Public Library of America 159
digital scholarship 48
digitised heritage objects 44
distant reading practices 8, 11, 16, 157, 161, 251–252
DMM (Digital Museum Map) 262, 270 – 278
DMT (Dunhuang mural thesaurus) 95–96, 98, 99, 101
DOLCE (Descriptive Ontology for Linguistic and Cognitive Engineering) 111
Dressel, Willow 212
Drucker, Johanna 1, 7, 8, 28, 32
Drucker, Peter F. 141, 142
DSfH (Digital Skill for Heritage) 112
DSM (Digital Single Market) 165
Dubin, David 211, 212, 214
Dublin Core 118, 212
Dunhuang Academic Resources Database) 95
Dunhuang CH dataset 93–97, 100
Dunhuang Dictionary 95
Dunhuangology 88, 92–95, 101
Düring, Marten 267
Dynamic Programming 96

EAC-CPF (Encoded Archival Context – Corporate bodies, Persons, Families) 246
EAD (Encoded Archival Description) 208
ECHO initiative 207
EDM (Europeana Data Model) 78, 212
Edmonds, Dean 249
EDRMS (electronic document and records management systems) 246

EF Dataset features 168
electronic records management 245
Ellison, John W. 158
ELMO 167
e-mail appraisal behaviour 247
Englebart, Douglas 142
E-RIHS (European Research
 Infrastructure for Heritage
 Science) 108
ESFRI (European Strategy Forum on
 Research Infrastructures) 206
ethics 48
EU Vocabularies 184
EuroGov 253
EuroParl 235
Europeana 68, 70, 76, 89, 90, 108, 111,
 124, 137, 159
Europeana Semantic Enrichment
 Framework 89
EuroVoc multilingual thesaurus 118;
 for topic modelling (TM) 245, 252,
 254–255

FAIR data principles 67, 106, 107–112,
 179
Fan, Jinshi 92
feature extraction 166
Felicetti, Achille 109
FISH, the Forum of Information
 Standards in Heritage
 Vocabularies 235
Flanders, Julia 7
FMIS 71
FOAF (Friend-of-a-Friend) 73, 79
FRBR (Functional Requirements for
 Bibliographic Records) 209, 216
FRBRoo (Functional Requirements
 for Bibliographic Records, object
 oriented) 209, 216, 218
Free Music Archive 166

Gardiner, Eileen, 4
General Catalogue of Dunhuang
 Caves 95
Geographic Information Science
 227, 231
Geographical Text Analysis 231
GeoNames 75, 91, 98
Giant Global Graph 91
GIS (Geographic Information System)
 227–231
GLAM community 87, 261
GLAM digital collections 263–264
GLAM institutions (sector) 106, 111, 124

GLAM websites 261, 263–264
Glinka, Katrin 266
GND (Gemeinsame Normdatei) 91
Google Books (project) 159, 160, 161
Google NGrams Viewer and Dataset
 160, 166, 171
GVP Ontology (Getty Vocabulary
 Program Ontology) 99

Hall, Mark 267, 270
harmonisation of library and archival
 models for resource description 44,
 52–53
HathiTrust Digital Library 158, 160,
 162–173
Heaney, Michael 48, 55
Hennesy, Cody 168
Heritage Connector (project) 111
Heritage Data Reuse Charter 108
Hestia (project) 232
Hinrichs, Uta 267
HMM (Hidden Markov Model) 96
Hobsbawm, Eric 142, 148
Holm, Poul 59
Hölscher, Tonio 234
HTRC (HathiTrust Research Center)
 158, 160–161, 162–173
HTRC Data Capsule 165, 171, 172

ICA (International Council on
 Archives) 45
ICT (Information and Communication
 Technologies) 106
IDS (Integrated Data Store) 135
IFLA (International Federation
 of Library Associations and
 Institutions) 45
IFLA's Permanent UNIMARC
 Committee 45
IMLS Digital Collections and
 Content 159
<indecs> 48
interfaces: 262–265; browsing-based
 interface 262, 265; exploratory
 search interfaces 262; faceted
 search interfaces 264–265; generous
 interface 265–266; manually curated
 exhibitions 265; rich prospect
 browsing 265; visualization
 266–267
Internet Archive 159–161
interoperability 182
IRI (Internationalized Resource
 Identifiers) 65, 66, 68, 70

ISAAR(CPF) (International Standard Archive Authority Record for Corporate Bodies Persons and Families) 45
ISAD(G) (General International Standard Archival Description) 51
ISBD (International Standard Bibliographic Description) 45
ISMI (The Islamic Scientific Manuscripts Initiative) 213
ISO 21127 *see* CIDOC-CRM
ISO 25964-1: 2011 178
ISSN (International Standard Serial Number) 47

Jannidis, Fotis 7
Jarrick, Arne 59
JDTA metadata model 40
Jockers, Matthew 164
JSTOR's Data for Research 166
Jupyter Notebooks (project) 216

Kiesling, J. Brady 234
Kilgour, Frederick G. 7
Kiryakos, Senan 40
KO (Knowledge organisation) 97, 181
Koch, Traugott 261
KOS (knowledge organisation system) 88, 91, 181, 183
Koster, Lukas 108
Kräutli, Florian 216
Kringla 70, 76
Kumar, Manoj 211
Kumar, Sampath 211

Lakatos, Imre 146
LCC (Library of Congress Classification) number 161
LCSH (Library of Congress Subject Headings) 90, 118, 269
LDA (Latent Dirichlet Allocation) 245, 269, 273
LDA algorithm 251, 253–256
LDN (Linked Data Notifications) 69
lexicographic works 178, 180, 181
LexisNexis 159
Library of Congress's Twitter Archive 159
LIDO 212
LINCS (Linked Infrastructure for Cultural Scholarship) 150
Linked Data 210, 246
Linked Data aggregation 65, 68, 69
Linked Data model 66, 68

Linked Data ontologies 66
Linked Data principles 109
Linked Data vocabularies 109
Linked Jazz (project) 90
Linked Open Data initiative 213
List of Protected Cultural Heritage by the Ministry of Culture and Media of the Republic of Croatia 49
LLOD (Linguistic Linked Open Data Cloud) 184
LOD (Linked Open Data) 64, 229, 233
LOD-DMT 94, 97, 99–101
Löwgren, Jonas 148–149
LRM (Library Reference Model) 45, 49, 52
Luhn, Hans Peter 8
Lui, Alan 137

MADB (project) 41
MARC (Machine Readable Cataloging) 138, 208
Max Planck Digital Research Infrastructure 215, 217–218, 220
Mayernik, Matthew 2
metadata aggregation 64
Metadata licencing 66–68, 71–72; Creative Commons (CC) 66; Creative Commons Zero (CC0) 66; Creative Commons Attribution (CC BY) 66; Open Data Commons licenses 67
Metalexicography 181
Metaphacts Open Platform 209
Metaphacts system 216
Michel, Jean-Baptiste 171
Million Song Dataset 166
Minsky, Marvin 249
MIR (music information retrieval) 166
Monument Material Thesaurus 235
MORDigital project 196
Moretti, Franco 8, 251
Morpurgo bookstore 49
Morpurgo repository 55, 58–59
Morpurgo Topotheque, The 49, 50, 58, 60
multifaceted description 46
Museum Computer Network Initiative 138
Museum of Gothenburg 77
Musto, Roland G. 4

Nagamori, Mitsuharu 40
Nakanishi, Tomonori 40
NARA (National Archives and Records Administration) 248, 249

NER (Named Entity Recognition) 231, 232, 234
NERL (Named Entity Recognition and Linking process) 121
Newman, David 251, 255
Nietzsche, Friedrich 247
NLP (Natural Language Processing) methods 94, 115, 231, 232, 246
NLP library Spacy 273
Nowviskie, Bethany 211

O'Sullivan, James 207
OAI-PMH (Open Archives Initiative Protocol for Metadata Harvesting) standard 71, 72
Object Material Thesaurus, 235
OED (Oxford English Dictionary) 145
Oldman, Dominic 208
Open Content Alliance 160
Open Data Commons Attribution License (ODC-By) 231
OpenCalais 90
OpenHeritage (project) 137
OpenRefine 98, 100
OWL (Web Ontology Language) 66, 73, 90, 109, 110, 121, 184

Palmetto Toolbox 254
Panizzi, Anthony. Ninety-One Cataloguing Rules 46
PARTHENOS (Pooling Activities, Resources and Tools for Heritage E-research Networking, Optimization and Synergies) (project) 107, 209
PATHS project 268
Pausanias 227, 228, 229, 232–238
PeriodO 75, 237
Pisanski, Jan 60
PM-DCH (Preservation Metadata for Digital Cultural Heritage) 91, 97
Popovici, Bogdan F. 51
Portal 171–172
Project Gutenberg 159
Python (programming language) 253

Qin, Jian 2

Radzikowska, Milena 261, 265
RAMA (Remote Access to Museum Archives) project 136, 137, 150
Ranganathan, Shiyali Ramamrita 46
RDA (Resource Description and Access) 2, 45

RDF Schema (Resource Description Framework) 65, 66, 68, 73, 90, 108–110, 184, 209, 216
Rebelo Goncalves, Francisco 186
Recogito (annotation platform) 229, 233, 234, 237–240
records management: typology of methods 246
records recontextualisation 47
Reed, Ashley 211
ResearchSpace (project) 132–133, 144–151, 209
Rey-Debove, Josette 185
RiC (Records in Contexts: A Conceptual model for Archival Description) 45, 49; Record 51; Record resource 51; Record set 51; Record Part 51
Riksantikvarieämbetet 70
Roe, Glenn 251
Rosch, Eleanor 135
Rosenblatt, Frank 249
Roth, Resa A. 264
RSLP (Research Support Libraries Programme) 48
Ruecker, Stan 261, 265
Runor (platform) 77

Sag, Matthew 164
Samberg, Rachael Gayza 168
Saracevic, Tefko 181
Scaife Digital Library 232
Schmidt, Benjamin M. 171
School Posters (digital exhibition) 77
Schreibman, Susan 4
Schultz, Jason 164
Scott, Dominic 59
SEASR (Software Environment for the Advancement of Scholarly Research) 172
SeCo (Semantic Computing Research Group) 90
Sellers, Jordan 167
semantic enrichment 89–91, 101–102
Semantic enrichment and data augmentation 119
semantic ontology infrastructure 90
Siemens, Ray 4
Sinclair, Stéfan 261, 265
SKOS (Simple Knowledge Organization System) 66, 110, 179, 183, 185, 188, 196, 212
SKOS-XL 184, 190–192
Smith, Adam 142

SNAC (Social Networks and Archival
 Context) project 246
SNARC (stochastic neural analog
 reinforcement calculator) 249
SOCH (Swedish Open Cultural
 Heritage) 64, 69–82
SOCH API 77
SOCH attributes 74–75
Sound & Science: Digital Histories
 (project) 214
SPARQL Query Language 108, 109,
 122, 210, 216
Speakman, Robert 266
Sperberg-McQueen C. M. 211, 212, 214
Stevenson, Mark 273
Stigler, Johannes Hubert 212
Stolterman, Erik 148–149
Suominen, Arho 251, 233

tagging: persons 236–237; relations
 237–238; time 236–237
Tasovac, Toma 182
TEI (Text Encoding Initiative) 179, 183,
 185, 212, 233
TEI Consortium 183
TEI Lex-0 183, 188, 192 – 197
Terra delle Gravine (project) 108
text classification 251
text mining and analysis 167
textual narrative and data 147–148
TGN (Getty Thesaurus for Geographic
 Names) 231
Thaller, Manfred 136
the Digital Heritage Lab 112
The Sphere: Knowledge System
 Evolution and the Shared Scientific
 Identity of Europe (project)
 215, 216, 220
Theimer, Kate 46, 47
thesauri 182
TM (topic modelling) 244
token count approach 167
Topić, Nada 49
traditional archival principle of
 provenance 47
transnational heritage 230
transparency 48
trustworthiness 48
Tsubouchi Memorial Theatre Museum
 of Waseda University 40

Turing's Learning Machine 249
Tzitzikas, Yannis 212

UGC Hub (User generated content)
 76, 79
Underwood, Ted 167
UNESCO World Digital Library
 Project 87
UNIMARC format 45
Unsworth, John 4, 157
URI (Uniform Resource Identifiers) 65,
 91, 109, 184, 210, 233

Valleriani, Matteo 216
Van Hooland, Seth 247
van Leusen, Martijn 111
Vassalo, Valentina 109
Vellino, André 247
VIAF (Virtual International Authority
 File) 75
Villena-Román, Julio 250
VI-SEEM (Virtual Research
 Environment in Southeast
 Europe and the Eastern
 Mediterranean) 110
Vlachidis, Andreas 118
VOLP-1940 (project) 178, 179,
 184–197

W3C standard 109, 110, 184
Walsh, David 261, 264
Web Annotation Data Model 233
White, Ryen W. 264
Whitelaw, Mitchell 266
Wikidata 68, 75, 76, 79, 98 99, 237,
 238, 270
Wikimedia 121
Wikimedia Commons 76, 79
Wikipedia 76, 79, 91, 121, 269
Willer, Mirna 45
Windhager, Florian 266
WissKi 209
WordNet 269

XML (Extensible Markup
 Language) 183

Zeng, Marcia Lei 2, 52
Zhlobinskaya, Olga 45
Žumer, Maja 60